LIEUTENANT - COMMANDER
GEORGE FAGAN BRADSHAW R.N., D.S.O., S.M.A.
(1887 - 1960)

- SUBMARINER AND MARINE ARTIST -

AND THE ST IVES SOCIETY OF ARTISTS

With best wishes.

DAVID TOVEY

ABOUT THE AUTHOR

David Tovey was born in 1953 and was educated at his father's preparatory school, Tockington Manor, near Bristol and at Clifton College. He won a scholarship to read Jurisprudence at Pembroke College, Oxford and qualified as a solicitor in 1979. While practising law in London and Cheltenham, he wrote his first book on art, a biography of his great-grandfather, the artist William Titcomb, who lived in St Ives between 1887 and 1905. Being interested in all eras of art from Cornwall, he has for many years been a regular attendee of the Penzance art auctions and it was there that the work of George Bradshaw first came to his attention. A meeting with the Commander's widow, then in her nineties, proved the spur for this book. In 1996, he resigned his partnership and has now completed a three year degree in History of Art at the University of Warwick. He is currently engaged in further art research and in organising exhibitions devoted to Cornish art.

By the same author
W.H.Y.Titcomb - Artist of Many Parts

First published in 2000 by
WILSON BOOKS
11-13 Mill Bank
Tewkesbury
Gloucestershire
GL20 5SD
(01684 850898)
Email:w.books@millavon.fsnet.co.uk
Copyright - D.C.W.Tovey

A catalogue record for this book is available from the British Library
ISBN 0 9538363 0 4

Printed and bound in England by Rowe the Printers, Hayle, Cornwall

Front Cover *Smeaton's Pier, St Ives* (1930) (Oil on paper)

GEORGE FAGAN BRADSHAW
- Submariner and Marine Artist -
AND THE ST IVES SOCIETY OF ARTISTS

CONTENTS

Preface		1
Acknowledgements		2
Introduction		3
1.	Family Background and Naval Training	9
2.	'The Trade'	23
3.	The Simpson School of Painting	39
4.	The Art Colony at St Ives	51
5.	The Formation of the Society	67
6.	The Cynics Confounded	85
7.	Social Pleasures	101
8.	Expanded Horizons	117
9.	The Artists and the Town	127
10.	Celebrations and Tragedies	133
11.	Interior Decorations	151
12.	Reactions to Modern Art in the 1930s	157
13.	O.H.M.S. - Again	163
14.	The Society of Marine Artists	173
15.	The Great Rift	179
16.	The Last Decade	193
17.	Influences, Technique and Appraisal	207
Illustration Acknowledgements		221
Appendix 1 - Specifications of Bradshaw's Submarines		223
Appendix 2 - Bradshaw's Exhibited Works		224
Appendix 3 - Principal Members of the St Ives Society of Artists (1927-1960)		228
Appendix 4 - The St Ives Society of Artists - Committee Members (1927-1957)		242
Selected Bibliography		244
Index		245

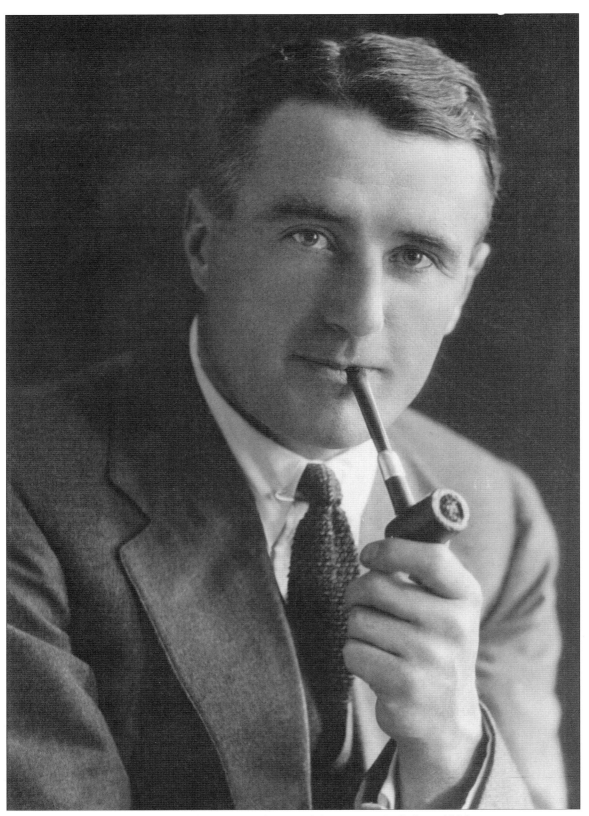

Lieutenant-Commander G.F.Bradshaw R.N., D.S.O., c.1922

PREFACE

This book was inspired by, and is dedicated to, the late Kathleen Bailey, the widow of Lieutenant-Commander George Fagan Bradshaw. At the first of our many meetings, she was already in her nineties but she retained the vivacity of her youth and painted such an evocative picture of life in the St Ives art colony in the 1920s and 1930s that I felt compelled to extend my knowledge. I started by delving into back numbers of the *St Ives Times*. Each time I uncovered relevant events or facts, her memory would come flooding back, breathing life into the bare newspaper reports. Her stories always betrayed her impish sense of fun - gossip and rumour were remembered as much as hard facts.

Although this book is a biography of her first husband, Commander Bradshaw, a marine artist of considerable ability, large sections of it are, in effect, a history of the St Ives Society of Artists, from its formation in 1927 until Bradshaw's death in 1960, as Bradshaw's artistic career was to a significant degree bound up with the fortunes of the Society. Bradshaw was instrumental in the foundation of the Society and maintained a passionate interest in its well-being for the rest of his life.

Behind the phenomenal success of the Society, particularly in the 1930s when many provincial museums hosted touring exhibitions of work by Society members, was a tightly knit group of dedicated professional artists, who determined to work together for the good of the colony as a whole. Accordingly, artists like Moffat Lindner, Borlase Smart, John Park, Fred Milner, Arthur Meade, Herbert Truman, Bernard Ninnes and many others are frequently mentioned and their work referred to, and illustrated, throughout. Although Moffat Lindner and Borlase Smart should be recognised as the key individuals in the Society's development, Bradshaw played a full supporting role, being described by Borlase Smart as "my old faithful one". After Smart's death in 1947, Bradshaw became further involved, being chosen as the spokesman of the traditionalists in the bitter battle with the moderns, which eventually led to the secession of the whole modern contingent amid great acrimony. The book seeks to explain the viewpoint of the traditionalists and why Bradshaw at the relevant meeting in 1949 lost his temper in such spectacular fashion. During the last decade of his life, Bradshaw was the acknowledged elder statesman of the Society, acting at different times as Secretary, Chairman and Vice-President, although he was often impaired by ill-health.

Many contemporary descriptions of Bradshaw's paintings are reproduced, not only because, in some cases, they form the only record of such works but also because they indicate the high esteem in which Bradshaw was held both by his colleagues and the critics. In an age where technique is not always appreciated or valued, it is worth recording the features that drew praise in the past.

In view of the impact that the debate on the respective values of traditional and non-representational art was to have on the colony, I have included comments on the issue by artists connected with St Ives in the 1930s so as to provide further background to the crisis that beset the St Ives Society of Artists in the late 1940s. These reveal the difficulties that many of the artists had with the modern movement and highlight the complete conversion experienced by Borlase Smart.

In order to evoke the era and the mind-set of many of the people of the time, certain non-artistic events, which would have dominated life in St Ives, are mentioned - events such as the loss of the *Trevessa* in 1923, the King's Jubilee in May 1935, the wreck of the *Alba* in 1938 and the lifeboat disaster of 1939. These are occasions when the artists would have been at one with the townspeople in their joy and in their sorrow, but there were other times when the artists had

stormy confrontations with the Town Council over such issues as slum clearance, slot machines and tourism, and with the local Methodists over working on Sundays and alcohol. The use of contemporary descriptions of the town by visitors helps to complete the picture of life at the time.

Bradshaw's background and Naval career are no less interesting. Coming from a distinguished family that had fallen on hard times, he was sent off to the Naval training ship, *H.M.S.Britannia*, at the age of fifteen and, upon admittance, decided to join the fledgling Submarine Service. My research into these pioneering days leaves me lost in admiration at the bravery of the men who risked their lives in these experimental craft. The dangers are vividly illustrated by the number of accidents that happened in peacetime, but the onset of war made the odds of surviving for any extended period of time pretty bleak. Bradshaw was one of the lucky ones who did survive, winning a D.S.O. in the process, but he had a number of harrowing experiences, which are well recorded. By the end, his nerves were "shot through" but, at least, he had developed a keen interest in marine art so that he could embark on a second career.

ACKNOWLEDGEMENTS

I, of course, owe a considerable debt to Kathleen Bailey and am pleased that she was able to read and approve a draft of the book before her death in 1997. I am also greatly indebted to her two children, Robert Bradshaw and Anne Bradshaw, who have shared with me their reminiscences of their father, answered numerous enquiries and made available to me all family papers.

Dr Henry McKee, a fellow Bradshaw enthusiast, has spent endless hours unearthing fascinating details of the Bradshaw family history in Ireland and all references to this derive from material kindly provided by him. I am greatly indebted to many people at the Royal Navy Submarine Museum at Gosport. Brian Head was exceptionally helpful when reviewing and correcting my account of Bradshaw's time in the Submarine Service. Margaret Bidmead enabled me to see and photograph the Museum's collection of Bradshaw paintings and Debbie Corner helped with my selection from the Museum's extensive photographic archive.

I am indebted to Arthur Credland for the early history of the Society of Marine Artists. John McWilliams willingly gave me the benefit of his extensive knowledge of St Ives fishing craft. David Wilkinson of the Book Gallery, St Ives, kindly agreed to review a draft and his constructive comments hopefully have resulted in more focus. Austin Wormleighton generously gave of his time to advise me on some of the pitfalls of the publishing process. Thanks also to Toni Carver for his enthusiastic support and to all at the *St Ives Times and Echo* who put up with me poring through over forty years of back numbers in surroundings already overcrowded. The librarians at the Cornish Studies Library at Redruth were always most helpful and the St Ives Archive Study Centre is an excellent new resource.

I am obliged to Rosamunde Pilcher, Sven Berlin, and to Hyman Segal for allowing me to reproduce extracts from their works and to Toni Carver (again) for permitting me to quote at length from the *St Ives Times*, an invaluable source. The extensive debts I owe for the provision of the illustrations used are acknowledged separately.

Finally, tremendous thanks are due to my former secretary, Rosemary Dalley, who in addition to coping with a daunting load of legal work, found the opportunity, often in her own spare time, to type up early drafts of this book. However, as she said, Bradshaw's life was considerably more interesting than arcane aspects of Trust law.

INTRODUCTION

It must have been extremely galling for George Fagan Bradshaw that each of his two distinguished careers - first, as a submariner and then as an artist - should end stormily and unsatisfactorily. Instead of retiring from the Navy, as a hero of the First World War, a submarine commander of repute with a D.S.O. to his name, his career effectively ended with a messy court martial, albeit he was acquitted. Similarly, as an artist, his career did not end with him being a significant player in an united group of professional artists, as he had been for the majority of his forty years in St Ives. Instead, he witnessed the break-up of the St Ives Society of Artists, of which he had been a founder member and stalwart supporter, amid terrible acrimony. His anger at this sequence of events, particularly the underhand machinations of Ben Nicholson, can be judged from accounts of the relevant meeting, which refer to the "quarterdeck oaths" of this "feisty old painter of storms at sea" and the brandishing of his fist rather close to sober chins. By this juncture, he was in his sixties and not in the best of health but one wonders whether his fiery Irish temper had not been his downfall on previous occasions. Had a similar outburst at the time of his court martial resulted in the decision that it was no longer appropriate for him to be a submarine commander?

Both squalls that blighted his two careers left Bradshaw greatly embittered and, sadly, in St Ives, there are few people who remember him other than as a gruff, ill-tempered old man, who could be rather formidable. However, a full review of his life reveals a much more rounded character - a highly respected and very brave submariner, a lauded artist, liked by his colleagues, an entertaining raconteur with a fine sense of humour, and a good family man. The novelist, Rosamunde Pilcher, in describing her childhood, has called the Bradshaws the "favourite artists" of her group of youngsters. Nevertheless, the Victorian values of the Commander's upbringing

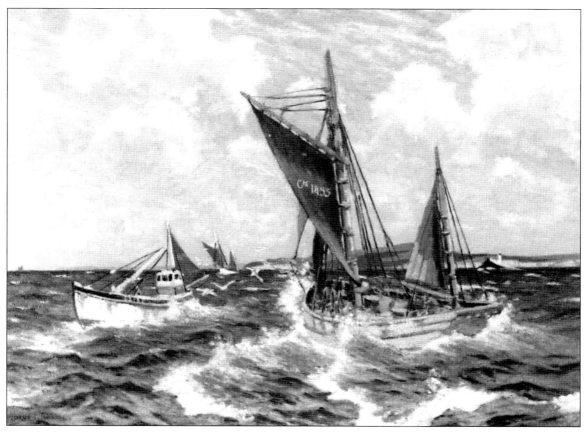

0.1 *Fishing Boats in St.Ives Bay* (Oil on canvas) (David Lay)
featuring a St Ives motor gig and a French crabber from Camaret

3

did not make it easy for him to accept the changes that were occurring in many features of life at the end of his days - but in this he was certainly not alone.

Given his Naval background, it is not surprising to find that Bradshaw chose to specialise in marine art. In his history of British marine painting, Cordingly frequently comments that the artists who were most adept at capturing the proper movement of boats in the water and the effects of different weather conditions on the surface of the ocean were those men who had become intimate with the sea's moods through spending lengthy periods afloat.[1] Such artists also knew the characteristics of each type of boat, the impact of hull shapes on a vessel's bow wave, the differences in the rigging of the various sailing ships and how a ship's sails would be set in the different conditions. Bradshaw may have served in submarines for most of his career but he had utilised his powers of observation well and was always concerned to ensure that important details were correct, that his boats moved realistically and that sea and sky reflected the same weather conditions. Such points may seem simple but many marine paintings, whilst satisfying the eye of the general public, have come in for severe criticism from knowledgeable seamen. Even the great J.M.W.Turner was caught out.[2] Bradshaw's work, however, frequently drew the comment that only a man who had had vast experience of the sea could have rendered such a truthful observation.

For the lover of the Cornish coast, Bradshaw is an artist to treasure. In the cosy confines of one's sitting room, he can evoke memories of the roar of Atlantic rollers smashing against the Cornish cliffs. One can hear the rumble of the undertow and the cries of the gulls; one can feel the wind

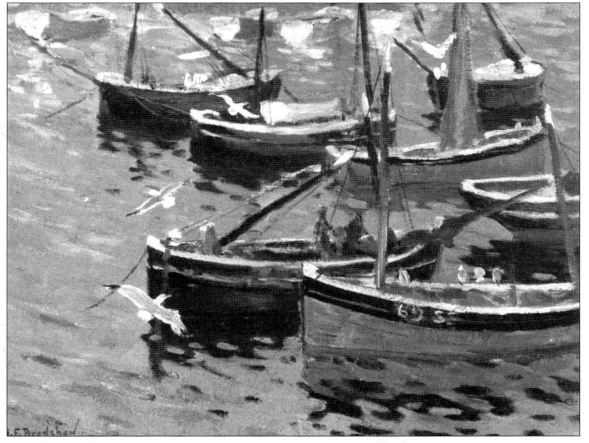

0.2 *Boats in St Ives Harbour* (Oil on board) (W.H.Lane & Son)

[1] Cordingly mentions, in particular, Dominic Serres, Nicholas Pocock, George Chambers, Charles Brooking and Clarkson Stanfield. D.Cordingly, *Marine Painting in England 1700-1900*, London, 1974, p.12
[2] In the painting *Spithead: two captured Danish ships entering Portsmouth Harbour, 1807,* Turner managed to depict a gaff cutter running before a wind, which elsewhere in the picture he had shown coming from the opposite direction - D.Cordingly, *op. cit.*, p.121

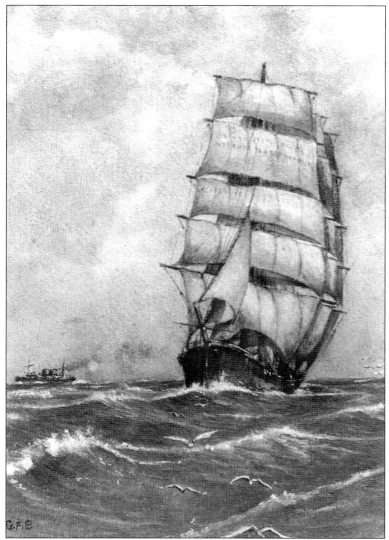

0.3 *Sailing Ship* (Watercolour)

whipping through one's hair and taste the salt on one's lips. Alternatively, he can remind one of those glorious sunny days with the sea a brilliant, deep blue and the sky dotted with fluffy clouds, or bring back the thrill of discovering a secret cove with its shallow waters glistening in a multitude of green and turquoise hues. The lapping of waters on the sea shore, the clink of the boats' rigging and the freshness of the sea air - all these are brought back vividly, seducing you into planning your next visit. Cornwall is a place that gets into your blood and, despite the eloquency of Patrick Heron as to the mysteries and enchantment of its interior, it is the Cornish coast and the old fishing ports that are Cornwall's premier attraction. These are what Bradshaw portrayed.

It is, of course, very difficult for an artist based in Cornwall to ignore the coast but few artists have devoted their skills so single-mindedly to the portrayal of the sea around the Cornish coast and the boats that sailed upon it as George Bradshaw. He first settled in St Ives in 1921, when he retired from the Navy and, apart from a break during the Second World War, when he was again called away to serve his country, he remained based in St Ives until his death in 1960. St Ives based artists tend to be peripatetic, going abroad or retreating to London in the winter; not so Bradshaw. He travelled very little, mainly for financial reasons, and made no attempt to break into the London market. He submitted work to the Royal Academy and, after its formation in 1939, was a regular exhibitor at the Society of Marine Artists. However, in the main, he relied on the exhibitions of his beloved St Ives Society of Artists. Almost exclusively, his paintings were

marine subjects. Yet, such was his versatility, that his paintings can never be accused of being "samey". He is constantly catching the sea in different moods and with different lighting and cloud effects. Furthermore, his pictures are also an invaluable record of a wide range of craft that no longer grace the high seas - clippers, schooners, brigantines and other sailing ships, French crabbers, Maltese fruit boats, mackerel luggers, early steam trawlers and many more.

There is no doubt that marine painting is a difficult art to master - much more difficult than is normally credited, as there are so many problems unique to the genre that have to be mastered over and above the principal skills of drawing, perspective, colour and composition needed by the general artist. One of Britain's greatest exponents, Julius Olsson, described some of the requirements as follows:-

"For one whose heart draws him to the sea must, in the first place, have an exceptionally retentive memory, and be able to grasp in a few moments the effect of the ever-changing movements of the sea and sky; he must have a delicate and subtle sense of colour, and have the ability to place the main features of his impression of the subject on the canvas with few strokes of the brush, and, beside this, he must be prepared to face a brave fight with the elements, which will be frequently against him".[3]

Just before Bradshaw embarked on his career as a marine artist, *The Studio* published a special edition devoted solely to British Marine Painting in which A.L.Baldry spelt out further problems that he would have to master:-

"There is no phase of sea painting in which difficulties do not abound. It is difficult to paint a breaking wave, to preserve its architectural quality of design and its appearance of massive strength, and yet show that it is a moving and momentary thing, disappearing as quickly as it is formed. It is difficult to represent the confusion of a stormy sea, churned into foam and tossing in the wildest turmoil, and yet to make intelligible the order and regularity of its movement and the right sequence of its changing forms. It is as difficult to render the smoothness of calm, quiet water without making it look solid and opaque, dull and lifeless, as it is to suggest the liveliness of a breezy day without lapsing into meaningless repetition and restless pattern-making. Every successful sea-picture is a difficulty overcome and a problem solved, and every successful sea painter is a man who has struggled earnestly with intractable material and has built his achievement on a foundation of laboriously acquired knowledge."[4]

Faced with these difficulties, it is not surprising that many marine painters struggled to produce a convincing representation of the movement and moods of the sea. Bradshaw, however, made remarkably quick progress in the acquisition of the requisite skills and, having become an acknowledged master of his art, resented the manner in which artistic trends led to a dramatic deterioration in the value placed upon technique.

In 1934, Bradshaw's friend and artist colleague from St Ives, Borlase Smart, wrote:-

"I have heard it remarked that seascapes are not good selling subjects; that people prefer landscapes or still life subjects. This would seem extraordinary, if true, in view of the fact that we are essentially a maritime nation. That the sea has an enormous appeal is evident by the lure of the seaside health resorts of the day, and this is inconsistent with the suggestion that such pictures are unpopular."[5]

Borlase Smart's comments still seem relevant now. As well as being an art centre, St Ives remains

[3] B.Smart, *Technique of Seacape Painting*, London, 1934, Foreword
[4] A.L.Baldry, *British Marine Painting*, The Studio, Special Edition, 1919, p.19
[5] B.Smart, *op. cit.*, p.1

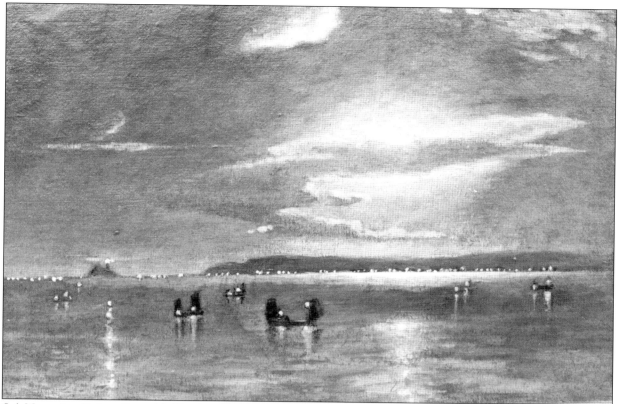

0.4 *Moonrise, St Ives Bay with Herring Fleet on Eastern Shore* (Oil on board)

a popular seaside holiday destination, with visitors continuing to be attracted by St Ives' unique combination of exquisite sandy beaches, an enchanting harbour filled with colourful boats and inspiring cliff scenery. Accordingly, it seems a shame that some space cannot be found for a display of paintings recording its maritime past - a past which, of course, is the key to its very existence. How many visitors, one wonders, enter the Tate Gallery in St Ives expecting to see paintings of fishing boats and fishermen and representations of the Cornish coast? Such a traditional style of painting is not within the Tate's remit but is marine painting still considered the poor relation? It seems so, for all St Ives' marine artists have been sadly neglected. Bradshaw was following in the tradition of Louis Grier, Julius Olsson, Edmund Fuller, Charles Simpson, Borlase Smart and others and yet none have been the subject of an in-depth study and no attempt has been made to assess the importance of the Cornish contingent in the development of British marine painting.

Furthermore, the period during which Bradshaw painted in Cornwall is in many ways an overlooked era. Attention has been focussed on the early settlers in the 1880s and on the achievements of the Newlyn School, while the Tate has reinforced the status of the modern movement. However, as the split in the St Ives Society of Artists in 1949 is usually attributed by the historians of the modern movement to the reactionary viewpoints of second-rate "traditional" artists, Bradshaw and his colleagues have received little favourable press. In fact, the St Ives Society of Artists, formed in 1927, was phenomenally successful for the first twenty years of its existence, mounting shows in a wide variety of provincial Galleries throughout the 1930s and 1940s and achieving both national and international recognition, culminating in an exhibition in South Africa in 1947 to coincide with the King's visit. Members of the Society included not only the many highly regarded artists based in St Ives but also those Royal Academicians, who had links with the area, such as Stanhope Forbes, Julius Olsson, Algernon Talmage, Arnesby Brown, Adrian Stokes, Lamorna Birch and Terrick Williams, and other distinguished artists based in Cornwall, such as Harold Harvey, Ernest and Dod Procter, Robert and Eleanor Hughes,

Richard Weatherby and Annie Walke. The Society's shows attracted thousands of visitors and many works from these exhibitions were acquired for the permanent collections of provincial Galleries. The Society also became an important force at the Royal Academy with over seventy works by members frequently being included in the annual Summer Exhibition and its dynamic leadership and high profile attracted artists from other leading Societies. It was this Society that Bradshaw had been instrumental in founding and he took great pride in its achievements. Nevertheless, despite its contemporary popularity, the Society and many of its principal members have been ignored by art historians.[6] Increases in sale-room prices in recent times indicate that collectors, in any event, are beginning to take notice.

[6] Again, there is nowhere in St Ives that an exhibition devoted to their works can be held.

FAMILY BACKGROUND AND NAVAL TRAINING

George Fagan Bradshaw was born on 6th December 1887 in Belfast. He came from no ordinary family. Boasting a lineage that has been traced back via Kings of Scotland to Charlemagne, the Bradshaws took their name from a manor in the Hundred of Salford, Lancashire. In the thirteenth and fourteenth centuries, they were prominent English landowners, a Sir William de Bradshawe being the King's Lieutenant for the County of Lancashire in the time of Edward III (1327-1377) and a Roger de Bradshaw being a Member of Parliament in the reign of Richard II (1377-1399). The family line also includes a regicide, as John Bradshaw signed the death warrant of Charles I.[1]

The first of the family to settle in Ireland was James Bradshaw (1619-1690), who had been born in Prestwich, near Manchester. He was a follower of Cromwell and was captain of the Forlorn Hope, leading the storming of Drogheda in 1649.[2] The subsequent massacre, ordered by Cromwell, of 3500 men, women and children is still viewed as the worst atrocity of English armies in Ireland. For his role in the campaign, James Bradshaw was awarded 1700 acres and Ballygarth Castle in East Meath, north of Dublin, but it is stated that his "conscience would not let him take land stolen from another, so he lost that to himself and family".[3] He in fact became a Quaker, the first of a long line of family members who were attracted by this sect. In 1657, he married the daughter of a judge of the High Court of the Isle of Man and they had ten children. One son, Lemuel, emigrated to Philadelphia in 1660, starting two centuries of close family contact between Belfast and America, whilst another, also called James, was to make his fortune in the linen trade. He obtained by industrial espionage while in Holland details of the methods and machinery used by the Dutch for weaving and bleaching figured diapers but was lucky to escape with his life, having been tipped off by a fellow Irishman that his activities had been uncovered and that he was due to be assassinated. The linen trade played a significant role in the family history, as the Bradshaws frequently married into the families of other linen traders, such as the Scotts and the Lopdalls.

The family continued to prosper, becoming significant landowners, and it is perhaps not surprising that subsequent generations were attracted into the professions. George Bradshaw's great-great-grandfather, Robert, who married Anne Scott, was one of the founders of the Belfast Commercial Bank in 1809 and James the younger's grandson, Thomas Bradshaw (1746-1810), married Sarah Hoare, the daughter of the prominent London banker, Samuel Hoare.

The next generation entered the law. Robert Scott Bradshaw, son of Robert and Anne, became a well-respected barrister in Dublin but Thomas' son, also called Robert and also a lawyer, had a rather more colourful lifestyle, becoming known as 'Mad Bradshaw'. He lived at the family home, Milecross House, near Kiltonga, County Down and he is still remembered in place names in the area and in nursery rhymes.[4] Stories abound as to his eccentric ways. When the law forbade the use of horse-drawn carriages, in order to protect the roads, Mad Bradshaw took to using a cart pulled by four bullocks, with a large box on the back which was equipped with an oven and a stove. He docked the tails of his bullocks, because he considered that switching tails wasted energy. He drove his bullock cart at a frenetic pace, often accompanied by an outrider who

[1] Genealogical notes re. Quaker family of Bradshaw, Bangor and Milecross, County Down and Lurgan, County Armagh, PRONI C/1042/1966 T.2486

[2] The name 'Forlorn Hope' was not without significance - this was a body of men who, in return for an increased share of booty, were thrown into the thickest of the fighting. For many, therefore, their pursuit of riches was forlorn.

[3] Quaker testimony of James Bradshaw to John Edmonson - Biographical note read at Ballylagan Quaker Meeting 1705, PRONI T/1062/37/106

[4] Milecross House had been built by Thomas Bradshaw, his father, when, in 1780, he had left Newtownards, County Down to found a Quaker colony at nearby Kiltonga.

had been cajoled into actually riding a bullock, and his advent in Newtownards, with quadruple reins firmly clenched, caused as much interest as the arrival of a circus, as he wheeled through the square "upsetting many a sceough of potatoes, scattering to every side pigs, dogs, heather-broom makers, chapmen, covingstone women, ballad singers, cripples, softies and children alike".[5]

With an uncanny sense of symmetry, the next generation was attracted to the Church. George Bradshaw's grandfather, the Reverend Macnevin Bradshaw, was a deeply religious man and became vicar of Ardamine and Clontarf. The young George complained, "Grandpa is so religious and will not look at things from other than a religious point of view".[7] On the other hand, Mad Bradshaw's son, Joseph, may have taken Holy Orders but he clearly had inherited some of his father's wild traits. The locals were prone to comment, "Queer things happen at the Mile Cross" and the Irish public had their appetite for scandal titivated in 1871, when the police inspector, Montgomery, who had married Mad Bradshaw's granddaughter, Anna, was charged with committing a murder during the course of a bank robbery. Montgomery had borrowed large sums of money from the family and, finding himself unable to repay it, had decided to rob the bank at Newtonstewart. However, during the raid, he killed the cashier. In his defence, he claimed that in 1870, he had been invited to Milecross House by Joseph Bradshaw where he had been deliberately drugged and poisoned, rendering him weak-minded, and then forced to marry Anna. As a result of his mind being impaired, he had subsequently engaged in ruinous speculations, and become violent, with a monomania for smashing banks. However deranged Montgomery might have been, this must have been exceptionally unwelcome publicity. Worse was to come in 1885, when the Reverend Joseph Bradshaw's own finances collapsed and he was declared bankrupt and the family home, Milecross House, and its rare and precious contents, were sold at auction.

Until this time, George Bradshaw's branch of the family had been the epitome of respectability - banker, barrister, clergyman, all of good standing and well thought of in the community. All that was to change with Bradshaw's father, Robert Macnevin Bradshaw, who worked as an estate manager. His life is shrouded in mystery, in the way that lives of black sheep tend to be, but gambling and the demon drink would seem to be fairly secure bets as to the cause of his downfall.[8] Whatever the cause, however, the end result was untold misery for his wife and family.

At the time of his birth in 1887, George's parents were living at Gloucester Villa on the Antrim Road in Belfast, an extremely prestigious address at the time.[9] His mother, Agnes, whose maiden name was Duncanson, was a Scot. George was the second of nine children, having an older brother Macnevin, who was born in 1886, five younger sisters, Agnes, Charlotte, Marion, Eleanor and Laco, who suffered from polio, and two younger brothers, Robert and Francis, the latter being the youngest member of the family, born in 1902.

Little is known of his early years. Although there is a delightful holiday photograph of George, with two of his sisters, standing, immaculately dressed, on some rocks in the middle of the River Liffey in 1899, the children earned the title 'the Wild Bunch' and being the eldest two boys, Macnevin and George may have been the instigators of any trouble. Certainly, it does not appear

[5] *The Tale of a Beetle - The Bradshaws of Milecross* from F.J.Biggar, *Four Shots from Down*, p.5. The bullocks did not meet a happy end. Mad Bradshaw, when himself a defendant in a patent infringement case involving a "beetle" (potato masher), decided to use his bullock cart to travel the 20 miles to the court-house. As usual, he travelled at break-neck speed, but on his arrival, he discovered that he had left his papers behind. As the judge would not grant an adjournment beyond that afternoon, the bullocks were subjected to four journeys of 20 miles in a single day, a feat which proved beyond them.

[6] The name Macnevin was a name used frequently in the family in honour of an ancestor, who was one of the most uncompromising leaders of the 1798 rebellion, and who became a focus for dissent in his exile in America.

[7] Private Diary, 3/1/1906

[8] The only thing that the Commander mentioned about his father was that he was fond of animals, once using his fine linen handkerchief to wipe away foam from a cow's mouth.

[9] George's middle name, Fagan, derived from his grandmother's family, her grandfather being General Fagan, Adjutant-General of India.

1.1 George Bradshaw with sisters, Charlotte and Marion, and dog, Donald, by the River Liffey, 1899

that life in the Bradshaw household was particularly happy. George was very close to his mother and was extremely upset at the treatment that she received from his father when worse for wear with drink.

To what extent the spectacular crash in the fortunes of Mad Bradshaw's side of the family impacted on the Reverend Macnevin Bradshaw and his eight children is not known. There is clearly the possibility that Macnevin had also invested in some of the ruinous speculations of his relatives. Severe losses at this time - just two years before George's birth - may explain why his father turned to the bottle for comfort. Certainly by George's late teens, money was in short supply but this situation may have been due to his father's own excesses.

When George was only 14, it was decided that he should apply to join the Naval training ship, *H.M.S.Britannia*, at Dartmouth, England. From what he said in later life, this does not seem to have been due to any burning desire on his part to join the Navy. The rapidly expanding family, the dwindling finances and his father's behaviour may have led his mother to believe that it would be better for him to be away from home. Possibly, if George's own behaviour had been a little wild, it was felt that some Naval discipline might stand him in good stead. However, it was standard practice for children who were interested in becoming officers in the Royal Navy to join the *Britannia* between the ages of 14 and 15 and so it remains a possibility that, despite his tender age, George himself chose a career in the Navy, realising that he was not academically inclined. To be accepted for *Britannia*, he had to pass an entry examination, which was held either in London or Portsmouth and to produce a certificate of good conduct from his school. In fact,

1.2 *H.M.S.Britannia and H.M.S.Hindostan* moored in the River Dart (Crown Copyright/MOD)

his Irish headmaster and his wife accompanied him in November 1902, when he went to take the exam and he later recalled how he had to spend most of the journey scratching the back of the Headmaster's wife. George's parents also had to confirm that they would contribute to the costs of his training - at least £75 per term - and provide him with pocket money.

When in January 1903, just one month after his fifteenth birthday, George arrived at Dartmouth to begin the first of four terms upon the *Britannia*, her days as a training ship were already numbered. Doubts had for some time been expressed about sanitation and overcrowding on the boat, particularly because of recurring epidemics of mumps, measles, influenza and scarlet fever, which had claimed several lives. In 1902, the King and Queen laid the foundation stone of the new Royal Naval College, which was to take over *Britannia's* role in 1905, just a year after Bradshaw had passed out. With her fate already sealed, there must have been a heightened sense of the passage of history during Bradshaw's time as a cadet, particularly as many of the academic staff had served on her for in excess of twenty years.

Each term was of three months duration, commencing in January, May and September and, with holidays included, the whole training programme lasted fifteen months. Sixty-four cadets joined each term. These were always referred to as the 'News' with the other terms being called respectively 'Threes', 'Sixers' and 'Niners'. The 'News' were generally regarded as the lowest form of life and the older boys would take great delight in exploiting their naivety. In the 1890s, bullying, extortion and general cruelty had been rife but, to a large extent, this type of behaviour had been stamped out. Nevertheless, such was the distinction between terms and the subjection of junior to senior, that it was an unwritten law that no cadet was permitted to mention a term above his own.[10] However tough Bradshaw was when he joined, he will not have found his first term particularly enjoyable. In fact, in April 1903, a new Commanding Officer, Captain C.H.Cross, was appointed with an express mandate to shake the ship up and a number of officers were replaced, including the messman who had been making £1,000 a year on the side from the cadets' messing.

[10] S.Pack, *Britannia at Dartmouth*, London, 1966, p.118

H.M.S. Britannia was the eighth ship so named. She had been laid down as a sailing three decker but was launched as an 131 gun screw ship at Portsmouth in 1860. She was 252ft long, with a beam of 60ft and a draught of 21ft. She had been commandeered as a training ship in 1869 and had lain in the River Dart ever since. Another sailing hulk, the *Hindostan*, was moored next to her and a connecting bridge linked the two. In addition to the three gun decks - main, middle and lower - , from which the description 'three decker' derives, there were in fact two other decks - the upper deck and the orlop deck (or cockpit).

The sleeping quarters of the first two terms were on the lower deck of *Hindostan* and those of the 'Sixers' and 'Niners' on the main deck of *Britannia*. At the fore end of each sleeping deck, there was a small salt water swimming pool, through which the cadets plunged first thing every day - a chilling experience none ever forgot. The cadets slept in hammocks, which took some getting used to, but these were the source of unending delight, as when fastened by an undetected slippery hitch, they resulted in friend or foe landing with an awful bump on the floor in the middle of the night. Each cadet had a white chest with a black lid, measuring 3ft 6in x 2ft 2in, for his personal belongings, which was kept on the sleeping

1.3 Sleeping deck on *Hindostan* (Swale & Son)
with hammocks and chests

deck. In the lid were fittings for stowing the strange combination of a telescope, parallel rulers, a dirk and a looking glass. It was an offence to leave this chest unlocked, as Bradshaw soon found out.

1.4 The poop deck of *Hindostan*
converted into a chapel (W.M.Crockett)

The study rooms were divided between the two ships and gangways were built along the sides of the ships, so that access could be gained to each room externally. The messroom was on the lower deck of *Britannia*. The poop of *Hindostan* was roofed in and fitted permanently as a chapel. The upper deck of *Britannia* was also covered in and used as a place for recreation in bad weather and for functions, such as prize giving. There were two floating swimming baths attached to the ship for swimming instruction, as it was a requirement that all cadets could swim proficiently before completing their training.

The teaching staff comprised eight naval instructors, two French masters, two drawing masters, an English master and a natural science teacher. The heavy bias towards topics of practical use to naval personnel is confirmed by the principal examined subjects - Algebra, Euclid, Trigonometry, Navigation, Nautical Astronomy, Instruments, Charts, Steam and Steam Machinery, French, Drawing and Mechanical Drawing. Lectures were given on English, Geography and History but they do not appear to have been examined subjects. Bradshaw may well have favoured the subjects involving drawing. Mechanical Drawing included the depiction of simple solids, plans and elevations, sections of machinery and rough figured sketches of parts of machinery. Drawing was taught in three modules - simple models and copies in the first term,

topographical sketching and oblique perspective in the third term and topographical sketching from 'Outside Nature' in the fourth term. The senior drawing master was John Spanton, the longest serving academic, who had been teaching cadets since 1867. His assistant, Smallfield, had himself been on the *Britannia* for fifteen years and used to admonish new intakes with the following utterance:-

> "Now, I'm Smallfield, 'e's Spanton - pointing to the classroom next door - I'm a gent, 'e's a cad, I'm perspective, 'e's free 'and. Now any gent I find sucking lollipops or any of them nasty things, art 'e goes." [11]

Such eccentricities were remembered in later years by other cadets but not their abilities as teachers. There is no record of Bradshaw's views. After such long terms of service, and with the end in sight, Messrs Spanton and Smallfield may well have lost their enthusiasm for their task. However, all teachers respond to a pupil with talent and enthusiasm and Bradshaw, finding a subject in which he could excel, is likely to have pursued his drawing studies with more relish than others.

There were a number of other characters among the teaching staff. One of the Naval instructors, Maurice Ainslie, an enormous man with a large beard, was nicknamed 'Wombat'. One ex-cadet recalled, "Never in my life have I known anyone whose food disappeared off his plate so quickly; it almost rose off the plate to meet him half-way."[12] Wombat was also rather partial to gin, but not to washing. By placing 1d a day on the lip of his hip bath which hung from the ceiling of his cabin, the cadets discovered that he had not washed for twenty-one days, when he excitedly came into the mess announcing he had found 1s 9d in his bath. French was taught by two long-serving Frenchmen, Paul Brunel (from 1875) and Leon Delbos (from 1887).

> "Delbos had a bad squint, and when rebuking a cadet for some misdemeanour always appeared to be looking at the one next door, which caused the real culprit some merriment until a finger shot out pointing at him, and handing out a 'day's three' (one hour's drill) for bad conduct. Brunel had been through the siege of Paris in 1870 something, and was fairly easily started off on reminiscences of those days when rats were one of the main sources of meat. This was, of course, far better than struggling with regular and irregular verbs." [13]

Generally, though, favourable comments are made about the standard of teaching on the ship. Strict discipline was maintained and slackers were not given an easy time. One cadet, later a Vice Admiral, recalled:-

> "Instructors kept control and imparted knowledge in a manner I have never known excelled. From a varying acquaintance with arithmetic algebra and Euclid, we were introduced to plane and later spherical trigonometry, advancing to celestial navigation. After four terms of three months, they sent forth boys who could not only solve spherical triangles and prove the formulae they employed, but who could also work a ship's reckoning by the sun." [14]

There were many practical matters to learn as well. "Brisk petty officers attached to each term, the very salt of earth and sea, were perhaps our widest and most shrewd counsellors on board. Others of the same rating taught us seamanship in a delightful model room and showed us how to row or sail."[15] The seamanship studies included signalling by semaphore, flag and Morse systems, working anchors and cables (learnt from a model on wheels) and knots and splices. An engineer officer also taught 'Steam' and the cadets were taught to prime and lay a boiler fire and to raise steam in a steamship, the *Wave*, which was attached to the training ship.

[11] S.Pack, *op. cit.*, p.127
[12] S.Pack, *op. cit.*, p.165
[13] S.Pack, *op. cit.*, p.126-7
[14] S.Pack, *op. cit.*, p.113
[15] S.Pack, *op. cit.*, p.113

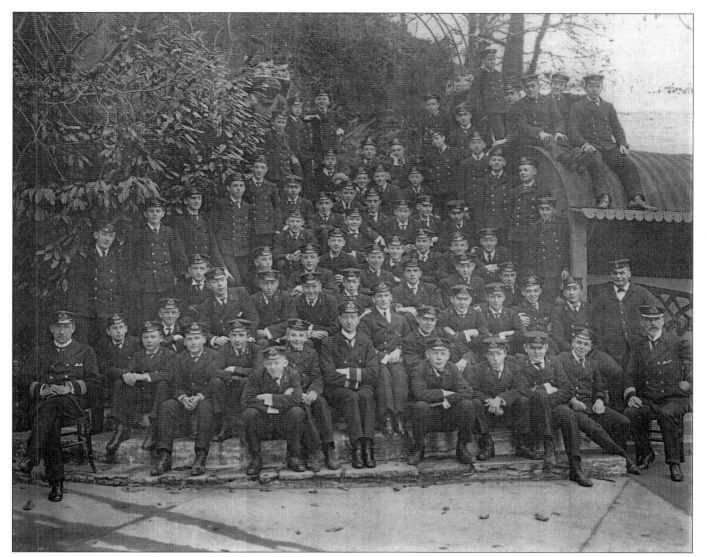

1.5 *H.M.S.Britannia* cadets - Christmas 1903 (Naval College, Dartmouth)
(Bradshaw is seated behind the right shoulder of the central officer)

The cadets' day was very regimented. Regular bugle calls punctuated the day's timetable, starting with the wake up call at 6.30. Morning drill took place between 7.15 and 7.50 followed by prayers and breakfast. Three hours of studies in the morning was followed by lunch at 12.10. There were a further two and a half hours of studies in the afternoon, which in the summer finished at 16.05, but in the winter were held after the permitted shore break, in which games were played. After supper at 19.15 (winter 18.30), there was a further study time of an hour and prayers before the cadets turned in at 21.30. Leisure time was extremely restricted but, nevertheless, to ensure no loafing, the cadets had to hand in a report each evening on how they had spent their free time. There were twenty-three headings of possible activities, including all the normal sports, swimming, walking, photography, sailing etc. and, what proved a regular feature, 'punishment'. However, some cadets had difficulty fitting in their punishment drills and so were often woken up at 5.25 so that their allotted task could be completed before the start of the day's timetable. Bradshaw was well-behaved during his first two terms but appears to have grown in confidence by the third term when he is punished on a number of occasions for skylarking after bedtime or talking out of turn.

The environment was very male dominated, the only adult females encountered being two long-suffering ladies who ran the tuck shop, nicknamed the 'stodge shop'. In fact, the food provided in the messroom was considered to be very good. Growing boys, however, put away a

15

prodigious quantity and the 'stodge shop' did a thriving trade, particularly in the long hours between lunch and supper. The other female recalled by all was the daughter of the canteen manager. Provided a group of at least seven cadets could be assembled, she would, for a penny a head, pull up her skirts in the nearby woods, revealing what many remember as a rather shapely pair of legs.[16]

One of the age-old customs on the *Britannia* was going over the masthead. The timing of such an event was dictated by the senior term on board and, on the appropriate cry, all cadets had to climb up the rigging and go over the masthead. However, the senior boys made it to the top first and would rap the hands of the juniors as they climbed the futtock rigging in a position almost horizontal with nothing below but a net. The slower ones might also be compelled to sing *Rule Britannia* as they hung precariously at the top with shaking limbs and fearful hearts.

The regime was strict but most cadets recalled their time on *Britannia* as tough but happy. The routine could become somewhat monotonous and days out on the *Wave* or in the sailing cutter were appreciated, provided it was not rough. Special activities would be organised on days like the King's birthday; for instance, in 1903, a sea-fishing party of fifty had an enjoyable foray while three teams played in cricket matches and a group of one hundred and forty went up river with a picnic. As in most schools of the era, sport played an important role in daily life but an unusual diversion was offered by the Britannia Beagles. Special warm baths were laid on for their mud-spattered followers on their return.

In Bradshaw's fourth term, he would have gone on a sea-cruise in one of the two cruisers, the *Isis* or the *Aurora*, attached to the training programme. This would have lasted most of the term and, if the routes of the previous year were followed, the cruisers would have headed south first to the Channel Islands and/or the Scillies before turning up the west coast, with stops in Ireland and/or the Isle of Man, to the north of Scotland. Such cruises had only been introduced in 1902 but proved popular and enjoyable as they enabled the cadets to acquire valuable first hand experience of life at sea. Another recent innovation was the establishment of a shooting class, using clay pigeons, for the senior term, with great emphasis being placed on gun safety.

Good marks in the final exams resulted in the allocation of increased sea-time, leading to greater seniority. Bradshaw's

1.6 *Britannia* decorated for the King's Birthday (W.M.Crockett)

results are not known but, as he was never academically inclined, it is unlikely that he achieved any additional allocation of sea-time, except perhaps for his drawing papers. In any event, he passed out of Dartmouth in April 1904 and was appointed a midshipman on 15th June. After an initial spell on the battleship *Prince George*, he was transferred on 15th July, across to a similar newly commissioned battleship of 14,900 tons, the *Majestic*. His diaries for 1905 and 1906 provide an insight into the way in which the Navy was run at that time. They also provide glimpses of George's own character, of the trials and tribulations that he experienced and of the worsening situation at home.

The beginning of 1905 finds him on leave at the family home of Ballynascorney, near Dublin. The house is mentioned in several histories and Robert Emmet, the famous Irishman, lived there for a while. The house, however, being built of greenstone, was often damp. The family owned another property at Lansdowne Road. It is not known when they moved from Belfast. George's pursuits, while at home, included playing golf with his father, going woodcock shooting, playing rounders and football with his brothers and sisters and trying to get the family pony to jump.

He was clearly not enjoying the Navy at this juncture as his diary entry for 20th January 1905 reads, "Got letter telling me to join on January 23rd to my anguish and misery" and having got down to Portsmouth to re-join the *Majestic*, he records on the 24th, "First morning watch for sometime - horrible agonies - more to come".

He was correct in these predictions as during the next six months, he received repeated beatings, for reasons often not clear and the persons responsible for reporting him are normally singled out for particularly vitriolic character studies. One week in March proves to be the nadir. On the Sunday, he received twelve strokes, describing the day in his diary as "about the most wretched day I ever spent in my life". The following day, however, it appears that he has transgressed again as he records, "Spent the day waiting to be called to the gunroom for eleven cuts more, which caused and still causes me great anxiety, never knowing when you are going to get beaten". Having had the threat of a further beating hanging over him all week, he was asked on Saturday whether his "stern" was alright, from which he deduced correctly that his wait would be over the following day. That day he received eleven strokes from one officer and seven from another.

Not surprisingly, this was not a happy period and the young Bradshaw began counting the days off to the time of his eighteenth birthday when he would become a Senior Midshipman or 'Senior Snotty'. One attraction of becoming a 'Senior Snotty' was the ability to smoke, which he believed would save him money due to his eating habits. Certainly, most diary entries recording days on shore make mention of tea being taken at one or other of the hotels.

The *Majestic* travelled quite extensively during the course of 1905. The ports at which the majority of time was spent were, naturally, Gibraltar and Malta. Time at Gibraltar tended to drag, as there was not a great deal to do on shore. Bathing at the beach at Rosia was popular and Bradshaw managed to fit in some horse-riding on occasions. There were nearly always a number of other naval boats in port at the same time and inter-ship team games were organised. Bradshaw was rather ashamed at his prowess at hockey and much preferred rugby, although he managed to break his leg at the end of 1905 in the first game. Bradshaw spent a number of his days off on his own, either not going ashore at all, most probably due to lack of funds, or going to the library to read or to write home. He found the peace and quiet of the library most comforting. A number of picnics were organised by the officers, and the padré and Lady White held a special picnic for midshipmen at Governor's Cottage.

At the end of March, the Queen arrived on the Royal Yacht *Britannia* for a meeting with the German Emperor. Great amusement was caused when the German Emperor's ship on arrival managed to ram another boat in the harbour. At the end of April, the *Majestic* put in at Marmaris in Turkey. Although its stay was short, this was one of Bradshaw's favourite places. His diary records a very different scene to the huge, bustling tourist mecca of today:-

"It is an inland harbour surrounded by mountains. The entrance is very narrow and winds through steep rocks. The town is picturesquely situated at the far end, two points on the starboard bow as you come in. It covers a hill with the ruins of a citadel showing out dark against the white flat-roofed houses, which come right down to the water. A tall white mosque sits beside a red tiled square house, adding to the beauty of the place. The inhabitants are mostly of Turkish origin, the streets narrow, very badly pathed and winding and mostly steep. The women wear long baggy trousers and a shawl covering their heads. They immediately cover their faces on seeing you. The town abounds in mongrels which are very ferocious but arrant funks. The country is very pretty all around and there is a wild, picturesque cemetery on the left of the town."

Malta, on the other hand, which the *Majestic* reached at the beginning of May, did not appeal. Bradshaw called it "without exception the very ugliest country I have ever seen". The mass of stone walls got him down, although he does admit that the town is "very handsome". The Royal Yacht also arrived in Malta and Bradshaw got a good view of the Queen as she came off her barge. She was dressed in mauve and apparently was looking "very bored".

After another spell in Gibraltar, the *Majestic* arrived in Brest at the beginning of July. The French and British sailors got on extremely well and that there was a lot of fraternisation in the Music Hall and the Casino. Although Bradshaw appears to have found himself a French dancing partner, he was not that sad when the ship left Brest after a week as, by that time, he was exhausted from the late nights, and penniless. After "the fair thing had been said goodbye to", the *Majestic* let go her moorings and "went out cheering each ship and they cheering us; then we fired 21 guns and they replied and the Brest Entente was a thing of the past".

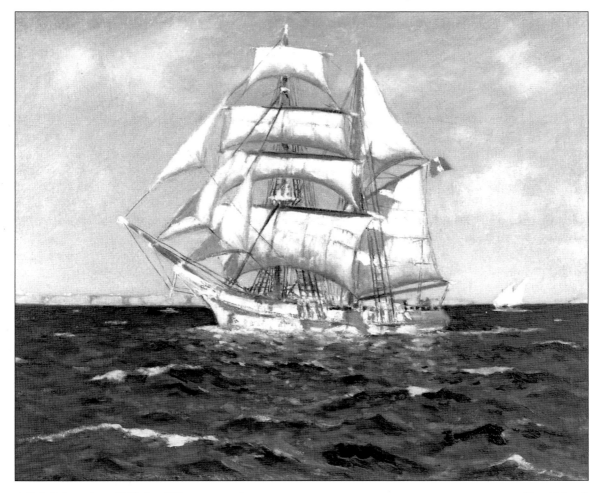

1.7 *A Brigantine off Malta* (Oil on canvas) (David Lay)

The *Majestic* sailed south calling in at a variety of ports including Lagos and then made for Madeira. By this time, Bradshaw seemed to be permanently short of cash, as additional pocket money from home was very sparse. His diary for 7th September reads:-

> "Did not go onshore today not having any funds. It is a terrible nuisance not having any funds at all especially in a place like Madeira, where you can enjoy a good tea for a shilling and then not have it because you have not got a shilling."

The *Majestic*, being a steamship, ran on coal and one of the most physically demanding tasks was 'coaling' the ship. This could take a full day. The training programme involved a series of 'evolutions' such as 'out nets', 'out bower anchor', 'take in tow' and 'clear decks for action'. The *Majestic* did well in these exercises, often coming first in the fleet, much to Bradshaw's pleasure.

Bradshaw was a keen sportsman and did not think much of anyone who was not athletic. In addition to the inter-ship team sports, there were also boxing contests which Bradshaw enjoyed. The *Majestic* cutter crew of 1905 felt that they had a chance of winning the Battenberg Cup in July and trained hard but, to their intense disappointment, in the race itself, their stroke 'caught a crab' right at the outset and was forced to jump out of the boat, leaving Bradshaw to take the role of stroke. Naturally, with one man short, they were no longer contenders.

In addition to his sporting exploits, Bradshaw did spend quite a bit of time sketching, particularly when he was laid up with a broken leg. Although he himself was never terribly pleased with the results of his sketches, other members of the crew did from time to time ask him to do a sketch for them. He even did a sketch for the Captain of *Temperley Floating Coal Depot Number 1*, a strange looking vessel, with a storage capacity of 12,000 tons. Its four principal cranes look like giant rectangular robots with arms stretched out straight and the mass of interconnecting hawsers almost take on the appearance of rigging so that the overall effect was like a stunted, metallic version of a four-masted square rigger. To many, it would have appeared a giant, dirty, rusty hulk, but Bradshaw clearly spotted its artistic potential.[17] In September, Bradshaw was very pleased when a new sub-lieutenant joined the ship as not only was he Irish but he also had a "wonderful talent for drawing". Towards the end of the year, Bradshaw was asked to contribute to *Naval and Military Record*. This was published by the *Western Morning News* in Plymouth and recorded developments in naval vessels both in England and abroad. Many issues had an illustrated supplement of one or more new ships. Often these illustrations were photographs but a number were reproductions of paintings and sketches. Borlase Smart, with whom Bradshaw was to be associated for many years in St Ives, became a regular contributor and, by 1911, was being described as the publication's "own artist". It was no doubt Borlase Smart who also initiated the inclusion in the magazine of a review of the marine paintings at the Royal Academy show each year.

Bradshaw continued sketching throughout his naval career and clearly was attracted by the majesty of the great wind ships. Already, it must have been clear that their existence was threatened by steamships, which could operate more cost effectively and were not subject to the vagaries of the weather. In later life, when they had almost ceased to be a feature on the high seas, he utilised for his paintings many of the drawings that he had made during his Naval career of barques involved in the Mediterranean fruit trade, of sailing clippers carrying tea and wool or of the great steel-hulled sailing ships that carried grain from Australia to Falmouth or timber or ice from the Baltic. Even as late as 1955, he used his memories of the snow-capped Pyrenees mountains as the backdrop to a tall ship in *Off the Spanish Coast* (fig 1.8). While based in Malta, he was also attracted by Maltese fruit boats, with their triangular sails, and a number of the paintings he executed in St Ives depict these colourful vessels. An early example is *Off Gibraltar* (1923) (fig 1.9), which depicts a fruit boat coming out of Tangiers. In the background is the Rock of Gibraltar, no doubt again sketched by him many times during his Navy days.

[17] The vessel is illustrated in *Naval and Military Record*, 11/5/1905

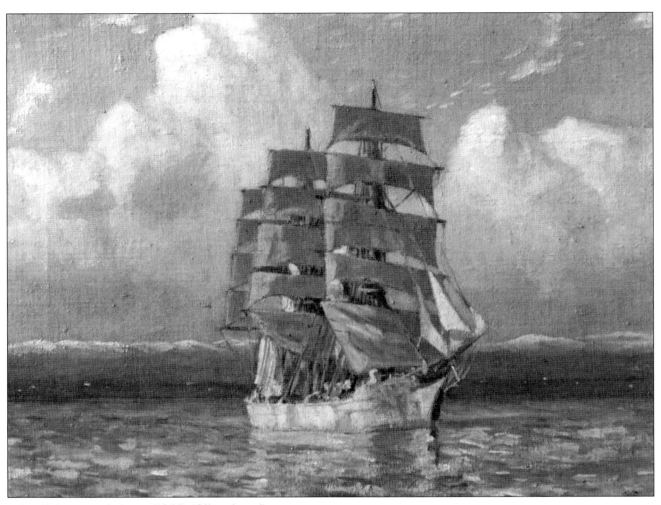

1.8 *Off the Spanish Coast* (1955) (Oil on board)

1.9 *Off Gibraltar* (1923) (Oil on canvas) (David Lay)

One should not, of course, read too much into the comments of a seventeen year old in his private diary. Nevertheless, some entries throw light on Bradshaw's character at this time. As a young, and probably fairly fiery, Irishman, he clearly had some difficulty in coping with the traditional English upper class officers. His description of one of his fellow 'Junior Snotties' reads, "F.T.Ormand is a very 'English' Midshipman, very weak and no good at anything athletic whatsoever ...To me he is at most times very uninteresting but has occasionally feeble sparks of humour." J.H.Godfrey, senior of the young officers, comes in for an even worse press. He is described as "a big-headed weak-minded freak. He is the most annoying person I ever met. He is no good at anything and as for being athletic! I always like kicking him."

Later in the year, he admits that some of the Officers and Senior Midshipmen, whom he had reviled initially, are "quite decent". However, he does not appear to have made any close friends. His entry for his birthday on 6th December, the day when he became a Senior Midshipman, is perhaps revealing:

> "I am overjoyed that it has arrived, although lately we have had a good enough time. I can smile as I look back on all my calculations as to how many more days until the 6th. Well do I remember the wishes innumerable before and after the many beatings. Now I need not stand cheek from anyone in the gunroom and if it comes to physical strength, I think I can hold my own with the present lot, although I like them all very well but vice versa does, I am afraid, not apply."

Towards the end of 1905, the news from home was getting progressively worse. It appears that mounting debts caused the family to sell their Lansdowne Road property and Bradshaw's allowance had to be provided by Uncle Frank, his mother's brother. In addition, Laco was severely ill with polio. On his arrival back in England on 16th December 1905, George went to stay with his Uncle Frank. His sister, Charlotte, was already there. He comments, "Charlotte has not much changed since I saw her last. Although I do not think she will ever be really pretty, she will be fairly passable, if her temper would improve a bit."

On 21st December, George and Charlotte went back to Ireland. He comments,

> "My heart is filled with mixed feelings. Father ought to try and look after his sons instead of his sons being left in the lurch by their father. In another year, all our social position will have gone and, oh my God, poor mother - what must it be to her. She is beginning to look a bit older and worn and then [there is] the trouble with Laco. It really seems as if we [have] had a little more than our full share of trouble and there is no way out of it. He [papa] is such a stubborn brute. Oh, I am fond of him but he has hardly played the game with mother. I wouldn't mind what happens, if it wasn't for mother and the girls."

Christmas that year was clearly not a happy time and his father did not join the family. In addition to Laco, the health of Bradshaw's sister, Marion was also causing concern. Bradshaw, in fact, doubted whether she would ever really be well again. Furthermore, Uncle Humphrey, his father's brother, tried to shoot himself, being nearly mad with gout. Other members of the family rallied around but Bradshaw continued to despair at the position in which his mother found herself. He considered her "terribly courageous" to live with his father at Ballynascorney without either his elder brother, Nevy, or himself around.

Not surprisingly, Bradshaw was less unhappy about rejoining his ship after the Christmas break than he had been the previous year. Nevertheless, whether the prospect of a career in the Navy really filled him with enthusiasm is doubtful. On 26th February 1906, he records in his diary that he had signed the pledge "but purely and simply for mother's sake. Of course it means a bit of a struggle at first but life can easily be mastered by a little willpower." Nevy and he had had long discussions over the Christmas period and had concluded that it was up to them to get jobs in the hope that they could provide some means of support for their mother. At much the same time,

1.10 *Maltese Fruit Boats* (Oil on board)

Nevy applied to join the Army, although unfortunately he failed to get in. In an interview in later life, Bradshaw indicated that he had waited 35 years before realising his ambition to become an artist. He had only joined the Navy because "I thought I had better learn to earn my living in some other walk of life first".[18]

Bradshaw's diary stops in March 1906, but one can imagine that the difficulties at home continued and that it was a blessed release when his father died in the following year. His grandfather, the Reverend Macnevin Bradshaw, and Uncle Humphrey also died in this year. How long Bradshaw's mother remained in Ireland is not known. There is the possibility that she immediately took the opportunity of moving the family away from Ireland, the scene of so much heartbreak, back to her native Scotland, but one story indicates that her move to Scotland was prompted by the family home being set on fire in one of the nationalist outbreaks.

In August 1906, Bradshaw was transferred, with a number of other midshipmen, from the *Majestic* to the *Russell*, another battleship which was part of the Atlantic Fleet. In August 1907, he was promoted to Sub-Lieutenant, although his exam results were not especially good. In May 1908, after a spell in Portsmouth, without a ship, he was transferred to the newly built *Minotaur*, an armoured cruiser of 14,600 tons, which was attached to the Home Fleet. The decision over his future in the Navy was now looming on the horizon. However, in making that decision, Bradshaw's own wishes played a subordinate role to family responsibilities. It is to his credit that he took these so seriously but, later in life, a veil was drawn over nineteenth century family history and even now it has not proved easy to unravel.

The very mixed fortunes of recent generations of his family affected George Bradshaw considerably. His own father may have been a renegade, but nevertheless, he would have gathered from his grandfather and other relations that the family had been highly respectable. His cry in his diary that in another year "all our social position will have gone" is revealing. Bradshaw seems to have been conscious of social status throughout his life, but naturally felt uneasy about opening up about the torrid childhood that he had experienced and the fall from grace that the family had suffered.

[18] Unattributed article of 1939 entitled, *Artist Served his Apprenticeship - in the Navy*

'THE TRADE'

Bradshaw always indicated that his decision to join the Submarine Service in September 1909 was dictated by monetary considerations. After the death of his father, he wanted to be in a position to assist his mother and his younger brothers and sisters as much as possible. In particular, his brother Robert, who wished to become a doctor, had a weak spine and the necessary operation was expensive. As the pay in the Submarine Service was higher than in the 'real' Navy, he elected to become a submariner.

In truth, the decision will not have been quite as simple as this. The Submarine Service was still in its very early days. It was only in 1901 that the Admiralty first admitted that the submarine may have a role to play in modern Naval warfare, ordering five *Holland* submarines, a type designed in the United States. For a century beforehand, the development of the submarine had not been encouraged as it threatened - or was thought to threaten - Britain's maritime superiority. The attitude towards submarines by leading naval figures was quite extraordinary. Use of submarines was considered to be extremely underhand and dastardly and Admiral Sir Arthur Wilson advocated treating submarine crews in war as pirates, and hanging them! It was only when France decided to build up its submarine fleet that the Admiralty felt obliged to assess their value.

The first *Holland* boats and the *A*-class submarines were very basic, not capable of long sea journeys and were used, principally, as additions to shore defences. The risks involved in the Service soon became apparent as *A-1* was lost with all hands on a Fleet exercise in 1904, when the *S.S.Berwick Castle*, unaware that it was passing over the top of the submarine, sliced open its conning tower.

Many Naval Officers considered it to be 'infradig' to be involved with submarines and, as Officers often looked more like plumbers' assistants while on duty, the Submarine Service was disparagingly referred to as 'the trade'. The name, however, took on a different significance during the First World War, and was accepted throughout the underwater branch of the Service with a certain affectionate regard.

The Submarine Service also appealed to Bradshaw, as he could be much more his own man. Here the ability to do a good job was of more importance than accent or schooling. The atmosphere was more relaxed, with everyone aware of the considerable risks that were being undertaken and the need for each man to play his part. The common experiences of a small group of men in cramped and often terrible conditions brought about a closely-knit team, confident in each other's abilities. Not all men made submariners, however; even the bravest Naval Officers could be reduced to a quivering wreck on their first trip out in a submarine.

At the beginning of 1910, Bradshaw was posted to Devonport and assigned to the submarine depot ship, *Onyx*. At that time, depot ships were not custom built and *Onyx* had originally been a torpedo gunboat. Its conversion in 1908 to a base for submarines led to its unusual elongated shape. Here Bradshaw will have received training in the *A*-class of submarines, although these had now become outdated.[1] After a year attached to *Onyx*, Bradshaw was transferred to another depot ship *Forth*, an old cruiser converted in 1903-4. This had *B*-class submarines attached to it. These were still driven by petrol and had a limited range. They had no gun for defence when surfaced and no rear torpedo. There was still no provision for wireless contact. Accordingly, they remained very rudimentary and were only able to operate in coastal regions on short patrols.

[1] The *D*-class were the latest model at this time, but only two had been built so far.

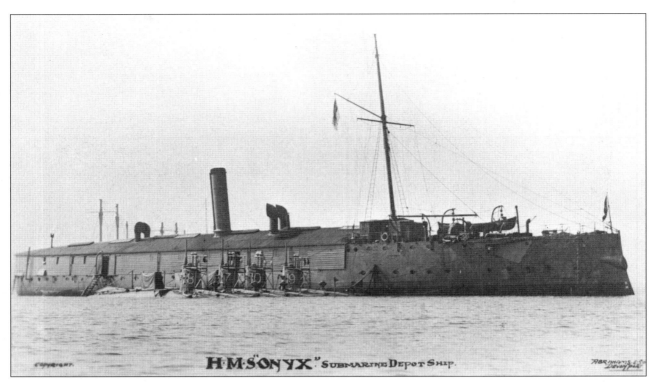

2.1 Depot ship *H.M.S.Onyx* with *A*-class submarines at Devonport (R.N.S.M.)

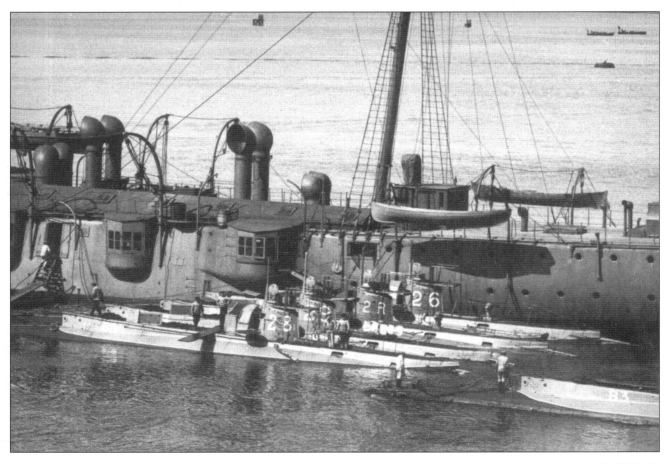

2.2 Depot ship *H.M.S.Forth* with *B*-class submarines (R.N.S.M.)

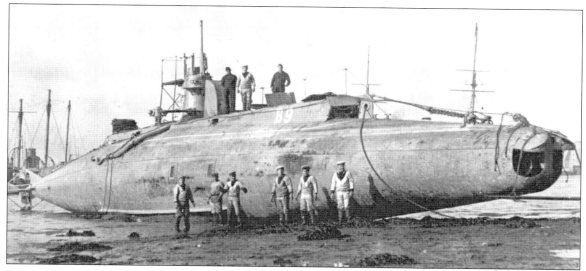

2.3 Submarine *B-9* grounded for repairs (R.N.S.M.)

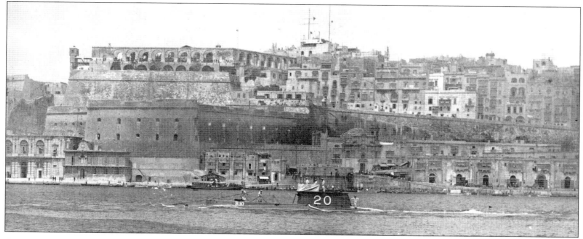

2.4 Submarine *B-10* in Valetta Harbour, Malta (R.N.S.M.)

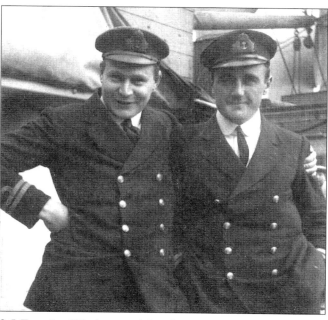

2.5 Eng. Lt. Whyham and Lt. G.F.Bradshaw on depot ship
Bonaventure, 1914 (R.N.S.M.)

In August 1911, it was decided to establish a submarine presence in the Mediterranean. Six *B*-class submarines made the not insignificant journey. Three were stationed at Gibraltar but Bradshaw was allocated to the small submarine flotilla, consisting of *B-9*, *B-10* and *B-11*, which was posted to Malta. During his time in Malta, Winston Churchill came to view the Fleet. As Bradshaw's boat at that stage was having engine problems, it was towed around to the neighbouring bay, so that the First Lord of the Admiralty would only inspect those submarines that were in full working order. However, Churchill, as he was being driven around Valetta, spotted Bradshaw's submarine and requested that he be shown around. Bradshaw, who was in his overalls working on some mechanical problem, was rather taken aback by this unexpected visit but nevertheless welcomed Churchill on board, only to discover with horror that in shaking hands with him, he had covered him in oil.[2]

It was during his time in Malta that Bradshaw found the time to pursue his art studies. His teacher was Edward Caruana Dingli, who became a director of the Malta Government School of Art. Dingli was a Maltese national, in his late thirties, who had studied at the British Academy in Rome as well as in Malta. He was a portrait and genre painter in oil and watercolour and executed many portraits of leading citizens, including Governors of Malta, Admirals, Generals and Bishops. There is no record of precisely what training Bradshaw received during 1912 and 1913 under Dingli but Bradshaw felt that he had made useful progress during this period.

With war imminent, Bradshaw was posted back to England in February 1914 to the *Bonaventure*, a depot ship based at Chatham and was given his first submarine command - *C-7*. This had been completed in May 1907 and had a crew of two officers and fourteen ratings. Its only armament was two bow torpedo tubes. Its maximum speed was twelve knots when surfaced and seven knots when submerged.[3] One of his officers during his time in charge of *C-7* was Charles Allen, who was to become a lifelong friend and a patron of his paintings. A joint interest in sketching may have been one of the initial attractions. Included in the papers left by Allen to the Submarine Museum are some sketches done by him while on *C-7* and a rough sketch done by Bradshaw in 1914 of a scene off Immingham, drawn on the back of North Sea Tide Tables.

The previous years had highlighted the risks run by submariners. In 1909, *C-11* had been sunk when it had been struck by a merchant ship, which had attempted to weave its way through a flotilla and, in 1912, both *A-3* and *B-2* had also been lost with all hands. The loss of *A-3*, struck by a torpedo gunboat on an exercise, probably due to the submarine being out of control as a baulk

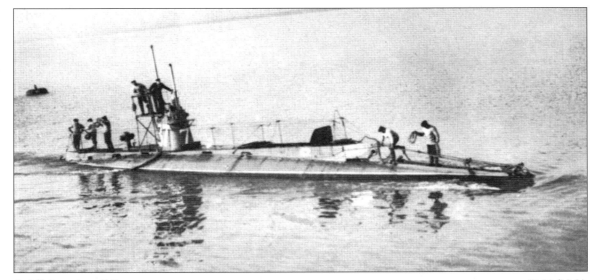

2.6 Submarine *C-7* (R.N.S.M.)

<hr />

[2] Bradshaw used to comment in later life that he was surprised what a wet handshake Churchill had. Another visitor was George V, who commented in his guttural accent, which Bradshaw enjoyed mimicking, "All very interesting and all full of brass".
[3] Full specifications are given in Appendix 1

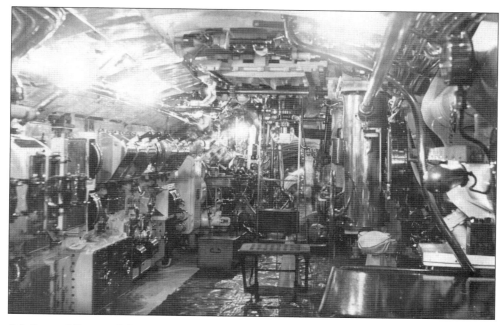

2.7 Control Room of Submarine *C-7* (R.N.S.M.)

of timber had jammed in its propeller, would have hit Bradshaw particularly hard, as it was under the command of two of his colleagues from his days on the *Majestic*. It is not surprising, therefore, to find in a review of the first ten years of the Submarine Service, the comment, "The men may serve only for a limited period in submarines, as the service is rather nerve wracking." [4]

In July 1914, Bradshaw in *C-7* was part of a flotilla that patrolled the east coast from the Humber to the Firth of Forth, as the Fleet was getting ready for war. The flotilla was initially based at Immingham and the submarines there operated patrols of forty-eight hours off Spurn Head. When war broke out, it was only the *D-* and the new *E-* classes of submarines that were capable of overseas operations. These soon performed heroics in the Heligoland Bight and in the Dardanelles but most of the *B-* and *C-* classes of submarines joined with the Surface Patrol Flotillas, which worked from the principal ports.[5] In November, *C-7* was allocated to local defence duties in the north-east. Boats from the flotilla were split into pairs and sent to Sunderland, Middlesbrough, Blyth and the Tyne. *C-7* and *C-10* covered Blyth, although the boats frequently changed their stations due to maintenance requirements.

It was not long before both sides demonstrated that the 'overseas' type of submarine would have a significant role to play in the war, the most startling feat being the sinking of the three British cruisers *Aboukir*, *Cressy* and *Hogue* by *U-9* on a single day in September 1914. A large building programme of new submarines was therefore initiated, with a number of different designs being tried. Another thirty-eight *E*-class submarines were ordered, six of which were fitted for carrying mines.[7] Fourteen *G*-class submarines were built in Britain and submarine building programmes were also instituted in Canada and America. As each new class of submarine was an experiment, the risks were considerable but this only served to heighten the camaraderie in 'the trade' and to lead submariners to believe they were special. Certainly, during the War, the threat of being transferred back to General Service was sufficient to ensure that a wrong-doer would not transgress again.

[4] Naval and Military Record, 31/5/1911, p.341
[5] The remaining submarines, chiefly the old *A*-class, were attached to the Harbour Defence Flotillas. *C-7* service history prepared by the Royal Navy Submarine Museum
[7] Charles Allen was serving on *E-24* in September 1915 on the first mine-laying trip by a British submarine when 20 mines were laid at the mouth of the Elbe. On its second mine-laying trip, *E-24* was lost with all hands. An attack of measles had caused Allen to miss the trip. How he must have despaired at the loss of all his comrades, no doubt feeling guilty that he had survived. There was no time for such modern notions as counselling.

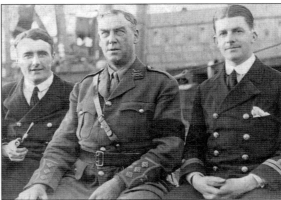

2.8 Lt. C.H.Allen at Blyth, 1914 (R.N.S.M.)

2.9 Lt. G.F.Bradshaw (left), with an army officer and Lt. J.F.Tryon, Blyth, 1915 (R.N.S.M.)

Tactics initially were rudimentary. Submarines had never featured before in a major conflict and this unseen foe, sending to the bottom many of Britain's prized ships, spread concern and alarm. It soon became clear that the normal procedure of challenging a suspected enemy ship to identify itself was inappropriate in the case of an enemy submarine - a torpedo being the usual answer. As a result, surface vessels were ordered to attack any submarine sighted. British submarines, therefore, often faced attack from their own side. The rationale was accepted in 'the trade' but it was the final straw at the end of a harrowing couple of weeks being tossed around in cramped conditions in the North Sea, dodging the ever-expanding minefields, to be attacked by one's own colleagues as one re-entered home waters.

The atrocious conditions on board the submarines cannot be over-emphasised. In a rough sea, the corkscrew motion of the submarine would cause even the most hardened submariner to be ill and yet, however nauseous one felt, the job still had to be done. The air quality after a long dive, particularly as the batteries often leaked, giving off a corrosive smell, was so poor that a match would not stay alight. In bad weather, the men stayed dirty and were nearly always wet. The food was monotonous and often diabolical. In these circumstances, maintaining morale was a significant task in itself. A successful action was, of course, a great tonic but often patrols produced no sightings of the enemy whatsoever. Nevertheless, concentration could not slip for a moment.[8]

In 1915, Rudyard Kipling was writing a number of articles about the Navy in wartime and was particularly interested in the role of the submarine. As Bradshaw's submarine was in-between trips, Kipling got permission to go out in the submarine on an exercise, in which two submarines were attempting to torpedo a destroyer. As they set forth, a neutral vessel hit a mine in the main channel leading into the port.

"Suppose there are more mines knocking about?" suggested Kipling.
"We'll hope there aren't" - was Bradshaw's soothing reply. "Mines are all Joss (Destiny). You either hit 'em or you don't. If you do, they don't always go off. They scrape along side."
"What's the etiquette then?" enquired Kipling.
"Shut off both propellers and hope." replied Bradshaw.[9]

During the trip, Kipling was fascinated by the faces and eyes of the men as they went about their work. Kipling was particularly taken by the features of the coxswain. He wrote:-

[8] This point was brought home to Bradshaw at the beginning of March 1915 when *C-7* collided with the Swedish freighter *Galatea*. The details of this incident are not known. Merchant ships could often be cavalier in their actions, even if they were aware that submarines were about. Whatever the circumstances, it would have been a worrying experience - such collisions had resulted in the past in the loss of the submarine and her crew. As a result, *C-7* was docked for repairs for the rest of the month.
[9] R.Kipling, *Sea Warfare*, London, 1916, p.48. Kipling does not mention Bradshaw by name, but Robert Bradshaw indicates that his father used to recount the story of this trip with Kipling.

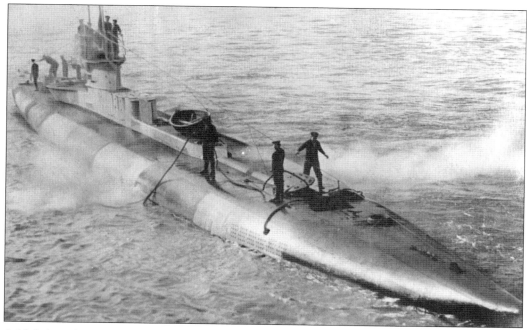

2.10 Submarine *G-13* in harbour, stern view (R.N.S.M.)

"On deck, his was no more than a grave, rather striking countenance, cast in the unmistakable Petty Officer's mould. Below, as I saw him in profile handling a vital control, he looked like the Doge of Venice, the Prior of some sternly ruled monastic order, an old-time Pope - anything that signifies trained and stored intellectual power utterly and ascetically devoted to some vast impersonal end." [10]

When Kipling's piece was published, Bradshaw asked the coxswain what he thought about Kipling's description of him. To his amusement, the coxswain replied that he was not too certain what it was all about but he certainly did not take kindly to being called a "Dog"!

Bradshaw was given sole command of his second submarine in August 1916 and was assigned to the depot ship *Lucia* in the Tees. *G-13* was a new boat. It was much bigger than *C-7*, with double the crew. It was faster, had a much greater range and was significantly better armed, with one stern, two bow and two beam torpedo tubes and fore and aft guns. [11] The submarine branch was now nicknamed the 'Suicide Club' and apparently the chances of staying alive while attached to this depot ship were about even odds, when you patrolled inside the 'Bight', and about 4-1 in your favour, if you were allocated to patrols off the Danish coast and the entrance to the Baltic. As fellow officer, William Guy Carr, commented, "Not bad odds when backing horses, but they seem damn short when you are gambling your life against the winning of a tin medal." [12] What is more, boats numbered *-13* were considered to be unlucky and Carr describes *G-13* as "always a Jonah boat". [13] This combination of superstition and disturbing reality meant that many of Bradshaw's friends, as they later confided in him, thought that they would never see him again. However, during this time of intense crisis, Bradshaw had, or made, some luck.

Although mines and barrage patrols could be employed in areas close to enemy bases and also in narrow straits and in operations areas close to shore, it was more difficult to catch *U*-boats in the waters between Scotland and Norway along their Northern route. Accordingly, the Admiralty instituted submarine patrols early in 1917 in the areas through which *U*-boats were accustomed to pass. At the beginning of March 1917, *G-13* and *E-49* began patrolling the waters to the north and the east of the Shetlands. When a gale started blowing on the afternoon of the 10th, *E-49*

[10] R.Kipling, op.cit., p.51
[11] Full specifications are given in Appendix 1.
[12] W.G.Carr, *Hell's Angels of the Deep*, London, 1932, p.212
[13] W.G.Carr, *By Guess and By God*, London, 1930, p.95. *E-13* had experienced considerable misfortune

sought shelter but Bradshaw in *G-13* remained on patrol. His hardiness was rewarded when just before 4pm a *U*-boat was sighted six or seven miles away near Muckle Flugga Light. After nearly an hour of manoeuvring, Bradshaw fired two bow torpedoes at a range of 2,300 yards. The chances of success were not great in such weather conditions, given that the optimum distance, even in fine conditions, was considered to be no more than 1,000 yards. However, one of the torpedoes hit *UC-43*, a mine laying submarine, just before the conning tower, and a heavy explosion left only some broken planking and a pool of oil a mile square.[14] Unfortunately, Bradshaw's joy at this success was short-lived, as two days later, *E-49* hit a mine that had just been laid by *UC-76* and was lost with all hands. Bradshaw's accomplishment was later recognized by the award of a D.S.O. and he was given a gold cigarette case with his name and crest on the front and "10th March 4.50pm 1917" on the back.

Shortly after this incident, Bradshaw's Commanding Officer, Captain Donaldson, recorded that Bradshaw was "a very sound and efficient officer with good judgement". However, not all was harmonious on the submarine as he did comment that Bradshaw had high ideals "which the Second Officer finds difficult to attain".

At this juncture in the War, Zeppelins were becoming a nuisance and Winston Churchill ordered two submarines, each equipped with four six-pounder anti-aircraft guns, to hunt them in Heligoland Bight. However, the Zeppelins proved to be much more annoying to submarines than planes because their endurance was far greater. A Zeppelin could hang on to a contact and it was very difficult for a submarine to shake it off. Bradshaw had a particularly harrowing experience. At sunrise one morning, some miles south west of Horn's Reef, Bradshaw, whilst his submarine was diving, spotted a patrolling Zeppelin to the north. He describes the incident as follows:-

> "It was a flat calm beautiful day with good visibility. Gun action stations were ordered and the boat surfaced. The gun's crew tumbled up in record time and brought their gun into action. It was extraordinarily difficult to estimate the range but fire was opened with five rounds in rapid succession while *G-13* got under way with her engines.
>
> The effect on the Zeppelin was peculiar and startling - the tail dropped until she was at an angle of 35° by the stern and she started to zigzag about in the most eccentric way. After several more rounds, the Zeppelin with a special effort got on an even keel, only to over-balance again, this time by the bow. She lost height rapidly and turned away from *G-13*.
>
> After about five minutes, she came roaring back on a level keel. She steamed around *G-13* in a large arc and, in spite of every effort on *G-13*'s part, eventually took up a strategic position dead astern of the submarine where the gun would not bear."

Finding himself in this precarious predicament, Bradshaw was forced to dive, which he achieved before the Zeppelin was able to drop a bomb on the temporarily defenceless boat. However, throughout the day, any attempt to surface was greeted with bombs. This happened so many times that, by the evening, Bradshaw thought the Zeppelin must be out of stock. Deep down, and wondering whether it was yet dark, he casually asked the telegraphist hydrophone listener, who was still wearing his headphones, what the time was. The 'sparker', stunned by the amplified noise of bombs over several hours, was in no shape to answer anything. "The time, sonny, what is the time?" Bradshaw demanded again. "The time, Sir, is slow ahead, Sir," was the response. In fact, when the submarine returned to periscope depth, the Zeppelin had gone and *G-13* was able to surface safely, but the incident is a good example of how a continual threat from the air could wear down a submarine and its crew.[15]

[14] R.M.Grant, *U-Boats Destroyed*, London, 1964, p.59
[15] F.W.Lipscomb, *The British Submarine*, London, 1954, p.99-100 and R.Compton-Hall, *Submarines and the War at Sea 1914-18*, London, 1991, p.104-5

There were, however, occasionally some incidents which provided a measure of light relief. One of these, which Bradshaw called the 'red eyes mystery' when he recounted it in later life, occurred when his submarine was on patrol in the North Sea. As was customary, Bradshaw had surfaced during the night in order to freshen up the air in the submarine, and he and the first mate were up in the conning tower having a look around. Very little was visible as it was a black, stormy night. Suddenly, the first mate staggered back, clutching his chest, and cried out "Sir! I've been shot." Bradshaw responded, "Don't be so darned silly. We're in the middle of the open sea. You can't have been shot." However, the first mate still insisted that he had been hit in the chest, and Bradshaw, unable to see any evidence of any wound, told him to go down below, lie down, and pull himself together. He had experienced the effect that prolonged strain could sometimes have on men, and, accordingly, the following morning he was not surprised to see the first mate at his duties without any ill-effects. Somewhat later, however, one of his officers approached him to say that none of the men would venture into the fore torpedo hold, claiming that a pair of red eyes were watching them. When the men were insistent that nothing would make them clamber into this small, dark area, Bradshaw realised that this was one of those times when he had to display leadership qualities.

He climbed through the hatch and, sure enough, there were a pair of red eyes staring at him. As uncertain as his men as to what he was facing, he was rescued from his predicament by the cook, who tossed in some raw meat. This had the desired effect, as the creature with the red eyes moved to reveal itself to be a hawk. How a hawk had managed to get itself into the torpedo hold, and survive, was initially a mystery but when the first mate's experience of the previous evening was recalled, they worked out that the hawk, attracted by the submarine's lights, must have dive-bombed the first mate, then, in a concussed state, fallen down the conning tower, before seeking sanctuary as far as possible away from human activity in the torpedo hold. The men soon made a pet of the hawk, but released it when they chanced upon some islands that looked a suitable haunt.

Bradshaw's most controversial achievement during the war was the alleged sinking of the *Bremen*. This was a mercantile submarine and was the sister ship of the famous *Deutschland*, which had caused considerable consternation when it arrived at Baltimore in the United States on 9th July 1917, with a mixed cargo, as it had not been thought feasible for a submarine to travel such a distance. Special arrangements were made by Admiral Bayly for intercepting the *Deutschland* by six different Q-Ships on her return journey, but she managed to evade detection, returning home to Germany on 24th August. The *Bremen* had also started on the voyage to America but was never heard of again. Officially, the fate of the *Bremen* is unknown. Some sources say she was damaged on her first voyage, repaired and converted to a surface ship;

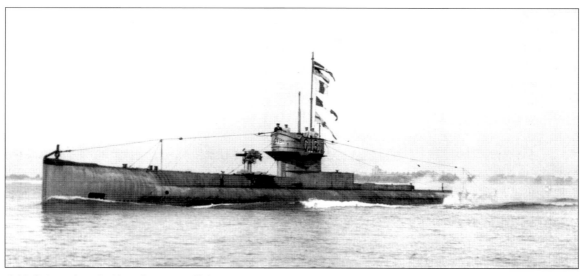

2.11 Submarine *G-13* under way off the coast (R.N.S.M.)

others say she was lost on her first voyage from unknown causes. Bradshaw's version of the story was recorded in Carr's *By Guess and By God*:-

> "Bradshaw sighted the large submarine while doing a submerged patrol. He manoeuvred and fired his two bow torpedo tubes. He missed with both. He figured he had made a mistake in estimating the enemy's speed. He put his helm over and brought his starboard beam tube to bear and, allowing a little more deflection, fired again. Once more there was no result. He manoeuvred and brought his other beam tube to bear and with a prayer on his lips gave the order to fire again. He had wasted about £4,000 worth of torpedoes with his first three shots, and he was more than anxious that the fourth should register a hit, but the expected explosion never materialised.Figuring he might as well be killed for a sheep as a lamb when he got back, he turned his stern to the fast disappearing enemy *U*-Boat and let go the 21 inch torpedo. To the amazement of every one of the crew, they distinctly felt the explosion register in the boat at the proper interval after the torpedo had been fired." [16]

The believed range of the last shot was 7,000 yards - without doubt one of the luckiest shots in the war, if it did indeed hit its target. Many commanders may have concluded after the first couple of torpedoes had been fired that it was imprudent to waste more. Bradshaw's decision to use all his torpedoes in this one encounter, particularly when the chances of success of the last torpedo were so small, reflects the intense pressure to perform that submarine commanders experienced at this time. There was also considerable rivalry between officers. Some cracked under the strain. Carr tells of one officer, who was considered to be a good all-round and efficient commander, who was sitting at the dinner table in the depot ship's wardroom, when news arrived that a fellow officer and good friend had pulled off quite a stunt and torpedoed something worthwhile. Instead of celebrating this news, he got to his feet without saying a word, climbed on top of the table, and began to crow like a cock. His mind had given way completely.[17] Bradshaw, on the other hand, convinced that he had performed a notable feat, had to cope with both his achievement and his word being doubted.

In his account of the sinking of the *Bremen*, Carr describes Bradshaw as "an exceptionally fine type of Officer". Bradshaw was also responsible for saving Carr's life. The incident happened on 8th January 1918, when Bradshaw and Carr were attached to the depot ship, *Lucia*, in the River Tees. The weather that night was foul with the wind blowing with hurricane force accompanied by a blizzard of sleet and hail. The flotilla Officers had just finished dinner and were sitting comfortably engaged in a game of cards in the smoke room of the depot ship when a seaman reported that a coal hulk had broken adrift in the river and was being blown by the wind towards the submarines, which were moored together. When the Officers arrived on the scene, they discovered that a big barge had also come adrift of its moorings and had wedged itself between the coal hulk and the sea wall. The seas were lifting the two wooden vessels on their crests and crashing them down on the sterns of the three submarines. Carr was the first one to react:-

> "There was only one thing to do and that was to get a hawser off to the coal hulk, make it fast, and let the seamen ashore haul the hulk clear with the aid of the steam capstans.
>
> I got safely on to the barge, which was tossing about like a mad thing, and, hanging on one moment as a wave broke over me, I scrambled across the heaving decks the next. The sides of the coal hulk towered high above the deck of the barge. She lifted high in the air on each succeeding wave top and came hurtling down with a sickening crash on the stern of the submarines.
>
> The task of getting aboard her seemed almost impossible. However, I noticed the end of

[16] W.G.Carr, *By Guess and By God*, London, 1930, p.211
[17] W.G.Carr, *Hell's Angels of the Deep*, London, 1932, p.222

the cable by which she had been moored when she broke adrift was dangling over the bow. I knew that would enable me to get aboard if only I could reach it. Both the hulk and the barge were adrift, free from any kind of control and at the mercy of the wind and waves. They were alongside each other one moment and thirty feet apart the next.

I scrambled along to the bow of the barge hoping they would drift close enough together to enable me to catch hold of the end of the parted cable. After several attempts, I managed to catch hold of it and started to climb aboard, but the cold had begun to get in its work. My hands were growing numb; my water-soaked clothes and the drag of the heaving line were added burden. It took every ounce of my

2.12 W.G.Carr RNR, when Navigator of Submarine *G-6* (R.N.S.M.)

willpower and energy to climb each extra foot up the cable that swung back and forth with the pitch and roll of the old hulk. I could feel every jar as she pounded down on the partly submerged sterns of the submarines. I realised that it would only be a question of time before she would either break them adrift or sink them, so I renewed my efforts to climb aboard.

Finally, I got within reach of the deck and pulled myself aboard. I beat my arms across my chest to get the cramps out of them and start the circulation again; then I signalled ashore that I was ready to haul off the heavy hawser. They bent it on to their end of the heaving line and I hauled it off and made it fast. I saw the men ashore take the hawser to a steam capstan; but the thing wouldn't work; it was like everything else that night, frozen stiff.

Few people can realise what wet cold really is like. You can have zero weather on a nice dry day without the slightest discomfort, but damp cold seems to penetrate into the very marrow of your bones. Your fingers and toes seem to swell to bursting point. The pain becomes excruciating.

As I stood there in agony, my clothes froze stiff as a board. However, I saw through the blinding storm dozens of men, yes, hundreds, collecting ashore. At first I didn't realise what it meant, but soon I saw them lay hold of the six inch manilla line and start to haul the hulk clear by sheer brute strength. The Officers laid hold with the men and lent their weight, while I could see Lieutenants Chapman and Bradshaw urging them on to superhuman efforts like coaches do a tug-of-war team. Slowly but surely their efforts were rewarded. I no longer felt the sickening bumps as the hulk crashed down on the submarines.

I had grown numb. The pain in my bones had mercifully grown less and less. A kind of tired, drowsy, comfortable feeling took the place of the excruciating torture I had at first experienced. Then I sensed something was wrong. I thought I heard tiny voices calling as from a great distance. I made a superhuman effort to arouse myself. I tried to beat my arms again, but they were simply made of lead. My legs were little better, but I could just move them. Forcing my eyes open, I dimly saw the figures ashore excitably waving to me. They were apparently yelling at the top of their voices, but they were shouting into the teeth of the gale. My senses seemed to register the fact that they were trying to warn me about something. I made another effort to collect my senses and forced my intellect to function, this time with success. The coal hulk was sinking under me. She had pounded a hole in her bottom.

It is extraordinary what the sense of self-preservation will enable a man to do. The shock of the discovery seemed to give me renewed energy. I realised I had to act to save myself, so I dragged myself over to the rail which was almost level with the water. The coal hulk was at this time about forty feet from the dock wall and about the same distance from the submarines. The top of the dock wall was at least twenty feet above the water, I realised that it was useless to swim to it, so determined to try to reach the barge, which was low in the water.

Frantically, I tried to beat some feeling into my limbs. The old coal hulk, which had in her day been a fine sailing ship, settled lower and lower. As she sank, the water actually felt warm. It revived me.

I don't think I would have made the barge if Chapman and Bradshaw hadn't come to my assistance, because the next thing I remember clearly, was being with them in the barge which was full of water to the gunwales. The waves were washing right over her, and the barge was still pounding herself on the sterns of the submarines. The men ashore threw down a line, and Bradshaw and Chapman made it fast to the floor of the barge. Then the men ashore hauled the barge clear, but she also was in a sinking condition, so the three of us entered the water again and swam to the submarines. This was the most dangerous part of the experience. The sterns of the boats projected quite a distance just beneath the surface. The after hydroplanes and propeller guards also formed ugly obstructions to avoid. The seas were running quite high and broke in a smother of foam against the sloping decks of the submarines.

I was nearly exhausted by this time, and the waves threw me up on the slippery decks of the submarines, only to suck me back in again before I could catch hold of anything. Bradshaw and Chapman managed to get on to the deck of the submarine, and then they pulled me out also.

One of the mooring lines had parted and, when we recovered sufficiently, we proceeded to get the submarine securely moored again. Under the existing weather conditions, this was no easy task. It was the wee small hours before we got back on the wharf and staggered to the depot ship, where we were given medical attention.

Following my experiences that night, I took a severe cold, but one simply hated to report sick when the flotilla was having a run of bad luck. Several of the *G*-Boats had failed to return from their last patrol. When these things happened, you feel that to report sick might be taken by others to indicate that you had developed an attack of cold feet".[18]

Carr was, not surprisingly, hospitalised after this incident but Bradshaw appears to have survived his ordeal with no lasting ill-effects.

The Commanding Officer's reports on Bradshaw continue to praise him highly. He is described as "an exceptional officer of the highest ability" who "makes extremely good attacks" and who "brings the junior members up well in the way they should go". It is accordingly no surprise that in April 1918, Bradshaw was promoted to Lieutenant-Commander and was immediately given command of submarine *L-11*. This submarine had only been launched in February of that year and was not fully commissioned until 27th June. It was a much bigger and better armed boat than *G-13*, capable of more than three times the speed when submerged and it carried mines as well as torpedoes.[19]

By this time, Bradshaw's artistic ability was also being recognised by his colleagues and Bradshaw started to depict scenes that he himself had witnessed during his career as a submariner.

[18] W.G.Carr, *Hell's Angels of the Deep*, London, 1932, p.244-7
[19] Full specifications are given in Appendix 1. It is not known what operations Bradshaw was assigned in *L-11*, but, as the boat went in for a refit within a few months, it is likely that it had some teething problems. By coincidence, Charles Allen had a spell in command of the boat in 1924.

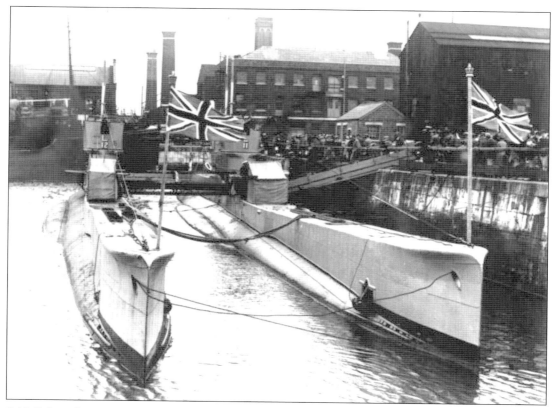

2.13 Submarines *L-11* and *L-12* in Portsmouth (R.N.S.M.)

He executed a watercolour of *H.M.S. Lucia in Scapa Flow*, showing the bow view of his depot ship, with a *J*-class submarine and a small boat on the starboard side and a cruiser in the background, and he also depicted his own great success, the sinking of the *Bremen*, although it proved a little difficult to make a good composition out of a periscope in the foreground with a vast expanse of ocean and a hardly recognisable submarine on the far horizon receiving a torpedo hit. A more successful work is a large oil entitled *On Patrol 1914-1918* (fig 2.14), depicting a submarine on surface patrol with heavy seas breaking over her which, until recently, hung in the Wardroom of *H.M.S.Dolphin*.[20]

Bradshaw also began to receive a string of commissions from his fellow officers for paintings of their submarines and the Royal Navy Submarine Museum in Gosport have a number of works by Bradshaw depicting submarines of each of the *C-*, *D-*, *E- J-* and *L-* classes. The Museum also has a Bradshaw painting of *Submarine D-4 torpedoing Bickfield*, an incident which occurred in 1915 (a work that was reproduced as a postcard) and a four scene representation of the sinking of *U-98*. A number of these paintings were presented to the Museum by Bradshaw's friend, Charles Allen. These include an oil of *Submarine C-30*, Allen's first command and a watercolour of *Submarine E-42*, of which Allen was in command when she torpedoed the German Battle cruiser *Moltke*, for which he was awarded the D.S.O. Allen had joined the Submarine Service in 1913 and had taken time to establish himself as an officer being described initially as "curious" and "not very good in an emergency". The *Moltke* was the lead battle cruiser of the German fleet in its last sortie in April 1918 but it broke down off Norway, whereupon the German Admiral decided to call off the operation and cover the battle cruiser's passage home under tow. Allen, who fired nine torpedoes, eventually managed to hit it with a long range shot, bringing down on himself "one of the hottest destroyer concentrations of the war", but he escaped.[21] Bradshaw's painting of this action was also made into a postcard.

[20] *On Patrol* was also presented to the Royal Navy Submarine Museum by Charles Allen, this time in conjunction with Lt. Commander M.W.Bailward. Bradshaw returned to the theme in 1937 with *Surface Patrol*, another large work showing a submarine silhouetted against a red and gold sky - see Appendix 2.
[21] F.W.Lipscomb, *The British Submarine*, London, 1954, p.104

2.14 *On Patrol 1914-1918* (Oil on canvas) (RNSM)

Although Bradshaw's depictions of submarines have historical interest, they demonstrate that he still had some way to go as an artist. It is most unusual for the water in a Bradshaw painting to be unsatisfactory, but there is no feeling of realism about the choppy seas upon which the submarines sit uncomfortably. However, some of the paintings have sections which are good. *U-Boat at Sunset* has a very tranquil atmosphere with an excellent effect as the sun disappears behind the clouds and, in *U-Boat Sinking Barque by Gunfire* (Plate 1), the burning barque is effectively depicted with black smoke billowing skywards. Such a sight may have been witnessed by Bradshaw repeatedly, as sailing ships provided an easy target for submarines. The War had a catastrophic effect on the numbers of sailing craft involved in the traditional trades of grain, wool and fruit and, after the War, circumstances had altered so that there was no point in building new wind ships. Their days were numbered.

At the end of 1918, Bradshaw's Commanding Officer changed, the highly regarded Captain M.E. Nasmith V.C. (later promoted to Admiral) taking over from Captain Donaldson. However, Bradshaw's glowing reviews continue. He is described as "a good submarine officer with a level head and a great deal of stamina" and that he "could be trusted in any position of responsibility" and has "plenty of self-reliance". Nevertheless, in November 1918, Bradshaw was involved in an unfortunate accident. While his own boat *L-11* was in for a refit, he had assumed temporary command of submarine *G-11*, as its commander Lieutenant Richard Sandford V.C. was seriously ill with typhoid. Although hostilities had ceased on 11th November, *G-11* was sent out on patrol off Dogger Bank on 19th November. When recalled three days later along with the rest of the Fleet, Bradshaw had set a steady speed of just under eleven knots, expecting to sight Coquet Island Light off the Northumbrian coast at about 1900 hours. At 1840, as the boat entered heavy fog, Bradshaw sensed something ahead but the coxswain on watch saw nothing. Nevertheless, Bradshaw immediately ordered both engines to be stopped, but it was too late. The fog had been obscuring both the lighthouse and the coastline and the submarine went aground near Howick. The boat ran up on shelving rock until its bows were almost out of the water and then rolled to

port. On grounding, the keel was torn off and the boat was holed on the port quarter. As rough seas were still breaking over her, Bradshaw considered that there was a real danger that she would capsize and, accordingly, gave the order to abandon ship, during which operation two men were drowned.[22]

His Commanding Officer recorded that the accident was due to "an unfortunate combination of circumstances" and "proved to be due rather to bad luck than bad management" but Bradshaw not only will have felt keenly the indignity of losing the submarine but also, more significantly, he will have been greatly saddened by the loss of two men - colleagues whose joy at the end of hostilities had been cruelly curtailed.[23] Bradshaw cannot have found it easy to give free rein to his own emotions of relief at the end of the conflict, knowing that two families who had made preparations to welcome home their loved ones had had to come to terms instead with their loss at the last hurdle. Notwithstanding the conclusions of his Commanding Officer, Bradshaw relived the situation many times, asking himself whether he should have avoided the tragedy - it was an incident which left an impression on him for the rest of his life.[24]

From time to time, all submarine officers were required to return to sea in a large surface ship in order to reacquaint themselves with the 'real' Navy. Having spent all the War in submarines, Bradshaw was well overdue for a return to General Service and in March 1919, he was transferred to the battleship *Resolution* which was serving in Russia. Bradshaw did not enjoy life back in the General Service, as he had grown used to being Commander of his own ship. Being based in Russia at that stage of the Russian Revolution was also not a pleasurable experience and Bradshaw's principal memory was of the night that the sailors managed to get on board the ship a Russian black bear, which they proceeded to make drunk. The bear, and its bowels, were soon out of control and Bradshaw's pristine white quarterdeck was almost irretrievably spoilt.

It was probably with some relief that Bradshaw gained another submarine command, *K-15*, in February 1921. *K*-boats had been developed with a view to them being able to keep up with the speed of the Fleet in Fleet exercises. They were more-or-less a destroyer that was capable of submerging. They could fight with their 4.1 inch guns when on the surface, and dive to deliver their torpedo attack but they required four minutes to dive, and had to be very carefully handled owing to their great length.[25]

The class had never really had the chance to prove itself during the War and there had been a major tragedy on a Fleet exercise in the Firth of Forth in 1918 when two *K*-boats were sunk and two others damaged. *K*-boats were disliked by Officers in 'the trade'; when asked his opinion later in life, Bradshaw commented, "I have never met anybody who had the slightest affection for the *K*-class and they were looked on with fear and loathing. After all, they murdered many of their officers and crews."[26]

Bradshaw only had command of *K-15* for a couple of months, as the boat, through a design fault, sank as she lay alongside the cruiser *Canterbury* in the tidal basin at Portsmouth. Bradshaw and

[22] Telegraphist Back was thrown overboard by a heavy bump of the submarine just as he came up the conning tower hatch. He was last seen only twenty yards from the shore and may have been dashed on the rocks. The stoker Foster was lost as the crew was making its way along the line that had been secured to the shore through the brave efforts of Lieutenant Smith and Able Seaman Birch. The poor visibility can be gauged from the fact that no one was aware of Foster's loss until the crew was mustered later, even though Bradshaw directed the Aldis lamp on to the line. Bradshaw was the last to leave the boat - the operation to abandon ship had taken an hour.

[23] Whether or not he knew about the accident, Lt. Sandford, the original commander of *G-11*, died from typhoid the following day - news that will not have eased Bradshaw's peace of mind.

[24] In *Beneath the Waves* (London, 1986 at p.134), A.S.Evans lists several possible contributory causes, other than the weather. On the morning of accident, Lieutenant McLure reported that he did not consider the Forbes log accurate as it had stopped several times for a minute or so at a time. If the log was inaccurate, this would be a reason why Bradshaw believed that he was much further away from land than he really was. Evans wonders whether Bradshaw, being only temporarily in command and, therefore, new to the boat, miscalculated the loss of speed due to the heavy sea running at the time, as the loss of speed in Bradshaw's own boat, *L-11*, under similar circumstances, would have been greater owing to the proximity of the propellers to the surface. However, Bradshaw had been in command of *G-13* for a number of years and should have been aware of the performance of *G*-class boats in these circumstances.

[25] Full specifications are given in Appendix 1.

[26] D.Everett, *The K Boats*, London, 1963, Chapter 4 - Heading

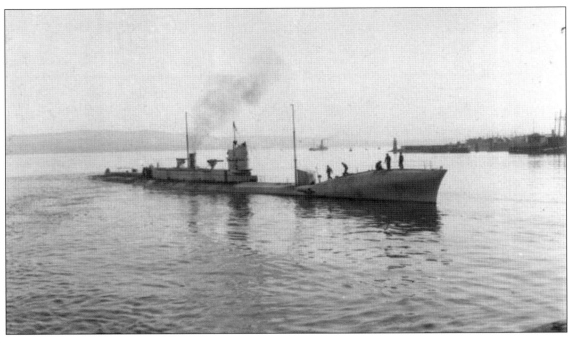

2.15 Submarine K-15 off Scott's Yard (R.N.S.M.)

most of the crew were on leave at the time. After a hot summer's day, the watchkeeper during the night noticed the stern of the submarine under water. Realising something was seriously wrong, he raised the alarm and the rest of the crew crossed over to the *Canterbury* alongside. They were powerless to stop the boat sinking. It transpired that the hot weather during the day had caused the oil in the hydraulic system to expand and overflow. The hydraulic system controlled the opening and closing of the main vents to the ballast tanks. In the cool of the evening, the oil in the system contracted, causing a drop in the oil pressure, thus loosening the vents and allowing air to escape from the ballast tanks and be replaced by sea water. Gradually, therefore, *K-15* became less and less buoyant, until she eventually sank.[27]

The powers that be in the Navy clearly felt that, whereas losing one submarine might be bad luck, losing two must be due to carelessness or negligence and Bradshaw was court martialled in August 1921.[28] Bradshaw did not take kindly to the indignity of such proceedings, after such a distinguished career. Perhaps he was unable to control his temper or to restrain himself from expressing his loathing of *K*-boats, for, although he was acquitted - as, quite clearly, he should have been, - their Lordships decided that he should not again be placed in command of a submarine. This decision effectively ended Bradshaw's Naval career and he was discharged immediately. Such an undignified exit from the Navy rankled with Bradshaw for the rest of his life.

At the age of 33, therefore, Bradshaw found himself unemployed. This may not have come as a great shock to him, as the Navy was at that time effecting considerable cutbacks due to the conclusion of the war. Accordingly, his job may not have been secure for too long, although his friend, Charles Allen, did remain in the Submarine Service until 1933. Bradshaw did admit to his wife that his nerves were by this time "shot through" and, having seen so many friends and colleagues lose their lives during the War, he may in any event have been contemplating a fresh start. Nevertheless, painful as his discharge was, he had little doubt what he should now do - it was time to pursue his great interest in art and discover whether he could refine his skills as an artist to make his hobby his second career.[29]

[27] A.S.Evans, *Beneath the Waves*, London, 1986, p.143-4

[28] The majority of submarine commanders who lost a boat did not survive to have an opportunity of losing a second.

[29] Wormleighton in *John Anthony Park*, Stockbridge, 1998, at p.45, indicates that Bradshaw had thought briefly about becoming a fruit farmer in South Africa.

THE SIMPSON SCHOOL OF PAINTING

Charles and Ruth Simpson had set up their School of Painting in St Ives in 1916. Charles, born in 1885, was the son of an Army Major-General but had been prevented by a riding accident from undertaking military service in the First World War. He was an ardent naturalist, gaining a considerable reputation as a painter of birds, horses and other animals. His interest in animals had developed during many family holidays at his grandmother's home, Pickhurst Manor, in Kent. He was largely self-taught, although he had short periods studying under the foremost animal painters of the day - Lucy Kemp-Welch, at Bushey and Sir Alfred Munnings, in Norfolk. He had first come down to Cornwall in 1905 and had taken lessons in landscape painting from the St Ives artist, J.Noble Barlow. He attributed his interest in depicting water to his days at Julian's Academie in Paris in 1910, as this was the year the Seine overflowed, converting the Champs Élysées into a river, full of floating barrels, cattle and other debris. He met Ruth Alison in Newlyn in 1911 and they were married in 1913, living first in Newlyn and then in Lamorna.

The prospectus for the School announced that all branches of painting and drawing would be taught and "especially the modern methods of handling oils, tempera, watercolour, etc and illustration work with a view to reproduction". Newspaper advertisements indicated that the subjects would include "portrait painting in oils (models daily), sketching in watercolour, tempera, etc; also the study of animal and bird life."

Kathleen Marion Slatter first attended the Simpson School of Painting in 1921. She was only 17 and had been born and brought up in Rhodesia. Her father, who was a well-known big game hunter, had been killed in the First World War and she had been sent to England under the guardianship of a great aunt, Lady Couchman, who lived in Gloucestershire. After finishing her

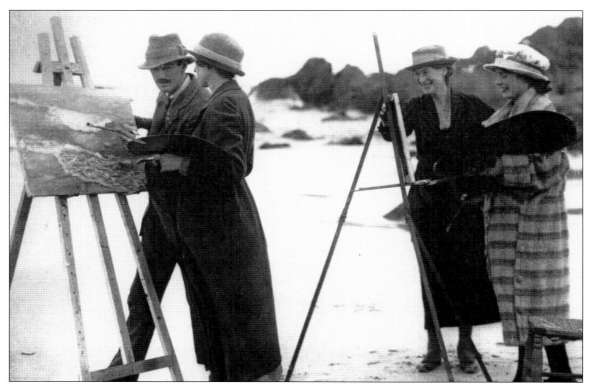

3.1 Charles and Ruth Simpson teaching on Porthmeor Beach (L.Simpson)

schooling at Cheltenham Ladies College, she wanted to attend the Slade School of Art. However, Sir Francis and Lady Couchman had felt it inappropriate for a young girl of her age and circumstances to be on her own in London. The Simpson School had already developed a good reputation and they felt much happier with their charge being under personal supervision in a small Cornish town.

Kathleen vividly recalled her arrival in St Ives. Charles Simpson had sent his father, an archetypal Major-General with a huge moustache, to pick her up from the station in his motor cycle and side car. Kathleen had to leap on the back of the motor cycle, with her trunk sticking out of the side car at a jaunty angle. She lived with the Simpsons in Loyalty Cottage, along with another student, Miss Leningsden, who was rather neurotic. One night, she burst into Kathleen's room at a late hour asking for a stamp and then proceeded to tie on her bonnet and go out in her night-gown to post a letter. Her stay was short-lived.

Classes were held in the Piazza Studios, overlooking Porthmeor Beach. The Simpsons had two studios, Nos 4 and 5, one above the other. The upper studio had specially constructed windows to provide a wide view of the sea, enabling the students to paint marine subjects indoors when the weather was bad but, on good days, painting outdoors on the beach was encouraged.

At lunchtime, a table in the studio was covered with a blue and white check cloth upon which, as often as not, were placed a bowl of anemones and a large bowl of fruit. The Simpsons provided a picnic lunch and this served as a break between the morning session when the classes were usually led by either Charles or Ruth Simpson and the afternoon sessions where the students were left on their own to pursue a particular task.

One afternoon, shortly after lunch, there was a knock on the studio door. As Kathleen Slatter was the nearest student to the door, she answered it and found a Mr Coates, who wanted to talk to Charles Simpson about enrolling in the painting class. Kathleen took him down the studio steps out on to the road and pointed out Loyalty Cottage and the best way of getting there. She had hardly had the opportunity of resuming her work before there was a further knock on the door. This time, it was George Bradshaw. Annoyed at the constant interruption, she was much more peremptory with her directions to Loyalty Cottage. However, on her return to the studio, the other students noticed that she was blushing deeply. She had just met her future husband.

It is not difficult to understand why George Bradshaw chose St Ives as the place to pursue his artistic career. Since the late 1880s, many of the leading artists had been drawn to Cornwall and the successes of both the Newlyn and St Ives artists on both the home and international stages had been well-documented. Imbued from his days in the Navy with a love of the sea and all that sailed upon her, Bradshaw had a particular affinity for marine painting and St Ives had developed a notable reputation in this genre. The Cornish coast and fishing harbours had always attracted marine painters, but the establishment in 1895 of a School of Painting by Louis Grier and Julius Olsson, which specialised in marine work, had proved a great draw.

Olsson was the better painter and, although largely self-taught, he was clearly influenced by Henry Moore (1831-1895). After the poetry and drama of the seas of Turner and the Romantic Movement, realism had become, in the late Victorian period, the principal objective for many marine artists, as it had for artists of other genres. Both John Brett and Moore were influenced by the Pre-Raphaelite demands for exactitude but, although Brett was perhaps too scientific in his approach, having a tendency to paint almost every ripple, Moore adjusted his earlier concentration on minuteness of detail to become adept at suggesting atmospheric conditions. His novel concentration on pure seascapes and his efforts to emphasize the vastness of the ocean inspired Olsson, who became celebrated for his own depictions of seas reflecting setting suns and rising moons. Olsson, though, was more poetic in vision and had a more robust style.

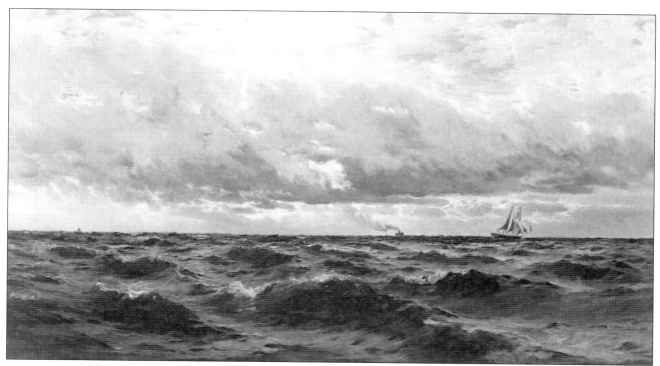

3.2 Henry Moore *The Newhaven Packet* (Birmingham Museums & Art Gallery)

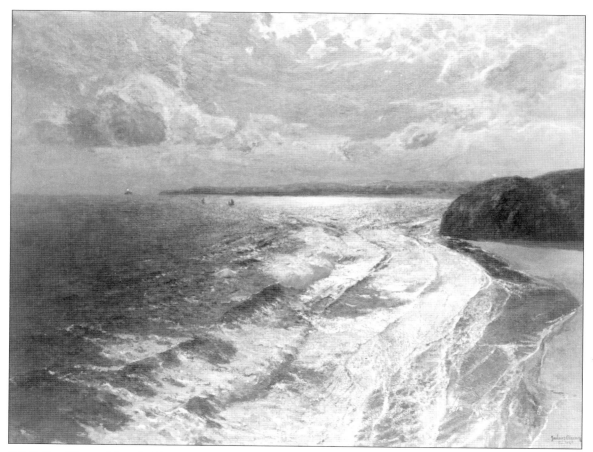

3.3 Julius Olsson *Moonlit Shore* (RA 1911 - Chantrey Work) (Tate Gallery, London, 1999)
This famous painting was originally sent to the RA with a consignment of fish in barrels. On arrival, it was found to be covered in fish oil. Olsson was given 48 hours to restore it.

Olsson's return to London in 1915 and the War brought the activities of his School of Painting to a halt but the marine tradition continued as John Park, considered by Olsson to be his star pupil, settled in St Ives as did a number of other former pupils, such as Borlase Smart. Bradshaw certainly would have known Smart, by reputation anyway, as he would have seen his work reproduced in *Naval and Military Record*. However, it is likely to have been the Simpson School that was the primary reason for Bradshaw's decision to come to St Ives. Bradshaw knew that he needed further training and he would have been aware that Simpson, amongst his many accomplishments, was a fine marine painter. With the right subjects at hand, an inspiring teacher and a strong marine tradition, St Ives was the obvious choice.

Simpson's forté was painting birds and animals but, although Kathleen recalled that he indicated that one should always paint a duck, starting with its tail, such subjects did not form a major part of the instruction received. He was equally adept at Cornish coastal scenes, in which he demonstrated his love of painting sunlight and reflections, and at depicting the local fishermen going about their ordinary working lives. A reviewer of an exhibition by Charles and Ruth Simpson at Leicester Art Galleries in 1922 commented:-

> "Mr Simpson's work, in particular, covers a quite remarkable range, and the possession of an extraordinary degree of technical skill does not tempt him into merely amusing himself with beautiful dexterity at the expense of higher aims. One feels that the highly personal manner in which he handles the problem of light, for instance, arises in a deeper-seated sense of beauty, and exultation is positively wrought into the texture of the paint with which he sets on record some evanescent magical glimmer of sun and air that only the quick eye of the artist could catch. To students, the exhibition is exceptionally valuable as representing what can be done in various media by a man who has completely found himself. Mr Simpson makes great use of tempera, which suits him because it enables him to get what he wants in the shortest possible time. He is a great and successful experimentalist; the use of gold leaf as a background for oils in one sunset picture is an example of audacity that comes off. Words cannot do justice to the atmosphere and poetry of some of Mr Simpson's moorland and seaside scenes, and occasionally he shows himself a master of decorative design, as for example in *Ducks on the Water*, and a screen treated more or less, in the Japanese manner." [1]

The instruction received at the Simpson School, therefore, would have been varied and stimulating and students were encouraged to develop their own individual style. In this environment, Bradshaw was able to develop his talent as a marine artist but was not forced to toil over portraits and still life, which held little attraction for him. The dramatic improvement in a short space of time in his depiction of water - from the jagged, unnatural seas of many of his submarine paintings to the convincing swells and breaking waves of his early St Ives work - suggests that Simpson was a significant help to him on this aspect and Bradshaw's ability to depict gulls successfully and to use them as important incidents in the composition is likely also to be due to Simpson's tuition.

Simpson liked to paint huge canvases. His paintings of horses were almost life size and his wife once wrote home marvelling about an "eight foot canvas of life-sized seagulls, blue sea and sunny cliffs".[2] Kathleen recalled that he painted very quickly - "like quicksilver" - and Laura Knight commented "He was so prodigal with paint, he could be traced by the colour left on the brushes!" [3]

Ruth Simpson, who had studied at Stanhope Forbes' School in Newlyn, was more of a specialist in portraits, with a fine sense of colour and a great ability to delineate character. Kathleen remembered a succession of "bonny" Cornish girls with straw bonnets that were used as models

[1] St Ives Times (" S.I.T."), 2/6/1922
[2] Letter dated 30/5/1912
[3] Laura Knight, *Oil Paint and Grease Paint*, p.162

3.4 The Simpsons entertaining in their studio c.1922.
Charles is standing, with Ruth sitting in front of him in the pale coat. Ruth's portrait of the artist, Charles Rollo Peters, *The American*, is on the easel.
Kathleen Slatter (no hat) (probably as yet unmarried to Bradshaw) sits on one side of the easel and the artist Eleanor Hughes from Lamorna on the other.
Prof. Alfred Sidgwick and the author Cecily Sidgwick, also from Lamorna, are on the far left.

for the students. Both Charles and Ruth Simpson secured a number of commissions and, from time to time, the students were allowed to help out. Kathleen assisted with the painting of draperies on several portraits.

These were happy days. Although not particularly wealthy, the Simpsons enjoyed entertaining and a number of dances and parties were held at the house and the studios, to which literary and artistic friends from Newlyn and Lamorna, including Stanhope Forbes, Lamorna Birch and Robert and Eleanor Hughes, were invited. Simpson, despite being of wiry build, was very fond of his food and hostesses soon learnt to prepare double portions for him. He ate with great gusto and a frequent party piece was to stick the feelers of a lobster up his nose! He also loved music, particularly Beethoven, with a passion, and there would be occasional concerts, to which Forbes might bring his cello.

Although there was an eighteen-year age difference between them, George and Kathleen fell in love immediately and were married in September 1922. He was a handsome man, assured and good-humoured, with a wealth of anecdotes from his days in the Navy and, although he would not have made much of his exploits himself, he was, of course, in the eyes of a young girl, a war hero. Bradshaw, for his part, had fought shy of a long-term relationship during his days in the Submarine Service, not only because of the constant partings but also because he never really expected to survive the War. How thrilled he must have been to discover immediately upon his arrival in St Ives a young, attractive and vivacious girl, who was equally passionate about art.

The wedding took place at Instow, in Devon, the home of Kathleen's aunt, Mrs Howard. Her mother, who had continued to live in Rhodesia, was unable to attend the wedding and she was given away by Sir Francis Couchman. Her dress was in white satin and georgette, with a train of

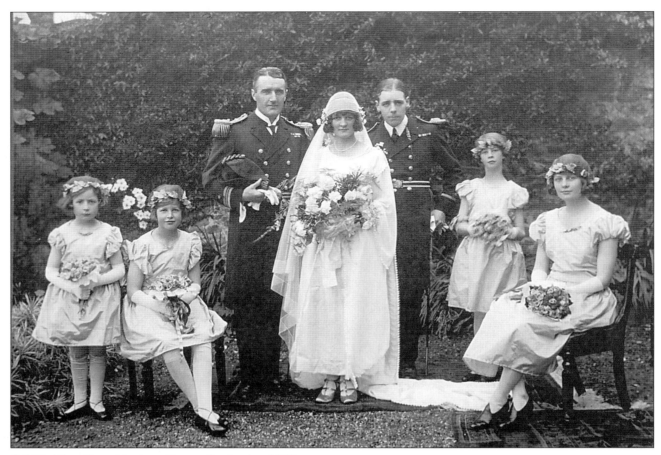

3.5 Wedding Day at Instow, Devon, September 1922
George and Kathleen Bradshaw with best man, Donald Currie and bridesmaids
Rosalinde & Marjorie Howard (left) and Verity & Doris Couchman (right)

3.6 Wedding Day, September 1922,
George Bradshaw with
Eng-Com. Masservy & Lt.D.Currie

3.7 Charles Simpson *Kathleen Bradshaw* (1922)

satin lined with georgette and gold. Her shoes were also in gold and she wore a long veil, decorated with orange blossom. Her bouquet was of roses, myrtle and white heather.

The bridesmaids were four cousins and they wore dresses of yellow taffeta, with garlands of autumn leaves. George's first choice as best man, Charles Allen, was unable to attend, due to naval duties and another naval officer, Lieutenant Currie, who was also studying with the Simpsons, assumed this role. He was not a favourite of Kathleen, as she considered that "he played at art, whereas he made a career of seducing other people's wives."

They lived initially in a cottage called 'The Meadow', just below the site of the present Tate Gallery, which had a studio attached. A visitor to St Ives in 1921 observed that the persons who had given the cottage the name, 'The Meadow', must have had happy thoughts, as it was a desolate spot, which did not boast a single blade of grass. It is not surprising, therefore, that the Bradshaws soon moved to Ship Studio in Down-a-long, which they acquired for £200.

Ship Studio, which is situated opposite Norway Stores, is no longer a dwelling and is merely used as a store, called Ship's Loft. It was never the most pre-possessing of properties, consisting of a large area upstairs, with timbered ceilings, and a cellar, which had been used for the pressing of pilchards. The pilchards used to be poured into the cellar through an opening, which became the kitchen window, and there were holes in the walls through which the large wooden boards would be put for the pressing process. The floor was sloped and had channels cut into it, with a hole in one corner for the oil from the pilchards to run out.

The Bradshaws sectioned off part of the upstairs room for their own bedroom, leaving the rest as an open-plan living area. The cellar they converted into a kitchen, bathroom and a spare bedroom. The windows downstairs were at ground level and it was very dark. To brighten it up, they painted the walls with maps and islands and sailing boats - their first excursion into interior design. It was to be their home until the Commander's death some thirty-seven years later.

The Bradshaws got on well with the Simpsons and George's progress was so rapid that he was soon asked by Charles Simpson to help out with the Painting School, and was described in adverts for the School as the Simpsons' Assistant. Such an appointment suggests that Bradshaw's earlier training with Dingli and his own extensive efforts during his Naval career had given him sufficient technical mastery to assist the students. Simpson may well also have appreciated his organisational abilities and have had an eye on his contacts in the Naval hierarchy. For Bradshaw, the appointment immediately enhanced his standing in the art colony, as well as offering a supplement to his Naval pension. Financial management, however, was not one of Simpson's strong points and an appropriate financial reward for Bradshaw's efforts became a bone of contention. For instance, he was more than a little annoyed to be sent to Scotland and Newmarket to secure various commissions for Simpson, without even having his expenses covered. The fact that Simpson was prepared to entrust such duties to a third party does, however, indicate the respect that Bradshaw commanded.

On Show Day in 1922, Charles Simpson exhibited a portrait of Kathleen Bradshaw, in profile, wearing a blue dress (fig 3.7) and Ruth Simpson one of George Bradshaw, in his naval uniform. A review described the latter as "a valiant attempt at an extremely difficult problem of rendering quietly the recurring spots of gold in the uniform. The painting of the head and hands struck me as being the best work I have seen hitherto from this artist's brush".[4] Borlase Smart also considered the portrait one of Ruth Simpson's greatest successes, showing "breadth of technique and spontaneity of touch". He felt that she had overcome the difficulty of portraying the dark uniform against a dark background "with much mastery".[5]

[4] S.I.T., 17/3/1922
[5] S.I.T., 17/3/1922. The present whereabouts of the picture are not known.

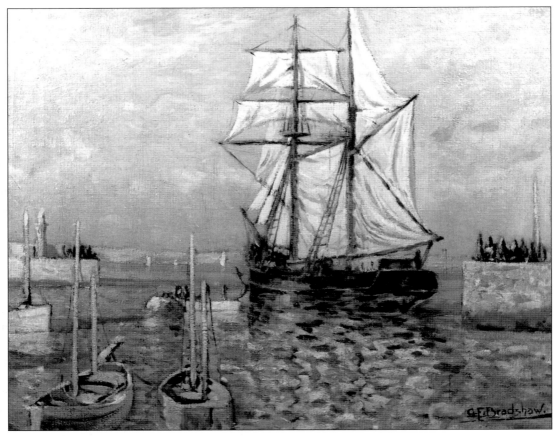

3.8 *Putting to Sea* (1922) (Oil on canvas) (David Lay)

George Bradshaw's first offerings at a St Ives Show Day provoked encouraging comment:-

> "Lieutenant-Commander Bradshaw showed his love of the sea in several ambitious seascapes. Commander Bradshaw has still a long way to go, which he is probably ready to acknowledge, but I think he is on the right road to eventually get there. I thought his *Up Channel* and *The Lady in White* the most successful of his exhibits." [6]

Another reviewer commented on the marked feeling of freshness in *Up Channel* and that the wave formation was well suggested.

In June 1922, Charles and Ruth Simpson organised an exhibition of paintings at Lanham's Galleries to include not only work by themselves but also a number of their students. Borlase Smart, who had been an art critic with a Plymouth newspaper, before joining the art colony in St Ives, observed:-

> "Lieutenant-Commander Bradshaw, who is Assistant Master at the School, has a very decorative achievement in *Putting to Sea* (fig 3.8), showing a schooner leaving St Ives harbour. The effect is a strong side light, and almost dramatic in intensity. The handling is expressive and full of observation as to the essentials of truth and breadth of expression." [7]

The topsail schooner depicted by Bradshaw leaving the West Pier is typical of the coasters that visited St Ives, frequently bringing coal. They would normally moor in the middle of the harbour and discharge their cargo over the side into carts (see fig 3.10) rather than dock by the pier. During the 1920s, their numbers dwindled and many were fitted with auxiliary power and lost

[6] S.I.T., 17/3/1922
[7] S.I.T., 7/7/1922. Smart also commented that *The Wreck* was full of atmosphere and that Bradshaw's picture of a three-decker going through *The Straits* showed good wave drawing and sentiment.

their square topsails. Not for the last time, Bradshaw has captured a scene that would soon be consigned to history.[8]

The speed with which George Bradshaw did make progress is evidenced by the fact that the very next year he had his first painting accepted by the Royal Academy. This was entitled *The White Barque* and was described as "a cleverly designed picture, catching the swell of the water and the impulse of a Barque driving before the wind".[9] The whereabouts of this painting are not known, but another work executed in 1923, *Off Gibraltar* (fig 1.9), recently came on to the market and, from this, one can judge how far he had come. The central feature is a lateen-rigged fruit boat, powering through a choppy sea, to which the eye is drawn by a breaking wave and white foam leading from the bottom two corners of the composition. The boat is set back some distance - perhaps, a little too far - to allow the inclusion of some colourful, dancing reflections. In the background, the distinctive shape of the Rock of Gibraltar on one side is matched on the other by a large multi-funnelled steamer. It is an assured work and clearly Bradshaw returned to the subject in later life, as the painting matches descriptions of his 1950 picture *His Majesty's Sea-Bound Mails*.

Charles Simpson also maintained a studio on The Wharf, overlooking the harbour, known as Shore Studio and, in 1923, he decided to execute a series of paintings illustrating the fishing industry, as it was then practised in St Ives. He traced all the operations of the fishermen, beginning with the empty quay before the boats come in and covering the fishpackers, the salesmen and the transport men. Titles included *Girls Awaiting the Gurries*, *Packers in Oilskins* and *Loading the Carts* (fig 3.10). One of the paintings - *From My Studio Window during the Herring Season* (fig 3.11) - was exhibited at the Royal Academy in 1924. The scene is early morning and the sun is gradually piercing through the thick atmosphere; "shafts of misty light are coming through the piles of barrels and diffusing among the figures that are silhouetted, with warm colour around their edges. It is a busy scene with the girls and men hard at work on the Wharf."[10] The series of paintings was described as "a sort of cinema story of the fisherman and his fish, set in the infinitely picturesque surroundings of the quaintest town in the British Isles."[11]

3.9 Charles Simpson sketching outside Shore Studio 1923

[8] I am grateful to John McWilliams for his comments on topsail schooners.
[9] S.I.T., 11/5/1923
[10] S.I.T., 21/3/1924
[11] S.I.T., 4/1/1924

3.10 Charles Simpson *Loading the Carts* (1924) (David Lay)

3.11 Charles Simpson *The Herring Season from my Studio Window* (RA 1924)
(Laing Art Gallery, Newcastle-upon-Tyne)

In July 1924, Charles Simpson went up to London to watch the Great International Rodeo at Wembley Stadium and was so fascinated by the event that he stayed up in town, got a permit to sit in the Arena and saw every performance. The *Daily Graphic* reported:-

> "Working in the Arena, in the midst of the broncos and steers had its excitements. Time and again, he was within a yard of the horns of a steer, and had to climb madly up the wire fence at the side of the Arena. In fact, before he began, he was warned about what would happen, and he had to practice his acrobatic stunts up the wire railings, with his canvas in one hand, and clutching the railings with the other. His pencil, india rubber, and penknife, were all tied around his waist with a string." [12]

During this time, Simpson produced a hundred sketches of action in the Arena and thirty portraits of cowgirls and cowboys. These were later exhibited at the Arlington Gallery in London and in Plymouth to considerable critical acclaim. The *Times* commented that the sketches were "essentially studies of movement; but Mr Simpson's feeling for design and quite remarkable sense of tone have enabled him to avoid altogether a 'snap-shot' effect. In almost every instance, the movement, however violent or abrupt, is adapted to the rhythm of the composition, as given by the swinging curves of the Stadium, whether in harmony or by way of contrast. Without any definition of individual figures, the banked audience is admirably suggested, even to the indication of a common mood, as when wind sweeps over a field of corn; and, particularly in the evening performances, the effects of light are very well managed. The whole exhibition, in fact, is a good object lesson in the way systematic training and composition and sureness in 'values' will prepare an artist to make effective use of his immediate impressions." [13]

3.12 Charles Simpson *The Saddling Enclosure at the Rodeo* (1924) (W.H.Lane & Son)

[12] Reproduced in S.I.T., 18/7/1924
[13] Times, 24/7/1924, Reproduced in S.I.T., 1/8/1924

These reviews demonstrate the considerable diversity of Charles Simpson's work and his mastery of a wide range of skills - an eye for composition, an instinctive colour sense, an ability to convey atmosphere, whether in marine or landscape scenes, and a flair for decorative detail. Couple these attributes, with a willingness to experiment and an infectious enthusiasm, and one can imagine what an inspiration he was to his pupils.

Despite the plaudits Simpson was receiving, he decided in 1924 to move to London. It was clear that there was a market for his hunting and other sporting pictures amongst wealthy landowners and he decided that it would be much easier to secure commissions if he was based in London, rather than in the depths of Cornwall. The move offered much better financial security, which at the age of 39, with a young daughter, was becoming of greater significance.

To what extent giving up the School of Painting was a wrench for the Simpsons is not known. The 1924 review of Show Day had highlighted a number of promising talents amongst the students. Nor does there appear to have been any shortage of students wishing to receive instruction. The author, Charles Marriott, who had been a resident of St Ives earlier in the century, commented in an article in 1922 that Lamorna Birch had told him ruefully that "you could not shoot rabbits any longer at Lamorna because there was a female student behind every gorse bush." [14] However, the initial appeal may well have worn off, now that greater financial rewards were in prospect. The School had become an unnecessary tie.

The Simpsons' decision was probably not too severe a blow to George Bradshaw. Having changed status from student to Assistant, he had received less help from the Simpsons with his own work, and his teaching and other obligations to the School had meant that he had had less time for his own painting. With the finance issue still unresolved, he may not have been prepared to carry on in any event.

[14] S.I.T., 24/11/1922

THE ART COLONY AT ST IVES

Although for many years previously, artists, Turner and Whistler amongst them, had visited St Ives, it was only in the late 1880s that artists began to settle in St Ives in significant numbers. Julius Olsson, Adrian and Marianne Stokes, William Titcomb, Louis Grier and Henry Harewood Robinson were amongst the earliest arrivals. This was much the same time as artists were also settling in Newlyn and other parts of Cornwall. Some artists had met in the ateliers of Paris and Antwerp and, fired with enthusiasm for the form of realism championed by the continental schools, with its emphasis on painting out of doors or on the spot, they had been attracted to Cornwall by the unique light and the multiplicity of subjects that the fishing villages and the surrounding spectacular coastline offered.

Some of the artists resident in St Ives, such as W.H.Y.Titcomb and Marianne Stokes, being figure painters, who depicted the fisherfolk at work and at worship, became classified as members of the Newlyn School. Most St Ives artists, however, prided themselves on not belonging to any particular school, valuing their own individuality. Landscapes and marine subjects were more prevalent than figure paintings. Nevertheless, the Cornish artists, as a whole, became widely known both nationally and internationally and were always well-represented at the exhibitions at the Royal Academy and other leading London and provincial galleries. As the reputation of the colony of artists at St Ives grew, foreign artists, such as Anders Zorn, Lowell Dyer and Helene Schjerfbeck swelled its ranks.

By the time Bradshaw arrived at St Ives in 1921, many of the original settlers had either moved away or died and the War had disrupted life in the art colony and slowed the influx of newcomers. Accordingly, doubts persisted as to whether St Ives would continue to attract artists of the highest calibre and whether it would be able to maintain its reputation as one of the leading art centres.

Show Day was one of the main events in the artists' calendar in St Ives. It was held in March each year and it was a tradition that the principal artists in the colony would exhibit in their studios the paintings that they would be submitting to the Royal Academy that year. The event became immensely popular and special trains were laid on for visitors to come down from London to St Ives with the sole purpose of touring the studios and meeting the artists. The day had a free and easy atmosphere to it and visitors from Town found it a welcome change from the somewhat stiff and formal private shows of London.

A review of Show Day in 1921 reveals the uncertain mood of these post-war years:-

> "The catalogue of exhibitors is more remarkable for the absence of names of artists whose work we have all looked forward to seeing in the past and so far there are no new men to whom to look with certainty that they will be able to replace what we have lost. Yet St Ives is not without hope that the tradition of the past may be worthily upheld by some of the younger artists, whose career is now starting. Notably, Mr Borlase Smart, whose work this year again shows a distinct advance over that of the last Show Day. He is an indefatigable worker, who takes his art seriously and therefore should make good in time. Then we have Mr and Mrs Simpson, with their School, which may attract a number of students in the same way as the Olsson and Talmage School did." [1]

One of the artists who was sadly missed in 1921 was Louis Grier, who had died the previous year. The first meeting of the St Ives Arts Club had taken place in Grier's studio and he is

[1] St Ives Times ("S.I.T."), 11/3/1921

acknowledged as its founder. The Club was not restricted to artists; architects, authors and musicians and their respective wives, husbands and relations were eligible for membership. Accordingly, it was primarily a social club, although the majority of the professional painters living in St Ives became members. It was not used as a venue for important exhibitions of paintings - it was more a showcase for the dramatic talents of the artists.

The one artist, whose longevity ensured that he witnessed all the ups and downs of the colony, was Moffat Lindner. He came from a wealthy family, who had made their money in steel but, at the age of 22, he resolved to take up art as a profession and he had his first watercolour hung at the Royal Academy in the 1880s. His principal works were executed in oils but he developed an impressionist style of watercolour painting, specialising in landscape and marine subjects and being particularly fond of sunset and moonlight scenes. He wrote, "pure transparent colour appeals to me most" and, accordingly, he made his watercolour paper a source of light and never destroyed the brilliancy so obtained by overwork (see, for example, Plate 3). He travelled abroad on a regular basis and his contributions to exhibitions are often scenes from Venice, Etaples and Holland. His works always drew high praise from the critics but he also contributed enormously, in both financial and other ways, to the development of the art colony in St Ives. He was President of the Arts Club in 1899 and again in 1912 and throughout the 1914-1918 War. His wife, Augusta (née Baird-Smith), was also a painter of some repute, specialising in flower studies. In her youth, Gussie, as she was known, had been a suffragette but Kathleen considered her very much a "home-bird".

Other artists, who had already served terms as President of the Arts Club and who remained

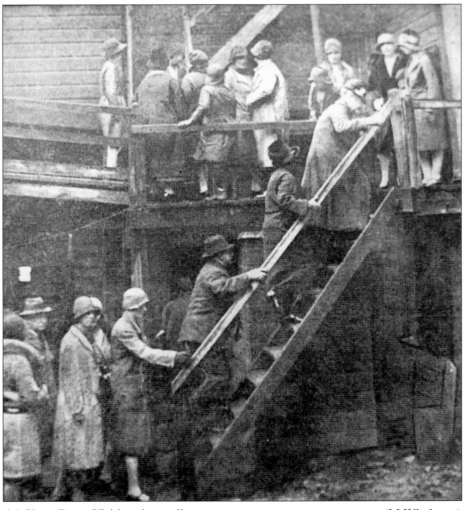

4.1 Show Day - Visiting the studios (M.Whybrow)

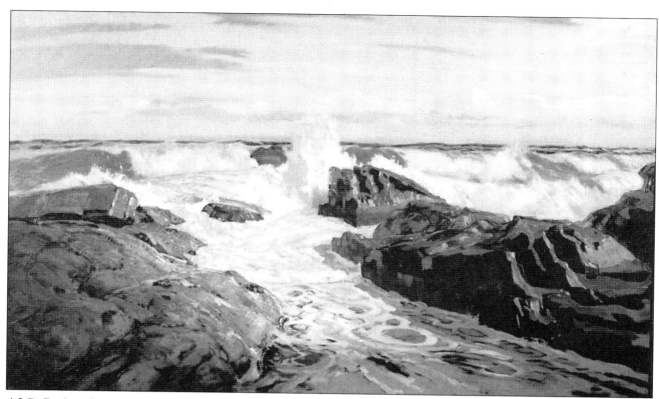

4.2 R. Borlase Smart *Morning Light, St Ives* (1922) (Royal Institution of Cornwall, Truro)

working in St Ives included Lowell Dyer, Arthur Meade, Fred Milner, W.B.Fortescue (who died in 1924) and John Henry Titcomb.

Lowell Dyer was an American who had first come to St Ives in 1889. He was very short-sighted but was a great wit and was a popular President of the Arts Club in 1893 and 1894 and again in 1918. As he loved both acting and dancing, he was an habitué of the Club and even arranged to have a private locker for his own supplies of alcohol. He was nicknamed "the Boston Swedenborgian", as his father had been a Swedenborgian minister, and he had a predilection for painting angels.

Fred Milner had moved to St Ives from Cheltenham in 1898 and was President of the Arts Club in 1905. He was a highly-respected and popular artist, who had achieved considerable success at the Royal Academy. He specialized in tranquil landscapes - the Cotswolds and Dorset were favoured areas - and worked mainly in oil, but, inspired by Cotman, he also did a number of studies in watercolour. He had 2, Piazza Studios, whose spacious proportions were felt to influence the bigness of style that was apparent in his work. The reviewer of Show Day in 1925 commented:-

> "Mr Fred Milner is another essentially English artist, master of a particularly attractive style of depicting an English landscape, and he leaves nothing to be desired in the matter of draughtsmanship and colour.... I left his studio feeling that our 'advanced' young 'self-expressionists' have a deal to learn from the Victorians." [2]

The comment pleased Milner - he was happy to be called a Victorian, as this implied a high level of technical accomplishment.

Arthur Meade, a small, well-built man who always wore plus-fours and was a very keen golfer, was another stalwart of the Arts Club, having been President in 1902, 1913 and 1920. He too was principally a successful landscape painter, exhibiting over sixty pictures at the Royal Academy during his career. He had the gift of presenting English landscape pictorially and attractively, earning for a while the sobriquet 'Bluebell Meade' due to his fondness for this motif. However,

[2] S.I.T., 20/3/1925

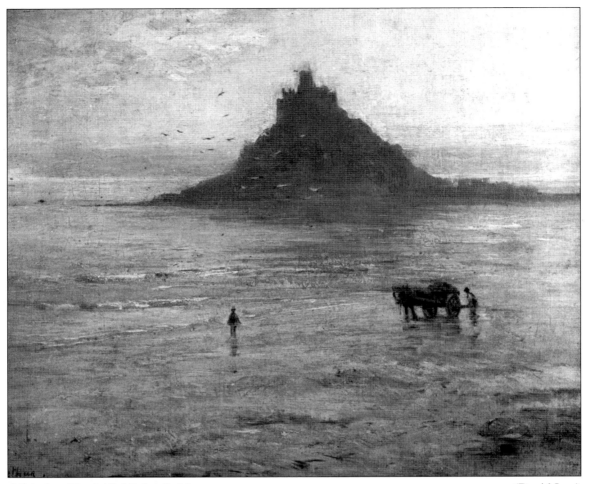

4.3 Arthur Meade *St Michael's Mount* (David Lay)

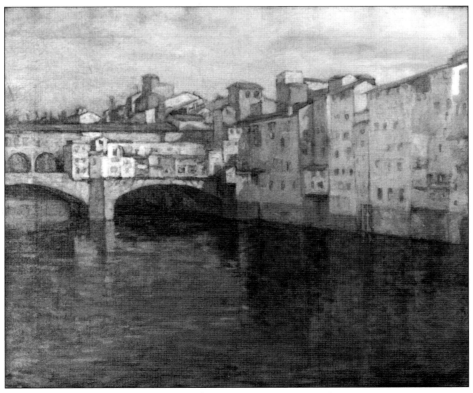

4.4 J.H.Titcomb *Ponte Vecchio, Florence*

Borlase Smart was also a great admirer of his coast and sea pictures (Plate 5 and fig 4.3), stating:-

> "His artistic approach to these Cornish cliff scenes was fearless and vital. He went straight to Nature with big canvases and he painted at white heat." [3]

Jack Titcomb was the brother of William Titcomb and, although not as talented, was passionately interested in art and extremely sociable. He also was President of the Arts Club on three occasions and became a good friend of the Bradshaws. During the 1920s, he travelled extensively, linking up with his brother who spent much of the decade in France and Italy (see fig 4.4).

If these were the established artists that Bradshaw met on his arrival in St Ives, what was St Ives itself like in those days? An evocative account of a visit to St Ives in 1921 is given by one D.P.Sedding.

> "The fish-odoriferous town of St Ives is a veritable gem of beauty, and inexhaustible in its attractions to artists.... Now there are some 200 studios tucked away in many an odd corner of the place, forming a little colony of the artistic world. The rent of a studio runs to about £20 a year - or less if shared. Some must cost very little, especially those converted from the attics of some tumbledown old house, and reached by worn old stairways from the road. The possessors of these are to be envied, for the attic is the ideal home of art and in this case, possesses an uninterrupted view of the harbour.
>
> It matters little how rude your studio is as long as you live in the art atmosphere of St Ives. The presence of other artists who have made a success of their work, sustains and encourages the young aspirant. Many a morning, as you wander through the narrow alleys of Down-along, you may meet a figure dressed almost as casually as the fisherfolk hastening along, a canvas tucked under her arm. You turn to your companion and whisper, 'that is the brilliant M. whose pictures hang in the Academy' - or that plainly-dressed elderly woman, who goes in to make her purchases at the butchers, with a crowd of less-gifted housewives, you recognise as one of the foremost water-colour artists of the day.
>
> From my window on the hill, I look down on the sandy beach on which the rows of trawlers are drawn up. Strung from bow to keel, like a prolonged rigging, is the family clothes line on which the mariner's shirt and the family washing blow to and fro with the breeze. From end to end of the little bay hang the lines of gay streamers - for it is washing day at St Ives.
>
> The beach shelves up to the road, and the cottage doors look out on to the sand-swept path. In the distance, the women and children are seen taking their flaskets to lay out the linen on the pebbles on the beach. The headland is covered with it also, and the fishing nets dry in the sun.
>
> The real old village of St Ives is Down-along, that mass of ancient habitations and bewildering by-ways, steep steps and cobbled paths that lie between the harbour and the beautiful little Porthmeor beach. Here you may lose yourself again and again..... Sometimes wandering away in the depths of the courts and alleys, you come across a studio where one would think Art would not deign to dwell. A door is left ajar and you look into a shaded court and see a tiny bed of flowers and beyond the gleam of books and an Oxford chair - and then you understand. For the artist lives the life of the Gods not only on the heights of Olympus but in the low places of the earth: and here there is Peace. Many are the strange names given to these abodes, such as the Hutch, the Fo'castle, the Cuddy, etc.

[3] S.I.T., 8/1/1943

Looking over the harbour, and arranged like a flock of sheep for warmth and comfort, are other studios. They are but converted sail lofts where here and there a rustic balcony has been built out..... Old, well-worn steps lead up from the quay to their simple doorways, which are enhanced here and there by some antique knocker. Here, in the summer months, one can never look in without seeing a wealth of wild flowers. Some of the windows also are edged with coloured bowls decked with vivid blooms.....

Out of the door, beneath a low arch, a woman sings at a tub. On the low benches, the mariners loll and smoke, interspersed with grave-eyed matrons, who rock their babies and gaze with strange indifference at the women with the brush. These stand at their easels and paint, oblivious to their surroundings....

No artist ever forgets St Ives. The early mornings, when the silent fishermen draw in their nets through the steel sea; when all is suffused in a rosy glow and no footprints have marred the smooth sand. Or those evenings when in the harbour the quaint lamps of the boats glitter and twist with the flow of the incoming tide. When from the windows on the hill, the stars seem on the sea, and far out gleam the lights of Godrevy." [4]

Another visitor in 1921 was equally complimentary about the inhabitants, whether of the human or feline variety:-

"St Ives is a painter's paradise. It is so unfailingly picturesque that there is scarcely a foot of the older part of the town that does not provide a 'subject'. Artists are as plentiful as blackberries, and there are few hours of the day during the summer months in which one does not stumble across half-a-dozen or so men and women at their easels capturing effects of light and shade in ancient archways or quaint streets. And then there are the cats! The cats form a sort of sub-population. They make dignified promenades in the gutters, they dream in the doorways and nobody ever thinks of disturbing them....One other thing which strikes the stranger is the remarkable cleanliness of the town and its inhabitants. Its houses, even the poorest, are models of tidiness, and the linen that, owing to the dearth of back gardens, hangs up to dry in the narrow alleys, is spotless. Here too

4.5 Mrs Borough Johnson painting in the harbour on a Monday in 1923 (M. Whybrow)

[4] S.I.T., 14/1/1921

cleanliness and hospitality go hand in hand, and for my part I do not wish to find a place where the people are more friendly, courteous and liberal in their treatment of visitors." [5]

Confounding the doubts expressed by local critics, fifteen of the artists resident in St Ives had paintings accepted for the Royal Academy in 1922. These included not only Charles Simpson, Moffat Lindner, Arthur Meade and Fred Milner, but also Borlase Smart, the etcher Alfred Hartley and John Park, whose work at 4, Island Studios, was considered to be one of the highlights of Show Day and, subsequently, the Royal Academy. One critic commented:-

> "Mr J Park's feeling for colour is a great gift. He seems to see more of the happiness of colour in Nature even on a grey day than most artists, and his work suggests the feeling that, like Whistler, his palette at the end of a morning's work would be a minor impression of his finished picture." [6]

Another critic commenting on his painting, *The Morning Tide, St Ives*, stated, "The light is tremendous; the gently moving water palpitates with it in Mr Park's deft chromatic handling: the boats cast vibrant reflections." [7] John Park was to be one of the leading members of the colony for the next thirty years.

The female section of the colony was also well represented at the Royal Academy with works being accepted from Marcella Smith, Helen Stuart Weir - a member of the Society of Women Artists, who specialized in still life studies (fig 4.7) - , Marjorie Ballance and the miniaturist, Mabel Douglas, amongst others. Many of the female artists in St Ives were to play an important role in the success of the colony. Dorothea Sharp, then the Vice-President of the Society of Women Artists, who was to become a friend of the Bradshaws, had already started visiting St Ives.

4.6 Charles Simpson *The Line Fishing Season* (Plymouth City Museum & Art Gallery)

[5] S.I.T., 20/5/1921
[6] S.I.T., 17/3/1922
[7] S.I.T., 5/5/1922

4.7 Helen Stuart Weir *Still Life with Fruit, Pewter and Glass*

The critic from the *Daily Graphic* commented:-

> "I found her painting on the Porthmeor beach, surrounded by children, mostly the daughters of fishermen, for these are her chief sitters. How they love to dress up in the pretty frocks from the children's wardrobe that she always carries about with her!"

Local exhibitions were held at Lanham's Galleries. James Lanham Limited played a major role in the lives of the artists. Not only did the company supply the artists with their materials and arrange for the transport of paintings to the Royal Academy and other exhibitions, but it also acted as agent for house and studio lettings. The galleries were small but provided a communal exhibition centre and members of the Arts Club were elected each year on to a Hanging Committee.

In 1922, the Hanging Committee, which comprised Lowell Dyer, Alfred Hartley, John Park, Borlase Smart, Frank Moore and W.B.Fortescue, were concerned that many artists were sending their best work to the London and other main provincial exhibitions and providing poor quality work for the exhibitions at Lanham's Galleries. Accordingly, a circular was issued to exhibitors:-

> "It is the desire of the Lanham Hanging Committee that the worthy exhibition at the High Street Gallery should show a greater standard of excellence, and considering the many well-known and gifted artists residing in St Ives, it is only fair to the reputation of the colony that these exhibitions should maintain a high level of artistic excellence. It is the earnest desire of the Committee that you will submit regularly your best work; this will help the Committee in their endeavours, and will reflect that credit on the colony which this Art Centre deserves." [9]

At this time, a yearly exhibition of the work of West Country artists was held at the galleries of Messrs Harris & Sons in Plymouth but the 1922 exhibition was felt to be of poor quality. A critic commented:-

[8] Reproduced in S.I.T., 3/8/1923
[9] S.I.T., 30/6/1922

> "Many former exhibitors have dropped out, and newcomers have done little that is worthy of the gallery's traditions. The tone of the annual exhibition has been maintained chiefly by the few remaining pre-war exhibitors." [10]

On the other hand, the St Ives artists were well-represented at the Jubilee Exhibition at the Liverpool Walker Art Gallery and also at the exhibitions in 1922 at the Royal West of England Academy, the Royal Institute of Oil Painters and the Royal Institute of Painters in Water Colours. In the latter exhibition, particular mention was made of Moffat Lindner's watercolours of which no fewer than eight had been accepted:-

> "No pictures in the exhibition appear to be done with greater ease, yet they are not easy things to do. *Evening, Dordrecht* is a splendid picture, the iridescent water, the drooping sails of the boats, and the roseate tinge on the piled-up clouds in the background are done with a few light touches of the brush which appear to be almost careless, yet the effect is nothing short of wonderful." [11]

There were also a number of Etaples sketches, "translucent, pearly effects, enlivened by little blobs of colour, expressing form by being just in the right place, with the right association." Moffat Lindner had extremely moist pug-like eyes and, despite the respect with which he was held in the colony, it was a standing joke that his watercolours were as wet as his eyes. Black and white illustrations certainly do not do them justice.

Bradshaw appears to have fitted into the artist community quickly and easily. He was exceptionally good looking, which may have helped in certain quarters, and immaculately groomed. Many of the artists were well-educated, from middle-class backgrounds and were not solely dependent on their art for a living. Bradshaw may not have been as secure financially, relying heavily on his Naval pension and some Irish ground rents that he had inherited, and he may have been uneasy about the deficiencies in his education, but he was a good story-teller and he was able to entertain his companions with a wealth of anecdotes drawn from his experiences in the Navy. He did not boast about his exploits but rather concentrated on the incidents - such as the 'red eyes mystery' - that had provided a measure of light relief during his period of service. Each story would be told, with his ubiquitous pipe in hand, and end with his own booming laugh.

His status in the art colony was no doubt considerably enhanced by his involvement with Charles Simpson and it was not long before his works are singled out for particular mention in reviews of exhibitions - and, as already mentioned, in 1923, he had his first painting accepted by the Royal Academy. This was *The White Barque* but, on Show Day that year, he also exhibited another picture of a sailing ship, *The Cutty Sark*. This famous tea clipper, which had set a record of 67 days on its voyage from London to Sydney in 1885, with the return journey taking only 75 days, had been sold to the Portuguese and converted to a barquentine. However, Captain Wilfred Dowman of Weymouth bought her in 1922 and restored her to her former clipper rig. She was now docked at Falmouth and used as a training ship for orphans. The publicity surrounding her restoration made her an obvious subject for Bradshaw's brush and the painting was soon acquired by the tea merchants, James Laity & Son. [12]

A dramatic maritime event dominated the local newspapers in the summer of 1923. The *Trevessa*, a vessel of 5,000 tons, sent out an S.O.S. on 4th June 1923, stating that she was foundering in the Indian Ocean. Her sister boat, the *Tregenna*, and the *Trevean*, also owned by the Hain Shipping Company, responded to the S.O.S. message but failed to find any trace of the ship. As many of the men aboard the *Trevessa* were local residents, the whole town was in mourning when, some three weeks later, a message was received that one of the ship's lifeboats had arrived with

[10] S.I.T., 30/6/1922
[11] S.I.T., 27/10/1922
[12] The painting may have been commissioned by the shop. It is illustrated in M. Whybrow, *St Ives 1883-1993*, at p.99.

survivors in Rodriguez Island, a hilly volcanic island about 400 miles away from Mauritius. A second lifeboat made it to Mauritius. Many of the survivors had to be carried off the boats on stretchers and were incoherent.

The survivors returning to St Ives had a remarkable story to tell. They had travelled some 1,700 miles in open boats in appalling weather, which had caused damage to the mast, rudder and other gear and which had frequently blown them off course. Both boats had resorted to steering by the sun and stars and, on dark nights, had to hove-to. The crew had suffered considerably. Daily rations consisted of one biscuit, a third of a cigarette tin of water and a lid of a cigarette tin filled with condensed milk. Several of the crew did fail to survive - four Britons dying of heart failure and a number of the Indian hands succumbing after having taken, under cover of darkness, to drinking sea-water. Only one St Ives man, Harry Sparkes, apparently of a delicate disposition, died.

Bradshaw, like many others, was very moved by the heroics of the survivors and exhibited on Show Day in 1924 a painting of the *Trevessa's* two boats setting out in a stiff breeze on their historic voyage after the foundering of the steamer, which he entitled *An Epic of the Merchant Service*. The skipper of the *Trevessa*, Captain Foster, spent some considerable time with Bradshaw as he painted the picture, conveying to Bradshaw his experiences and feelings and was very pleased with the end result.[13] The critics, however, felt that the restful scene depicted in *The Old Timber Ship*, in which Bradshaw had captured the effect of golden sunlight on the vessel's side and on the sea, was a more successful work. In fact, one pronounced that it was "quite the best canvas that he has done; it is full of rich quality of paint and good transcription of sea surface movement [and] the vessel is beautifully drawn."

Another painting that Bradshaw exhibited at Show Day that year was a large picture of a dark blue sea at dusk with a small tramp ship labouring in the distance. For Show Day, it was entitled *A Pensive Sky, Sad Days, and Piping Winds* but, having been accepted for the Royal Academy, it was exhibited there as *The Western Ocean*. The following year the same painting was exhibited at the Royal Scottish Academy. This was the only time Bradshaw exhibited there and may have resulted from his trip to attend his mother's funeral.

Charles Proctor, author and journalist, who was to retain an association with St Ives for many years and who contributed regular reviews of Show Day, decided in 1924 to use his alias,

4.8 The 3,121 ton *Trevessa*, which was carrying zinc, when she sunk in the Indian Ocean in 1923
(Daily Telegraph/Phillips, London)

[13] A survivor's account of the shipwreck, sent anonymously to the Captain's widow, was sold at auction by Phillips in May 1996 fetching £2,645.

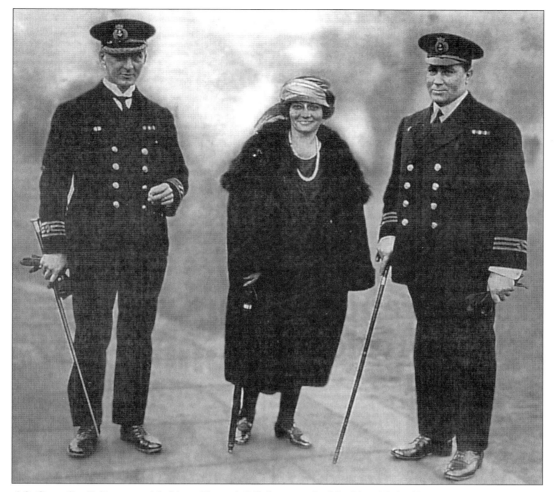

4.9 Capt Cecil Foster, with his wife and J.C.Stewart Smith, his chief officer, whose skills and indomitable courage reduced the loss of life (Daily Telegraph/Phillips, London)

'Marcus', a cockney whose weekly articles had been a feature of the *Empire News* for some years. Marcus' comments, however, found both the fishermen and the artists a little lacking in a sense of humour:-

"It says in the guide book that the chief industry of St Ives is fishin', but I reckon that's only a rumour. They've got a fleet of fishin' boats, but I think they only keeps 'em so's ter give the artists somethink ter paint, and the visitors somethink ter take photos of. If yer wants a bit of fish in St Ives yer 'as ter wait until it comes to the town from some other place, 'cos it's always the wrong kinder weather for the local fleet ter go out in.

I never knew till I got to St Ives 'ow particular fish is about the weather they gets caught in. If there's a' East wind blowin', the fishing boats don't go out, 'cos the fish won't come up ter get caught; if it's rainin' it ain't no use the fishermen goin' out, 'cos the fish objects, I suppose, ter gettin' wet; if it's stormy, the fish goes round and get theirselves caught at Newlyn, and if the weather's fine, the fishermen can't go out 'cos they ain't got no bait. And if they've got bait, and the weather's orlright, and the fish is there waitin' ter be caught, it's very likely Sunday, and the boats can't go out 'cos the men 'as ter go to chapel.

They tells me they used ter catch millions of pilchards at St Ives years ago, but the shoals don't come round no more, and they can't understand it. If yer asks me, the last shoal waited so long ter get caught that orl the fish died of old age! I ain't sayin' as 'ow the fishermen ain't energetic. I never was in a place where the men does so much walkin'

without gettin' anywhere. Y'see, they only walks four paces each way, but they keeps it up for 'ours and 'ours, and some of 'em 'olds the short-distance walk-in' championship.

No, yer can't kid me that the chief industry of St Ives is fishin'. The chief industry is art, or, any'ow, paintin' pictures, which ain't quite the same thing, for I've seen a lot of pictures wot ain't art. St Ives is full of artists wot lives by paintin' pictures wot nobody don't buy, and 'ow some of 'em looks so prosperous is a mystery ter me. I reckon artists and the fishermen must 'ave found out some way of livin' without earnin', or else they lives on the interest of their overdrafts. Incidental, the fishermen'll tell yer that the artists don't do no work, and the artists'll tell yer the fishermen don't orften go fishin'.

Every year at St Ives orl the artists 'as wot they calls a 'Show Day'. The idear of 'Show Day' is ter prove to the fishermen, and their missuses and kids, that artists does do some work even if they don't earn no money, and I reckon the fishermen ought ter return the complerment by orl goin' out fishin' tergether one day a year on' takin' the artists with 'em ter prove their nets and lines ain't just kept for ornaments.

Any'ow, larst week when I was in St Ives, the annual 'Show Day' was 'eld, so of course I 'ad a look round. Orl the studios is open to the public, and for one day everybody in the town, and a lot from outside the town, is a' art critic. Some of 'em as lives in the town, and mixes with the artists reg'lar knows wot ter say. They goes about sayin' 'Ow perfectly charmin',' if the artist is listenin' and waits till they gets outside before they bursts out larfin', but others wot ain't bin brought up genteel asks the artists wot 'is picture is supposed to represent, and 'as 'e ever thought of tryin' ter earn a honest livin', or remarks that 'is pictures don't make 'em feel so sick this year as they did larst or words ter that effeck.

Besides bein' for the purpose of provin' that artists works as 'ard as fishermen, 'Show Day' is supposed ter be the occasion on which the artist shows the pictures wot they intends ter be exhibited in the Royal Academy. Well, I went round the studios, and orl I can say is that there must be more optimists in St Ives than any other place I've ever struck. Most of the pictures I saw stands as much chance of gettin' ung at the Royal Academy as a celluloid cat does of coming whole out of a furnace. But hope springs infernal on the 'uman chest, as my pal 'Orace says, and I likes 'opeful people.

One bloke told me 'e was paintin' for posterity and I couldn't 'elp wonderin' what posterity 'ad done to 'im that 'e should 'ave a grudge against 'em. I ain't sayin' I never saw no good pictures - I saw lots of fine work, and I ticked orf 'alf-a-dozen big pictures as bein' certs for the Academy, and eight others as bein' wot yer might call probables, and I'm willin' ter back my fancies. But there was 'still life' so blomin' still that yer might be forgiven for thinkin' they was dead, and seascapes wot looked like a jam factory in eruption or confetti floatin' in pea soup, and some as looked like the effecks of a billious attack.

P'raps I ain't eddicated enough ter be a judge and dunno good art when I see it, but, arter orl, everybody is a art critic on Show Day, as I told yer before, and I've been asked ter say wot I thinks about it orl and it ain't my fault if yer don't agree with me. I don't mind tellin' yer, without mentionin' no names, wot studio I liked the best and stayed longest in. It was the one where the artist asked me ter step inter the back office where the chief exhibits was a decanter of Scotch and small bottles of soda." [14]

In June 1924, the artists put on a special show in their respective studios for the visit of H.M.First Flotilla to St Ives. Bradshaw was actively involved in the organisation of this event, along with Captain Frank Moore and the etcher, Engineer-Captain Francis Roskruge, a retired Naval Officer,

[14] S.I.T., 28/3/1924

who had also won the D.S.O. while serving in East Africa. Bradshaw may well have shown various of his oil paintings recording engagements or incidents experienced during his days in the Navy. At the exhibition at Harris & Sons in Plymouth that year, he had exhibited a painting of a battleship going full steam ahead in a rough sea. A reviewer, who castigated the poor quality of the exhibition, felt that Bradshaw's picture was one of the few to be highly recommended. "The picture is palpitating with life and movement, vigorous in drawing and rich in colouring. It is reminiscent of Napier Hemy." [15]

Bradshaw had also painted during his early years in St Ives a picture of a convoy of ships, with *Royal Oak* in the lead, entitled *Line Ahead* and an oil entitled *A Broadside from a Super Dreadnought*. He continued to receive commissions from his friend, Charles Allen, whenever he was placed in command of a new submarine, and he would have been particularly pleased at the honour Allen received when he was promoted to Commander in 1926 and subsequently given command of submarine *X-1*.[16] This 'mystery boat' was then the largest and most expensive submarine in the world, costing over £1 million.[17] It was designed as a cruiser submarine and was the product of the committee on designs that, after 1919, interviewed the most successful British submarine commanders of the War. No doubt Bradshaw was one of those interviewed and the majority opinion called for the development of a long-range submarine capable of raiding enemy commerce and provided with a large gun armament to drive off escort vessels. The design also embodied all that had been learnt from captured *U*-boats. The expense was considered necessary as the Admiralty was seriously considering the possibility of war with Japan.[18] Allen's appointment was a compliment to his seamanship skills, as *X-1* was renowned to be difficult to handle and her engines broke down on a number of occasions. She was an impressive looking craft, as Bradshaw's painting (fig 4.10) demonstrates, but the many problems that Allen experienced during his three years in command meant she was the only one of her class to be built.

4.10 *Submarine X-1 off Palma* (1930) (Oil on canvas)

[15] S.I.T., 6/6/1924

[16] Allen was promoted to Commander on 30/6/1926 and, in October of that year, was in command of the Depot-ship *Alecto*, on a cruise of the Baltic with 4 *H*-class submarines. He assumed command of *X-1* in Salonika in July 1927, remaining in command until July 1930.

[17] *X-1* was launched in June 1923 and great secrecy as to her specifications was maintained. She was reputed to have a cruising range of 6,000 miles and to be speedy "but it is her internal construction and mechanism that is intriguing the naval experts of foreign powers". S.I.T. 22/6/1923

[18] *X-1* service history prepared by the Royal Navy Submarine Museum. Full specifications are set out in Appendix 1.

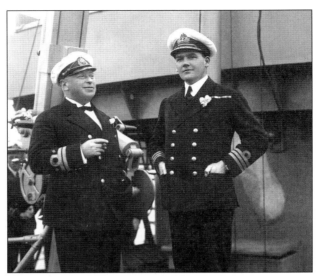

4.11 Charles Allen (right) with Capt. Keyserling of the Latvian Navy after lunch (which included 14 vodkas) June 1927 (R.N.S.M)

Despite Charles Simpson's return to London, Bradshaw continued to make progress and must have been delighted with Charles Proctor's review of Show Day in 1925.

> "The work of Mr G. F. Bradshaw, on view at the Ship Studio, shows a distinct advance on anything previously exhibited by this artist - which is saying a good deal. His picture, *The Wool Clipper*, indeed definitely stamps him as a marine artist to be reckoned with. It is excellent in colour and composition, and one feels that the full-rigged clipper is 'alive'. The sea, too, and the sky are full of movement and colour. Mr Bradshaw is less successful in *Maltese Fruit Boats*, a smaller canvas, which, however, is pleasingly decorative in effect but *Sunset Sails*, showing a big sailing craft bathed in golden sunlight, is attractive and has 'atmosphere'." [19]

Show Day in 1925 was also the first occasion on which Kathleen Bradshaw exhibited her decorative lampshades. She designed and painted these herself and had some commercial success, supplying the London department store, Heal's and having an exhibition devoted to them at the De Vere Hotel in Kensington. However, she later recalled some embarrassment with her earlier efforts, which were merely glued together, as the glue tended to come unstuck as the lampshade heated up. Accordingly, she took to stitching the shade. She even managed to effect a sale to an Indian Princess, but securing payment had proved rather more difficult. Her first efforts were described as "very charming" and "dainty in colouring and designs" but were dismissed by Proctor because "the grave signeurs of the Royal Academy are not interested in lampshades, which might destroy the colour value of the pictures exhibited, so praise or criticism would be superfluous."

1925 saw the first public exhibition outside St Ives devoted solely to works by St Ives artists. This was organised, principally by Moffat Lindner at the Municipal Gallery, Cheltenham, although the choice of venue may have been influenced by Fred Milner. The exhibition included a selection of pottery by Bernard Leach and a group of etchings by Alfred Hartley as well as over sixty oils and watercolours. Works by artists formerly associated with St Ives, such as W.H.Y.Titcomb, Algernon Talmage and the late Louis Grier and Thomas Millie Dow, were included as well as three paintings by Henry Tuke. Most of the artists currently based in St Ives were represented and the catalogue gave brief resumés of each artist's career.[20] The catalogue prices - some over £200-

[19] S.I.T., 20/3/1925
[20] It is from this resumé that it is known that Bradshaw's teacher in Malta was Dingli. It also mentions that Bradshaw held an exhibition at Gieves Gallery in 1922.

4.12 Arthur Hayward *In a Sunlit Garden* (Sotheby's)

Priced at £25 10s in the 1925 Cheltenham show, this painting was later purchased for the MacKelvie Collection in Auckland but was sold by Sotheby's in 1999 for £25,000.

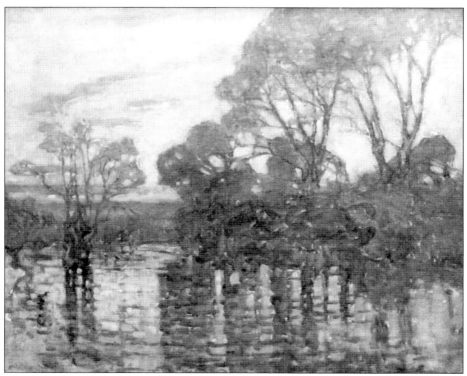

4.13 Moffat Lindner *Golden Autumn* (Cheltenham Museum and Art Gallery)
Bought from the 1925 show for the Gallery's permanent collection.

clearly indicate that the artists had been requested to contribute significant pieces, so as to ensure an impressive show. Simpson exhibited two of his *Herring Season* series, Borlase Smart included *Cornish Cliffs* (R.A. 1923 and Paris 1924), Olsson showed contrasting moonlight and sunset scenes, Park included *When the Boats are in* (R.A.1922 and Paris 1923) and Arthur Hayward, a student of Stanhope Forbes, who had relinquished architecture for painting, contributed two recent Royal Academy exhibits, *The Crinoline* and *In a Sunlit Garden.* (fig 4.12) Bradshaw's exhibit, most likely a depiction of a sailing ship, was entitled *In the Doldrums* and was priced at £21. The local paper urged the public to assist with the purchase of Milner's huge oil *September in the Cotswolds* but the price of £210 proved too much and the Gallery settled for Lindner's oil *Golden Autumn*, (fig 4.13) an atmospheric sunset scene showing trees reflected in a river.[23] The important influence of this exhibition on future promotional activities of the colony was recalled eleven years later when the St Ives artists mounted another show in Cheltenham.

A further innovation was the launch of the Five Guinea Exhibition at Lanham's Galleries, which required all works to be modestly priced. This new feature was noted to have "a stabilising effect on the size of the pictures" but the ability of some of the well-known artists to paint on a smaller scale was considered better than others. Park, in particular, was felt to struggle.

These initiatives did not have any great unifying effect upon the artists in St Ives and, during 1926, no reviews appear of any exhibitions at Lanham's and no exhibition was organised in another provincial centre. Naturally, however, Show Day was held in March and Bradshaw's large principal picture, *Crabbers Returning*, was well-received and was accepted by the Royal Academy. It depicts a white gig, loaded with crab pots, coming home round the Island. In the background is Godrevy and a number of other boats sailing home. The reviewer commented:-

> "It is full of evening light. A fine sea is well-painted and there is plenty of motion in the picture. The transparency of the wave at the boat's bow is particularly well-rendered." [22]

The *Daily Sketch* published a photograph of Bradshaw, with palette in hand, standing by the picture (see Appendix 2), which Charles Allen, delighted at his friend's success, cut out and kept with his papers.[23]

Another picture to gain favourable mention on Show Day was one of an old Danish sailing ship, loaded with timber, bound for Hayle and becalmed off the Island. "It is late evening, and the sky is suffused with the sunset's glow. A very clever and attractive canvas."

Bradshaw's early years in St Ives had been remarkably successful. In an interview in 1939, he commented, "Coming to St Ives was the luckiest thing in my life - I met my wife here for one thing." [24] Certainly, he could hardly have imagined, when he first knocked on the door of the Simpsons' studio, not only that he would find personal happiness, perhaps for the very first time in his life, but also that his art would progress so quickly that he would soon become a respected and influential figure in the art colony.

[21] Other exhibitors include A.C.Bailey, Percy des Ballance, J.M.Bromley, the Australian David Davies, Lowell Dyer, whose exhibit *Angel with Daffodil* was to become a regular feature of exhibitions for some years, Nora Hartley, Pauline Hewitt, R. Heyworth, Mary McCrossan, J.H.Titcomb and M.F.A.Williams.

[22] S.I.T., 19/3/1926

[23] This cutting is now in the Allen collection at the Royal Navy Submarine Museum.

[24] Unattributed article from 1939 amongst family papers entitled, "Artist Served His Apprenticeship - in the Navy"

THE FORMATION OF THE SOCIETY

Despite the increasing critical acclaim that he was gaining for his paintings, Bradshaw was dissatisfied with the general apathetic state amongst the artists in St Ives and the lack of any forum for discussion and the cross-fertilisation of ideas. Many of the well-known artists kept themselves to themselves and there was no mutual assistance and no constructive criticism. He was also concerned, following the departure of Charles Simpson, at the lack of assistance given to the many students, who had been attracted to St Ives by the colony's reputation.[1] His concerns were shared by Herbert Truman, a new arrival. Truman had just spent fourteen years in Egypt. At the instigation of Lord Kitchener, he had gone there in 1912 to undertake the revival and reorganisation of its arts and crafts and had been appointed chief inspector of art and trade schools in the country. As a result, he had an intimate knowledge of Egyptology, which was often reflected in his work. Both men were, accordingly, aware of the needs of students and were used to efficient and organised operations. Both also were keen to make their mark but were frustrated by the haphazard way in which things happened in artistic circles in St Ives, if they happened at all.

The first move was made by Bradshaw at the annual meeting to elect the Lanham's Hanging Committee on 15th November 1926 when he requested that the election should be postponed so that "the present state of the St Ives Arts Colony might be discussed and suggestions brought forward to raise the Colony from its present unimportant position in the Arts World".[2] Truman pointed out that the general lack of enthusiasm in the colony was exemplified by the poor attendance. Although the meeting had been advertised in the *St Ives Times*, only seventeen artists were present and only three of the retiring committee of seven had deigned to put in an appearance.[3] It was pointed out that such slackness on the part of St Ives artists was typical and one of the causes of the present decadence in the colony.

In the ensuing discussion, it was agreed that most artists did not send their best work for exhibition at Lanham's and that the standard of exhibitions could be raised by the introduction of pictures by well-known artists living at Newlyn, Lamorna, Falmouth and in other parts of West Cornwall. There was also a desire that a gallery at Lanham's should be reserved for the exclusive use of the artists. Alfred Hartley, in particular, deplored the use of the gallery for commercial purposes unconnected with art and felt that it was scandalous that the artists did not have complete control over their only exhibition venue.

The lack of cohesion in the colony needed to be tackled by encouraging esprit de corps. The artists needed to pool their efforts and to promote the colony as a whole. Comments were also made that there was unnecessary touchiness and egotism in certain quarters, causing the few remaining artists of repute to hesitate before giving honest criticism to those whose work called for such. This adverse spirit also made the task of the Hanging Committee most difficult and trying.

The lack of a meeting room, where matters relating to the graphic arts might be freely discussed, was also felt to result in a lack of artistic atmosphere and a sense of isolation. Similarly, from the students' point of view, the colony was felt to be moribund and, at present, survived on a

[1] Although Arthur Hayward had started a School of Painting in 1924, it does not appear to have been as influential or as highly regarded as the Simpson School.

[2] Minutes of meeting, as transcribed by the St Ives Society of Artists

[3] Those present included the Lindners, the Bradshaws, the Hartleys, the Dreyfus', Messrs Truman, Roskruge, White, Dyer and Spenlove and the Misses Ewan and Russell Armstrong.

5.1 H.Truman and four works showing his diverse styles - *Egypt, Gorsedd 1933,*
Cornish Clay Pit and *Old St Ives* (1934) (Western Morning News)

reputation built up in former years by a group of brilliant and energetic artists, the majority of whom had unfortunately left St Ives.[4]

Bradshaw and Truman proposed that a new Society, completely separate to the Arts Club, should be formed and it was agreed that the new Hanging Committee of Messrs Lindner, Bradshaw, Spenlove, Milner and Park, and Mesdames Hewitt and Hartley should look into the question.[5] Given that Milner, Park and Pauline Hewitt had not even attended the meeting, Bradshaw took it upon himself to take the matter forward and realised that Truman would provide some useful input. Together, they pooled ideas for the formation of a Society that would improve standards, attract new talent and lead to the promotion of the whole colony, so that they all could gain greater national and international exposure. Bradshaw was happy to rely on Truman's ability for concise and rational exposition when the proposals were first published but it was more appropriate for Bradshaw, now well-known in the community, to introduce them at meetings.[6] However, before any formal step was taken, Bradshaw was aware that it was crucial to ensure that Moffat Lindner was in favour. Without his support, any scheme was doomed to failure, such was the respect afforded him by the other artists. Furthermore, a new Society may well need financial assistance in its early years and Lindner's wealth made him the most likely benefactor.

After much discussion, the issues were set out by Truman in a letter to the *St Ives Times* on 14th January 1927. In this, he mentioned that, as a result of certain criticism of the exhibitions held in Lanham's Gallery during recent years and in response to a general desire to improve the quality of work in the St Ives artists' colony, various suggestions had been made for the basis upon which a new society should be formed:-

> "That a society of St Ives artists be formed the founder members of which should be selected on the merit of work submitted for their election. That such members be called upon to pay a nominal subscription. The advantages of such a society, backed by a fund, was pointed out.

[4] The content of the discussions at this meeting has been divined not only from the Minutes of the meeting held by the Society but also from Truman's letter to St Ives Times ("S.I.T."), 14/1/1927

[5] Truman, having been elected on to the Committee, for some reason expressed a desire not to act.

[6] Bradshaw's status in the art colony can be judged by the fact that, in the election, he received the highest number of votes (13) after Lindner (16).

1. *U-boat sinking Barque by Gunfire* (Oil on board)

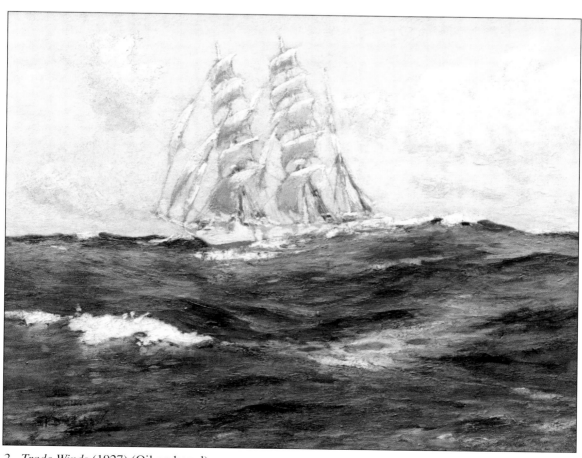

2. *Trade Winds* (1927) (Oil on board)

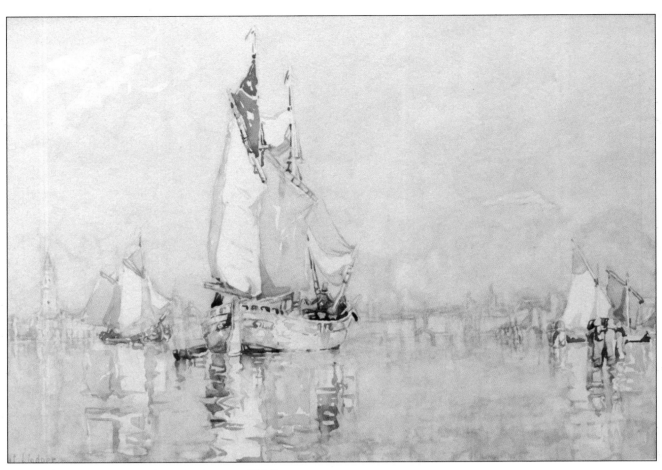

3. Moffat Lindner *Venice from the Lagoon* (1936)

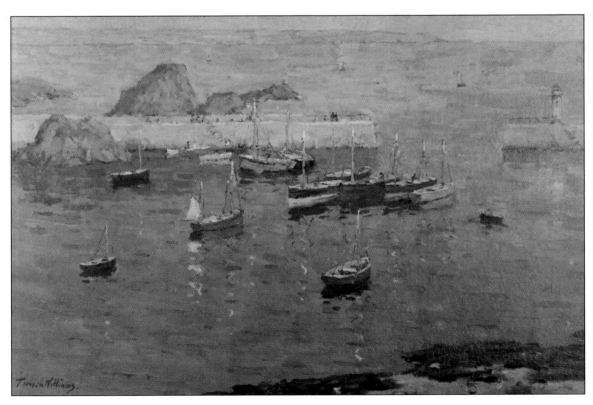

4. Terrick Williams *The Quiet Harbour, Mevagissy* (1935)
(Leamington Spa Art Gallery and Museum. Warwick District Council)

5. Arthur Meade *The Fishing Fleet*

(W.H.Lane & Son)

6. Lamorna Birch
A June Morning:The Deveron at Rothiemay (RA 1929)

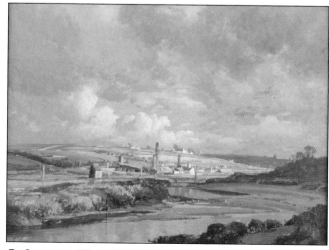

(Plate 6 courtesy of Leamington Spa Art Gallery &
Museum, Warwick District Council and Plate 7
courtesy of Newport Museum and Art Gallery)

7. Lamorna Birch *November, Bissoe, Cornwall* (RA1932)

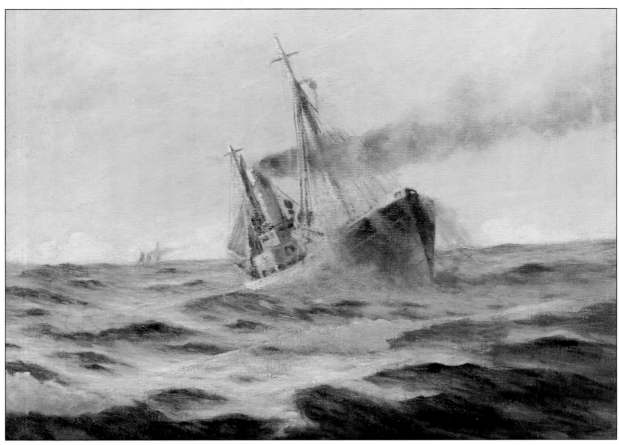

8. *The Trawlers* (1928) - detail (Oil on canvas)

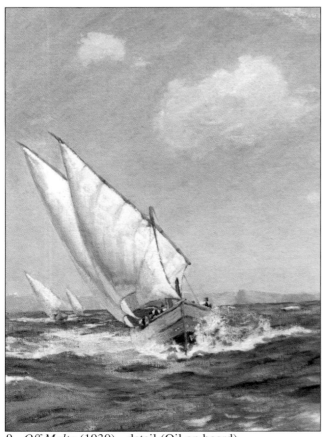

9. *Off Malta* (1930) - detail (Oil on board)

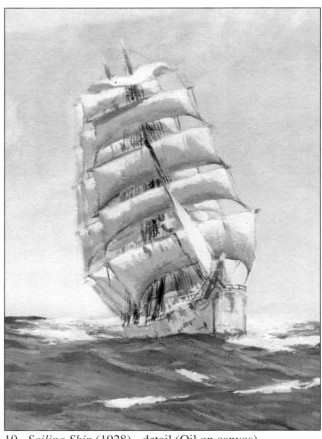

10. *Sailing Ship* (1928) - detail (Oil on canvas)

That a society similar to the above should be formed, but in addition to elected members, the society should be augmented by the affiliation of amateurs and devotees of art. This, it was maintained, would place the society on a strong financial basis and increase public interest in the movement.

That a St Ives group of artists should be organised, having common principles and aims.

That if a society of St Ives artists is formed, that its amalgamation with the Newlyn Society be discussed and that the Newlyn Committee be approached on the subject. It is understood that a clause referring to the district embraced by the Passmore Edwards Gallery, includes St Ives.

That in order to attract the student and to advertise the colony a St Ives school should be established. Various artists of the colony should be appointed to lecture on and to teach the subjects in which they are specialized.

That the Lanham's Hanging Committee be asked to visit the studios of artists who so desired, to give useful criticisms and advice. By this means they would keep in touch with work in progress and with new ideas and movements that appear in the colony.

That outside artists be invited to give criticisms on the pictures exhibited in Lanham's after each hanging.

That the question of publicity be considered with the object of attracting outside artists and students to the colony, dealers in pictures and agents for commercial work.

That a special committee be appointed to study the present situation and report to a general meeting called of all artists and others interested in the matter." [7]

In deciding what was the most appropriate structure for a society, it was important to be aware of the categories of artists, who were presently settled in St Ives. Truman felt that the colony could be divided into four groups:

"1. The small group of professional artists who have made successful reputations and whose works are well-known both at home and abroad.

2. A student group which has settled in St Ives, attracted by its one time reputation and in which it hoped to obtain the help and influence which are associated with artists' colonies. Those in this section are keen, hard-working, anxious to become proficient in their calling and hope to make their art a successful profession.

3. A few conservative artists of local repute and who are content to remain in the restricted furrows they have chosen for themselves.

4. A large section of gifted amateurs who, for divers reasons, have chosen art as a pleasant pursuit, but on which they do not have to rely for a livelihood."

Truman then listed what Bradshaw and he considered to be the principal attractions of St Ives as an art centre:

"The advantages possessed by St Ives as a centre for artists, are many. The great variety of subject matter includes cottage architecture, harbour and coast scenery, seascape, moorland, boat and figure subjects in correct environment. The town is splendidly equipped with large well-lighted studios, situated to give excellent view points. There is a brilliance of light and colour, even on grey days. The weather effects are beautiful especially during winter and the climate is healthy and mild, making sketching possible

during the greater part of the year. It is served by an agent for the transport of pictures to and from London and provincial exhibitions and also for artists' materials. Lanham's Gallery, although small, is well known and a great asset. Perhaps the one disadvantage is its distance from London."

Truman concluded:

"Any plan intended to improve the conditions and to follow the proposals outlined above, should embrace the wishes of the majority of artists belonging to the colony. In order that no invidious distinctions be made and that the wishes of artists are carefully considered, it is hoped that all St Ives artists will attend the future meeting. I am confident that by constructive criticism and helpful suggestions at this meeting, that the foundation of a scheme can be laid on which to rebuild the colony and inaugurate a successful society of St Ives artists."

The challenge was laid down. A change in attitude was required - the artists needed to work together for the benefit of the colony as a whole. They needed to help each other by offering constructive criticism of each other's works and to combine their marketing and publicity initiatives. Truman's letter provoked a good response and a meeting was set up at Lanham's Galleries, at which Bradshaw took a leading role. However, although the motion for the formation of a Society was carried, a number of the artists were not at all certain that the colony at that time boasted artists of sufficient standing to make a real impression. There was, for instance, no current Royal Academician actually living in St Ives, but the principal difficulty with St Ives as a home for an artist of repute, as Simpson, Olsson and others, found out, was its distance from London, which was always likely to remain the commercial centre of the British art scene. The minutes of the meeting are worth reproducing in full, so as to highlight the varying views and the general uncertainty as to the chances of success of the new venture.[8]

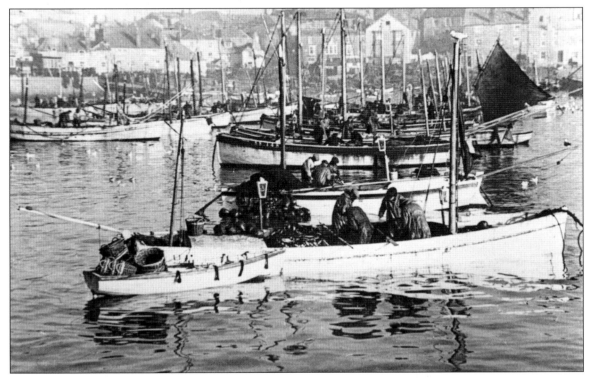

5.2 Gigs unmeshing herring, St Ives - 1920s
(J.McWilliams)

[8] Among those present were: Mesdames Shearer Armstrong, Boyer, Bradshaw, Day, Hartley, Hewitt, Lindner, Shone and Truman; Misses Bodilly, Cork, Falkner, Fradgley, Freeman, Jackson, Lane, Seddon, Sophie Thompson and M.F.A.Williams; Messrs A.C.Bailey, G.F.Bradshaw, A.Cochrane, J.C.Douglas, L.Dyer, W.Emery, S.H.Gardiner, A.Hartley, A.Hayward, W.H.Lanyon, B.Leach, M.Lindner, H.A.Minton, R.Norton Nance, J.A.Park, C.Proctor, F.Roskruge, Sirrett, F.Spenlove, J.Titcomb, W.H.Truman.

"Mr Bradshaw, Hon. Sec. of the Hanging Committee, said that the meeting was called for the purpose of discussing the possibility of forming a Society of St Ives Artists to forward the advancement of the Graphic Arts by mutual co-operation. The last few years everyone felt the work in general had been declining. There were a few Artists in St Ives with reputations, but the younger Artists felt that the lack of encouragement and artistic discussion was beginning to affect their work very adversely, and it was with the object of hearing people's opinions that the meeting was called.

On the proposition of Mr Bradshaw, seconded by Mr Truman, Mr Moffat P Lindner was unanimously voted to the chair.

Mr Lindner stated that Mr Bradshaw had given the outline of the scheme and they were there to discuss it and, if possible, try to get some definite arrangement. He asked any of them who had ideas on the subject to come forward and state them.

Mr Dyer remarked that, in the old days, when the Colony was strong, there was never any artistic discussion.

Mr Lindner said conditions had altered since the old days. Many of the Artists now had friends outside the Artists' circle and it was not so easy to get together as it was in the old days.

Mr Hartley thought the idea of a Society of Artists was admirable and, if it could be carried out, would be of great service. At the same time, when he looked around, he could not help feeling a doubt in his mind as to whether there were now sufficient Artists of standing to form this Society and, if it were not a strong Society, one wondered whether it were worthwhile.

Mr Lindner stated that there were Artists who were not so well known and students who wished to form the Society.

Mr Bradshaw said that, at present, there were not sufficient Artists of repute to form a Society but they felt that, if a Society was started in a small way, it would lead the Artists who belonged to it to do better work. It was also hoped that it would grow in strength and gradually produce work that mattered in Artistic circles, not only in St Ives but in London and elsewhere.

Mr Hartley remarked that, if the Society was formed, no doubt there would be a certain emulation amongst the members, which was lacking now.

Mr Bradshaw stated that the rough idea of the Society would be that they would meet for artistic discussion, they would endeavour to get their work criticised by Artists of repute and eventually endeavour to interest the outside world in the work of the group. It would be a very slow thing and they could not hope to meet with success under a couple of years, but anything was better than the present state of affairs.

Mr Leach stated that there were a great many points about which the majority of people there had ideas. It struck him first of all that the Artists who were in St Ives now did not seem to have a common faith. Many people said the same thing. The point was that the old St Ives painters did have a certain amount of common faith which made St Ives a colony, and gave it a driving force. It was no use to have a Society unless there was a driving force behind the members.

Mr Dyer: The hope is to get that driving force.

Mr Leach agreed and said, if that was recognised, they could commence first of all by having a gallery where the standard was a good standard, a standard which would

compare with the London exhibitions, where they could have an opportunity of seeing each other's work and talking about their work. He did not wish to say anything about the St Ives Art Club, which was only a social gathering, but they wanted a place where they could meet and talk about their work.

Mr Lindner pointed out that the Society was intended for that.

Mr Bradshaw said he did not see that it was necessary for Artists to do as in the Newlyn Society. Mr Lindner would tell them that the Newlyn School were all after the same idea of painting. Artists should paint in their own way without influencing the Society.

Mr Lindner: In former days, the St Ives Colony were rather proud of each going on their own way.

Mr Dyer: They never did have the same ideas of painting.

Mr Lindner: They had exactly the opposite. We did not agree with the ideas of the Newlyn School, because they all adopted the same style of painting.

Mr Dyer proposed and Mr Hartley seconded that a St Ives Society of Artists should be formed.

This was carried unanimously.

Mr Lindner suggested that a small committee be elected to go into full details and plans as to whether there should be lay members or not and then bring up a scheme before another meeting.

It was decided to elect a committee to prepare details of a scheme for presentation at a general meeting to be held in the near future and, on a ballot being taken, Messrs. Bradshaw, Hartley, Leach, Lindner, Spenlove and Park were elected......" [9]

Having got a measure of support for his proposals, Bradshaw wasted no time in holding the first meeting of the St Ives Society of Artists, at which he put forward the aims and objects of the Society and read out a number of suggestions. Several important issues were agreed. The Society was to consist of "Working Artists, Lovers and Patrons of Art". Only Working Artists were to have a vote in the Society. Lovers of art, etc., would have the privilege of attending meetings and joining in discussions. It was felt that there may be other privileges that could be bestowed upon the Working Artist members - such were to be agreed later.

It was decided that there should be a committee, appointed by Working Artists members, to control the Society and Moffat Lindner, Arthur Hayward, John Park, Francis Spenlove, and Herbert Truman were elected, with Bradshaw and Francis Roskruge as joint secretaries and Alfred Bailey as librarian.

The committee was empowered to look for a suitable room or studio which could be used for meetings. Martin Cock offered the free use of Lanham's No. 3 Gallery as a headquarters for the Society for the first few months, the hours to be uniform with the closing hours of James Lanham Ltd.

It was envisaged that a technical library would be established and members were asked to lend books on the Graphic Arts to this library, which should be housed in the meeting room. Members were also asked to lend reproductions of famous pictures, which could be hung in the meeting room for educational purposes, thus mitigating the lack of public galleries in the vicinity where pictures of repute could be studied.

[9] S.I.T., 21/1/1927

It was considered that the Society should initially meet fortnightly for lectures and discussions, and that Artists of repute should be asked to give short lectures at these meetings, which should be open to all members.

After a prolonged discussion and several suggestions, it was eventually decided that the subscription for Working Artists be 7s 6d per annum and for lay members 10s 6d per annum.

The foundation members were then enrolled at the meeting. The principal male artists were Lindner, Park, Bradshaw, Truman, Francis Spenlove, Hugh Gresty, Jack Titcomb, Lowell Dyer, Francis Roskruge, Arthur Hayward, Alfred Hartley, John Douglas, Alfred Bailey, Alfred Cochrane and Messrs Lockwood, Yabsley and Minton together with the potter, Bernard Leach and the craftsman, Morton Nance. The female contingent comprised Nora Hartley, Shearer Armstrong, Kathleen Bradshaw, Gussie Lindner, Helen Knapping, Mary Grylls, Winifred Burne, Emily Allnutt, Miss M.F.A.Williams, Lady Blumberg, Mrs K.Day (the widow of the artist William Cave Day), Miss Fradgley and Miss Freeman. Foundation members who are not known to have painted, who were probably enrolled as associate members, were Mrs Roskruge, Mrs Gresty, Mrs Truman, and Mr Martin Cock of Lanham's, who was to play an important role, being also Editor of the *St Ives Times*. Miss Lane, the daughter of Lady Blumberg, was also enrolled as an associate member but, on Bradshaw's initiative in 1930, was elected a full member.[10]

5.3 Show day - Visiting the Piazza Studios (M.Whybrow)
Fred Milner is the bottom figure.
Kathleen and George Bradshaw may be in front of him.

5.4 Sailing Ship drawn by Bradshaw on the Society's Minute-book, with his initials.

[10] Bradshaw's proposal may have been inspired by his friendship with Sir Herbert and Lady Blumberg. Miss Lane's work is rarely mentioned and she became a sad figure, reduced to begging for bread.

The St Ives Society of Artists can, therefore, be said to have been formed at the instigation of George Bradshaw. He clearly played a pivotal role in these initial meetings and, in the Society's records, Truman and himself are acknowledged as the founders. In view of the role that Borlase Smart later played, it is easy to identify the Society with him, but, in fact, he played no part whatsoever in the Society's formation, as he had moved back to Devon, living for three years at Salcombe. He was only invited to become a member in January 1928. Bradshaw's key role in the Society's formation explains his pride, in later years, at the Society's achievements and the intense emotions aroused in him at the time of the acrimonious split in 1949.[11]

It was noted that the local papers had carried excellent reports of the first Meeting and Bradshaw, realising the importance of publicity, stated that the assistance of the Press would be of great value to the Society.[12] This proved to be the case, and the lengthy reviews of exhibitions in the various local papers engendered increased interest and now represent an invaluable record of the paintings on view. On Show Day, art critics were given a guided tour of the studios so that styles and trends could be explained and the desired message imparted. Press photographers were always welcome. Apart from illustrating some of the major works destined for the Royal Academy, they found the sight of groups of visitors climbing up tortuous wooden stairways to enter attic studios an irresistible subject. The whole of Cornwall was, therefore, soon made fully aware of the importance of the artistic community at St Ives and, in due course, many of the photographs were also published in the London papers. The *Daily Sketch* seems to have taken a particular interest. Other publicity initiatives were the production of a brochure, containing a brief history of St Ives as an art centre and a map of the studios drawn by Francis Roskruge (fig 5.5), which was issued to local hotels, the railway company and to members, and the printing of posters advertising the Society's shows, which shopkeepers were encouraged to put up in their windows.

The new Society was given an extra fillip when a considerable number of its members were successful with their submissions to the Royal Academy, in a year which the etcher, Fred Farrell, described as being

> "the best since the War; best because one comes away from it with an almost opulent feeling of satisfaction; best because every tendency and phase of modern painting - except the ultra-rebel element - is represented; and best because the whole show demonstrates that British art has settled down to what is, perhaps, a contradiction in terms - conservatism with an enquiring mind.

> The fact of the matter is that Bolshevism in art, like Bolshevism in anything else, did not pay, and so we are back again, not to the type of Victorian picture that sold by their hundreds of thousand as colour re-prints, but to a sound, straightforward phase of picture painting, which mirrors the prevailing spirit of the times. There are no sensations and no daring innovations in the 1927 Academy - and on the whole nobody wants them." [13]

Bradshaw was successful with two pictures - *Breakers* and *Trade Winds* (Plate 2), which was described as "a spanking picture of a barque on a rolling sea".[14] Herbert Truman, John Park, Arthur Hayward, Moffat Lindner, Fred Milner, Alfred Hartley and Shearer Armstrong were also hung at the Academy. All these artists were to make significant contributions to the reputation of the colony during the 1930s, although Hayward, who ran his own School of Painting and was rated the best portraitist in St Ives (see, for example, Plate 28), later dissociated himself from the Society.

One of the first exhibitions organised by the new Society was a retrospective exhibition, comprising forty-one oil paintings by artists who had been associated with the St Ives colony in

[11] As Borlase Smart died in 1947, he also did not participate in this crucial event in the Society's history. Again, it was Bradshaw that took the leading role.

[12] S.I.T., 28/1/1927

[13] S.I.T., 6/5/1927

[14] In 1991, a picture fitting the various descriptions of *Trade Winds* was sold at W.H.Lane & Son, Penzance and this picture is used as the illustration for *Trade Winds* in this book.

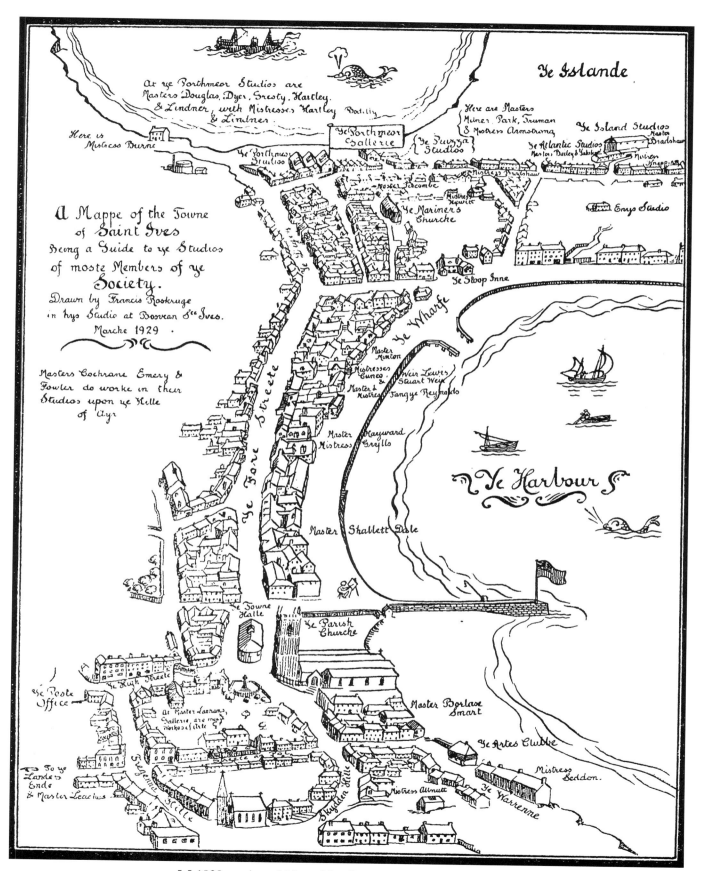

5.5 1929 version of Map of Studios drawn by Francis Roskruge

the past, such as Terrick Williams, Adrian Stokes, Louis Grier, William Titcomb, Julius Olsson, Algernon Talmage and Arnesby Brown. The idea was to publicise the high professional status of the artists that had worked in the colony in the past, whilst also including works of the principal artists still working in the colony. In an effort to secure for the exhibition works that had been acquired by local residents, Bradshaw wrote a letter to the *St Ives Times* in the following terms:-

"The St Ives Society of Artists are arranging a retrospective exhibition of the works of artists who have painted in St Ives in the past. It is proposed to hold the exhibition during the month of May at Messrs Lanham's Galleries. The joint secretaries would be very glad to hear from residents who own and are willing to lend good examples of the work of artists who have been in this neighbourhood during past years. The exhibition will not be commercial in any sense, none of the pictures will be for sale. The greatest care will be taken of all loaned pictures and they will be insured against damage." [15]

The retrospective exhibition did generate considerable interest locally and was considered a success, although top class examples of each artist's work had not been easy to obtain.[16]

The Summer Exhibition, which was devoted to works of current artists only, was said to demonstrate that "St Ives artists are making a steady effort to maintain their standard". A dominant note of the exhibition were the seascapes, with Bradshaw's large canvas *Squalls at Sea* being singled out for particular mention as showing "conscientious work and a great observation of the more subtle nuances of colour and wave formation". The critic also highlighted Kathleen Bradshaw's work, commenting that her "dainty little portrait in the primitive style of English watercolour drawing shows that modern camera portraiture is still far behind the work of the artist." [17]

By the Autumn Exhibition, the Committee's efforts to obtain contributions from distinguished artists living elsewhere in Cornwall or with earlier connections with St Ives had begun to bear fruit. Julius Olsson contributed two typical seascapes to the show and Harold Harvey, Ernest Procter and Stanley Gardiner from Newlyn also exhibited.[18]

Despite all this activity, a proposal was put to the A.G.M. of the Society at the beginning of 1928 that it should be discontinued, because of bad attendance. Even Bradshaw wondered whether the Society could fulfil any useful purpose by continuing. An associate member, writing to the *St Ives Times*, commented:-

"In the first place, I joined the Society in order to learn something about pictures and their appreciation and I feel that we associate members have not had the consideration due to us. We have never had discussions or lectures on Art. At the first two meetings, there was some talk about oils and varnishes, very interesting to artists, but not to those who do not paint. At subsequent meetings, no topics for discussion were arranged and I, for one, ceased to attend." [19]

At a Committee meeting held prior to the A.G.M, Truman lambasted the rest of the Committee at length, saying that the failure of the Society was, as Bradshaw wearily records in the minutes, "entirely the Committee's fault etc, etc, etc, etc". He considered that a more active policy was required. Clearly, somewhat piqued, and disheartened by the apathy that had been shown by poor attendance at the monthly meetings, Bradshaw indicated at the A.G.M. that he wanted to stand down as Secretary. For some unspecified reason, he had had to limit his activities in the previous three months and he did not feel that he had the time to devote to the post. Nevertheless, it was decided that the Society should continue and Moffat Lindner was again elected President, with

[15] S.I.T., 1/4/1927
[16] About 200 people attended the exhibition.
[17] S.I.T., 17/6/1927
[18] Olsson's works were *November Morning at Carbis Bay* and *Sunset near Bude*. The Newlyners exhibits were: Harvey *Seaweed* and others, Procter *Burmese Peasant* and Gardiner *Lamorna Stream*.
[19] S.I.T., 1/1928

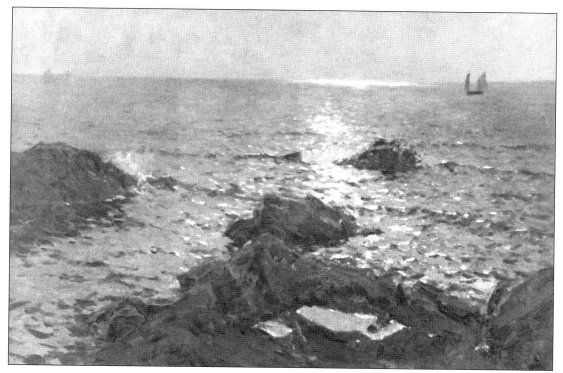

5.6 Julius Olsson *A Fine Summer Morning* (W.H.Lane & Son)

5.7 Arnesby Brown *Silver Morning* (Tate Gallery, London, 2000)
A Chantrey work included in the Society's 1947 Exhibition in South Africa

Shearer Armstrong (Secretary) and Francis Roskruge (Treasurer). The new Committee comprised Truman, Pauline Hewitt, Arthur Hayward and Hugh Gresty, with J.C.Douglas as librarian and, in a newly created post, Martin Cock of Lanham's representing the associate members. Shearer Armstrong, elected as Secretary in her absence, indicated that she could not accept the role and Alfred Cochrane was subsequently appointed in her place. Truman, true to his word, ensured that the Committee became more active.

It was now no longer appropriate for the Lanham's Hanging Committee to be appointed by Arts Club members and it was decided that this election would, in future, be organised by the Society. The make-up of the Hanging Committees for each exhibition was changed to allow all senior members of the colony to partake and Bradshaw was often included, despite no longer being on the main Committee. Arthur Hayward commented that the need for a private gallery was urgent and the new Committee made this an early priority. Eventually, 5 Porthmeor Studios, was selected as the Society's headquarters, at a rent of £8 per annum. This was not only sufficiently large that drawing classes and talks and readings on art could be held there but also well enough lit for it to be a venue for the Society's exhibitions. There was ample hanging space even for large works. The artists set about the studio's redecoration and refurbishment with great enthusiasm. Gas needed to be installed for both lighting and heating and the total cost involved was £21. The transformed Gallery was to provide the physical focus for the Society for seventeen years.[20] It afforded not only a place where members' works could be seen by the public throughout the year, but also became a meeting place for the artists. Greater cohesion on the social front would aid agreement to and achievement of unified artistic objectives. In addition, students, who might only have had the opportunity of studying the techniques of the better known painters in the mêlée of Show Day, could now do so at leisure, with the likelihood of members being around to answer their queries. Pauline Hewitt, who had studied at the Slade under Augustus John and Sir William Orpen, and in Paris, was also asked to organise drawing classes.

The first exhibition in the new Porthmeor Gallery was held in June 1928 and, as the Gallery had for twenty-five years been Julius Olsson's studio, he was asked to open the exhibition.[21] In his speech, he paid special tribute to the time and trouble devoted to the Society by Moffat Lindner. The newly formed Ladies Committee provided teas in Lindner's own studio next door. In addition to the St Ives resident artists, work was shown by some of the Newlyn artists who had been asked to contribute, such as Stanhope Forbes, Lamorna Birch, Harold Harvey, Thomas Gotch and Ernest Procter. Particular interest was shown in the work of Miss Joan Manning Sanders, who, at the age of fourteen, had had a work accepted by the Royal Academy which had been highly praised. Bradshaw showed *Summer Evening*, which was described as being "full of colour", and *Tempest*, which was complimented on its skilful treatment of the sea in an angry mood.

The Trawlers (Plate 8), which came on to the market in 1993 under the title *Tankers at Sunset*, was one of Bradshaw's exhibits for Show Day in 1928. It is a large work, painted on canvas, and may well have been the painting which Bradshaw hoped would be selected for the Royal Academy exhibition. He was to be disappointed, but it is in many respects a fine picture. It depicts three of the large long-distance steam-powered trawlers that operated from ports such as Hull and Grimsby. These would not have been regular visitors to Cornish waters and Bradshaw is more likely to have come across them in his Navy days. The leading trawler is admirably depicted powering through the choppy waters, spray flying over its bow. Equally important to the composition, however, is the multi-coloured sea, taking on tints from the orange glow of the sky.[22] It is an evocative sunset piece. The other works that he displayed, using on this occasion, 1, Island Studios, were *Cape Horn*, showing a barque running eastward in a heavy sea in "the sombre

[20] Because of the increased commitments, the annual subscription was raised to 10s 6d. The admission fee for visitors to exhibitions was fixed at 6d and commission on sales at 10% (non-members 20%).

[21] The hanging committee elected for this exhibition comprised, in order of votes cast, Lindner (ex-officio), Hayward, Hartley, Gresty, Bradshaw, Milner, Cuneo, Park and Meade.

[22] The golden tints of his seas of this period are often remarked upon.

5.8 Moffat Lindner and Julius Olsson at the opening of the first Exhibition of the St Ives Society at the Porthmeor Gallery 1928

(M.Whybrow)

dreariness of that inhospitable region that sea stories have conjured in our fancies" and a large oil *November Twilight, St Ives* in which the lights of the fishing fleet are shown reflecting across the bay, with the Island looming in the distance. A critic commented, "At no season is St Ives so wonderful as in November. The artist has caught it in an almost Neapolitan effect."

Kathleen Bradshaw did not show with her husband but in Ship Studio:-

> "Mrs Bradshaw has five dainty studies of flowers, a new departure for her. The reflection of the vases and the flowers on the table beneath are cleverly painted, and all pictures are bright in colour. She also shows a portrait of a lady, in her usual style, pencil drawing with colour wash." [23]

Due to the considerable assistance given in the past to the artists by Lanham's, the artists were keen to preserve the exhibitions in Lanham's Galleries as well as the new exhibitions in the Society's own premises. Accordingly, there were new hangings of pictures in Lanham's Galleries in June and August 1928, notwithstanding further exhibitions by the Society in the Porthmeor Gallery in August and December.[24] The St Ives artists had, however, always had a reputation for working hard and maintaining a prodigious output. The quality did not appear to suffer, the reviewer of the Winter Exhibition commenting:-

> "It was predicted by many wiseacres when the Society was started that it 'would not last long', 'mere flash in the pan', etc. but it appears to be still full of energy and one hears it is prospering. A visit to their Winter Exhibition convinces one that there is a good deal of vigour left; over 120 pictures are shown and a very high average of quality is maintained." [25]

[23] S.I.T., 23/3/1928

[24] The Society was also asked to link up with the Royal Cornwall Polytechnic Society for an Exhibition in St Austell but as several members declined to send pictures at their own expense, the offer was turned down.

[25] S.I.T., 14/12/1928

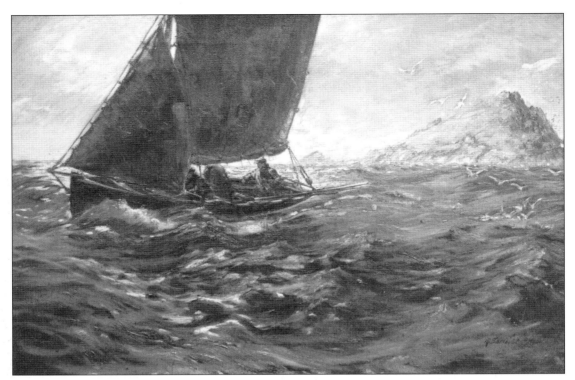

5.9 Borlase Smart *A Plymouth Crabber off the Mewstone* (Sims Gallery)
Rated Smart's best work to date when exhibited in Plymouth c.1926

At the 1929 A.G.M., it was reported that over 500 people had paid for admission to the Porthmeor Gallery during its first year. This was considered to be a good performance. 36 paintings were sold. Artist members had increased by 27 to 75 and associate members by 34 to 57.[26] A similar Committee to the previous year was elected although Borlase Smart, recently returned from Salcombe, was elected to the Committee for the first time. He was a man of broad vision, who was to play an important role in the development of the Society. After the 1929 Show Day, which some people felt had been marred by some poor behaviour by unaccompanied children, he wrote to the *St Ives Times*:-

> "I noted in the *St Ives Times* last week that several of your readers had suggested that in future children under 16 should be under the care of a responsible person when visiting the studios on future Show Days. I may say I had scores of young children in my studio on Thursday last unaccompanied by any grown up, and I found their behaviour all that could be desired. They showed an intelligent interest in what they saw, especially if any work on view contained local interest.
>
> I always make it a practice to endeavour to interest the children in the various pictures, and anything I feel may appeal to them, I give them a little talk on it. I have invariably found them very attentive listeners and, that they appreciate such consideration, is shown by their general behaviour.
>
> I should like to make the suggestion that, in future, a feature should be made by the head teachers of the various schools in St Ives in bringing a number of really interested pupils around on the morning of Show Day. The endeavours of the artists would prove, I am sure, a source of as much education to the young mind as an hour or two spent in the various scholastic establishments learning arithmetic or geography etc. - especially as Show Day in the art colony is quite a feature of the life of our dear old town." [27]

[26] A motion proposed by Bradshaw was passed at the meeting, namely that members should have the opportunity of hanging their pictures in the Gallery a fortnight before Show Day to see how they looked in a different light and compared with other pictures so that artists would have time to make alterations if necessary.

[27] S.I.T., 29/3/1929

Smart also immediately took over the role of art critic of the Show Day exhibits. Given the acquisition of the Porthmeor Gallery, some artists had decided to exhibit there rather than in their own studios, a trend which Smart hoped would not develop, as one of the unique aspects of Show Day was the ability of visitors to view works in the personal habitat of the artist rather than in the formal atmosphere of a Gallery. A studio revealed much about an artist and his way of working and the tour of the studios down back alleys and up rickety steps into attic lofts was one of the features of Show Day in St Ives that attracted visitors and differentiated the event from Newlyn where the artists all showed their works in one gallery.[28] In his review of the works on show, Smart, after praising Moffat Lindner's *Storm Cloud, Etaples* for radiating the real light of nature and calling it one of the outstanding works of the year, turned to the works of Hugh Gresty, depicting *Alcantara Bridge, Toledo*:-

> "This artist is quite an acquisition to the St Ives Arts Colony and also shows three of the finest works this year. They reflect sound constructional ability and rich sense of colour, and a great searching after truth. Last, but not least in these *modern* days when so many so-called artists take the line of least resistance, they are full of most beautiful and appealing sense of perfect drawing." [29]

Such comments reveal as much about Smart's artistic outlook at that time as Gresty's. Although

5.10 Hugh Gresty *Spanish City Avila*
(Walker Art Gallery, Liverpool -Board of Trustees of the National Museums and Galleries on Merseyside)
Works entitled *Spanish City* were exhibited at the RA in both 1932 & 1933

[28] The Minutes reveal that the artists vacillated as to the best way of utilising the Gallery on Show Days. It was at first felt that it should be reserved for work with Academy or other Exhibition labels but this idea did not work satisfactorily on Show Day in 1930 and accordingly, it was decided that artists showing in their own studios should send one picture each to the Gallery and that these should be judged by a Hanging Committee.
[29] S.I.T., 22/3/1929 - One of these works is now owned by Towneley Hall Museum and Art Gallery, Burnley.

Gresty was to contribute for a couple of years highly-praised depictions of foreign ruins, drawn so as to emphasize their monumentality, tensions appear to have built up between Smart and himself and Gresty ceased to exhibit with the Society.

There would have been great celebrations in the Bradshaw household when news of paintings accepted for the Royal Academy in 1929 filtered down to St Ives as both George and Kathleen Bradshaw had a work accepted. At Show Day, the Commander had exhibited four works. Borlase Smart was enthusiastic:-

> "Commander G.F.Bradshaw gives us pure glowing colour in *The Golden Shore* with its fine incident. In the foreground, a gig's crew is hauling crab pots in the evening glow, with well-placed details of a schooner and other craft supporting the golden distance of Hayle Towans. *Flood Tide at Evening* is another oil painting of much power, and exactly reflects that feeling of romanticism prevailing along the shore under such an effect. Perhaps his most appealing work is *At Sea*, an intimate study of the open, with a very telling cloud effect reflecting on the planes of the heaving wave forms. His other work is *Passing Showers*, with a tramp steamer emerging from a rain squall, a clever and intimate picture." [30]

The Hanging Committee at the Royal Academy agreed with Borlase Smart that *At Sea* was the most appealing work and it was, in fact, the first exhibit in the catalogue.

Kathleen Bradshaw's selected work was *Marigolds and Others*, which Borlase Smart described as a powerful flower study 'in which pure colour and a direct method of handling play an important part.' The drawing was 'fearless in style and glowing in directly painted tints'.

5.11 Mary McCrossan *Ruins in the Forest*

[30] S.I.T., 22/3/1929

Kathleen's own recollection of the painting, in typical self-deprecating fashion, was that it was 'a horrid little thing', which had only been selected due to the influence of Stanhope Forbes, whose friendship the Bradshaws enjoyed. Kathleen gave the painting to the Dominican Convent, which she had attended in Salisbury, Rhodesia between the ages of fourteen and sixteen. She recalled that her time at the Convent had not been without incident and that she used to feign fainting fits if she did not like a lesson. Miraculously, she had always recovered by the time the art class was due to start!

The Society's Summer Exhibition demonstrated that the hard work put in by the Committee had been rewarded. A Curator of the Gallery had now been employed and to encourage her to work on the artists' behalf, she was paid a commission on sales.[31] The exhibition was opened by the Mayor of St Ives and each of the local political candidates were in attendance. Moffat Lindner expressed the view that this exhibition was the best that the Society had put on.[32] Arnesby Brown, Julius Olsson and Adrian Stokes, three Royal Academicians, who had worked in St Ives, were now members or honorary members of the Society as were Stanhope Forbes from Newlyn and Lamorna Birch. Of particular note was Forbes' *The Terminus, Penzance* and Arnesby Brown's *Study* for his Royal Academy picture of the year *The End of the Village*. Lindner said the picture was a joy to see and urged members to note the lovely sky. However, the works by the principal artists living and working in St Ives, such as Moffat Lindner, Borlase Smart, John Park, Fred Milner and Arthur Meade drew equal praise. Other artists whose works always gained favourable mention were Mary McCrossan, who had also studied under Olsson, Truman, who at this show exhibited some Egyptian studies and Bradshaw, who exhibited three works. Two were powerful marine studies:-

> "G.F.Bradshaw excels in his method of depicting sailing vessels ploughing their way through rough seas. Nothing of the kind could be much better than *Southwards She Thundered*. It is a close-up study of the deck of a barque all awash, where the crew are kept busy managing the ship, over which the green seas are pouring in cascades. Life and movement are seen on all hands."[33]

In complete contrast, Bradshaw also showed *Jones' Travelling Amusements* (Plate 18), depicting the gaily coloured caravans and carousels of a visiting amusement troupe, who used to put on shows on the Island periodically. Bradshaw rarely strayed from his marine world and yet, whenever he did, the result tended to be warmly applauded. This is an attractive work, which was included in the 1999 *John Park and the Painters of Light* exhibition. Given that this is the only time Bradshaw is known to have depicted animals, his choice of a backview of a piebald pony as a central feature is brave, but the inclusion of the ponies and the various figures add important additional interest and works well. Such successes makes one wonder why Bradshaw did not experiment with landscape more often. However, the changing moods of the sea and his love of boats drew him back to marine subjects time and again.

St Ives itself continued to entrance the majority of visitors. One correspondent wrote:-

> "We feel the magic and romance of yet another world as we enter the old fishing town for the first time. Down-[a]-long we cast aside, with a sigh of relief, the materialism of now-a-days. We enter a land of enchantment. It is no wonder that St Ives with its quaintness and beauty, its lovely bay, its island, its narrow streets, its harbour crowded with fishing craft has for many years attracted, and still attracts, artists. Not only do they find beauty, there is also a wonderfully clear light and unequalled sky effects to tempt the brush to canvas."[34]

[31] The first Curator was Miss Harding, who was paid 30s a week. Her commission rate was 4%.
[32] The Hanging Committee on this occasion comprised Lindner, Smart, Gresty, Hayward and Truman. Smart had agreed to take responsibility for publicity and Truman collected the Newlyners' works. Harold Harvey and the Procters were invited to show despite not being members. Harvey sent *Tommy* and *The Flower Farm*.
[33] Western Morning News, 5/7/1929
[34] S.I.T., 22/4/1927

Others had difficulty appreciating this "spiritual aura" because of the noise. "Bells are allowed to clang, bands to play, hooligans to shout, and fruit and vegetable sellers to bleat to their heart's content." [35] Food shops seemed to have flies swarming in their windows and people were disobeying the unwritten rule that no bonfires should be lit on Washing Day. However, visitors themselves came in for some caustic comments, particularly from the outspoken editor of the local paper:-

> "If anyone could turn some of the freaks we see in the streets at this time of year into ordinary decent human beings, they would be doing some good. Beach pyjamas are surely intended for the beach and not for the streets, and if ordinarily pretty girls know how horrible they look in these shapeless garments they would surely hesitate before wearing them. Rouge, powder, lipsticks, etc. make hags of many naturally pretty girls" [36]

St Ives has always had the difficult task of maintaining its quaintness whilst exploiting its popularity. Tourists are welcome - provided they are of "the right type". The correct balance was an issue argued about in Bradshaw's day, and has been and most likely always will be the subject of passionate debate. No-one at the time of the formation of the St Ives Society of Artists, however, would have predicted how significant the artists of the Society would prove to be in promoting tourism to their beloved town.

[35] S.I.T., 28/9/1928
[36] S.I.T., 24/6/1932

THE CYNICS CONFOUNDED

The St Ives Society of Artists entered the 1930s in good heart and not only managed to survive the Depression but, as the decade progressed, achieved an increasingly higher profile as exhibitions by the Society were staged at many leading provincial galleries. Whereas in 1928, satisfaction was expressed that visitors to the Society's exhibitions numbered 500, by 1936, the figure had increased to 4,200. In the same year, the Society's exhibition in Birmingham attracted crowds totalling 64,000.

Although many people contributed to this remarkable success, members would have had little hesitation in bestowing the plaudits on Moffat Lindner and Borlase Smart. In order to ensure good publicity for the exhibitions that were organised around the country, it was imperative that those Royal Academicians, who had at one stage worked in St Ives, should contribute quality work to such exhibitions. The reputations of Julius Olsson, Algernon Talmage, Adrian Stokes, Terrick Williams and Arnesby Brown were well-established and the inclusion of works by them in an exhibition of the Society ensured that public interest was aroused and that the leading art critics reviewed the shows in the major papers. As Moffat Lindner had worked with these artists during their respective sojourns in St Ives, it was he who persuaded them of the value of becoming involved.

Equally important to the success of the exhibitions was the inclusion of other successful artists who were working in Cornwall, such as Stanhope Forbes, Lamorna Birch, Harold Harvey, Laura Knight and Ernest and Dod Procter, and here again Moffat Lindner's long association with many of these artists would have been a key factor in persuading them to support what might have been considered a rival to the Newlyn Society of Artists.

Lindner was a quiet, shy man and he does not appear to have contributed greatly, in print in any event, to the artistic discussions that took place between the artists, but his artistic integrity was never challenged and he was widely recognised both within and outside St Ives as the leader and figurehead of the art colony.

In order to ensure that the support of the Royal Academicians and the other Cornish artists was utilised to the best effect, it was necessary for the Society to have an organiser and a motivator. This it found in Borlase Smart. His boundless enthusiasm and tremendous energy were principally responsible for the ever expanding goals that the Society was able to set itself. Having raised the standard of the exhibitions held in St Ives, he then sought to bring the work of the St Ives artists to the attention of a wider public by arranging for exhibitions in a variety of provincial galleries. By the 1940s, he was making plans for the Society to take the international stage.

Borlase Smart was born in 1881 at Kingsbridge in South Devon. He obtained first class honours in design at South Kensington and first exhibited at the Royal Academy in 1912. He had an enquiring mind and was passionately interested in art and was, for a time, art critic to the *Western Morning News* in Plymouth. He first came to St Ives in 1913 to study at the Olsson School but did not settle in the town until 1919, when he quickly took an interest in public affairs, being elected to the Town Council in 1920. Although he returned to Salcombe for three years in the 1920s, and was away when the St Ives Society of Artists was first formed, he returned at the end of the decade and soon gained a place on the Committee. Smart was not afraid to speak his mind and he regularly wrote to the *St Ives Times*, expressing views on a variety of subjects. Sometimes his fellow artists took issue with his opinions on art but this did not seem to affect his ability to

ensure that all artists pulled together for the greater good of the Society and, by the time of his death in 1947, there was hardly an artist, whether of the traditional or modern persuasion, who did not admit that he was indebted in one way or another to Borlase Smart.

Bradshaw's role was a supportive one. Whether or not he had in any particular year been elected on the Committee, he could be relied upon to help with the organisation of exhibitions, whether they were held in St Ives or around the country. He was often on the Hanging Committee and was involved in the both the selection and arrangement of pictures. He was a solid society man - dependable and willing, efficient and organised. Borlase Smart described him as "my old faithful one". The precise relationship between the two in the 1930s is difficult to gauge, as Kathleen's memory was clearly affected by the disagreements of the late 1940s. Whether or not they knew each other from the First World War, their military backgrounds and joint interest in marine art would have provided an immediate bond and they appear to have become good friends, mixing together socially on a regular basis. In relation to the affairs of the Society, they made a good team. Smart was the articulate ideas man, who readily made contacts in London and elsewhere with figures in the art world. He was bubbly and enthusiastic, and it was he who persuaded provincial museum curators that the St Ives Society of Artists had something of interest on offer. He then had to stir up enthusiasm for such ventures among the artists, some of whom objected to the additional expense in the harsh times of the Depression. Bradshaw, who relied heavily on sales achieved at the Society's exhibitions, was an eager supporter, and provided the efficient organisational back-up so often lacking in artistic ventures. He also demonstrated his keen interest in the reputation of the Society by regularly tabling motions for changes or improvements in the way that members were elected, exhibitions were organised and the Society was run. At talks or at the opening of an exhibition, it was invariably Bradshaw that proposed the vote of thanks. He was the dependable right hand man.

At the A.G.M. in January 1930, the principal officers of the Society remained unchanged, with Lindner as President, Roskruge as Treasurer and Cochrane as Secretary. In fact, this combination was only broken when Cochrane resigned through ill-health in 1933. However, the influence on proceedings of Borlase Smart, who had already agreed to be responsible for publicity, was most noticeable. Nearly all resolutions were proposed by him, including a special vote of thanks to Moffat Lindner. The continued existence of the Society's headquarters, and the other Porthmeor studios, had been threatened by proposals put forward by the freehold owner and "this serious crisis in the history of St Ives art" had only been overcome by Lindner's generous decision to buy the freehold of the whole group of studios. Truman, who was rather a loner and who could be quite sharp with his colleagues, was not re-elected to the Committee, his place being taken by Bradshaw. The wheel had turned again and Truman was to have little further involvement in the running of the Society.

For Show Day in 1930, the Bradshaws exhibited at Lanham's Galleries, along with George Turland Goosey, amongst others. Goosey had been a successful American architect, but had given up his career to concentrate on his true loves, painting and etching.[1] His painting style is often reminiscent of Park - an impressionist approach and use of vibrant colour - and, like Park, he depicted time and again boats in the harbour. Although invited to become a member, he seems rarely to have exhibited with the Society.

George Bradshaw had three exhibits. *Wind and Canvas* was of an old windjammer painted from a somewhat unusual angle. The picture shows the forepeak of a vessel in full sail, viewed from the bridge, with men at work on the forehatch. A critic commented, "No-one but a sailor could give to a sailing ship in the wind so evident a feeling of motion and rise and fall of the prow." *Off Malta* (Plate 9) is one of his pictures of gaudily-coloured Maltese fruit boats racing through sunlit blue seas. On this occasion, three boats are heading towards the viewer, their lateen rigs billowing in the stiff breeze. The treatment of sunlight and shadow on the sails and the colourful

[1] In 1922, Goosey designed the St Ives War Memorial and its surroundings to considerable critical acclaim. He later preferred go under the name George Turland.

6.1 Borlase Smart *St Michael's Mount from Marazion Marshes* (David Lay)
Smart painted landscapes as well as marine subjects

6.2 Terrick Williams *Low Tide St Ives* (Rochdale Art Gallery)
A typical St Ives harbour scene contributed by Williams to the Society's shows in the early 1930s

6.3 The entrance ramp leading down to the Society's Porthmeor Gallery (Roy Ray)

reflections of the hull of the lead boat are well done and the picture is full of movement. Another seascape, *Herald of the Storm*, depicting a steamer labouring in the trough of the ocean beneath threatening skies, was his third exhibit but, on this occasion, Bradshaw was not successful at the Royal Academy.

The manner in which exhibitions were hung was taken seriously. Many members would have experienced, after the elation at acceptance by the Royal Academy, the dismay at finding that the work had been 'skied' or poorly lit. An extract from Winifred Burne's *Drawing and Design* had been reproduced in the *St Ives Times* in 1927 under the heading *'Hangmen' of our Exhibitions*. In this, the author had commented that an axiom with hanging committees seemed to be 'the best places for the best persons', the best places being seemingly the middle spaces of the most brightly-lighted wall. She concluded:-

> "Most mistakes in arrangement of exhibits will be found to be sins against a favourite precept of Sir Joshua Reynolds to the effect that whereas contrast seems a powerful aid to design, actually the opposite expedient, adding light to light, and dark to dark, warm colours to warm and cold to cold, is more potent. And this is true both in designing, and in arranging collections of, pictures." [2]

In practice, the task of the Hanging Committee was always a difficult one, given the varied styles of the artists exhibiting and, certainly, a work would not have been rejected purely because it failed to fit in to the preferred design of the Committee on a particular wall. However, the exhibition at Lanham's Galleries in 1930 drew particular praise for the way in which it was hung. "As far as possible, the pictures have been grouped with regard to colour schemes, and the general effect is interesting. One wall in particular contains all paintings that strike a silvery blue and grey note. Conspicuous among these are the brilliant works by Miss Mary McCrossan, especially the clever still life of marigolds against a striped curtain. G.F.Bradshaw's glowing centre picture of St Ives Bay fills the wall with real light. Another wall centres around Arthur Hayward's clever portrait. Hugh Gresty's fine bridge picture is well supported by John Park's

[2] St.Ives Times ("S.I.T."), 4/2/1927

Down-a-long (fig 9.2), a scene of a St Ives street, and several rich still life notes, including Alfred Cochrane's oriental motif."[3] Bradshaw's painting of St Ives Bay was acquired by the MacKelvie Art Gallery in Auckland, New Zealand, along with a watercolour *Breakers*. The reputation of the Society was now spreading overseas and the Gallery's representative, E.W.Payton, toured the studios of a number of St Ives and Newlyn artists, making several purchases.[4]

When the Society was formed, it was hoped that lectures on art would play a useful educational role. In 1928, a paper on *The History of Painting in Watercolour* by Alfred Bailey was read and talks were given by Park on *Painting in Oils* and by Alfred Hartley on *Etching*, the latter being particularly well received. In 1929, Borlase Smart spoke on various technical aspects, such as the preparation of canvasses, the use of mediums and of colour. He expressed a preference for pure linseed oil and warned against the use of copal in painting. Moffat Lindner gave a talk on *Water Colour Painting*, in which he referred to some of his own paintings and sketches to illustrate his method of working. Practical demonstrations were also given, with Francis Roskruge showing how Aquatints were made and Borlase Smart dealing with *The Art of Stencilling as applied to Home Decoration*. In 1930, Bernard Leach spoke on *The Training of an Eastern Artist*, highlighting the very different training techniques used in Japan, which he had witnessed during his sojourn there. Borlase Smart selected as his topic *The History of Cornish Art*, emphasising the great traditions of the past which the Society was seeking to uphold. He was to give this lecture many times when promoting the Society's touring exhibitions. In 1931, seeking an input from some of their honorary members, Stanhope Forbes and Lamorna Birch were sounded out but whereas Birch consented to give a talk on *Watercolour Drawing*, Forbes declined through nerves. Smart again was to the fore, entertaining members with a lecture on *Art Criticism and Press Notices* and subsequently giving a demonstration on *Cliff Painting in Oils*.[5]

To make the Spring Exhibition of 1931 distinctive, only small pictures were to be submitted. This

6.4 Fishermen mending nets, St Ives (Royal Institution of Cornwall, Truro)

[3] S.I.T., 9/5/1930
[4] In 1992, *At Sea* was returned to England and sold at W H Lane & Son, Penzance. Other artists who had work purchased on this occasion were Forbes, Birch, Gotch, Lindner, Meade, Milner, Hurst Balmford, Hambly, A.Hartley, Park, F.Roskruge, Smart and Miss E.M.Willett. The MacKelvie collection also included work by T. Williams, Olsson, Sharp, Hayward and Littlejohns.
[5] Bradshaw was due to give a talk in 1934 but at this juncture the Minute Book runs out.

decision probably recognised that, due to the Depression, pictures of any size, let alone large works, were difficult to sell. Large works, however, were much in evidence on Show Day for which Charles Proctor, in his review, utilised again the assistance of his cockney alias, Marcus. He was particularly taken by Lindner's work:-

> "Mr Moffat Lindner, the doyen of the Colony, has again triumphed. His *Golden Evening* is a glamorous, triumphant, artistic success, which seems to be constructed of translucent mosaic, liquid gold, and the lights that stream through the stained glass windows of a Cathedral. A picture to live with, and one which made me break the Tenth Commandment. Only with difficulty did I restrain Marcus from stealing the little masterpiece."

Bradshaw had three works singled out for comment. *After Rain*, a scene off Godrevy Point, showing fishing boats clustered on green seas, while dark clouds passed away in the distance, was pronounced full of charm but most reviewers felt his best work was *Onward*, depicting just the prow of a sailing ship, with pointed figurehead, cutting a deep ultramarine sea into folds of green water, while dolphins played in its path. "It is a great thing to be able to express motion in line and colour", commented one. Marcus, however, selected another work as his favourite:-

> "Mr G.F.Bradshaw's big picture of *Porthmeor Beach* is 'the goods'. There is the beach as we have often seen it. The pools and the great stretch of golden sand, the great Atlantic rollers curling in, breaking and about to break. 'That's sea, that was!' commented Marcus."

Kathleen Bradshaw's three still lifes were pronounced by Marcus to be quite delightful, the 'witch ball' in *Christmas Roses* being exceptionally well-done. Still life was a staple feature of Kathleen's oeuvre, but reviewers tended to deal with all the still lifes done by the lady artists in the colony by making a sweeping generalisation to the effect that they were very decorative. Her works in this genre, therefore, only tend to get a specific mention, when she attempted something novel.

6.5 Ben Phillips' cart landing fish (Studio St Ives)

⁶ S.I.T., 20/3/1931

In May, the Curator, Miss Thomas, who had only recently taken over from her sister, was sacked for lack of punctuality and Marjorie Sandow, who was to hold the position for many years, was appointed in preference to John Park's wife. She was repeatedly praised for her efforts on behalf of the Society. Smart commented, "She has unfailing loyalty and tact - she favours none, yet favours the whole." [7]

In the Summer Exhibition, one of Bradshaw's exhibits was *Westward and Candida* (Plate 13), a fine painting of a pair of celebrated racing yachts in full sail. It is a relatively calm hot summer's day, thus allowing some delicious multi-coloured reflections, which are the central feature of the work. *Westward* was designed and built in 1910 at Bristol, Rhode Island by the famous American, Nathaniel G. Herreshoff for Alexander Corcoran so as to enable him to mount a challenge to the Kaiser's schooner *Meteor IV*. She was built of steel and rigged as a gaff schooner, carried 15,498 square feet of sail and needed thirty-five crew.[8] She was very successful, winning eleven races in her first year, but by the time Bradshaw painted her, she was owned by F.T.B.Davies of Guernsey, who raced her against the big class yachts, winning the King's Cup in 1934.[9] *Candida* was one of the phenomenally expensive J-class yachts - only ten were built - that constituted the premier league of racing yachts in the 1930s.[10] Dating from the late 1920s, she was owned by the banker, Herman Andreae until in 1935, he acquired the famous *Endeavour*. In the early 1930s, these two yachts would have raced each other a number of times and such a spectacle would have attracted considerable interest due not only to the fine craft but also the personalities involved.

The Summer Exhibition was opened by Lamorna Birch and he encouraged members to continue to strive for excellence notwithstanding the difficult economic circumstances. He exhorted his brother artists to "be brave" both in their work and in their outlook on life. "In your work, never let the idea of "that will do" suffice. Work never so hard for perfection; appreciation may not come to you at the moment, but assuredly it will; besides, think of the reward of the mind when you can say, "Well done"." [11] Birch was fond of this theme, returning to it at opening ceremonies in later years.

In exhorting those at the private view to buy pictures, Birch said, "I feel sure you will find here many pictures which will give you pleasure and to those of you who can foster your pleasure, do not forget a picture bought helps the artist to continue his work, and I assure you it is certainly needful to him today." Bradshaw was not immune to the effects of the Depression and it is no coincidence that both he and Borlase Smart begin to offer their services as interior decorators at this time, in an attempt to establish an additional revenue stream.

In December 1931, the Society organised an exhibition at Huddersfield Art Gallery.[12] Although there had been an exhibition by St Ives artists in Cheltenham in 1925, this was the first of the travelling exhibitions during the 1930s which so enhanced the reputation of the colony. As anticipated, reviews of the exhibition in the local press concentrated on the work of the members or associates of the Royal Academy, although work by Moffat Lindner, Borlase Smart, Pauline Hewitt, Hugh Gresty and the etchings of new member, Job Nixon, also drew favourable comment. As a result, in the period of just under three weeks during which the exhibition was open, it drew some 3,900 visitors.

The reputation of the Society was spreading rapidly for, at the A.G.M. in January 1932, Lindner reported that it was becoming increasingly difficult to cope with all the invitations that the Society was receiving from galleries around the country. An invitation by the City of Portsmouth to hold an exhibition in their new galleries in March and April had already been accepted and further

[7] S.I.T., 9/2/1940
[8] *Westward*'s dimensions were:- overall length - 135ft, length at waterline - 96ft 1in, beam - 27ft 1in and draught - 16ft 11in. Information courtesy of John McWilliams.
[9] *Westward*'s last racing season was 1935, when she raced against *Candida*. In 1939, she became a cruising yacht with two diesel engines and in 1948 was sunk at sea under the terms of her owner's will.
[10] J-class yachts were between 76ft-87ft long on the waterline and their masts were over 160ft high.
[11] S.I.T., 6/1931
[12] The selection committee comprised Lindner, Smart and Park.

invitations had been received from Stoke-on-Trent and Brighton.[13]

1932 was a bleak time for artists, as it was for the majority of people in the country. Many artists became deeply depressed at the derisory values being placed on their work and *The Studio* commented, "There is a limit beyond which the contemporary artist cannot economically produce pictures at all." Even well-known artists such as Harold and Laura Knight, Lamorna Birch and Harold Harvey were struggling and it must therefore have been of some comfort to members of the Society that potential new markets were opening up for them. There could, of course, be no guarantee that more exhibitions meant more sales but the artists' predicament would have been significantly worse if they had been reliant solely on the local market.

Money matters appear on the face of it to be the reason why Arthur Hayward and Hugh Gresty did not rejoin the Society in 1932. However, there is a possibility that there was a clash of personalities with Smart. At the 1932 A.G.M., Roskruge, the Treasurer, reported that the Society's funds had dwindled and that the Committee proposed that subscriptions be doubled to a guinea. Hayward and Truman objected strongly to any increase whatsoever and others pleaded for the level to be raised only to 15s. However, the full increase was approved and Hayward and Gresty never exhibited again with the Society, despite continuing to live in St Ives. This suggests that finance was not the only issue. In the years 1928 and 1929, both Hayward and Gresty had been active Committee members, helping Truman, but although re-elected in 1930, when Truman had been ousted, they were not re-elected in either 1931 or 1932. It is possible that the pair merely felt that the additional expenditure involved in the touring shows planned by the Committee was not justified in such difficult times, but some animosity seems to have accompanied the break as Gresty wrote on several occasions in 1933-4 to the local paper disputing the value of some of Smart's utterances on art.[14]

The Brighton exhibition was the most important show that the Society had yet staged. It ran from 21st May to 10th July and Bradshaw, Smart, Lindner and Park were responsible for selecting the best canvasses, and for packing and arranging transportation to Brighton. As the exhibition comprised 150 works, this was no mean feat. Brighton Art Gallery had been at the forefront of arranging exhibitions of foreign art but this was the first time that the Gallery had devoted an exhibition to one art society. When the curator was complimented on the manner in which the paintings had been hung, he indicated that all the pictures were so consistently good that he was able to hang them all in three hours and, directly the finishing touches were made with the sculptures, the individual works appeared as if they had been especially painted for the spaces they occupied.[15]

The exhibition was opened by the St Ives M.P., Walter Runciman, who travelled down especially from the Hebrides for this purpose. Owing to illness, Lindner was unable to attend and the St Ives artists were represented by Smart and Olsson. A number of Royal Academy exhibits of the past featured in the show, with Lindner and Park including their 1930 successes *Fresh Breeze on the Maas* and *Winter Sun* respectively. Milner showed his 1928 depiction of Corfe Castle *An Ancient Stronghold* and the prolific Lamorna Birch went back to his 1923 exhibit *King Charles' Castle, Salcombe*, which at £250 was the most expensive work on view. There were also several works by Brown, Forbes, Talmage, Olsson, Terrick Williams and Adrian Stokes. Bradshaw's contributions were two oils *Wind and Canvas* (£42) and *Porthmeor Beach, St Ives* (£63) and a tempera picture entitled *Rough Sea* (£7 10s). Kathleen Bradshaw also had three paintings selected - *Reflections*, *The Red Lacquer Tray* and *Voyage of Discovery*. When these works were exhibited on Show Day that year they were described as "three exquisitely delicate pictures in tempera, full of complicated reflections." The reviewer added, "She has never done such good work before."[16]

[13] As the Museum was bombed in 1941, there is no record of the works exhibited at Portsmouth.
[14] Another artist, who used the pseudonym 'the Enquiring Rebel', did likewise, but there is no evidence this is Hayward.
[15] S.I.T., 27/5/1932
[16] S.I.T., 18/3/1932

6.6 Bernard Ninnes *In for Repairs* (1932) (The Potteries Museum and Art Gallery, Stoke-on-Trent)

The exhibition at the Hanley Museum, Stoke-on-Trent, which ran from 23rd July to 1st October, was smaller, containing only 50 works from the Brighton show, including *Wind and Canvas*. As often happened during these touring exhibitions, the host Gallery decided to buy a work to add to its permanent collection and, on this occasion, the choice fell on Bernard Ninnes' painting *In for Repairs* (fig 6.6). Ninnes was a newcomer and this painting, which he had exhibited on Show Day that year, immediately attracted attention:-

> "St Ives art circles will welcome Mr B.T.Ninnes, for he can paint. By a happy chance, his principal picture is founded on a local incident. In the summer, the *Gladys May* was wrecked and had to be repaired. His picture is of the boat-builder's shed. The yacht is shored up amid the timber and a man works, while (true to custom) others look on. In such subject, the greatest difficulty lay in the necessarily subdued light. In this and in general handling of his subject, the artist has succeeded well. He ought to do well." [17]

Another newcomer to make an impression was Tom Maidment, whose works became appreciated for their intricate and carefully observed detail. He had first exhibited at the Royal Academy in 1905 but his 1932 exhibit, *A Bit of Old St Ives*, was his first success for nearly twenty years. His move to St Ives clearly inspired him, as he became a regular exhibitor at Burlington House for the next twenty years.

[17] S.I.T., 18/3/1932

6.7 *Decks Awash* (1932) (Tempera on board)

A further fillip to the St Ives art colony in 1932 was the selection by the Royal Academy of 69 works produced by members of the Society.[18] Bradshaw was among the successful artists, his exhibit, which was hung 'on the line', being a fine tempera painting entitled *Decks Awash* (fig 6.7). A reviewer observed:-

> "Only such a practical seaman as Commander Bradshaw could have painted *Decks Awash*. In this picture, there is evidence of the roll of the ship in the trough of the sea. Sails are shortened, and the bows are drenched deep with salt water. To a good sailor, it may appear all safe, but to a landsman the effect is of a great wetness and alarming insecurity. That is where the art comes in." [19]

The Society's Summer Exhibition at Porthmeor Gallery coincided with the exhibition at Brighton and yet the number of works included in the show - 160 - exceeded all previous totals. At the same time, there was also an exhibition at Lanham's where over 200 works were on view. Accordingly, at this one time, there were over 500 works by members of the Society on show - testimony either to the prodigious output of the artists or, more probably, to the fact that works were not selling. In his opening address at the Summer Exhibition, Moffat Lindner stated that although artists were suffering from the difficult times through scarcity of money, they were not downhearted and "lived in hope" for better times.

The Exhibition was opened by Her Highness The Ranee Margaret of Sarawak, the widow of the Second Rajah of Sarawak, who had died in 1917. She lived in Lelant and was a talented musician but her passionate interest in all aspects of art and culture led her to become a great supporter and friend of the art colony. In her address, she paid compliment to a number of the artists in an individual way:-

[18] The successful artists also included Park (2), Smart (3), N.Hartley (2), Lindner (2), Milner, Gresty (2), Hayward, Turvey, Armstrong, Truman, Maidment and M.Douglas (2).
[19] S.I.T., 18/3/1932

"I will let you into a secret. To tell you the truth, I felt very shy and diffident about accepting the task offered me, that of opening this beautiful Exhibition, for although I love art, and love artists, who have power to fill human hearts and minds and souls with the real meaning and beauty of our wonderful world, I am absolutely ignorant about, may we call it, grammar or technique of either painting, music or literature, and it was this feeling of incompetence that led me to ask one or two dear artist friends of mine living in St Ives to give me some ideas on the subject. This they most graciously and kindly did, and their papers were lovely. I began to learn it by heart and in the midst of my learning, a frightful thought assailed me. The paper was so beautiful, that I became convinced that no-one here present, knowing my limitations, could possibly believe the words had come from me. If I could possibly have imagined I could have taken you all in, I should not have hesitated to make use of it! But I dreaded discovery of borrowed plumes, so I made up my mind about not minding an exhibition of my shortcomings on this occasion; and there it all is. But knowing you are all so kind, I am hazarding a few more remarks. Those remarks are to explain that whenever I see a lovely picture, such as you St Ives artists all paint, I long to snatch at them and bear them home. I long to snatch Mr Moffat Lindner's lovely creations, but I have one of Mrs Lindner's beautiful works and I have been fortunate too, I have been able to snatch away some pictures from my friends, Mr Arthur Meade, Mr Alfred Hartley, Mr Truman and others, and they have become such friends. Every morning as I come into the rooms where they are hanging, I stand a few moments before each to say, "good morning", and they somehow respond beautifully, and make each day bright and lovely for me.

Then I also snatched a picture from Commander Bradshaw. It represents a lovely ship, with all sails spread, sailing over the most exquisite sea - its background a sunrise - a very dream of Paradise. The picture hangs over my piano, and when alone I try to recall Beethoven or other masters of music from its keys, I realise that I am in a ship of dreams, wafting me to lovely things.

I am very happy to declare the Exhibition open, and I hope for the happiness of lovers of pictures, that those surrounding us now will be snatched from their walls - and give as much happiness to their possessors as mine do to me." [20]

In addition to her delightful personality, the Ranee was also extremely attractive and a number of artists were heard to comment that there was no more beautiful picture in the room than Her Highness sitting on the temporary throne declaring the Exhibition open.[21]

The poor economic climate did not prevent Bradshaw from supporting the proposal to acquire the adjoining studio (No.4) so as to give increased wall space to the Porthmeor Gallery for the Society's exhibitions. At a Special Meeting held in October 1932, Moffat Lindner indicated that, ever since the Gallery had been acquired, many members had asked whether it would be possible to obtain the studio next door, which Lindner himself used. The opportunity now offered itself and it was for the members to decide whether to proceed. The Society was flourishing, they had several new members of reputation and the present gallery was hardly big enough to do justice to the pictures submitted. He felt confident of the future of the Society, if they all pulled together. Borlase Smart indicated that it was proposed to keep the present room for oil paintings and to use the adjoining room for water colour drawings and etchings. The addition of the new studio would mean that they would not have to hang up to the ceiling as at present. Bradshaw seconded the motion and the decision was taken to go ahead. Bradshaw also proposed a motion, that was seconded by Park, that no new members should be elected, unless they had exceptional merit. This reflects enormous confidence in the future of the Society at a time when economic conditions were harsh.

[20] S.I.T., 10/6/1932
[21] S.I.T., 18/9/1936

The first Exhibition in the new enlarged galleries was the Winter Exhibition of 1932, which Charles Proctor considered to be without doubt the best yet, although many of the exhibits had been included in the Brighton and Stoke Shows. New, however, were John Park's superb *Fringe of the Tide* (Plate 19), his Royal Academy exhibit of the year, and Lamorna Birch's *November, Bissoe, Cornwall* (Plate 7), which prompted Proctor to comment, "Lamorna Birch could not paint a bad picture if he tried". However, Proctor was particularly taken with the work of Job Nixon, whom he described as a genius.

> "His *Italian Festa* is a 'tour de force', an amazing achievement, a technical and artistic triumph. I think it was Whistler who said that an etching could never be big and successful. *Italian Festa* is both." [22]

Nixon, who had moved to Lamorna the previous year, worked in watercolour as well but his etchings were better known and he assumed the mantle of resident head of the 'black and white' section from Alfred Hartley, who had left St Ives for health reasons and who died the following year. It was possibly Nixon, who also persuaded Sydney Lee, a fellow master etcher, who had been elected to the Royal Academy in 1930, to become a member of the Society and for the next few years, the 'black and white' section was prominent at exhibitions, as other distinguished etchers joined, such as Geoffrey Garnier, Raymond Ray-Jones and Daphne Lindner.

Proctor also noticed that, very unusually, Bradshaw's exhibits were not all marine subjects.

> "Hitherto, I have known G.F.Bradshaw only as a marine artist, and as a marine artist, he makes a successful reappearance by showing *Sunset and Evening Star* (Plate 14), a canvas full of light and colour and with a fine sky effect. Bradshaw also makes an unexpected excursion into landscape, and succeeds so well that I am wondering whether he would not be well-advised to turn his eyes landwards in future instead of seawards. True, there is sea in his *Zennor Church Town*, a picturesque and typically Cornish huddle of grey houses around an ancient church, viewed from a height, but the almost-too-blue sea is merely a background. Composition and colouring are alike admirable, and I hail the marine artist's adventure into landscape painting as a striking success."

6.8 Geoffrey Garnier *Trencrom Castle* (Aquatint)

[22] S.I.T., 2/12/1932

6.9 Alfred Hartley *Christchurch Gate, Canterbury*
Rated as one of Hartley's finest aquatints

6.10 Job Nixon *The Slipway, St Ives, Cornwall*
An example of his watercolour style

Both works were included in the 1932 Brighton Exhibition

Although Bradshaw did continue to produce the occasional landscape painting, he stuck principally to the marine painting which had won him his reputation. He clearly had a fascination with boats, for these feature in the majority of his works. Unlike Olsson or Smart, he rarely attempted a pure seascape. This is not because his seas are unconvincing - far from it. However, he considered that boats made a natural focal point around which effects of sea and sky could be arranged. The direction of travel, the curve of the sail, the listing of the mast, the reflections of the hull could all be exploited as compositional features and boats introduced useful additional colour tonalities, against which the colour of sea and sky and breaking wave could be played off. His versatility as a marine artist was now fully recognised in the colony and a satisfying number of works were being accepted by the Royal Academy. Having established a certain level of pre-eminence in his chosen sphere, he may have felt that there was little to be gained from competing with the landscapes of acknowledged masters, such as Milner and Meade. Possibly, he found that his landscapes did not sell so easily - certainly, *Jones' Travelling Amusements* (Plate 18) was never sold -, whereas during the 1930s, he seems to have had little difficulty selling his marine works. However, the real reason for his single-mindedness was most probably that his days in the Navy had given him an all-consuming love of the sea and all that sailed on her.

It is by no means certain when Bradshaw was offered 3, Porthmeor Studios on a full-time basis, although it is likely to have been after Lindner acquired the freehold in 1929. Previously, it had been occupied by Marcella Smith but, during the 1920s, she lived principally in London and the studio must have been under-utilized. Certainly, Bradshaw was using it in 1931 and Lindner's preference for Bradshaw led to further ill-feeling with Herbert Truman, who had also coveted it. The sore festered as, in a letter to the local paper prior to the 1934 A.G.M., Truman accused Bradshaw of exploiting his position adjacent to the Society's own Galleries, a taunt that provoked a strong reaction from Bradshaw.[23] Bradshaw's studio had a spectacular view over Porthmeor beach, similar to that in the Society's new Gallery extension, which had prompted Proctor to comment:-

6.11 Porthmeor Studios from the beach (Roy Ray)

[23] S.I.T., 19/1/1934. The full text of the letter is reproduced in Chapter 8.

"........easily the best picture is the view from the great window of the new gallery. Even the most conceited and swollen-headed artist (if you can conceive the absurd idea of an artist being conceited or swollen-headed) would scarcely dare to argue that anything he (or she) has ever put on canvas can rival the view of Porthmeor, the Atlantic, the Island and Carthew, as viewed from the gallery window on a day when sunlight and shadow are alternating." [24]

Bradshaw loved the studio and it is no surprise that, at the Summer Exhibition of the Society in 1933, one of his exhibits should have been a large canvas of *Porthmeor Beach* - and this was by no means the last of his representations of the beach in all its moods. He found the days when a northerly gale was blowing exhilarating, as the breakers pounded on to the beach, sending spray high into the air and leaving spume on the foreshore. He captures such a day in *Atlantic Breakers* (Plate 29) and it was a subject to which he returned many times. He was less enthusiastic about the summer crowds on the beach, with the blare of radios and the screams of uncontrolled children infiltrating into the studio but in *Porthmeor Beach - Summer* (Plate 22), he depicts a crowded section of the beach lined with colourful bathing tents in an interesting composition, based on a series of diagonal lines formed by surf, beach and rows of tents sweeping across the picture plane.

Despite the attractions of the great window, the studio was impossibly large and was accordingly freezing in winter. A pot-bellied stove was there to attempt to heat up the room but it made little impression. Despite the light pouring through the window, the back of the studio was very dark and Bradshaw decided to divide the studio into half, using an old sail as the partition, in the hope of reducing some heat loss. Apart from his period of absence during the Second World War when the studio was let out to Wilhelmina Barns-Graham, this was to be his painting base for the rest

6.12 Robert Morson Hughes *The Usk from Abergavenny*
Hughes and his wife, Eleanor, lived at St Buryan but delayed joining the Society until 1933.

24 S.I.T., 25/11/1932

of his life. However, he was a great believer in painting out of doors as much as possible, only using the studio to finish off his works. In an interview in 1939, he gave some indication of his painting technique:-

> "I spend a lot of time making notes and sketches, but once I set to work on a picture, it does not take me very long. I work for economy of effort, and with the idea of getting the most striking effect." [25]

The opening of the 1933 Winter Exhibition in the combined galleries by Brigadier-General Lord St Levan was a time for reflection at all that had been achieved in the seven years since a mere handful of people had met to discuss the formation of a new Society. Those persons who had originally shrugged their shoulders and smiled superciliously when the new Society came into being - the cynics and the pessimists - all now stood confounded that the Society had achieved so much in such a short time. There were no less than 215 pictures, apart from the sculptures, in the Exhibition and membership had risen to 167. At the outset, Bradshaw had not dared hope for such a level of success and the doubts and misgivings of the first year were now far behind him. Although he himself had devoted many hours to the Society, he would have recognised the greater contributions of Lindner and Smart and the efforts of the other members who had served on the Committee. They could all be proud of what they had achieved and the spirit that had been kindled amongst the artists in the colony. The figures produced at the A.G.M. at the beginning of 1933 provided yet further encouragement as, in spite of the expense of adding the new Gallery, the Society finished the year with an improved bank balance and sales for the year totalled a record £425.[26] Borlase Smart commented that the Treasurer's Report struck a note of optimism, especially in a year when other places had done badly. "It meant that artists would *have* to come to St Ives." [27]

[25] Unattributed article in 1939 entitled, *Artist Served His Apprenticeship - in the Navy*

[26] This brought total sales to £2,083 15s. At the 1933 A.G.M, the Treasurer reported that since the inception of the Society, 226 works had been sold realising a total of £1,658 15s. The previous year the sales total had been £1,500, of which £500 was attributed to the works of Royal Academicians.

[27] S.I.T., 27/1/1933

SOCIAL PLEASURES

The success of the Society artistically led to an increase in the bonhomie amongst the artists. No longer were they consigned to working alone in their studios with their doubts and misgivings as to whether they were making progress. Styles and techniques were freely discussed and the worth or otherwise of modern trends argued about - and if these discussions could take place with a glass of beer in hand, then so much the better. The 'Sloop Inn' has always been a favourite haunt of artists and visitors alike. Samuel Rogers, who until his sudden death in June 1935 at the age of 62, had been the licensee of the 'Sloop' for 23 years was a character well-loved by the artists and the walls of the pub were hung with works by local painters. John Park was a regular, who could often be found, in the words of Sven Berlin, "hanging on the bar like an old, but very friendly, parrot"[1] and his works were likely to be adorning the walls, either because they were for sale, or because he had exchanged them with Sam Rogers for beer. Later, a series of caricatures of the locals by another regular, the artist Harry Rountree, were hung.

A group of artists also organised regular weekly meetings at their respective houses for the purpose of discussing 'Art' over a couple of beers. A candle was stuck into an empty bottle of beer in the middle of the table and the discussions continued until the candle burnt out. This was often in the early hours of the morning. The principal artists involved in this circle during the 1930s were Borlase Smart and Bradshaw along with John Park, Fred Milner and Jack Titcomb.

7.1 John Park *The Sloop Inn* (David Lay)

[1] S.Berlin, *The Coat of Many Colours*, Bristol, 1994, p.170

7.2 Greville Irwin *The Inner Harbour, Mevagissy* (David Lay)

Early in the decade, they were joined by the artist, J.Tiel Jordan, but, during one evening hosted by the Bradshaws, he had a heart attack and subsequently moved to Newcastle, Staffordshire. The evenings in John Park's studio were often memorable. Park might well have warmed up in the 'Sloop' beforehand and Kathleen's enduring memory of his chaotic studio was the stock pot which he kept constantly on the stove, into which he threw all food scraps, be they fish, meat or vegetable. This tended to result in an overriding smell of fish permeating through the studio.

Milner's Piazza studio was another favourite haunt. Smart maintained that its vastness gave it a dignity and personality of its own; it conveyed the impression that big things had been created there. Milner, who was a gifted conversationalist on artistic subjects, was encouraged to reminisce about the great artists he had met and was questioned as to their outlook and methods, but he also took a keen interest in the work of his fellow artists and believed in encouraging the younger painters in the colony.

Bradshaw thoroughly enjoyed these evenings during which the artists could air their own hopes and aspirations and put the art world to rights. The group were joined after the Second World War by Greville Irwin and Harry Rountree. Irwin, a landscape and figure painter, had suffered severe injuries at the beginning of the First World War but had battled on to study in Paris in 1924 and Brussels in 1926 and had achieved considerable success as an artist. He was renowned for his camaraderie, enthusiasm and cheerfulness but, in 1947, his injuries became too much for him and he committed suicide. The Bradshaws were given one of his paintings by his girlfriend, Betty, by way of thanks for their support at this distressing time.

Artists seem to have a reputation for enjoying their drink and the St Ives artists were no exception. Bradshaw liked a tipple but was not an excessive drinker, his father's drunkenness remaining a vivid memory. When he learnt that his brother, Frank, who was a factor in Scotland, had become an alcoholic, he sighed, "It runs in the family". However, at the Eastbourne

7.3 Harry Rountree and Fred Bottomley in the Sloop Inn

exhibition in 1936, an artist was reported as commenting:-

"I do not smile until a picture is actually converted into beer - and the beer is inside me."[2]

Park might seem the obvious candidate, but Robert Bradshaw believes that the quip was made by his father, whose work, *The Lobster Fishers*, was illustrated with the article. However, in St Ives, the artists had to tread carefully so as not to arouse the wrath of the Temperance movement and, in particular, the Primitive Methodists. Concern about the actions of certain sections of the Primitive Methodist congregation had been expressed by Charles Proctor in a letter to the *St Ives Times* in November 1926, after a fire had broken out at the 'Sloop'.

"To such degrees of fanaticism have certain people of St Ives 'advanced' on the drink question that when there was an outbreak of fire at the famous and picturesque 'Sloop Inn' on Thursday afternoon, several people in the crowd that assembled loudly expressed the impious hope that the ancient inn would be burned to the ground! Christian charity evidently is not extended to the resort of artists and visitors, a place which has, in its way, helped to make St Ives world famous. Presumably, these rabid Prohibitionists would have allowed the fire to continue if the fire brigade had not, happily, appeared on the scene."[3]

An incident occurred on a Sunday in August 1929 which caused St Ives to feature in headlines around the world. Largely due to the influence of the local Primitive Methodists, Sunday was considered to be a day of rest upon which all shops should be shut and no-one should pursue any business activity. The extent to which the Methodists went in policing observance of the Sabbath

[2] News Chronicle, Eastbourne, 27/6/1936
[3] S.I.T., 19/11/1926

7.4 Fish sale on the Slipway (Studio St Ives)

was frequently commented upon with incredulity by visitors and annoyed many residents intensely.

The strictness of the observance of the Sabbath in St Ives appears to have originated from an occasion in the seventeenth century when the fishermen had experienced a particularly poor pilchard season. A local Minister, the Reverend Tregose, indicated that this was because God was punishing them for not keeping proper observance of the Sabbath. The fishermen decided, accordingly, that no boats should put out to fish on the following Sunday and that this should be a day of humiliation and prayer. On the very next day, a shoal of pilchards appeared in the bay. For the rest of the season, the fishermen had no difficulty in filling their nets with fish but, during the next season, after one particularly heavy catch on a Saturday, some of the fishermen continued working on the Sunday. The following day, so the story goes, the glut ended.[4]

Over the years, the fishermen had been rather inconsistent with the level of their observation of the Sabbath. When boats from other ports attempted to land fish caught on a Sunday, they were met with a stormy reception, with the fish often being thrown into the sea but, on other occasions, particularly if the state of the tide would mean a delayed departure on Monday morning, boats would set off for the fishing grounds on a Sunday afternoon. This would often lead to disputes but, normally, the fishermen who were members of the Primitive Methodist congregation would be able to ensure that strict observance of the Sabbath was reimposed.

There was no Sunday activity, whether of a business or pleasure nature, which was necessarily exempt from the fury of the Primitive Methodists. Even artists were prevented from sketching; one lady artist, having been ordered to pack up her belongings, was told " ...and you're lucky to have me telling you so politely; if you were further up the alley they'd say it with a bucket of

[4] Local lore also records the vision of Mary Stevens during the eighteenth century. Mary's father had a large interest in the pilchard fishery and, after a particularly heavy catch one Saturday, told his daughter to go down to the women who were packing the fish for curing in the cellars near the old market-house and instruct them to continue working until the job was finished, as the fish, if left until Monday, would spoil. Having carried out her errand, Mary was startled, on passing the open window of the George and Dragon, to see the form of a man lying on the market-house floor, on which he appeared to be writing with his finger, his head supported by the other hand. She stopped to watch the writing, and by a great light which emanated from the man's side, she was able to trace the words "Remember the Sabbath Day to keep it Holy". The narration of this vision caused a great sensation in the town, and did much towards securing the strict observance of the Sabbath, particularly as at that time Methodism was taking a hold upon the town.

water." [5] In fact, on one occasion, both Arthur Hayward and his dog were thrown into the harbour by local methodists for painting on a Sunday.[6] The artist, Frank Emanuel, writing in 1930, was forthright in his condemnation of this religious fervour:-

> "The bigots have been known to enter private studios in which artists have been reported at work on Sundays and to have destroyed or damaged works intended for exhibition...I have known of inoffensive lady artists' work destroyed by native women on week-days on some idiotic charge, and destroyed, moreover, with impunity. This lawlessness should be put down with a strong hand." [7]

In the summer of 1929, some speedboats - then new fangled inventions - had obtained licences to operate in St Ives and, although popular with the visitors, they had caused a lot of noise, which had angered some inhabitants and they had also been accused of being a danger to swimmers and of damaging the nets of some of the fishing boats. The Reverend W.A.Bryant, who was the Primitive Methodist Minister at that time, had preached a sermon about the desecration of the Sabbath and it appears that a number of the fishermen were whipped up into a frenzy. On the Sunday in question, in August 1929, one of the speedboats, which had been plying for hire in the harbour, attempted to pick up some passengers, one of whom happened to be the director of the speedboat company. A crowd gathered and refused to allow him to embark. Later in the evening, when the speedboat was returning to harbour, a crowd assembled on the pier and refused to allow the driver to land. A visitor heard the threats being issued by the crowd and swam out fully-clothed to the speedboat to advise the driver not to land there that night, as not only the boat but his life would be in danger. The crowd then turned their attention to a couple of cafés on the harbour, where visitors were having refreshments. The owner of the Promenade Café did not attempt to argue with the mob and closed but Bradshaw's fishing companion, Job Boase, who kept the Harbour Café, refused to close, as he had the requisite licence for Sunday trading. Boase no doubt recognised many of his fishing colleagues in the crowd and thought that he could reason with them. However, the mob became increasingly hostile and two lady visitors in the café fainted. Boase, on the advice of the police, eventually gave in and his forty customers were evicted. Considerable vandalism occurred subsequently and well over 3,000 people in fractious mood stayed on the Wharf until after midnight.

Not surprisingly, this riot gave St Ives a poor reputation and the flood of correspondence sent to the local papers about the incident demonstrated the concern that a number of residents had about the influence of the Primitive Methodists on the town. Boase no doubt expressed his indignation to Bradshaw but, given that Boase himself had been known to tick off an artist for painting on a Sunday, Bradshaw may well have maintained a tactful silence. Greville Matheson, a regular contributor to the *St Ives Times*, was moved to write one of his poems on the subject:-

"1. On Sunday 'tis a curious place
crammed full of charity and grace
You may go to church, to chapel too,
but other things you may not do,
in St Ives upon a Sunday.

2. At home you mustn't stand or sit,
and watch the folk go by, or knit
You mustn't walk upon the grass,
or smile to see a lady pass.
You mustn't yawn, you mustn't laugh;
you mustn't take a photograph.
You mustn't wear a Homburg hat,
you mustn't stroke the household cat,
in St Ives upon a Sunday.

[5] S.I.T., 12/10/1928
[6] Denis Mitchell in an interview with Radio Cornwall 1988
[7] F.L.Emanuel, *The Charm of the Country Town Pt.III*, Architectural Review 7/1930

3. By 'bus or train you must not go,
or motor idly to and fro.
You mustn't park upon the quay,
look through your glasses at the sea,
or saunter slowly thro' the town
with coloured parasol and gown,
or trousers with conspicuous check,
or College scarf around your neck,
in St Ives upon a Sunday.

4. The *Sunday Times* you mustn't buy,
polluting both your mind and eye;
and crossword puzzles, sinks of sin,
you must not wallow vainly in.
You mustn't turn your wireless on
to hear the news and which has won;
you mustn't use your gramophone;
you mustn't give your dog a bone,
in St Ives upon a Sunday.

5. All fiction is, of course, taboo
from Edgar Wallace to le Queux;
'tis only sermons you may read;
and you mustn't drink, you mustn't feed;
you mustn't snuff; you mustn't smoke;
you mustn't try to make a joke;
you mustn't sneeze; you mustn't cough;
you mustn't take your jacket off
in St Ives upon a Sunday.

6. You mustn't sketch or even seek
a subject for the coming week.
Of course you must not bathe, or be
upon the sands and ask for tea.
You mustn't glance into a shop;
if somebody falls you mustn't stop;
if someone tumbles off the quay,
you must walk away and let them be,
in St Ives upon a Sunday.

7. It is a very curious place,
crammed full of charity and grace.
You may go to church and chapel too,
but other things you may not do
in St Ives upon a Sunday." [8]

The artists were great party lovers and all-night parties and midnight swims were not uncommon. Kay and Bey, as the Bradshaws were known to their friends, were eager and welcome participants.[9] In 1932, the Committee of the Society decided to lay on in February a fancy-dress party. All the artists made a real effort and there was a wonderful array of costumes. Prizes in the form of paintings were contributed by Moffat Lindner, Lamorna Birch, George Bradshaw, Fred Milner, John Park, Francis Roskruge and Borlase Smart amongst others and Borlase Smart acted as Master of Ceremonies. The event was so successful that it became an annual spectacular for many years. In 1933, it was decided to make the fancy dress ball coincide with Show Day, so as to provide a fitting climax to the most eagerly anticipated day in the artists' annual calendar.

As the years passed, the decoration of the Drill Hall itself became a work of art, with novel designs being utilised and the decorations becoming more and more lavish and sumptuous in colour. These arrangements were organised by Mr Clair Knight of the Vanity Box in Fore Street. In 1935, when the subject was *Blossom Time*, the Hall was festooned with imitation apple blooms and presented the effect of a huge bower of flowers. The decorations were so widely praised that they were retained and hung in the lower part of the town as a contribution towards the King's Jubilee celebrations.

It became a tradition for many of the senior members of the colony to donate pictures as prizes and Bradshaw was normally a donor. Kay always entered into the spirit of the occasion and in 1934 was one of the prize winners. In 1938, she was the subject of a drawing by Borlase Smart, entitled *Kathleen Bradshaw at the Arts Ball*, which was described as a good portrait with clever drawing.

[8] S.I.T., 16/8/1929
[9] None of the family are able to explain where George's nickname 'Bey' originated.

A number of the artists joined in various drama productions in the town. Kathleen recalled a village concert in the Old Guild Hall in aid of the British Legion. George Bradshaw had taken the role of a vicar, with Pauline Hewitt as his wife. Kay and Miss Magness played the daughters of the vicar and had been taught dancing steps by the leading London choreographer, Holliday. The Bradshaws also hosted private drama evenings for a small circle of friends. *Blythe Spirit* was one play that they put on for fourteen elderly friends, with parts being taken by both George and Kay, their old friend, Charles Allen and Kay's brother Bill, who was home from Sandhurst. There was also a performance of *Anthony and Cleopatra* with George taking the part of Anthony, Miss Magness the part of Cleopatra and Kay playing a handmaiden.

The St Ives Arts Club continued to provide a range of social activities and most of the artists were members. However, literature and drama rather than art tended to dominate the activities of the Club. Tea Talks were given by writers, such as A.K.Hamilton Jenkin, who specialized in Cornish History, and Crosbie Garstin, the son of the Newlyn artist, Norman Garstin. Crosbie also took part in a number of the dramatic productions put on at the Club and was a regular and popular visitor. The Bradshaws knew him well - he was a personal guest of George Bradshaw in February 1924 - and, accordingly, were deeply distressed at the news that he had drowned off Salcombe in 1930. Harry Welchman, considered to be without equal in English musical comedy between the wars, became another good friend and Bradshaw later asked him to open one of the Society's Exhibitions. Various plays performed were written by members. Fellow artist, Francis Roskruge, was a keen and respected playwright and the Club actually hosted in 1926 the premier of the stage version of Margaret Kennedy's controversial novel, *The Constant Nymph*.[10] The Bradshaws enjoyed acting and were frequently involved in the productions, along with other keen participants from the artist community, such as Roskruge, George Turland Goosey and Lowell Dyer. George Bradshaw was no doubt flattered to be elected President in 1931 and, in customary fashion, donated a painting, *Regatta Day - Slipway, St Ives*, to the Club. Unfortunately, the Club's records do not indicate what activities were organised during Bradshaw's Presidency, but his election demonstrates that, at this time, he was a popular figure in the St Ives social scene.

Shearer Armstrong and Pauline Hewitt were two of the female artists with whom the Bradshaws socialised. They had all arrived in St Ives at much the same time. Shearer Armstrong, who lived

7.5 Borlase Smart and his picture of St Ives Arts Club (M.Whybrow)

[10] M.Whybrow, *St Ives 1883-1993*, Woodbridge,1994, p.103

7.6 The Bradshaw and Slatter families in Ship Studio
Standing: George Bradshaw and Kathleen's brother, Bill Slatter (right)
Seated (from left): Kathleen, her mother, Ada and her sister, Barbara with boyfriend (on floor)
Pauline Hewitt's portrait of Kathleen hangs on the back wall

in Carbis Bay, had studied at the Slade, in Germany and with both Algernon Talmage and Forbes, and was evolving a distinctive style of still life painting. Pauline Hewitt had also studied at the Slade, and in Paris. Initially, she occupied St Peter's Street Studio but she then moved to the Balcony Studio in St Andrew's Street. Card games were the usual activity on evenings hosted by Hewitt. One evening Kathleen recalled with horror, as when she went to wash her hands in the bathroom, red water came out of the taps - it had been a heavy day at the slaughterhouse! In addition to landscapes with figures, Hewitt also specialized in portraits in oils, but her portrait of the normally vivacious Kathleen (Plate 25) captures her in somewhat sombre mood. On the back of this, Hewitt is careful to record that she was a pupil of Augustus John and it may be through Hewitt that the Bradshaws met Augustus and Gwen John.[11] Bradshaw referred to Augustus John as 'Disgustus' John and considered his sister, Gwen, to be the better artist.

Although the success of the Society of Artists did depend upon the maintenance of the quality of the work exhibited and the enrolment of new artist members of talent, the Society did also rely on the support of prominent associate members. One of the most distinguished of the associates was Sir Herbert Thirkell White, who had spent thirty-three years in the Civil Service in Burma, eventually being appointed Lieutenant-Governor of Burma in 1905. On his retirement, he had settled in St Ives and became very involved in St Ives society. The Bradshaws first got to know him as Kathleen's uncle, Frank Couchman, had served with him in Burma, and they became very good friends. In an appreciation published in *The Times* on his death in December 1931, Lionel Jacob wrote:-

[11] The status of Augustus John at this time is demonstrated by T.W.Earp in an article *The Recent Work of Augustus John* in The Studio 1929 (XCVII) at p.236, who states "That he is our greatest living portrait painter - and, incidentally, without a rival in portraiture upon the Continent - is now an accepted fact."

"He loved St Ives, the charm and quaintness of the ancient seaport, and the walks on both sides, with an intimate in his company, to Carbis Bay and on to Lelant, where the golf links are, and to Gurnard's Head by the rugged coast to the cliffs, where the waves of the blue sea break upon rocks of fantastic shapes and gulls and cormorants abound. He liked the congenial St Ives Society, the residents and the artists, the summer and winter visitors, and made himself part and parcel of the place. In his service in the East, he had risen to high positions by virtue of his great abilities and tireless zeal, but it was part of his genius to be able to put aside things that did not concern him at the moment, and it almost seemed that he had brought back to England with him something of the brightness of the people of the province he had served for three and thirty years, the lightheartedness of the men and of the dainty little women whose plumage is so gay with colour. He was catholic in his tastes, he loved books, the sentiment of fellowship, and he was never lonely, as there was always his pen. He had a charming literary style and it was never more charming than in his letters to his friends. At a time when the old art of letter-writing has practically disappeared and letters read like telegraphic messages for economic advantages, Sir Herbert was a wonderful letter-writer. He wrote long letters, and there have doubtless been many people who have wished that they had been longer. There was no subject on which he had not something to say, and with his rich and rare vocabulary, he would discourse on State affairs, the politics of the day, the Indian question, books, theatres, sporting contests, and switch from grave to gay to tell some priceless story. He had his likes and dislikes, but once he had made a friend, he was a friend for life, and even letters had to be good enough for him. He could be cheery in his congratulations and a genuine sympathiser in distress; his real friends always felt that they had in him 'amicus certus in re incerta.'" [12]

The Bradshaws enjoyed the company of Sir Herbert Thirkell White immensely and Kathleen recalled that Lady White had a sunny disposition and was always cheerful. Although not part of the bridge circle, they were regular guests at the White's house in St Ives and the Whites and their two daughters were, in turn, guests at the Bradshaws' drama evenings. Sir Herbert indicated that he wished to be buried at sea off Falmouth and for the funeral to be a private affair. The extent of their friendship can be gauged from the fact that George Bradshaw was one of only four mourners invited to attend.

Another distinguished associate member with whom the Bradshaws were friendly was General Sir Herbert Blumberg. Notwithstanding Bradshaw's limited financial resources, his achievements during the War clearly enabled him to mix with and be a valued friend of members of the military hierarchy. With people who had actually seen action and shared nerve-wracking experiences, Bradshaw had no problem and it is not surprising that he gravitated towards the other military officers who had retired to St Ives. Lady Blumberg, who was a difficult woman, who wore Edwardian clothes, invariably with a high collar, and had a penchant for floppy hats, was a sea painter, who had studied under Stanhope Forbes and exhibited under the name E.Tudor Lane. They had settled in St Ives in the mid-1920s and became actively associated with the art colony. The Bradshaws played tennis and badminton at their house and the Commander assisted Sir Herbert with the local British Legion. Kathleen recalled a narrow escape on a return trip from a fête organised on behalf of the Legion. Because his brakes had been squeaking, Sir Herbert decided to oil them. The result had been that on descending a steep hill, the car had failed to slow down and Sir Herbert had steered it up a private drive leading off the main road. The car eventually ground to a halt when it demolished the front porch of the house in question. The occupants of the house were more than a little bewildered to find a General in full uniform amidst the devastation of their porch, but he merely left his calling card and reversed the car out with a perfunctory "Send me the bill".

Accidents involving cars were unfortunately quite common and the local paper is full of stories

[12] Reproduced in S.I.T., 1/1/1932

7.7 *Our Cove* (Oil on canvas)

of visitors losing control while driving down the steep streets of St Ives or going too fast over the moors. One tragic occurrence would have affected the art community deeply. Moffat Lindner's daughter, Hope, was helping to ferry some of the locals to the polling station on the day of an election in 1929 when she collided with another car in Carbis Bay and three occupants of the other car died. No doubt Lindner was grateful to the support given to him by the other artists at this difficult time.

Kathleen Bradshaw had yet another lucky escape in 1927. She had been asked by a rather timid lady masseuse, called Alice Gray, to accompany her on a drive to Land's End in order to help Miss Gray "change gears". This rather alarming request had led George Bradshaw to tell her not to go but Kathleen was a free spirit and decided the outing would be fun. The day out passed relatively uneventfully, although Miss Gray was certainly not a very good driver, and when they arrived back at The Wharf in St Ives, Kathleen indicated that she would get out and walk back up to Ship Studio, as the streets were rather narrow. Miss Gray, however, insisted on turning the car round first and in carrying out this manoeuvre, she lost control and the car ploughed off the road and dived some sixteen feet into the harbour, despite the valiant attempts of a passer-by to stop it. Luckily the tide was not fully in but, nevertheless, the car was still in a couple of feet of water and Kathleen was flung out of the front seat into the back seat, ripping a huge gash in her leg where it caught between the bucket seats. She also hit her head and was knocked unconscious as the car rolled over on landing. When she came round, she thought she had lost her sight but this gradually returned and the two ladies were helped out of the car by the passer-by, Robert Care, who had also fallen into the harbour. Miss Gray was not too badly hurt and insisted on staying with the car in the hope of being able to salvage it, notwithstanding the fact that the tide was coming in and it had been badly damaged in the accident. Kathleen, in her rather concussed state, was led back bloodied but unbowed to Ship Studio where, after a bath and a stiff brandy, she was happy to recount her "little adventure" to a crowd of well-wishers.

In the 1920s, cars were still a relatively new luxury and reaction to them varied. Some abhorred this new, noisy, smelly infiltration into the town and bemoaned the excessive speeds at which

drivers travelled. Others were exhilarated not only by speed but also by the new technology. One of the leading artists in the colony (as yet unidentified) developed a passionate interest in cars, which completely outweighed his interest in art, as Greville Matheson found out to his cost in 1929.

"Having been instructed by the Editor of the *St Ives Times* to interview Mr.X., and obtain his views on art at the present time in St Ives, I called one morning at Mr.X's studio. The door was ajar and after knocking I walked in. The studio was apparently empty. I have often been in it before, but there were one or two pictures in evidence which were new to me, and I strolled round looking at them before going away. While doing so I suddenly caught sight of a pair of legs on the floor, protruding from a large table that stood against one of the walls. I do not mind owning that I was startled. Was I at last to meet with an experience about which I had often read in those thrilling detective stories which nowadays are 'as thick as leaves in Vallambrosa'? Had another murder been committed in a studio, and was that the body of the victim hidden beneath the table? I looked vainly round for the weapon. I felt that I must be very careful. I must not leave any finger-prints about anywhere; I must not drop any cigarette ends. I knew full well how clever and ruthless such sleuths as Dr. Thorndyke, and Poirot, and Hanaud were. I was in a dangerous position. What had I better do? Should I quietly go away, if I could do so unobserved, or should I fetch a policeman and a doctor and raise an alarm?

While I was deliberating, I saw one of the legs waggle slightly, and in a few seconds more, I was relieved when Mr.X himself emerged from underneath the table, looking rather dishevelled and dirty. He greeted me cordially, while brushing himself down with his hands.

"You will pardon me, I feel sure," he said "for keeping you waiting. As you probably know, I am an ardent motorist, and when my car is out of order, and I cannot get out for a spin, I find that I derive immense refreshment and relief from imagining I am out motoring. My car is under repair at the present moment at the garage, as I unfortunately damaged it by colliding violently with the Mayor yesterday. Some of my happiest hours - I may almost say days - have been spent on my back underneath my car on the Bodmin Moors and elsewhere. When you came in, I was, in imagination, on that fine thoroughfare, the Bodmin road, engaged, as is usual, in rectifying one or two slight defects in the machinery of my car. But, now, what can I do for you?"

"Well," I said, "I have come to ascertain your views on...."

"On cars?" broke in Mr.X eagerly, "I shall be delighted to tell you all I know and.... "

"No," I said, "I want your views on the present condition of art in St Ives."

"Art?" exclaimed Mr. X, "My dear Sir, I've no time for trifling matters of that sort. I'm much too fully occupied. But look here, what do you think of this new idea for preventing skids?" And he handed me a much-thumbed catalogue entitled *Gadgets for Motorists.*

"I may as well tell you at once," I said, wishing to clear the air, "that I don't know any thing about motors. I don't own one, I can't afford one. If I won the Calcutta Sweep I daresay I should buy one, and a good one. But I should most certainly have a chauffeur, because though I wouldn't mind driving, I should be helplessly bewildered if I had a break-down. The mechanism of a car to me is worse than a Torquemade Cross-word puzzle."

"My dear Sir," exclaimed X, looking quite sad, "I can't understand the mentality of a man like you. Why the most enjoyable part of motoring is the break-downs, the having to put

things right, the lying on one's back in the road under the car. But I am forgetting my hospitality. Excuse me."

He strode across the studio and blew three tremendous blasts on a motor-horn that was screwed on to the table, and that evidently served as a bell.

"I have a regular code of signals" he remarked. "Three blasts means whiskey and soda. Ah! here it is."

His housekeeper appeared carrying a tray with a decanter of whiskey and a syphon.

"Help yourself." said X.

"And now," I resumed, after drinking X's health, "what about art in St Ives?"

"Ah! yes," said Mr X thoughtfully, "yes, let me see, art in St Ives, well - by the way what do you think about that new tyre that's being advertised - think its any good?"

"I know nothing about tyres" I firmly remonstrated, "what I want to hear about is art in..."

"Oh!" said Mr.X, losing his temper, "look here, as I said the other day when a hen nearly ran over me..."

But I was fated never to hear what he said to the hen, for at that moment there was the sound of a motor-car coming along outside, and in a few seconds it drew up, coughing, at the door. I looked at Mr X. His face was glorified. Leaping to his feet from the chair, he blew five times loudly on the motor horn on the table - apparently a signal to his housekeeper that he was going out - danced a few steps of a fandango, and seizing a cap and a leather jacket, disappeared incontinently through the door. And as the car, drew away, I heard him in the distance, trying to play *God Save the King* on his Klaxon." [13]

Other artists who owned cars were not so enthusiastic about mechanics and used them to spend enjoyable days picnicking on the moors or visiting neighbouring beaches. On occasion, it was pure fun and frivolity but, of course, the presence of a number of artists together often led to discussions about art. Sometimes the canvases and paints were brought along as well and the artists found some vantage point overlooking a sandy cove while their partners and children played on the beach or leapt in and out of the waves. Bradshaw often used figures to add some colour to a coast scene. In one painting, he depicts Kathleen sitting with her back against a rock reading a book, the bright yellow and red of her clothes providing a useful contrast to the deep blue of the sea. In another, *Children Watching a Rough Sea* (fig 7.8), a couple of children are shown on the edge of a cliff watching the waves crashing against the rocks sending spray high into the air, their clothes showing that there is a blustery wind. These group outings reflect the bonhomie amongst the artists that developed during the 1920s and 1930s and assisted the close-knit spirit which characterised these years.

The Bradshaws were very fond of surfing, which at that time was quite a novel pastime, and there was a rope ladder which could be thrown out of Bradshaw's Porthmeor studio to provide direct access on to the beach. Horace Kennedy, the grandson of the artist, Thomas Millie Dow, can remember using Bradshaw's studio as a changing room after swimming on Porthmeor Beach.[14] Other friends that used the Porthmeor studio as a changing room were the family of Commander Scott, who had also served in Burma with Herbert Thirkell White. Commander Scott's daughter, Rosamunde, was a frequent visitor to the studio and as the novelist, Rosamunde Pilcher, used it as the basis for the studio of Lawrence Stern, in her best-selling novel *The Shell Seekers*.

[13] S.I.T., 25/1/1929
[14] M.Whybrow, *op. cit.*, p.89

7.8 *Children Watching a Rough Sea* (Oil on board)

"His studio was an old net loft, high ceilinged and draughty, with a great north window facing out over the beach and the sea. Long ago, he had put in a large pot-bellied stove, with a pipe chimney that rose to the roof-top, but even when this was roaring, the place was never warm.

It was not warm now.

Lawrence Stern had not worked for more than ten years, but the tools of his trade were all about, as though, at any moment, he might take them up and start to paint again. The easels and canvasses, the half-used tubes of colour, the palettes encrusted with dry paint. The model's chair stood on the drape dais, and a rickety table held a plaster cast of a man's head and a pile of back numbers of *The Studio*. The smell was deeply nostalgic, of oil paint and turpentine mingled up with the salty wind that poured in through the open window.

She saw the wooden summer surf-boards, stacked in a corner, and a striped bathing towel, tossed, forgotten, across a chair. She wondered if there would be another summer; if they would ever be used again.

The door, caught by the draught, slammed shut behind her. He turned his head, he sat sideways on the window-seat, long legs crossed, an elbow propped on the sill. He had been watching the sea birds, the clouds, the turquoise and azure sea, the endlessly breaking rollers." [15]

In the May 1996 edition of *Country Living*, Rosamunde Pilcher recalled her childhood in St Ives:-

"Christmas holidays were a round of parties and plays. Not plays we went to watch, but plays we took part in. In St Ives there was the Arts Club, and some enthusiastic mother would somehow dragoon us into putting on a show. The Arts Club was an integral part of St Ives, because not only painters settled in the little town, but potters, sculptors, poets

[15] R.Pilcher, *The Shell Seekers*, London,1987, p.170-1

and writers, too. My mother was, for some reason, an honorary member, although she had never created anything more ambitious than a cotton frock, but it meant that we met all the interesting inhabitants of St Ives, and more importantly, their children. Our favourite artists were George and Kay Bradshaw. Their studio looked out over Porthmeor Beach, and we used to go there for picnic teas, climb out of the window by means of a rope ladder and ride the pounding surf on wooden belly-boards."

The Bradshaws made a special surfboard for the young Rosamunde. George Bradshaw fashioned the wood into the correct shape and Kay painted the face of a devil on it with horns and a beard. Kay, in fact, taught Rosamunde how to read when she was four years old and Rosamunde recalls, "She was very pretty and charming and we all loved her." [16]

The surf pounding on to Porthmeor beach was a favourite subject for Bradshaw and he was very adept at capturing its power and majesty (see, for example, Plate 29). A reviewer at Show Day in 1935 commented:-

"One of the outstanding pictures of the day is *Surf Bathing*, by G.F.Bradshaw. The point of the picture is, of course, not so much the bathing as the tremendous roll of waters on Porthmeor. Foam, white foam; roller, after roller; green water nowhere, except in the far distance. It is all there, even to the suggestion of the rumble of the sea. Can you hear it?" [17]

It is perhaps not surprising to learn that the Bradshaw household was an efficient one. When speaking to a reporter in 1939, Kathleen stated, "Artists are never supposed to get up early or to have meals on time. This is quite a mistaken idea. We are a very punctual household. My husband goes off to the studio about 9.30 a.m. every morning." [18] Bradshaw may have become an artist but he had not thrown off his Naval upbringing on matters such as punctuality and efficiency. Kathleen also admitted to being very domesticated. In fact, she was teased for being so houseproud.

Having people to tea was an accepted custom and, as likely as not, the Bradshaws would welcome new arrivals in the art colony by inviting them round for tea. As far as the Bradshaws were concerned, such invitations were demonstrations of proper social etiquette but, on his arrival in St Ives, Sven Berlin found the constant enquiries as to his background and artistic viewpoint rather more sinister. As he states in *The Dark Monarch*:-

"In cuckoo town [St Ives] everybody knew everybody: No-one could live in the town for more than a week without being gutted like a herring and spread out in the sun to dry and for all to see. But if you stayed a month, that would bring upon you the same fate as the great mucus-covered ray from the night fishing, with which the fishermen dealt on the promenade during the hours before lunch. One by one the still living monsters were first gaffed, held aloft in one hand, and with a few expert strokes of the knife, disembowelled and castrated in one act, leaving a kind of window through the body." [19]

In fact, Berlin, although young, unconventional and with modern leanings in his art, did not have any difficulty with Bradshaw. One day when Berlin was in St Ives, trying to sell some of his sketches for a pound each, Bradshaw stopped and looked through them. "Have you any in colour?" Bradshaw asked. "Not for a pound" replied Berlin. Bradshaw, keen to offer encouragement, bought one anyway. In addition, he would often pop in to Berlin's studio on the Island when he was out walking. On one occasion, Bradshaw admired a sculpture of a lion that

[16] Letter to the author 5/2/1994
[17] S.I.T., 22/3/1935
[18] Unattributed article in 1939 amongst the family papers entitled *Artist Served His Apprenticeship - in the Navy*
[19] S.Berlin, *The Dark Monarch*, London, 1962, p.11. The extraordinary dexterity of the fishermen can be witnessed on the Barnes Brothers film on St Ives of the 1930s entitled *Gem of the Cornish Riviera*.

7.9 Gutting fish in the Harbour, c.1935 (Royal Institution of Cornwall, Truro)

7.10 Sven Berlin working on his sculpture of a lion (Estate D. Val Baker)

Berlin had carved. "Very good - said Bradshaw - but the tail is not quite right." "I know, I know - responded Berlin - I knocked the bloody thing off!"[20]

Having once settled in St Ives, the Bradshaws did not feel the need for foreign holidays or travel. The Commander had, of course, done a considerable amount of travelling during his time in the Navy but their finances meant that foreign travel was a luxury, which could not be contemplated. During her marriage to the Commander, Kathleen was not able to afford to return for a visit to her roots in Rhodesia, where her mother continued to live. Nevertheless, her mother and her sister and brother came to visit quite regularly. Her sister, Barbara, had also become based permanently in the United Kingdom, having studied fashion drawing in Edinburgh. She worked in London for Libertys and Harvey Nichols, but her flamboyant life-style did not endear her to the Commander, who maintained the Victorian attitudes of his upbringing. She eventually married Garnet Passe, a Harley Street ear, nose and throat surgeon. It was through Garnet Passe that Barbara Hepworth was able to effect her series of sketches in the operating theatre of the hospital. Kathleen recalled that these sketches, which are often on view at the Tate Gallery in St Ives, were, in fact, originally commissioned by Dettol. It was during a journey back to London, having visited the Bradshaws, that Garnet Passe suffered a severe haemorrhage and died.

George Bradshaw was, of course, a member of a large family and a number of his siblings visited from time to time - in particular, Robin, the doctor, who settled in Colchester, Margaret, who had become a missionary and Charlotte, who was a teacher. In 1923, when his mother died, the Bradshaws went up to Edinburgh for the funeral. They also visited Ireland in the early years of their marriage to see some of George's relatives, taking the cattle boat from Plymouth to Wexford, but Ireland did not hold happy memories. None of Bradshaw's many siblings remained there.

[20] Letter to Author 18/2/1994

EXPANDED HORIZONS

The success of the various exhibitions in provincial galleries, coupled with signs that the effects of the Depression were receding, boosted confidence amongst the artists and further challenges were sought. The increasing reputation of the colony had also attracted new talent from many quarters. Not only did a number of further artists settle in St Ives to benefit from the artistic environment - a move which appeared to boost many a career - , but also visitors, whether regular or occasional, began to take up membership.[1] In fact, any artist with a Cornish connection was either encouraged to participate or found it served his best interests to do so. Old students of Olsson or Forbes, now members of London Societies, suddenly remembered the haunts of their youth and leading members of the St Ives fraternity clearly set out to persuade fellow prominent members of other major societies of the merit of becoming involved.[2] The increase in the numbers of initials, such as RE, RI, ROI, RBA, SWA, after members' names was noticed with pride and satisfaction.

With the quality of the membership ever on the rise, the 1930s was a period of high profile and high achievement. The St Ives Society of Artists became well-known and well-respected throughout the country and regularly seventy or more works by members were selected for the annual Royal Academy Exhibition. There was little need to search for new venues for shows. The difficulty now was satisfying all the requests received, as word of the popularity of their exhibitions spread between curators.

1933 saw the only change in the principal officers of the Society in the period 1928-1940, when Alfred Cochrane was forced to resign as Secretary through ill-health. In thanks for all his efforts on behalf of the Society, he was asked to select a work from the current exhibition. Although Bradshaw had stood in as Secretary during Cochrane's, sometimes lengthy, absences, the post was offered to Fred Bottomley, a Slade-trained artist who had become a member in 1929 and who exhibited landscapes and still life as well as his more well-known views of St Ives. He, however, declined it and, as no-one seemed very keen, Smart agreed to take it on. He was to hold the post for the rest of his life.

For Show Day in 1933, Bradshaw included amongst his exhibits *Zennor, Church Town* which had won such favourable reviews the previous year, in the hope of success at the Royal Academy. All three works shown were highly regarded, the reviewer commenting:-

> "G.F.Bradshaw's marine paintings are in a class of their own. He not only knows intimately the moods of the sea, but he knows his ships as well. His *Off Malta* (Plate 9) embodies the depth and volume of a Mediterranean sea; and the lateen-rigged Gozo ships suggest actual movement and a tinge of romance. His *Fishermen* is a welcome picture of a typical Cornish cove, with all the wonderful transparency of the cove-water on a sunny day. Lastly, *Zennor, Church Town*; - if this is not actually remarkable, it is surprising.

[1] Artists falling into the former category include Bernard Ninnes, Fred Bottomley, Thomas Maidment and Amy and Millar Watt. In the latter category can be included Dorothea Sharp, Marcella Smith and Leonard Richmond

[2] Former students include the marine artists Arthur Burgess, Charles Bryant, Will Ashton and William Parkyn. The St Ives connections of artists such as F.S.Beaumont RI, John Littlejohns RI, Hely Smith RBC, Bernard Fleetwood-Walker RBA and Constance Bradshaw ROI RBA (no relation) are not known. Bradshaw is likely to have become involved as she succeeded Helen Stuart Weir as acting President of SWA. Laura Knight was President of SWA but, due to other commitments, a succession of acting Presidents were provided, all of whom were members of SISA - Dorothea Sharp, Weir and then Bradshaw. Knight herself became a member of SISA in 1936. Some of the female artists in the colony who did not exhibit regularly with other societies - such as Mary Grylls, Helen Seddon and Frances Ewan - did occasionally have a work hung by SWA, confirming a close link between the two societies. The connections between SISA and RE, leading to the recruitment of Lee, Ray-Jones and Daphne Lindner, have been referred to earlier. Later many of the founder members of SMA were persuaded to join SISA.

8.1 Fred Bottomley *Fore Street, St Ives* (W.H.Lane & Son)

More than that, it is welcome. It is landscape painting from a marine painter - and it is full of charm. The little village beside the church, encircled by fields, is painted in its unique quietude. And the heart grows tender to look at it." [3]

In fact, it was Bradshaw's tempera picture of *Fishermen*, retitled *The Lobster Fishers*, which was selected for the Royal Academy. The fishermen's motor gig, with its small red steadying sail at the rear, is surrounded by gulls, as it enters a cove, but the principal feature is the deep green water, dappled with myriad reflections of the sun's rays. Bradshaw depicted the activities of the lobster fishermen as they checked and baited their pots on a number of occasions. He loved going out with local fishermen and, as the lobster fishers often set their pots in small, isolated coves, he was able to visit parts of the coast not easily accessible by foot and to view the impressive cliff formations from the sea. The scene in *Hauling Pots in Rough Weather* (Plate 23), in fact, looks positively dangerous, as cliffs loom behind the boat as it faces into a rough swell. Such a scene would have been played out before him repeatedly (see also Plate 15) and, in addition to any artistic considerations, he would no doubt have admired the seamanship and shared the exhilaration of the wind and spray beating into his face. He always took his sketch-book with him and a number of works entitled *In St Ives Bay* (see, for example, Plate 31 and fig 0.1) will have been inspired by incidents witnessed on these fishing trips, as a variety of craft criss-crossed the Bay on their various missions.

[3] St Ives Times ("S.I.T."), 17/3/1933

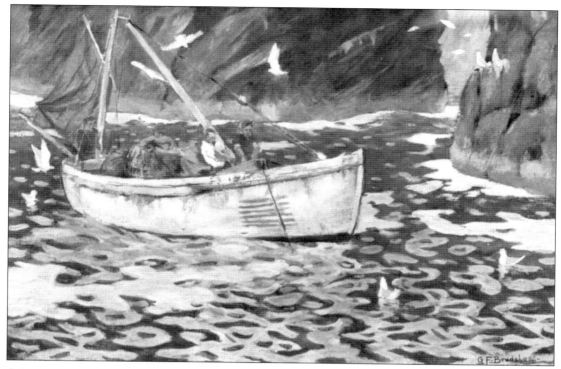

8.2 Lobster Fishing in 'Our Girls' (Watercolour)

The boat featured in many of Bradshaw's paintings of lobster fishing is *Our Girls* - ss 131. This typical St Ives motor gig, built in 1921 by Tommy Thomas in the boatbuilder's shop on the Wharf (see Plate 11 and fig 6.6), belonged to Job Boase, with whom Bradshaw was very friendly. She was only the second St Ives gig to be fitted with a wheelhouse, in 1932, and Bradshaw depicts her both with and without this feature (cp. Plate 23 and fig 8.2). Although equipped with a fore mast, this was rarely used and was often lowered down. The small sail at the rear was used for steadying the boat whilst fishing. Job Boase was a tall, broad man, and a successful fisherman. He invested his profits in property in the town and also ran a café on the harbour. Being confident in his seamanship, he was prepared to go out in his boat in the wildest of weathers and to fish in areas close to treacherous rocks, given a wide berth by other skippers. On one occasion in May 1929, however, he was caught in a gale near Godrevy and had to be escorted back by the old sailing life-boat, *James Stevens No.10*, which, prior to its replacement in 1933, had done valiant service for 33 years, during which time it had saved over 300 lives.

8.3 Our Girls landing herring (Studio St Ives)
Job Boase is standing by the cart with a cigarette in his mouth.

The new lifeboat, called the *Caroline Parsons*, - being named after the lady through whose generosity she came into being - arrived a week after Show Day. She encountered weather on her trip from the shipbuilders at Cowes in the Isle of Wight that tested her severely, as she was required to sail into the teeth of a 70mph gale, with wave after wave breaking over her. When she was eventually sighted off Clodgy, welcoming rockets were fired and crowds rushed down to see the gallant craft battle round the pierhead and come alongside Smeaton's Pier, where her crew were greeted with rounds of cheering. However, she was only destined to survive for five years.

At the same time as Show Day, the St Ives artists were also contributing to a private exhibition at Barbizon House, in Cavendish Square devoted to the work of Cornish artists. There were seventy-two works in all and the exhibitors included eight members of the Royal Academy with Cornish associations. The outstanding work in the show was considered to be Arnesby Brown's "exquisitely tender green and silver landscape" *The Valley*. Adrian Stokes also contributed a landscape from his French travels, *A Shadowed Stream in the Dauphiné* - "a real gem of light and atmosphere" - which was to grace several of the Society's shows. Lindner reverted to his 1928 Royal Academy exhibit *The Setting Sun, Amsterdam* and Smart was complimented both on his watercolour drawing *Low Tide, St Ives* and his "brilliant little oil painting" *The Pilots of St Ives*.

Bradshaw had three works included, an oil and two tempera paintings.[4] The exhibition was the first exhibition of works exclusively by St Ives artists held in London and received excellent reviews. Frank Rutter writing in the *Sunday Times* commented:-

> "One of the charms of this collection is its unpretentiousness, each exhibitor being more concerned in depicting the beauty of the things seen than displaying his own virtuosity."[5]

In June 1933, Bradshaw wrote to the local paper, airing a particular concern of his:-

> "There appears to be a growing habit in St Ives of asking professional artists to exhibit their works on loan in hotels, shops etc without payment to the artist. The usual inducement being 'such crowds of people come into our establishment, it will be such a good advertisement for you. We will do our best to sell your works.'

> This practice seems to be confined almost entirely to artists. I find no trace of furniture makers, china merchants, carpet manufacturers or even house builders exhibiting their wares under these conditions.

> To me this amateur art dealing appears to be extremely unfair to legitimate art dealers and to those enterprising people who have purchased pictures, or commissioned artists to decorate their premises. In practice too, I believe that pictures have been known to remain on loan for years without any sale or payment to the artist for the loan of the work.

> It would be interesting to obtain the views of professional artists on:-

> 1. the percentage of sales which take place under these conditions and

> 2. whether they consider it in keeping with the etiquette of their occupation to encourage the exhibition of pictures on loan to other than professional art dealers in art galleries."[6]

Borlase Smart was quick to back Bradshaw and responded by confirming that he considered the practice 'unprofessional and undignified, especially where an artist is a member of a Society

[4] The names of the works shown by Bradshaw are not known. Other artists involved include Forbes (*Roseworthy, Cornwall*), Birch (*Trewoofe Mill, Lamorna* and *Spring at Lamorna*), Talmage (*Suffolk Marshes*), Lee (*The House with Closed Shutters*), Williams (*Boats, St Ives*), Nixon (*Peasants Resting*) and A.Burgess, C.Bryant, L.Richmond, Park, R.M.Hughes, McCrossan, Turvey, Armstrong, Ninnes, Bottomley, N.Hartley, P.des Ballance, Mildred Turner-Copperman and F.Roskruge.
[5] Reproduced in S.I.T., 24/3/1933
[6] S.I.T., 2/6/1933

11. Bernard Ninnes *The Boatbuilder's Shop, St Ives* (1934)

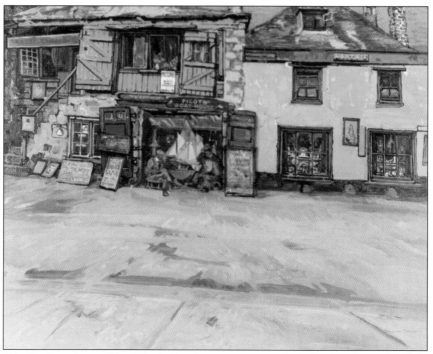

12. Borlase Smart *The Pilot's Boathouse* Laity's shop is on the right
(both plates reproduced courtesy of Leamington Spa Art Gallery & Museum, Warwick District Council)

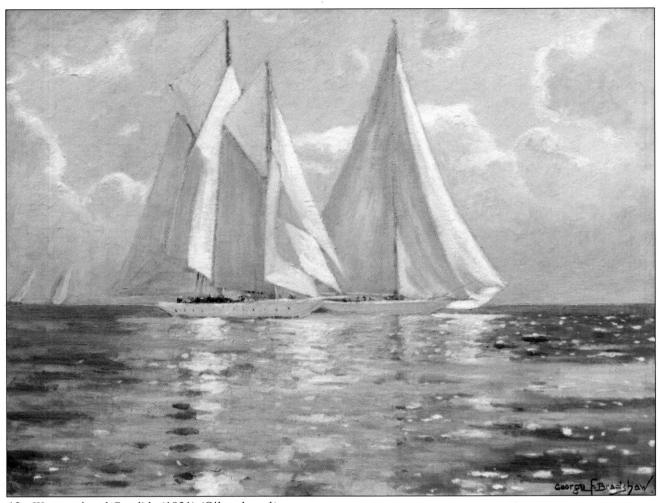

13. *Westward and Candida* (1931) (Oil on board*)*

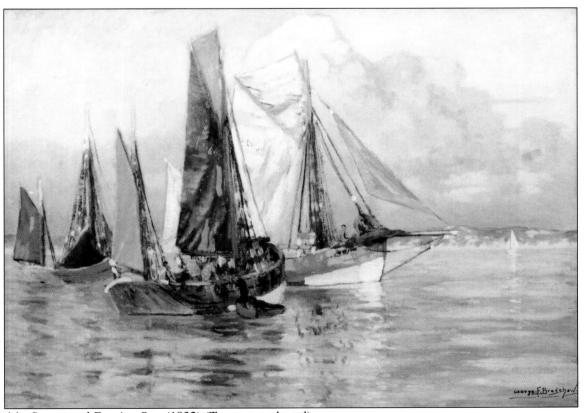

14. *Sunset and Evening Star* (1932) (Tempera on board)

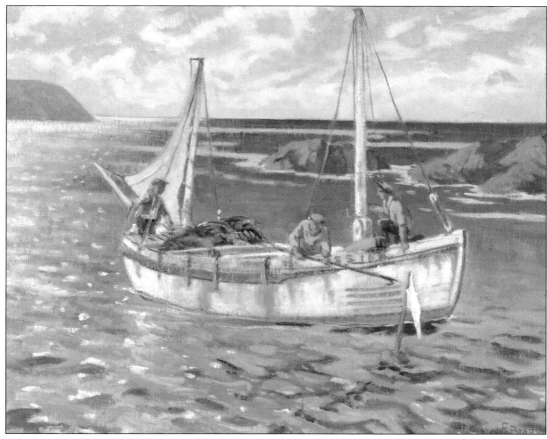

15. *Lobster Fishing* (Oil on canvas) (Sunderland Museum and Art Gallery)

16. *Rolling Home* (1937) (Oil on board) (Bearnes, Exeter)

17. *Bosigran Castle* (1936) (Oil on board)

18. *Jones' Travelling Amusements* (1929) (Oil on board)

THE ST. IVES SOCIETY OF ARTISTS

PORTHMEOR GALLERIES, ST. IVES, CORNWALL

8.4 The heading on the Society's notepaper from the mid-to-late 1930s

whose very existence depends upon the sale of pictures at its own exhibitions. The loans to hotels constituted an unfair competition to such societies, and that is why the Committee of St Ives Society of Artists has refused to recognise such requests in the past." [7]

The educational role of the Society was not forgotten. Job Nixon gave a talk on *The History of Drypoint and Etching*, while Herbert Truman contributed a series of articles to the local paper containing advice to the student of painting. Olsson, a former art teacher himself, commented that he had never read more instructive or sound advice.[8] In the following year, Robert Sielle, the London framer spoke on *The History of Frames and their proper Application to Pictures*.

The Society's own shows in the Porthmeor Galleries continued to be successful. The Summer Exhibition contained the massive number of 232 works, all hung in eight hours. Again, a work by Brown - *The Coming Harvest* - won some of the highest praise, but the exhibition also contained the first fruits of the Majorcan trips undertaken independently by Park and Ninnes. Wormleighton considers Park's trip to be a turning-point in his career leading him to be "fired again by colour" and to adopt a freer hand in his compositions.[9] Opulent colour was also one of the most noted features of Ninnes' Majorcan works over the next few years, a period during which Ninnes enjoyed as much success as any of the St Ives resident artists.

The Winter Exhibition was once more considered to be the finest exhibition that the Society had put on. The outstanding work on this occasion was again judged to be by the hand of a Royal Academician, namely Olsson's vast canvas, *Approaching Gale*. "The subject demanded the outlet of a big vision and a big space for its translation....and Mr Olsson has convinced us in terms of strength, colour and form that such an effect could be painted in no other way than the one he has taken. It is one of his finest works in his finest style." [10] It was now noticeable, however, that the Society's success was enticing new recruits of distinction. From the Lamorna circle, Stanley Gardiner, Frank Gascoigne Heath, Eleanor Hughes, recently elected to the R.I., and her husband, Robert, all began to exhibit regularly and the bold work of Richard Weatherby, another friend of Lamorna Birch, was also attracting attention. Dorothea Sharp and Marcella Smith, regular visitors to St Ives for some years, now joined the Society, as did the well-known artist and art critic, Leonard Richmond, who began contributing works in his broad style to the Society's shows. Furthermore, a number of local artists had made great strides forward. For instance, Mary

[8] S.I.T., 19 & 26/5/1933
[7] S.I.T., 9/6/1933
[9] A.Wormleighton, *Morning Tide*, Stockbridge, 1998, at p.65
[10] S.I.T., 24/11/1933

8.5 Mary McCrossan *Brixham* (1933) (Sims Gallery)
One of a series of Brixham scenes shown in 1934, the year she died

Williams' *Melody*, a study of a girl holding a Cairn terrier, had been signalled out for especial praise at the Royal Academy that year. The initial fears about lack of quality amongst the membership were now a distant memory.

The first exhibition of 1934 was a major exhibition at Oldham Art Gallery, then one of the principal provincial galleries in the country. In view of the many tourists that visited St Ives from the North of England, it was hoped that large numbers of visitors would be attracted to the exhibition and this proved correct, as a total of 9,741 people attended. To increase the interest of the exhibition, the Gallery also hung earlier work by several members from their permanent collection, including the very fine *The Drinking Place* by Stanhope Forbes, *Moonrise, St Ives Bay* by Olsson, *The Serpentine Quarry, near Mullion* and two watercolours by Birch and works by Lindner, Terrick Williams and Eleanor Hughes. Bradshaw's exhibits were a large oil, simply entitled *Trawler*, a similar composition to *The Trawlers* (Plate 8), although not a sunset scene, and his successful Royal Academy exhibit of the previous year, *The Lobster Fishers*.

In late February, the exhibition moved on to the Atkinson Art Gallery in Southport. Other invitations were received from Harrogate Art Gallery for June and July and the Usher Art Gallery, Lincoln for September. For these, a separate show was put together, which featured an impressive 'black and white' section, comprising Hartley, Lee, Nixon, Ray-Jones, Garnier and Roskruge. Bradshaw's exhibits at Lincoln were *Zennor, Church Town*, *Porthmeor Beach* and *A Bridge over the Dart*, the latter suggesting that the Bradshaws had recently taken a trip up to Devon. In total, over 36,500 people viewed these shows - a phenomenal figure, and the policy of mounting provincial exhibitions was clearly working, as payments made to artists doubled those in the previous year.

1934 saw the publication of Borlase Smart's book on *The Technique of Seascape Painting,* aimed at both working artists and students. It was a work that was well-received and went through several reprints. In his preliminary comments, Smart is keen to draw a distinction between "real sea painters", who confine their works to sea and coast, and marine artists, who introduce incidents of shipping or of figure. He bemoans the lack of true seascape painters in British art

8.6 Borlase Smart *Ebb Tide on the Reef* (RA 1943) (Swindon Museum and Art Gallery)
Four of Smart's RA exhibits depicted this reef at Clodgy

history, singling out only the late Henry Moore and Julius Olsson. Marine painting he considered to be a lesser art:-

> "When a seascape picture calls for the addition of incident to make up for its apparent emptiness, it proves there has not been enough convincing sea interest in the work. It is lacking in observation, colour, form, composition, and the study of sea phenomena necessary to its completeness." [11]

Bradshaw, in whose work incidents of shipping played a key role, cannot have taken kindly to such comments and there were probably a number of other marine artists whose feathers were ruffled by such a generalisation. Smart, in his own work, seeks to convey the impression of the surging power of the sea as it swirls and eddies around rocks, and his cliffs, painted with broad, thick brushstrokes, have grandeur. He commented, "The sea and coast is at all times dignified and big in spaces" [12] and, accordingly, he tended to portray the larger patterns formed by water and rock rather than intricate details and he was much more bold and free in his handling of paint than Bradshaw. Nevertheless, his works can lack a powerful focal point, which the inclusion of some incident of figure or shipping may well have provided. Another difficulty for seascape painters is to avoid monotony when the subject matter comprises only sea, sky and rock. Even a well-respected artist, like Olsson, is not immune to such criticism and, furthermore, on occasion, in order to add romantic or dramatic effect, he exaggerated effects of sunset or moonlight, resulting in one critic calling his paintings 'Neapolitan ices'. [13] Nevertheless, for any painter interested in the depiction of water and rock, Smart's book was full of practical tips and interesting observations, which Bradshaw would have appreciated. Smart, in fact, while composing the book, may well have discussed some of his ideas and techniques with Bradshaw - who would there have been more appropriate to turn to than a good friend and a fellow specialist?

[11] B.Smart, *The Technique of Seascape Painting*, London, 1934, p.1
[12] B.Smart, *op. cit.*, p.2
[13] T.Cross, *The Shining Sands*, Tiverton, 1994, p.142

8.7 Herbert Truman *Gorsedd 1933, Roche* (Royal Institution of Cornwall, Truro)
The painting shows the first Grand Bard, Henry Jenner, presiding for the last time at this assembly of old Cornish Societies, which took place at Roche Rock.
The Sword Bearer is George Sloggett, who donated the painting to the Museum.
Truman reworked the picture during 1934 and re-exhibited it on Show Day 1935.

A small contretemps occurred immediately prior to the A.G.M. in January 1934. Bradshaw and Job Nixon had put forward a proposal, "that the Committee shall have power to reserve a wall for 'one man shows' at exhibitions in the Porthmeor Gallery." [14] This prompted Herbert Truman to write to the *St Ives Times* prior to the meeting:-

> "May I trespass on your valuable space to examine and make suggestions on this proposal? My reason for so doing is to give more time for careful consideration. One also has difficulty in collecting one's thoughts and placing them lucidly before a meeting.
>
> 1. The Committee recently decided to reduce the number of works submitted to exhibitions from four to two, owing to the large number of pictures sent in. If a wall is now put at the disposal of a single individual, this will further restrict the hanging space allowed to the rest of the members.
>
> 2. In addition to the Society supplying wall space, the money for catalogues, advertising and general expenses will also have to be provided from the funds.
>
> 3. The Porthmeor Gallery is a shop window, in which St Ives Artists are allowed to display four pictures a year, for which privilege they pay one guinea. It seems hardly fair that one member should be represented by a whole wall, for the same subscription.
>
> 4. There are about 100 artist members and the Society holds 2 exhibitions a year. If members are allotted a wall in rotation at each exhibition, it will take fifty years to work through the whole of the membership. Of course, if exhibitions are upset by a series of 'one man shows', the number of years will be reduced in ratio. Those members who are allotted the summer months will have the greatest advantage in sales.
>
> 5. The question of the situation of studios should be considered. The members having the advantage of well-placarded studios near the Porthmeor Gallery, in which they are

[14] Borlase Smart had held a one-man show in the Porthmeor Gallery in October 1930 - S.I.T., 23/1/1931

holding a 'one man show' will be able to reap a better harvest than other artists not so fortunately situated. It will also create a bias in favour of such members, at the expense of the rest of the Society.

6. Most studios in St Ives already display a 'one man show' and are open to visitors. The St Ives Society of Artists provide a representative collection of pictures chosen from the arts colony as a whole. It seems incongruous to now wedge a 'one man show' into the Porthmeor Gallery, the reputation of which the members have worked hard over a series of years to build up as the headquarters of the Society.

7. May I suggest, that if the Committee are anxious to give a 'leg up' to any individual members, and should the funds allow, that they apply to Messrs James Lanham Limited, who are willing to supply a whole room for the purpose of the 'one man show'." [15]

The publication of this letter resulted in a flock of letters of protest being sent in to the Editor. Bradshaw clearly took objection to the suggestion that he might gain unfair advantage by virtue of his studio being located next to the Society's own Galleries and wrote a strong letter denying that he had ever adopted any means of advertising himself at the expense of the Porthmeor Gallery, or in a manner derogatory to the etiquette of artists in St Ives. The reference to the possible benefit accruing to adjoining studios is the weakest point made by Truman and, as mentioned before, may suggest that he was upset that Bradshaw had been offered 3, Porthmeor Studios. Certainly, Kathleen recalled Truman as being very "prickly". After some consultation, the Editor decided merely to publish the letter received from Olsson, which stated that the proper place to discuss how the Society should be managed was at its meetings, and not in the Press.

Truman may not have acted in the proper fashion but his logic was unassailable and the proposal for 'one man shows' was not successful. However, a further proposal of Job Nixon - this time seconded by Truman -, that a sum of money be set aside each year for the purchase of up-to-date books on art for the Society's reference library, was passed, with £10 being allocated initially for this purpose.

This period in Bradshaw's life seems to have been happy and fulfilling. He had become a significant figure in the art colony. In reviews of exhibitions, his works are invariably some of the first to be singled out for laudatory comment and he was often successful at the Royal Academy.[16] Of more practical relevance, he enjoyed an encouraging level of sales. In addition, he was making a name for himself as an interior decorator, with original ideas. Cinemas, hotels, cafés and, even, churches were being decorated with his designs.[17]

With the Society of Artists having expanded its horizons, Bradshaw's organisational abilities were greatly appreciated and he served on the Committee most years during the 1930s. For each of the provincial exhibition tours, works had to be handed in by the artists, selections made, and the successful exhibits labelled, catalogued and packed ready for transportation. Bradshaw will have played his part in all these processes, as well as in the selection and hanging of the local exhibitions. Clearly, his judgement on artistic matters was respected by the other leading artists.

Photographs show that he thickened out considerably in the 1930s and his big physical stature enhanced the aura that his military bearing and booming voice afforded him. Like many of his fellows, he dressed, seemingly perpetually, in thorn-proof tweeds and always wore a jacket. A flat cap often concealed his thinning hair. His principal recreations were sea-fishing and shooting, an activity popular with many of the artists, and Kay and he enjoyed walking and playing tennis. He remained very much in love with his radiant, young wife and they had an enjoyable social life with friends both within and outside the artists' circle. Kay's vitality made her popular wherever she went. Perhaps all that was missing was the patter of tiny feet.

[15] S.I.T., 19/1/1934
[16] In the fifteen years between the date of his first exhibit, 1923 and 1938, Bradshaw was successful at the Royal Academy ten times.
[17] See Chapter 11

8.8 Thomas Maidment *Old Houses, St Ives* (RA 1935) (Williamson Art Gallery & Museum, Birkenhead)

THE ARTISTS AND THE TOWN

Having experienced artists sketching in their midst for nigh on fifty years, the local people had come to accept that they were good for business, if sometimes eccentric in their ways. The artists needed not only places to live but studios in which to work, thus enabling many a run-down sail-loft or pilchard cellar to bring in some rent. Painting supplies were, of course, in perpetual demand and local tradesmen learnt to cater for all the artists' many other requirements, however odd. What was much more significant, however, was the tourist trade that they encouraged. The publicity that the artists gave to St Ives through their pictures, posters and postcards opened up the town to a new category of visitor, who was able to take advantage of a better train service. The impact that such visitors had on the town was, however, not all positive, as more quaint old properties were converted to cafés and guest-houses, and shops began to stock typical tourist paraphernalia. It was a situation that the artists could never quite resolve in their minds. On the one hand, they were proud that their efforts had had such an impact on the local economy, but on the other, they bitterly resented the disappearance of favoured old haunts. As a result, the artists and the Town Council, who were quite properly also concerned about public health in some of the less salubrious places in the town, fell out on a number of occasions.

In his opening address at the Spring Exhibition of the Society of Artists in 1930, Terrick Williams recalled his first visits to St Ives in the 1890s and regretted some of the changes that had occurred in St Ives since that time:-

> "In those early days, cows grazed on the meadows which adjoined the beaches, but now horrible things including bungalows have replaced them. It is a disappointing thing that haunts discovered by artists are soon spoilt. Artists advertise the place too much and people flock there and build bungalows." [1]

Charles Proctor took up the theme, decrying how putting greens and rock gardens had taken the place of seine boats and that the Quay and the Wharf at times looked like an untidy garage:-

> "An artist discovers a beauty spot, paints it, exhibits his pictures of it, and talks about his discovery to fellow artists, with the result that more, and still more, artists visit the place and portray its charms, more and still more pictures of the place appear on the walls of the Academy and other Exhibitions, and as a result the tourists, first [as] single spies and then in battalions, begin to arrive. And within a few years the place has changed from an old world town into a popular holiday resort, tumble-down sail-lofts have become studios, garages, and cafés, and the price of everything has gone up, and up, and up." [2]

Moffat Lindner was a frequent critic of inappropriate change. In his inaugural piece for *Art Notes* in 1933, he merely made a plea that the beautiful silvery-grey tone of the town should be preserved. "It is restful to the eye, and harmonious. The staring red roofs and any positive colours are quite out of keeping with the rest, and spoil the general effect, and it would be a great pity if its character should be changed in any way." [3] Later in 1937, when one householder had painted his property blue, he took issue with Borlase Smart over the appropriateness of such a colour in the townscape. Many agreed with him, including the artists Hugh Gresty, Marjorie Ballance and Shearer Armstrong, but Smart, perhaps reflecting a shift in his artistic outlook, was unabashed:-

[1] St.Ives Times ("S.I.T."), 18/4/1930
[2] S.I.T., 18/4/1930
[3] S.I.T., 12/5/1933

> "What we want is the happiness of colour; we have been too long walking about in blacks and greys, and living in colourless surroundings." [4]

During the 1930s, there were a number of occasions when proposals by the Town Council for so-called 'improvements' to the town led to howls of outrage from the artistic community, who were concerned that the Town Council was spoiling the very features that made St Ives attractive to both tourists and artists alike. One such occasion was the proposal to construct a bus park near the Malakoff. This prompted the whole Committee of the Society of Artists to affix their names to an open letter to the Town Council in the following terms:-

> "The members of the St Ives Society of Artists view with grave concern the possible erection of a motor omnibus park near the Malakoff, at a point from which can be viewed the finest panorama of the Harbour and the picturesque old town, with an immediate foreground of the Warren forming a perfect setting. We beg you will use your utmost endeavours to preserve this site, situated as it is....at the entrance to our quaint town. The view from here is of especial interest to visitors, as it is comprehensive and appealing." [5]

A similar letter was written signed by Bradshaw in his capacity that year as President of St Ives Arts Club. The Malakoff was, of course, one of the prime sketching positions for the artists, as works by Richmond, Maidment (see fig 10.1), Stanley Spencer and many others attest, which no doubt ensured that concerted action was easier to secure than normal. They are careful to state, though, that it is the visitors' interests that they have in mind, not their own.

In April 1933, there was another tiff between the artists and the Council, which had installed Automatic Slot Machines on the Malakoff and Westcott's Quay, right outside the St Ives Arts Club. This brought letters of protest from the Society of Artists, the St Ives Chamber of Commerce and the Arts Club. Borlase Smart, who could be rather "peppery", also wrote in his own capacity, stating:-

> "Unless the Council see their way to remove this blot on the landscape, I shall reluctantly be compelled to withdraw my gift through the Chamber of Commerce of the Pictorial Map of St Ives, which I am completing as a reference for visitors to the town to be placed on the Malakoff. Professionally speaking, the juxtaposition of the slot machine with its blatant design and colouring will have a depreciating effect upon the character of the map and its setting, which I am endeavouring to make a work of art." [6]

Smart's ruffled feathers were sufficiently smoothed for him to continue with his map, which was well-received.

Nevertheless, occasional displays of hubris by the artists cannot have endeared them to Council officials. In 1933, Borlase Smart arranged for the Society to send a letter to the Town Council suggesting that two members of the Society be available to advise on new building plans so that the character of the old town be retained as far as possible.[7] No professional takes kindly to being told by an amateur that he is incapable of doing his job and the touchpaper was lit the following year in a row, which rumbled on for much of the rest of the decade. An enquiry had been held by the Ministry of Health into the plans of the Town Council for the demolition of a number of old properties in St Ives under their Five Year Slum Clearance Scheme. The Town Council took the view that many of the old cottages in the Down-a-long district were hovels and health hazards and that modern working men's houses should be built in their place. As Ship Studio was in Down-a-long, the Bradshaws were very perturbed by these proposals and, like many of the artists, were aghast that the picturesque old houses, which gave St Ives so much of its character, should be demolished. The artists, pulling together, lodged objections to the

[4] S.I.T., 18/7/1937
[5] S.I.T., 6/3/1931
[6] S.I.T., 28/4/1933
[7] Extract from Minutes held by the Society

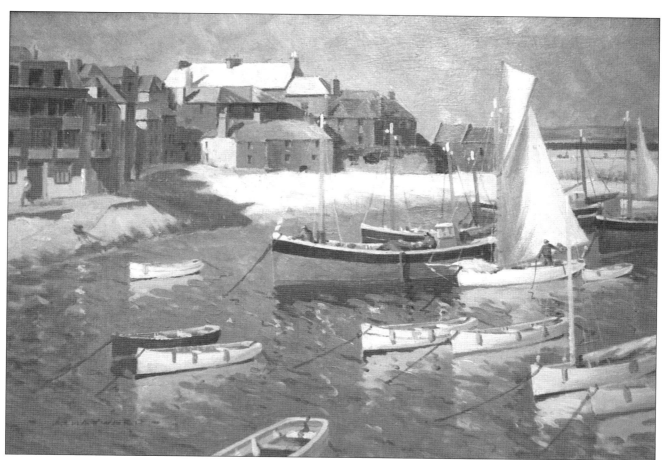

9.1 Arthur Hayward *Summer Evening, Harbour* (W.H.Lane & Son)
Frost and Reed prints of Hayward's harbour scenes were very popular

9.2 John Park *Down-a-long* (W.H.Lane & Son)

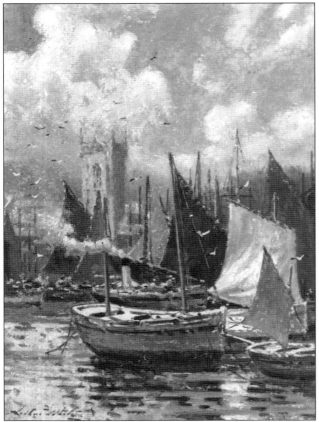

9.3 Arthur White *The Harbour, St Ives*　　(David Lay)　　9.4 Arthur White *Barnoon Hill, St Ives*　(W.H.Lane & Son)
White's views of the old town were well-known but he was late joining the Society

proposals, suggesting that the houses should be re-conditioned rather than pulled down, and they then arranged for the Royal Institute of British Architects to give free advice on this question.

In talking to the *News Chronicle*, the Town Clerk stated:-

> "It is to be hoped that the Council will never have to choose between attracting artists and trippers, and the health of the working class people of St Ives." [8]

The equation of 'artists' with 'trippers' rankled with Borlase Smart, who wrote to the *St Ives Times* with strong words:-

> "I should like to point to him [the Town Clerk] that unlike the 'tripper', the artists are a permanent institution throughout the whole year...This cunning simile between artists and trippers is calculated bluff of the 'red herring' type. St Ives always will have its trippers, but if, through the demolition of the old town, St Ives attracts less of that monied type of visitor who is fascinated by its quaint characteristics, then the 'Slum Clearance' scheme will bring a reaction that will jar this town very considerably as time passes.
>
> The art colony has advertised this town for the last fifty years throughout the world and by comparison with which the propaganda of the Publicity Committee of the Council and the Chamber of Commerce is a mere pin-prick, and such a half-century of endeavour has not cost the town one penny." [9]

This letter provoked an extraordinary attack on the artists by Councillor Sullivan, the Chairman of the Public Health Committee:-

[8] S.I.T., 7/9/1934
[9] S.I.T., 7/9/1934

"I should like to say something, if I may, in reply to these scurrilous letters which have been sent to the local papers and to others regarding the Council's proposed Slum Clearance Scheme for Down-a-long. It is true that the Assistant Sanitary Inspector has inspected 300 houses, but it is no more true to say that the whole of these are condemned, than it is to say that all pictures by artists inspected at the Royal Academy each year are condemned. What is the exact position?

The Inspector suggests that only 46 of the total should be dealt with under Slum Clearance in five years, less than an average of ten per year. There are 95 which are suggested to be dealt with under Section 19, only 57 of which are actually in the five year scheme.

Under this section, full opportunity will be given to the owners to place before the Council their wishes and suggestions with regard to the properties concerned, and to prove that these properties can be made reasonably fit for human habitation. This is the mare's nest that Captain Smart and his friends have discovered. This scheme works out at somewhere between 20 and 30 houses to be built each year, surely not a very ambitious programme, and not one that is calculated to arouse disquiet in any reasonable mind. But these Don Quixotes who tilt at windmills, these Oswald Moseleys in miniature, are not concerned with facts. They are not concerned as to how a large number of their fellow citizens live. In their prejudiced class-conscious minds, anything is good enough for the working man. Let them keep their hovels, they say, so that we can come down now and then from our £1,000 mansions and paint the outsides of these dwellings.

We do not desire to paint the interiors, say they. We do not wish to paint the leaky roofs, the crumbling walls, the uneven walls, the non-ventilated bedrooms, in which five or six or seven fellow human beings toss every night in uneasy slumber. We shall not paint a picture of that woman creeping out stealthily in the dead of night to throw an accumulation of filth on the nearest beach, because she has not even a closet in which she can dispose of it. And so in order to please these so-called artists, this Council must refuse to carry out the behests of the Ministry of Health. It must refuse to re-house these people in decent homes, at a cost of something less than half a crown a week, and it must condemn fellow creatures to live under conditions which they themselves would not consider fit for a dog or a cat to live in.

I am glad, however, to be able to report that the Ministry has upheld in its entirety the action recently taken by the Council, as I am sure they will uphold, in the future, any action this Council in its wisdom may wish to take. For the Ministry realises that despite what a few non-entities may think of us, in the main, we are neither knaves nor fools, and can be trusted safely to look after all the amenities and at the same time do justice to those who are not so well-housed as ourselves." [10]

As can be imagined, this attack by Councillor Sullivan caused absolute furore, the artists taking none too kindly to being referred to as 'non-entities' and 'so-called artists' apart from being judged to be prejudiced and class-conscious. Ship Studio was certainly not a £1,000 house situated a safe distance away on the hill, but a meagre dwelling in the very district under discussion. Councillor Sullivan was eventually forced to apologise but the saga continued for a number of years, like a running sore, and many of the old houses were eventually demolished. The artists' actions had, however, caused the refurbishment option to be considered more readily.

One of the important points that emerges from these exchanges is the impact that the traditional artists were aware that they were having on tourism. There can be no doubt that the popularity of St Ives as a holiday resort was significantly increased as a result of the paintings of this group of traditionalist artists. Not only were special trains laid on for artistic highlights, such as Show Days,

[10] S.I.T., 29/9/1934

9.5 Herbert Truman *Old St Ives* (Plymouth City Museum and Art Gallery)
This painting was exhibited at the Royal Academy in 1933 and was also included in Truman's one-man show at Plymouth City Museum and Art Gallery in 1935. The curator, A.J.Caddie, who was retiring after nine years in the post, rated the picture so highly that he purchased it himself and then immediately presented it to the Museum.

but representations of the Cornish coast, sandy beaches, quaint cottages, attractive harbours and colourful boats on Gallery walls around the country tempted more and more people to take their holidays in Cornwall. Knowing the fondness of northerners for Cornwall, the Society of Artists ensured that their touring shows circulated northern towns - and they were not disappointed. More visitors to their shows resulted in more sales and more publicity for the town.

Following the success of Norman Wilkinson's idea of railway posters designed by Royal Academicians, the Great Western Railway commissioned Smart, Truman, Richmond and others to design posters advertising the attractions of Cornwall. Having arrived, visitors bought postcards of the town's attractions by Park, Truman and Richmond to send to their friends, so ensuring yet further publicity for both artist and town. The increasing popularity of the fine art print also had a significant impact. Dealers such as Frost and Reed were constantly on the look-out for paintings that would reproduce well as prints and artists like Hayward and Truman consciously produced works with cool pastel colours and hard edges to take advantage of this market. Truman had over sixty of his works made into colour prints.[11] Collecting, or even viewing original works of art, might still be the preserve of the middle and upper classes but posters, prints and postcards advertised the attractions of Cornwall far and wide to all and sundry. They were of immense importance to the prosperity of the town. With the continued inexorable decline of the fishing industry, St Ives became increasingly dependent on tourism. The artistic eye saw what made the town full of charm and how unnecessary changes to its character could prove fatal. The artists would not have been human, however, if an element of self-interest had not influenced their actions.

[11] S.I.T., 2/7/1937

CELEBRATIONS AND TRAGEDIES

May 1935 witnessed the celebrations of the King's Jubilee and a special effort was made by all the townspeople to commemorate the occasion in fitting style. The report in the *St Ives Times* highlights the patriotic fervour and respect for the Monarchy which existed at that time.

> " "Never in the whole history of St Ives has the town looked so lovely". This from one of many of the oldest inhabitants. But what would decorations mean without the loyal co-operation and spirit of homage behind their use, and without that peculiar pride one feels in seeing our Union Jack fluttering in the breeze. This pride, this co-operation, this universal endeavour to show our loyalty to our Sovereign and what he represents, has been manifested in amazing fashion in St Ives. Triumphal arches were erected in quick-time, and their characters reflected almost an inspired touch. The run on flags was phenomenal. Streamers and festoons spanned the streets, and in the twinkling of an eye, St Ives was transformed into a town glittering like a jewel. The very character of its architecture seemed to make the pageantry all the more beautiful. The individual greyness of its tone provided a perfect background to the decorations, and in no case was this more manifest than in the Digey, Bunkers Hill and Porthmeor Square and a bit of Chapel Street. The eagerness of those to whom flags and bunting was a difficult matter to obtain vied with one another in home-made paper decorations. The Malakoff with its strip electric lighting of red, white and blue and festoons of flags was a beautiful sight. The cars of the townspeople and visitors gaily decorated with emblematical ribbons, and shops and house windows with portraits of our King and Queen were all eloquent testimonies to a prodigious wave of unbounded loyalty to King and Country. It was good to feel the aura of joyfulness and thanksgiving reaching from everyone and everything. In fact it was good to be alive in this Jubilee time." [1]

Bradshaw, who had fought for King and Country in the War, would no doubt have dusted off his Naval uniform for the service of thanksgiving and he would have been joined by the other artists who had done likewise, such as Borlase Smart and Francis Roskruge. There is no record of a special Jubilee exhibition being arranged by the artists, but the Jubilee attracted a number of people from the colonies to St Ives and significant extra picture sales resulted.[2] Painting sales in 1934 had been double those in 1933 and sales in 1935 more than doubled sales in 1934 - an indication that the Depression was well and truly over.[3]

On Show Day, it was noticed that, since the previous year, many artists had responded to the artistic environment in St Ives and "added to their stature". Ninnes' works were regarded as "proofs of increased strength in craftsmanship", the paintings of Thomas Maidment, with their clear-cut lines, figures and outlines, were noted for their originality of composition and Bradshaw's *Surf Bathing* was rated "one of the outstanding pictures of the day". After noting the distinctive treatment by Truman of the view from his cottage, Trezion, in *House Tops and Harbour*, the reviewer observes:-

> "Another painter of a distinctly individual style is Mrs Shearer Armstrong. Almost [always] she specializes in flowers or still life. She stages bold and, at times, crowded subjects; she uses a special medium that gives an air of solid reality; and then to cap it all,

[1] St.Ives Times (S.I.T.), 17/5/1935

[2] The Jubilee celebrations encouraged Oldham Art Gallery to restart its Spring Exhibitions and 21 works by Society members were included. There was a similar exhibition at Southport, again with a good representation from Society members.

[3] Sales were as follows: Winter £112 2s, Spring £106 7s 6d, Summer £338 5s, Polytechnic £29 6s, Harris & Sons £354 7s 6d - S.I.T. 7/2/1936

10.1 Thomas Maidment *The Old Harbour, St Ives* (RA 1937) (Manchester City Art Galleries)

10.2 Shearer Armstrong
Still Life with Staffordshire Figure (1927)

10.3 Sydney Lee *The House of Mystery*
(Cheltenham Museum and Art Gallery)

paints backgrounds of neighbouring landscape of the most picturesque delicacy. She occupies a special place among still life painters." [4]

Shearer Armstrong was successful at the Royal Academy most years during the 1930s and, on this occasion, *Decoration : Bamboo and Fruit*, was selected.

Frustratingly, there are no detailed reviews of the Society's Spring, Summer and Winter exhibitions for 1935. Perhaps because of commitments to the various Jubilee exhibitions organised around the country, no exhibitions were held during that year by the Society in provincial galleries but an extremely successful exhibition was held at Harris & Sons in Plymouth. There was also an exhibition of 170 works in Penzance organised by Smart in conjunction with the Royal Cornwall Polytechnic Society, which was opened by Viscount Clifden.

During the year, the artists made some improvements to the Porthmeor Galleries. The gallery in which oils were hung was re-decorated and electric light was installed in both galleries so that the hours during which visitors might view the exhibitions could be increased. Further talks given included a lecture by R.Morton Nance on *Fifteenth Century Shipping* and an account by Bernard Leach of his return visit to Japan.

At the 1936 A.G.M. of the Society, Bradshaw put forward a proposal, seconded by Bernard Ninnes, that there should be four exhibitions a year and that all members should receive a card indicating the receiving, opening and closing days of each Show. He considered that there were now enough members and enough good work that there would be no difficulty in holding four exhibitions a year and his proposal was carried unanimously. However, whether the artists were aware of quite what a punishing schedule of exhibitions was proposed for that year is unclear, for in addition to its own exhibitions, the Society ended up by having exhibitions in Hastings (3,506 visitors), Plymouth (Harris & Sons), Birmingham (64,000 visitors), Hereford (2,712 visitors) and Cheltenham (4,572 visitors). A separate show started at Eastbourne and then toured Lincoln and Blackpool before finishing in 1937 at Leamington.

The Birmingham exhibition contained 193 works and ran from 10th July to 29th August. The list of exhibitors contained the names of many stalwarts from the Society's inception - some, unfortunately, for the last time - , with a similar balance between Royal Academicians, Newlyners and St Ives residents, but new blood was evident, as artist members now totalled 118. Frank Brangwyn was a new honorary member from the ranks of the Royal Academicians. Although works by Adrian Stokes and Terrick Williams were included, Stokes had died the previous year and Williams was to do so before the year was out. Of the Newlyners, both Ernest Procter and Frank Heath were again shown for the last time. New talent was, however, emerging. The striking religious paintings of Annie Walke had recently attracted attention and she included *Men and Angels* and the much debated *Christ Mocked* (fig 10.4) in this exhibition.[5] Another artist from the Lamorna circle, who had made great strides forward, was R.C.Weatherby, who contributed his 1935 Royal Academy exhibit *The Chestnut Mare*. Nicknamed 'Seal', Richard Weatherby was a popular man, who was best known for his horse paintings and his portraits, executed in a bold style. One reviewer observed:-

"One can imagine that Mr Weatherby works at top speed, and with a definite touch and disciplined hand, he places each tone on the canvas with conviction and finality. His work certainly looks untouched and fresh, and the consequent luminosity is a feature of his art. Add to all this a bigness of style and the result is a dominant note of breadth which contributes character to the exhibition." [6]

[4] S.I.T., 22/3/1935
[5] When *Christ Mocked* was exhibited at the Spring Exhibition of the Society that year, the reviewer commented:- "It is painted by a reverent hand in an unexpected way: the mockery on the faces is very evident, but some would wish for a different presentment of the Christ." - S.I.T., 6/3/1936
[6] S.I.T., 16/10/1936

10.4 Annie Walke *Christ Mocked* (c.1935) (The Royal Institution of Cornwall, Truro)
This painting engendered so much interest that it was included not only in the Birmingham tour of 1936 but also in the Society's much later Exhibitions at Cardiff in 1947 and Swindon in 1949.

Lamorna Birch said of his friend, Weatherby, that "he has somehow given me a bigger outlook".[7]

Of the St Ives contingent, Mary McCrossan had died in 1934 and Meade was not represented, his contributions to the Society's exhibitions now tailing off. Park had moved in 1935 to Dedham, although he still contributed to this exhibition, as did Truman, who also appears to have moved - to Devon - at about this time.[8] Lindner, now in his eighties, contributed his 1930 Royal Academy exhibit *Fresh Breeze on the Maas* in the oil section and a series of typical watercolours, including the fine *Venice from the Lagoon* (Plate 3). Milner yet again showed a depiction of *Corfe Castle*, this time in watercolour, and his Royal Academy exhibit of 1933, *Westerly Seas*, a large

[7] In A.Wormleighton, *A Painter Laureate*, Bristol, 1995 at p.125. Portraits of Birch and his wife by Weatherby are illustrated on p.216.
[8] One of Park's exhibits, *May Pageantry,* was bought by Oldham Art Gallery the following year.

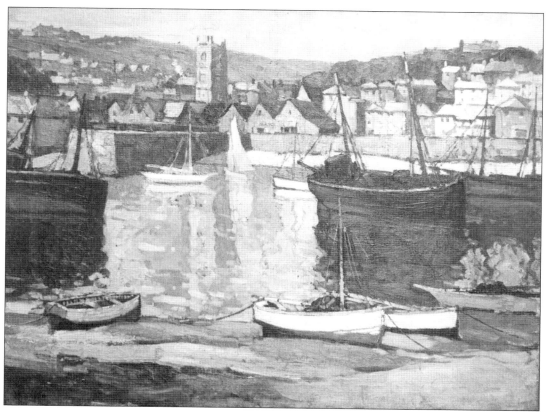

10.5 Leonard Richmond *The Harbour at St Ives* (Sims Gallery)

study of Atlantic waves breaking over a rocky foreshore.[9] *A June Morning* (Plate 6) was one of
the fruits of Lamorna Birch's many fishing trips to the Scottish Highlands. It depicts the River
Devoran at Rothiemay in Aberdeenshire. Leonard Richmond included *St Ives from the Malakoff*,
which had been one of the successes of the 1934 Royal Academy Exhibition and which had
adorned the cover of the prospectus for his Summer Painting School, which he had
established in St Ives the previous year. New arrivals included Millar and Amy Watt, Guy
Kortright, who had written and illustrated a lengthy series of articles on *Decorative Landscape
Painting* in *The Artist* in 1934, and John Barclay, a Scot, whose work was welcomed as modern
in spirit, yet still in touch with tradition. Another new member to make an immediate impression
was Bernard Fleetwood-Walker, whose figure studies had been a feature of recent Royal Academy
Exhibitions. Bradshaw's exhibits were three oils, *Inside the Long Ships*, one of his Show Day
exhibits, *Cruisers Manoeuvering*, his Royal Academy exhibit of the previous year and *Bosigran
Castle* (Plate 17), a striking and colourful view of the cliffs near Bosigran Mine, handled with
more breadth and vigour than usual.

The massive number of visitors (64,000) confirms that traditional painting well-executed was still
enormously popular. Eighty-nine works from the Birmingham Show were selected by Hereford
for an exhibition in October, during which Ninnes' *The Cafe Born, Palma* was bought for the
permanent collection, before the whole exhibition was reunited in Cheltenham in November.
Both Galleries acquired a copy of Sydney Lee's large aquatint etching *The House of Mystery*
(fig 10.3).

The Eastbourne exhibition was different in that it was not devoted solely to works by Society
members - paintings by Devon and other Cornish artists also being included -, and the works were
selected by A.F.Reeve Fowkes, the Curator of the Towner Art Gallery, on visits to the artists'
studios. Nevertheless, the Curator acknowledged his indebtedness to Borlase Smart, who had

[9] Seascape was not a new departure for Milner. Borlase Smart in an appreciation written after Milner's death in 1939, commented:-
"I remember in the early days seeing two six-footers of marine subjects on the line, which impressed my novice mind as the work of
master who knew his subject and who knew how to paint. What breadth and mastery." S.I.T., 10/39

recommended that he visit certain studios where good work was being produced, with the result that some pictures were transported to Eastbourne with their paint hardly dry. This collection was certainly not inferior in quality to the Birmingham show. Birch contributed two important works *Under the Bough, Lamorna* and *A Border Stream 'twixt Cornwall and Devon*. Olsson included one of his Royal Academy exhibits of the year, *Land's End and Longship Light*. Forbes sent *Roseworthy* and a depiction of *Sir Walter Raleigh's House, Mitchell* and there were major works from Frank Heath, Ernest Procter, Richard Weatherby and Harold Harvey. Moffat Lindner's most expensive exhibit was *Sleeping Waters, St Ives Bay*, a moonlight vision of St Ives harbour. When it had been exhibited at Show Day the previous year, the reviewer had observed, "The oil medium is so deftly used that the effect has the quality of a softer medium. And the blue, moon-tinted atmosphere is enchanting."[10] From Bradshaw's studio, Reeve Fowkes selected *Zennor, Church Town, Penzance* and his 1933 Royal Academy exhibit *The Lobster Fishers*, which was, in fact, the only painting illustrated with the article reviewing the Eastbourne exhibition. Walter Runciman, the St Ives MP, in opening this exhibition remarked:-

> "If you are proposing to buy any of these pictures, you should not delay. Not only may the pictures not be here, but the subjects as well. The sailing craft are rapidly becoming motorboats, the fishermen are being so well-dressed that you would not recognise the profession and we have a town planning scheme held over our heads at St Ives from which I hope we may have divine protection."[11]

Under the auspices of the London Art Exhibitions Bureau, the Eastbourne selection then toured the Municipal Art Galleries at Blackpool, Lincoln and Leamington, where the purchasing committee again plumped for a Ninnes work, his 1934 Royal Academy exhibit, *The Boatbuilder's Shop, St Ives* (Plate 11), to add to their permanent collection. This was painted in the old boat building workshop near the life-boat house on Wharf Road. Leamington Art Gallery also now own John Park's *Fringe of the Tide, St Ives* (Plate 19), an oil and a pastel of Mevagissy harbour by Terrick Williams (Plate 4) and Mary Duncan's *Whitesand Bay*, all purchased from the exhibition by Alderman Holt and later donated to the Gallery.

Despite all these commitments, sixty works by members of the Society were also included in the Royal West of England Academy Annual Exhibition in Bristol in November. The publicity gained by the Society during this momentous year must have been enormous and, as Borlase Smart pointed out at the following year's A.G.M., members' efforts were not restricted to the walls of Galleries. Commissions for posters, postcards, church decoration, stage and interior design were all coming the way of members due to the high profile that the Society now had. Bradshaw was one of the artists who received design commissions and, for Navy Week, held in Portsmouth at the beginning of August, he was asked to paint the scenic background for a naval display.[12] He also showed three naval oils in an art exhibition staged for Navy Week - these are likely to have included *Outposts*, a painting of a submarine battling through the seas, with an excellent sky effect, which he had also exhibited at Show Day earlier in the year. Attendance records were broken day after day during the course of the week, the highlight being the first appearance of the Fleet Air Arm in displays.

However, without doubt the main event for the Bradshaws during 1936, was the birth of their first child, Robert. Bradshaw was in his forty-ninth year when Robert was born - quite an age to be able to cope with the disruption to a household and to a relationship that a child can bring. Nevertheless, George and Kathleen were absolutely delighted and doted on their young son. In particular, they soon discovered that they had a compliant new model and both parents wasted little time in sketching the young Robert in various poses. In fact, a number of these sketches were exhibited on Show Day in 1937. Charles Proctor had assumed again the role of reviewer:-

[10] S.I.T., 22/3/1935
[11] News Chronicle, Eastbourne, 27/6/1936
[12] Bradshaw's interior designs are dealt with separately in Chapter 11.

10.6 Kathleen Bradshaw *Robert Asleep* (1937)

"Bradshaw is not yet in the 'veteran' class, in proof of which let me whisper that the exhibits which attracted the admiration of lady visitors to his studio are two tender portraits of The Baby. Yes, you guessed rightly, The Baby is Master Bradshaw....and his artist mother shows him soundly asleep and very much awake. Both studies have some of the qualities of the daintily delicate flower paintings which Kathleen Bradshaw has shown in past years." [13]

Her charming tempera study of *Robert Asleep* (fig 10.6) was accepted by the Royal Academy.[14]

The most novel work on display on Show Day was Bernard Ninnes' *At the Sign of the Sloop*, an irreverent caricature of a wide range of personalities caught on a busy Bank Holiday outside the 'Sloop'. Young and old, fat and thin - trippers, artists, fishermen, dog walkers, men in uniform and girls in shorts - all feature with the landlord taking centre stage as he doles out pints of beer through an open window. The artist no doubt included some barbs, whose significance is now lost, but the amusing and colourful panorama raised a chuckle from many lips.

Charles Proctor also reviewed George Bradshaw's works:-

[13] S.I.T., 19/3/1937

[14] The painting has a R.A.label on the back, although it is not included in the list of Kathleen's R.A. exhibits.

"Although G.F.Bradshaw's 'big' picture *Surface Patrol* (see Appendix 2) depicting a submarine in the wash and spume of an uneasy blue sea with an excellently handled red and gold brilliantly luminous sky, is very impressive, I liked best the smaller canvas which he has simply titled *Gulls*. Here are the stately grey gulls we know so well, wheeling, gliding, planing and screeching (yes, one can almost hear them screeching) over, around and above a St Ives fishing boat in a limpid sea."

It is likely that *Surface Patrol* was another painting exhibited by Bradshaw during Navy Week in Portsmouth the previous year and the reason for Bradshaw's return to Naval scenes was the fact that his old friend from his submarine days, Charles Allen, had been able to secure some commissions for him. In addition to the big canvasses, such as those exhibited at Navy Week or those aimed at the Royal Academy, Bradshaw also picked up commissions to depict individual naval vessels from officers who had served on them. A typical example is his depiction of *H.M.S.Whirlwind* (fig 10.7), a V/W class destroyer (*D30*), built in 1917 and sunk in 1940. Bradshaw retained a number of contacts in the Navy, but Charles Allen was more active in Naval organisations and is more likely to have made the initial recommendations. He, of course, had his own large collection of Bradshaw paintings to which reference could be made if stylistic criteria were relevant. Although Allen remained unmarried, he lived in Worcester with Sylvia, a woman of gypsy descent. The Bradshaws spent one Christmas at his home, 'The Rhydd', where Kathleen recalled Allen was rather proud of a pair of candlesticks that had once belonged to a mistress of Charles II. Allen, who was always immaculately turned out - white linen suit, white shoes and panama hat was a favourite outfit - was a regular visitor to the Bradshaws and became known to the family as 'Uncle Charles'.

Two of the new arrivals who soon became good friends of the Bradshaws were Millar Watt and his wife, Amy. Millar Watt, in the words of Charles Proctor, was "the black and white genius who created 'Pop', that delightfully comic figure whose face is practically devoid of features yet full

10.7 *H.M.S.Whirlwind* (Oil on board)

of expression, and who gives me a smile seven days a week in the *Daily Sketch* and the *Sunday Herald*."[15] Both Millar Watt and his wife were accomplished artists. Millar Watt specialized in landscapes and still life and was immediately elected on to the Committee. His wife also painted floral pictures but it was a view from her Chy-an-Chy studio, entitled *The Wharf*, that initially attracted attention, the drawing of the fishermen lounging by the 'Sloop' and the expressive way in which the houses along the Wharf were depicted being of particular merit. Amy Watt was very beautiful but was not the easiest of persons to get on with. Nevertheless, she and Kathleen became friends and she gave Kathleen a couple of maternity smocks during her pregnancy. Going to tea at Amy's house was, however, a little odd as she would never have organised anything but would merely ring a bell linked to the local shop. Upon the appearance of the shopkeeper, the guests then put in their respective orders.

After the hectic pace of 1936, which resulted in picture sales of £557, no significant exhibitions were held in provincial galleries during 1937, although the touring show organised by the London Art Exhibitions Bureau continued to run its course.[16] In March, a petition for a Royal Charter was lodged by the Society - an action reflecting immense self-confidence - but this was turned down by the Privy Council. Dame Laura Knight accepted the Committee's invitation to become an honorary member and one of her first exhibits, her large painting *Self-Portrait and Model*, attracted much attention. In the well-known photograph (fig 10.8) showing Lindner passing comment on it to Smart, Millar Watt, Shearer Armstrong and Ninnes, Bradshaw is seen standing on a chair checking that it is properly hung - the practical man captured at his duties.

Dod Procter also exhibited with the Society in 1937 and *Light Sleep*, her study of a nude child lying on silk cushions and a patchwork quilt, was highly regarded, despite concern that the public might find it provocative. Fred Hall, an ex-Newlyner also became a member and *Up from the Shadowed Vale*, a typical scene of cows with the glow of sunset on a distant castle, was rated one of the most beautiful works of the Autumn Exhibition. The 'black and white' section was bolstered by the election of the established etcher, S.Van Abbe and Daphne Lindner.

Of Bradshaw's exhibits at the Society's exhibitions during the year, two works were singled out for special comment. *Penzance Harbour*, a view of the harbour with the high land towards Mousehole as a background, was praised for the beautiful effect of sunlight, streaming across the Bay, emphasising the greens and greys of the composition and *Rolling Home* (Plate 16) was noted for the successful adoption of an unusual viewpoint:-

> "An inspiring picture of the sea is Mr G.F.Bradshaw's [*Rolling Home*][17] showing a barque ploughing its way through a heavy swell. One looks towards the bow along the deck. There is wonderful work in the shadows caused by the side light of the sun casting a varied pattern over the ship. The tilt of the vessel is conveyed by the pose of the skipper as he gazes towards the bow."[18]

The unusual composition is well-handled and the surge of the boat through the water is convincingly portrayed. It has the mark of an artist with significant experience at sea.

Events of a non-artistic nature dominated the headlines in St Ives in the early part of 1938. Towards the end of January, there was a very beautiful appearance of the 'Aurora Borealis', or Northern Lights. The local paper records:-

> "The glow, which became visible just after sunset, was at first like the reflection of a great fire, and a great many people rushed from their homes in some alarm. Later, when the light formed a flaring arc across the sky, and other colours began to appear, they realised

[15] S.I.T., 19/3/1937
[16] There is the possibility that there was a separate show in Bath.
[17] The review merely refers to No.137 but a painting fitting this description was sold by Bearne's, Exeter on 25/6/1997 under the title *Rolling Home*.
[18] S.I.T., 9/7/1937

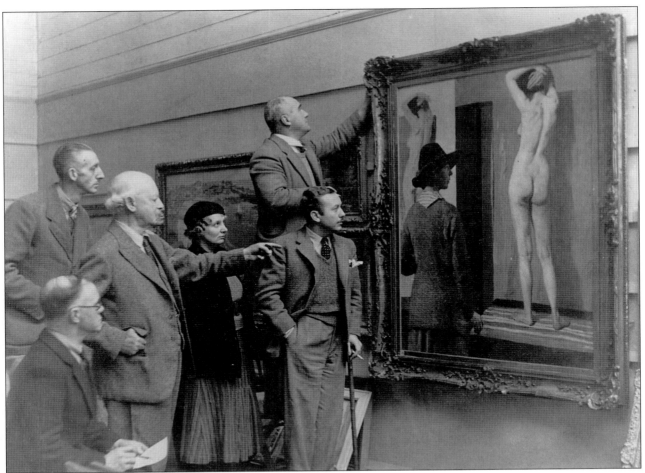

10.8 Laura Knight's *Self-Portrait and Model* being studied by (from left) Borlase Smart (seated) Millar Watt, M.Lindner (pointing), Shearer Armstrong, B.Ninnes and Bradshaw (adjusting frame)

> that the display was indeed the 'Aurora'. From the arc...shot innumerable shafts of white light like searchlights, and orange/red streamers. The duration of the display varied in different places, including St Ives, from half an hour to an hour and a half, the variation being probably due to the cloud movements. Nearly everywhere in the County, people climbed to the vantage points near towns and villages the better to see the rare beauty of the sky." [19]

Elizabeth Cogan, William Titcomb's granddaughter, can still vividly recall the evening. Her father, aware that it could be a once-in-a-lifetime experience, woke her up so that she could witness the unique display.

A week later, the paper was reporting a night of very different weather conditions when a howling gale and blinding rain led to a tale of tragedy and heroism that is still remembered in St Ives. This was the night that the *Alba* was wrecked on the rocks of the Island, the distinctive promontory off Porthmeor Beach. The *St Ives Times* reported the drama as follows:-

> "The tragedy, which came with amazing suddenness, has been brightened by tales of heroic actions on the part of the townspeople of St Ives, the full stories of which probably will never be told.

> Shortly after 7.00p.m., the siren of a steamer obviously very close in, was heard off Porthmeor Beach, and the lights of the steamer could be seen from the shore. It was soon evident that she was aground. The town was thrown into excitement at the sound of the rocket summoning the lifeboat, and hundreds rushed to the West Pier ready to assist with the launch, which was carried out in record time.

[19] S.I.T., 28/1/1938

The steamer proved to be the *Alba*, a 3,700 ton vessel, registered at Panama, owned by a firm in Genoa and bound from Barry to Civita Vecchia, Italy, with a cargo of coal. Battling its way through mountainous seas in the teeth of a north-west gale, the lifeboat soon made its way around the Head, finding the *Alba* on the rocks on the Porthmeor side of the Island. Skilful handling on the part of coxswain, Thomas Cocking, soon brought her to the leeside of the vessel, and watched by hundreds of spectators from the shore, the crew of 23 were taken off into the lifeboat, which then moved off from the wreck. As she rounded the bow of the wreck on the return journey, a huge wave struck her broadside on, and to the dismay of the onlookers, the lifeboat capsized. Mothers, wives and other relatives of the lifeboat crew watching anxiously for the return of their menfolk broke down at this tragic spectacle and the cry of terror struck at the hearts of all, and will not easily be forgotten. Excepting for three of the crew of the lifeboat, Messrs W and M Barber and J Cocking, who clung on or were pinned underneath, all the occupants were thrown into the raging sea.

The lifeboat is of the self-righting type, and in a few seconds, was on an even keel again. Most of the men struggling in the water managed to regain the lifeboat, but with her engine out of action, she was unmanageable, and was soon dashed upon the rocks.

At this further tragedy, hundreds, without thought for their own safety, made their way to the beach, and over the rocks, and a line was got across the lifeboat by the Life-saving Apparatus, secured to the bow and made fast to the shore. By this means, helped by men and women, the survivors were dragged ashore over the rocks, and on the beach.

The scene was one of the worst witnessed in the history of wrecks at St Ives. By the aid of searchlights, and the headlamps of scores of cars which by this time had gathered on the Island, the men were dragged from the sea and too much cannot be said for those men and women who plunged into the foaming sea to the rescue. They were beaten by the fury of the waves, and dashed among the rocks, many of the survivors sustaining injuries as a result." [20]

10.9 Herbert Truman *The Wreck of the Alba* (Western Morning News)

[20] S.I.T., 4/2/1938

George Bradshaw had been in his studio overlooking Porthmeor Beach when the siren of the *Alba* had first been heard and he witnessed the whole drama. Along with others, he clambered over the rocks towards the stricken steamer and helped pull survivors out of the raging seas. The most distressing moment was when he was asked by one of the lifeboatmen to help remove from his back one of the five crew of the steamer, who lost their lives in the tragedy, as his body was already showing signs of 'rigor mortis'. When Bradshaw eventually returned home after his exertions, he was too overwhelmed to tell his wife what he had experienced and merely asked her to dry out his tobacco patch.

There was noted to be a slightly different slant to Show Day in 1938. Normally, artists exhibited on Show Day the three works which they intended to submit to the Royal Academy. However, in 1938, a number of the artists elected to display some of the interior decorations that they had been working on. John Barclay showed a twenty-six foot mural decoration of *Summer*, supported by two thirteen foot murals of *Autumn* and *Winter*, part of a commission from the City of Leicester Education Authority for a children's school in Leicester. Shearer Armstrong showed a panel decoration of *Eve* and Borlase Smart showed a large panel depicting the departure of Sir Francis Drake in the Golden Hind from Plymouth Barbican. Other new members included Elmer Schofield, an American, who was a member of the U.S.A. National Academy, and who had just purchased Godolphin Manor, and Leonard Fuller, who established the St Ives School of Painting, which was to play such a leading role in the development of art in St Ives in the coming years. Since 1927, Fuller had been Art Master at Dulwich College and had secured a fine reputation as a portraitist. A number of his successful Royal Academy portraits of the past were shown at the Society's exhibitions during his initial years in St Ives. Fuller was married to another respected painter, Marjorie Mostyn (the daughter of the artist, Tom Mostyn) who was also to make an important contribution to the colony, and one of his early Show Day exhibits was a charming portrait of his wife knitting (Plate 24).

Bradshaw's three works on view on Show Day were complimented, the light and shade and beauty of colour being "so reminiscent of actual nature" and *Low Tide in the Cove* (see Appendix 2), depicting one of the Bradshaw's favourite bathing spots by Hor Point, was accepted by the Royal Academy. Kathleen Bradshaw also drew favourable comment from an unusual experiment:-

> "Mrs Bradshaw breaks entirely new ground with two delightful floral panels painted on apparently an aluminium background, which strikes a new note in floral decoration. We liked especially the one in the beautiful thin mirrored frame which added to the decorative qualities of the design." [21]

When the verdict of the Royal Academy's Selection Committee was announced, it transpired that the Society's members had achieved their best ever result, with 80 pictures selected and 48 hung 'on line'.[22] In addition, Arthur Hayward had been successful with two works and Hugh Gresty with one and Lamorna Birch's painting, *St Ives* (fig 10.10), was purchased by the Chantrey Bequest. The St Ives Society of Artists accordingly were yet again a major presence at the Academy - and this in a year when attendances were the highest for some considerable time due to the controversy caused by the attacks on its organisation by Augustus John and Wyndham Lewis. This can perhaps be seen as the zenith of the traditionalists' success. The onset of War and the advance of Father Time would soon make their impact felt.

Any fears of a decline would have been far from the minds of Smart and Bradshaw at this time. Smart, always keen to encourage interest in art from a tender age, came up with a new initiative by suggesting that the Gallery be made over for four days at the end of March 1938 to house an

[21] S.I.T., 18/3/1938

[22] The successful artists were Birch, Forbes, Knight, Olsson & Talmage with 6 each, Procter (4), Park, Midge Bruford, Fleetwood-Walker, Hewitt, Maidment, Sharp with 3 each, Brown, Balmford, Burgess, Robert Hughes, Kortright, Smart and Amy Watt with 2 each and Armstrong, Percy des Ballance, Bottomley, Bradshaw, Nell Cuneo, Maude Forbes, Fuller, Eleanor Hughes, Lindner, Blanche Powell, Richmond, Weatherby, Stuart Weir and E.M.Wilkinson with 1 each.

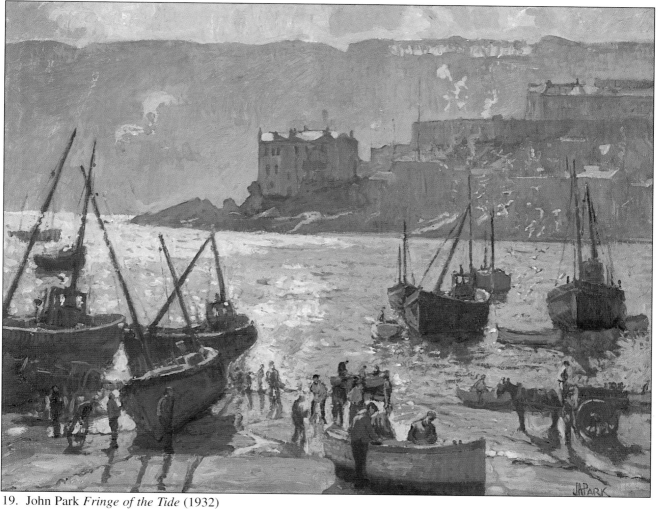

19. John Park *Fringe of the Tide* (1932)

20. Terrick Williams *Evening, Mousehole* (1933)

21. Dorothea Sharp *Still Life*

(Plate 19 Leamington Spa Art Gallery & Museum, Warwick District Council,
Plate 20 Newport Museum and Art Gallery
Plate 21 - Sims Gallery)

22. *Porthmeor Beach - Summer* (Oil on board)

23. *Hauling Lobster Pots in Rough Weather* (Oil on board)

24. Leonard Fuller *Knitting* (1939) (a portrait of his wife, Marjorie Mostyn)

25. Pauline Hewitt *Kathleen Bradshaw*

26. Kathleen Bradshaw *Still Life with Roses*

27. Helen Stuart Weir *Top Hat* (1939)

28. Arthur Hayward *The Onion Man* (1935) - a self portrait
(Reproduced courtesy of Leamington Spa Art Gallery & Museum, Warwick District Council)

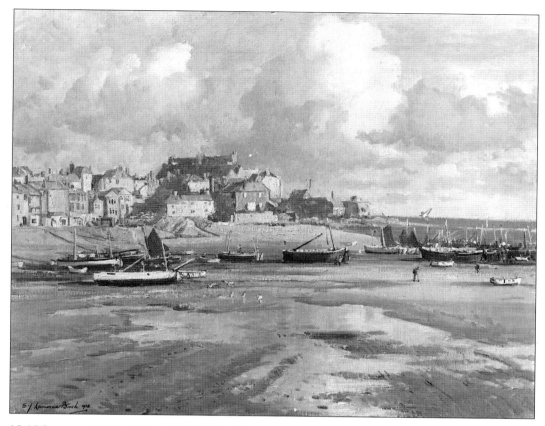

10.10 Lamorna Birch *St Ives* (RA 1938 - Chantrey Work) (Tate Gallery, London, 1999)

exhibition of paintings and drawings by schoolchildren of Greater St Ives. He then arranged for the County Secretary to open the Show. 5,000 visitors attended.

Another novel feature was to persuade Oldham Art Gallery to lend to the Society's Autumn Exhibition works by members from its permanent collection. Early works by Olsson, Birch, Talmage, Laura Knight and Frank Brangwyn were therefore juxtaposed with their latest contributions for comparative purposes. Laura Knight's portrait of Bernard Shaw (fig 10.11) was highly regarded:-

> "This head and shoulders of the great satirist are seen in strong relief against a blue sky and mountainous background. As in this artist's watercolour work, the vigour of approach is notable. The sitter is lit by a real out-of-door effect of half sunlight, emphasised by the complimentary of background to the warm-toned features." [23]

Stanley Spencer, who had recently visited St Ives and completed a magnificent painting of the town from the Malakoff, also was represented and the works of Stanhope Forbes, Dod Procter and Elmer Schofield won high praise. It was yet another successful show.

Bradshaw's exhibits at the various exhibitions of the St Ives Society of Artists during 1938 included two landscapes, *Trees in Winter* and *St Hilary Spire* along with his normal marine subjects. For the first time, he resorted to poetry for the title of one of his paintings:-

> "The stirring lines from a poem by Sir Francis Newbold, *Round the World if Need Be and Round the World Again*, make an apt title for Commander G.F.Bradshaw's fine picture of a sailing ship in a heavy sea. The work has an amazingly beautiful sky and the whole picture follows up the romantic feeling conjured up by the title." [24]

[23] S.I.T., 7/10/1938
[24] S.I.T., 18/4/1938

10.11 Smart, Fuller and Bradshaw hanging the 1938 Autumn Show, helped by Tonkin Prynne. Laura Knight's portrait of Bernard Shaw is being adjusted by Smart
(Roy Ray)

The weather returned to the headlines of the local papers when terrific storms lashed St Ives during the August Bank Holiday weekend. Torrential rain fell at such a velocity that the drains in the main streets were unable to carry away the flood water and many of the shops were flooded. There was a particularly alarming experience on Porthmeor Beach, outside Bradshaw's studio, when a thunderbolt, appearing from the east like a rocket, fell within a few feet of the water's edge, exploding with a streak of fire and blue smoke.

Despite mounting concern at events in Europe, it was again the weather which dominated the headlines in the early part of 1939, as the town came to terms with one of its greatest lifeboat disasters. On 22nd January, the lifeboat in responding to a distress call from a vessel off Cape Cornwall, was wrecked and seven of the eight crew members lost their lives. In the face of terrific seas whipped up by a gale that was considered to be even more severe than that on the evening that the *Alba* had been wrecked, the lifeboat had capsized on three occasions, on each occasion further crew members being lost, so that when the lifeboat eventually was driven on to the rocks by Godrevy, only one of the crew was left on board. Five of the men who had performed so valiantly at the time of the wreck of the *Alba* lost their lives in the disaster.[25] Bradshaw, with his love of sea fishing, would have known these men intimately and, like many others, was deeply affected by the tragedy.

There is no doubt that the town would still have been numb with grief by the time that Show Day arrived in March 1939 and the reviewer for the *Western Morning News* commented that, for the first time, the exhibition was disappointing, largely because a number of major artists had been ill or had left the district. John Park, Arthur Hayward and Hugh Gresty had been incapacitated through sickness and Bernard Ninnes and the Millar Watts were absent. As a result, the "burden of the day" had to be borne by Bradshaw, Borlase Smart, Fred Milner and Leonard Fuller. The reviewer was lavish in his praise of Bradshaw's work:-

[25] Several days later, when two bodies, both of strangers, were washed up on Porthmeor Beach, it became apparent that further disasters had occurred on the same night. It eventually became confirmed that the S.S. Wilston, a 3,000 ton Glasgow steamer, had been lost with all her crew of 32 at Wicca Cove between St Ives and Zennor.

"One of the most appraised pictures in the exhibition was Commander Bradshaw's *French Fishing Boats off the Cornish Coast*. Boat lovers are always attracted to Com. Bradshaw's studio because of his remarkable ability to put the indefinable, but yet very pronounced, personality of a boat on canvas, and this picture is one of the best, if not the very best, that he has painted.

His subject is simple enough - just two or three Breton crabbers under sail coming up to the foreground, and close by, less prominent, and serving to enhance the picturesqueness of the sailing craft, a modern motor trawler, proceeding in the opposite direction. But there is more than prettiness in this picture. It has animation and atmosphere. One could almost feel the wind in the rounded belly of the brown sail, and the thrust of the bluff bows of the nearest ship. A clever dapple of sunlight and shadow gives the water under the lee of the boat a wonderfully heaving limpid quality. There is plenty of height, breadth and depth in the sky, and one has the impression that the space underneath is filled with fresh salt breeze. It is a very bright, cheering picture - as bracing as one of those rare days in Cornwall with a north wind." [26]

Unfortunately, the whereabouts of this work are unknown. Bradshaw was, however, now at the height of his powers and to have his picture singled out as the most impressive work on show must have been immensely gratifying - a real cause for celebration. The review continues to be of special interest, as it proceeds to compare Bradshaw's style with Smart's. Here, then, are the two principal marine painters of the colony assessed at their peak by a reviewer, with an affinity for and an understanding of their craft.

"It is rather a coincidence that the second most interesting picture.....is also a sea picture. It is to be found in Capt. Borlase Smart's studio under the title *Sea Power* (fig 10.13). But, while Com. Bradshaw paints the sea from the viewpoint of a seaman, Capt. Smart paints it from the point of view of a designer. It is not its salty quality that attracts Capt.

10.12 *Departure for the Herring Fishing*, another of Bradshaw's 1939 Show Day exhibits here being reviewed by the Hanging Committee of (from right) L.Fuller, B.Smart, Bradshaw himself and T.Maidment. Tonkin Prynne of Lanham's stands by the work

(H. Segal)

[26] Western Morning News, 17/3/1939

Smart so much as its swirling power and the pattern of its foaming surges.

In order to show the massive framework of ocean waves, Capt. Smart has taken out of this picture all the innumerable tints usually associated with sea pictures that might lead one in the direction of appreciation of the beauty of colour. He has given his picture, what one might call an undercoat, a monochrome tint, possibly, the delicate pink of the first flush of dawn, but it is unimportant, as it is intended merely as a basis. His main idea was to create a patterned design suggesting movement and power. He has used as his implements a number of battle cruisers in line ahead formation. They have been little more than outlined in, and, though they are practically on the horizon, they suggest an irresistible forward movement of solid strength.

The foreground is occupied with sweeping surges of sea, painted with great boldness and vigour, even fierceness, and with an appreciation of the massive design of the open ocean. They suggest the same sense of power as the battleships, but of a different kind - the one solid, static, the other liquid, indefinable, but nevertheless real." [27]

The two friends painted in contrasting ways, with Bradshaw working in a more traditional style, keen to evoke atmosphere, whereas Smart followed the techniques that he had recommended in his book to suggest grandeur and power.[28] The evolution of Smart's style is confirmed by a review of *Bosigran* (cp. Plate 17), a work of much the same period:-

"Borlase Smart has forsaken the....representation of actual facts of cliff and landscape scenery in the endeavour to grasp the essentials of particular effects. *Bosigran* may not convey a message in topography, but it certainly gives one the feeling of bigness, and a

10.13 Borlase Smart *Sea Power* (1937) (Roy Ray)

[27] *Sea Power* is the subject of an archetypal Borlase Smart story told to me by Roy Ray. Smart was an enthusiastic leader of the Sea Scouts and when teaching them signals, he rigged up a light behind the painting and made a hole in the canvas where he had painted the bridge of the leading destroyer. One scout was then deployed to flash the required message and the others were trained to look at the bridge of the ship in an effort to decipher it. An air of reality and a novel trick transformed what could have been a boring lesson and it is no coincidence that so many St Ives young men joined the Signals Corps during World War II.

148

sense of the fitness of colour to the particular time of day when the cliffs there look tragic in tone before the evening sets in." [29]

Kathleen Bradshaw continued with her experiments in still life portrayal and amongst her Show Day exhibits, she included *Floral Decoration* (fig 10.14), which had won praise at the Autumn Exhibition:-

"She uses [flower motifs] as a basis for self-expressions along the lines of a decoration in tempera. The beautiful design is emphasised by the original setting of a mirrored framing. Her *Floral Decoration* provides that interesting feature in an exhibition - 'variety' and its originality is to be welcomed" [30]

She also again utilised Robert as a model, showing a conté drawing *Robert Asleep* together with profile and full face studies in pencil and chalk. In a newspaper interview given at this time, Kathleen indicated that she loved babyhood but that it passed much too quickly. Her mischievous offspring's needs also severely hampered her ability to paint. When there was time, however, she could not expect a compliant model. "Children are so difficult - she laughed - They are so rarely still, and one cannot expect them to pose. That would be far too tedious. I find it easiest to catch Robert asleep".

Robert was already showing signs of wanting to follow in his father's footsteps; "he prefers a paintbrush to any toy", commented his mother.[31] He was also the proud possessor of a teddy bear, given to him by Stanhope Forbes. The Bradshaws linked up with the Forbes on a regular basis, always remembering to pay due homage to the Forbes' Pekinese, with whom Stanhope Forbes was quite besotted. Forbes was very fond of the vivacious Kathleen and was an admirer of George Bradshaw's work. He recommended to Bradshaw that he should sign his works - or in any event his most important works - "George F. Bradshaw" rather than "G. F. Bradshaw", as he considered that this gave a better impression to a potential purchaser.

10.14 Kathleen Bradshaw with Robert on Show Day 1939
She holds *Floral Decoration* and *Robert Asleep* hangs on the wall

[28] Despite this praise, neither work was selected by the R.A. Members of the Society who were successful included Fleetwood-Walker (3), Park (3), Harvey (3), Amy Watt (3), Sharp (2), Constance Bradshaw, Fuller, Gertrude Harvey (2), Weatherby, Hewitt, Kortright, A.C.Dalzell, A.Burgess, Stuart-Weir, Bottomley, A.Wyon and Dod Procter's *The Orchard* was bought by the Chantrey Bequest.
[29] S.I.T., 7/10/1938
[30] S.I.T., 7/10/1938
[31] Unidentified paper dated 17/3/1939

10.15 Design by Smart used for catalogue cover of the Society's Exhibitions 1936-1949

Stanhope Forbes was the artist who performed the opening ceremony for the Summer Exhibition of the Society in 1939. Bradshaw, in fact, presided over this opening ceremony, as Borlase Smart had been called away to an important meeting in London. Stanhope Forbes again reiterated that the Society owed much of its success to the tireless efforts of Moffat Lindner and Borlase Smart. In expressing his gratitude to Borlase Smart, he stated:-

> "He is one of those who has time not only to produce some very fine work himself, but also to help other artists. I have every reason to be grateful to him for what he has done for me and the help he has given me in my work." [32]

Such a compliment from a highly-respected artist would have been gratefully received. However, many of the principal artists who had played such a large role in the success of the Society during its first decade were now well-advanced in years. Job Nixon and J.C.Douglas died in 1938 and Algernon Talmage, Fred Milner and Lowell Dyer died in 1939. Arthur Meade and Julius Olsson would not survive the War. New talent had joined the Society but events were to dictate that the unity of purpose with which the majority of artists had worked during the period since the formation of the Society was soon to be upset by the war clouds gathering over Europe and completely destroyed by the storm within the artistic community as the cessation of hostilities on the political front gave way to a fiery battle between the traditionalists and the moderns.

[32] S.I.T., 14/7/1939

INTERIOR DECORATIONS

As a sideline to his serious painting, Bradshaw obtained a number of commissions to carry out interior design projects. He was first persuaded to embark on such an enterprise in 1929 by the owner of the Scala Cinema in St Ives, Cecil Drage, who may well have been impressed by the way the Bradshaws had decorated their own home. Drage was struggling to attract the local inhabitants to the new-fangled invention of the cinema and to find films that suited all tastes, as a reporter for a specialist cinema magazine discovered:-

> "One of the most interesting picture houses I visited was the Scala at St Ives. I am sure that Cecil Drage, the proprietor-manager, who welcomed me as an old friend, will not be offended when I say that his second name ought to be Perseverance. Everything is against Mr Drage.
>
> The population of St Ives consists mainly of simple-minded fisherfolk who are still apt to regard kinemas and dancing as inventions of the devil. Visitors are either artists or fresh air fiends, who spend their days out in the open. If they do visit a kinema, their tastes must be studied.
>
> The inhabitants can't understand anything out of the ordinary. The visitors must have something high-brow and up-to-date. Yet Mr Drage wears a smile - and his kinema would put to shame many in Town.
>
> Hardly any kinemas in Cornwall open before 6.30pm, yet the Scala in the apathetic town of St Ives has a matinée every day. Mr Drage admits that his matinées don't pay, and yet he goes on. His idea is that the older biased generation is dying out, and that he looks to the younger modernised people to back him up in his enterprises.
>
> By opening without fail at 2.30pm every day, and running his full show, whether the audience be four hundred or four, he hopes to educate the new generation to realise that kinema-going should be a regular, healthy habit. How far Mr Drage will succeed remains to be seen, but if it is a matter of grit and determination, he'll get there in the end." [1]

Bradshaw did attend the cinema on a relatively regular basis and, surprisingly, for such a blunt and outspoken man, he found it very hard to sit through a film, which included any hint of sentimentality, without shedding a tear. In any event, Cecil Drage and Bradshaw became firm friends and it was Drage who suggested to Bradshaw that the cinema could do with being redecorated. Not surprisingly, Bradshaw came up with a nautical theme for the design, the principal feature being depictions of ships of the Elizabethan era. Nevertheless, the arrangement was given a fanciful air by the inclusion of sea-monsters, porpoises, mermaids, whales and large waves. The end result was highly acclaimed, the magazine reporter commenting:-

> "The mural decorations caught my fancy at once. The artist, Commander Bradshaw, has painted on the wall panels striking pictures of the sea. There are Spanish galleons and stately carracks - all lifelike and splendidly done. If the fisherfolk and the artists of St Ives don't appreciate those pictures, they ought to be shot."

In addition, Bradshaw painted the crest of the Borough of St Ives on the proscenium arch of the theatre. Various sections of the decorations were discovered when the Scala Cinema eventually

[1] Reproduced in St Ives Times ("S.I.T."), 13/9/1929

11.1 Scala Cinema - Two fragments from Bradshaw's decoration scheme of 1929

(St Ives Times and Echo)

closed in 1992 and, regrettably, the photographs taken at that time form the only record of Bradshaw's interior decoration style.[2]

Bradshaw does not seem to have gone out of his way to secure further commissions in the next couple of years, but as the effects of the Depression began to be felt and sales of his paintings decreased, he decided that he might well be able to supplement his income by offering his services as an interior designer. In 1932, he was extremely successful. At the Western Hotel in St Ives, utilising a similar style to that he employed in the cinema, but on a smaller scale, he painted over the mantelpiece in the Resident's Lounge a large striking picture of a three-masted

[2] The building now houses Boots the chemists.

sailing ship in full sail. Right around the top of the walls was a frieze in which he portrayed St Ives Bay, "with its typical exquisitely-coloured sea", the far-reaching dunes and moors, Godrevy lighthouse and numerous fishing and other vessels.[3]

His success with this project led to Mr. Garbutt, the proprietor of the Regent Hotel, asking Bradshaw to design a café with an underwater theme. This also drew considerable compliments.

> "Leaving the glare and heat of the main road, I entered the Regent Hotel the words 'Deep Sea' Café intrigued me, and descending some steps, I entered a room with not only one of the most magnificent views of St Ives to be seen from its window, but with a scheme of decoration that would make Joseph Lyons green with envy.
>
> Commander G.F.Bradshaw has surpassed himself in his wall paintings of the bed of the ocean. Such a scheme is by no means an easy one to adapt to interior designing. But I must say the effect is dignified, beautiful in restful colours and well composed in rhythm of movement. The whole design is made up of fish forms, sea flora and deep sea life, contributing a most unique setting to an artistic room, in which the floor covering and furniture harmonises with the wall tones. The undulating line of young fish moving around the walls in shoal formation conveys space to the room. Cool, refreshing and restful, this new note in Café designing harmonises with the dainties provided by the management, and the fact those dainties taste better amid such surroundings is a psychological aspect that reflects the happy co-operation of Mr. Garbutt, the proprietor, and of Commander Bradshaw, the artist." [4]

In 1933, he won a commission for the interior decoration of a new hotel in St Ives and designed other schemes at the Tregeye Tea-Rooms and for various over-mantels in and around Falmouth.[5]

11.2 Leonard Fuller *Laity's* (detail) showing tea canisters decorated by Bradshaw (M.Whybrow)

[3] S.I.T. 3/6/1932
[4] S.I.T., 4/8/1932
[5] Perhaps impressed by the success that Bradshaw was having with these designs, Borlase Smart also started offering his services as an interior designer and redecorated the Seagull café at the end of Wharf Road. S.I.T. 4/8/1932

Aware of the importance of publicity, Bradshaw always ensured that the press reviewed his efforts and the following justification for the use of an artist for works of interior design is likely to have been provided by Bradshaw himself:-

> "The practical beauty of such work provides a solution to the distracting circumstances arising from the choosing of proper wallpaper, which is often expensive, and compared to which the artist's work is more economical and personal to the client." [6]

Amongst his clients was a local shop, James Laity & Son (see also Plate 12). The Laitys imported tea from China and arranged for Bradshaw to paint pictures of Chinese Junks on the large tea canisters (fig 11.2). They also acquired Bradshaw's painting of *The Cutty Sark*, which he had exhibited at Show Day in 1923, as it was reputed to be the fastest Tea Clipper, and displayed it in the shop window. When the shop eventually closed, the tea canisters were sold at Christies. [7]

Kathleen was also interested in interior design and, as already mentioned, she had some considerable success with her novel lamp shades. Her subjects varied - some were inspired by medieval motifs, some featured ships and the sea, some reflected her interest in flowers, but she was also prepared to use more modern designs. The shades often received favourable comment both for their design and the quality of their execution. Kathleen also indulged in creating fanciful creatures for use in the decoration of furniture. The bearded and horned devil painted on Rosamunde Pilcher's surf-board has already been mentioned and she painted a cupboard for her friend, Dorothea Sharp, which she adorned with anchors, mermaids and beatific whales, merrily spouting water. Kathleen recalled that Sharp wore long shirts, floppy hats and her hair in a bob and was "always smiling, always painting".

11.3 Kathleen Bradshaw and her mother with some of her lampshades in Ship Studio

A rather different commission, however, came the Bradshaws' way in 1935, when they were asked to re-decorate the church at Porthleven. The result was warmly applauded by the local paper:-

> "Parishioners of Porthleven are to be congratulated on the redecoration of their church, which has just been carried out under the direction of Commander G.F.Bradshaw, a member of the St Ives Society of Artists.
>
> The whole of the church is now in keeping with the new Lady Chapel, recently presented by Captain J Lionel Rogers, and has an atmosphere of cheerfulness that springs from a modern outlook on interior decoration and colour schemes.
>
> Commander Bradshaw was engaged to superintend the decoration of the Lady Chapel, which was designed by Mr C R Corfield, Diocesan Architect, and the Parochial Church Council was so pleased with his work, that they asked him to take charge of the redecoration of the Chancel. This he has done, with a success that proves that the sphere of the modern artist is not confined to the production of oil and water colour pictures.
>
> Formerly, the apse over the Chancel had been painted in night blue, and the angel figures that decorated these sections were brown. After the walls had been thoroughly cleaned,

[6] S.I.T., 19/5/1933
[7] M.Whybrow, *St.Ives 1883-1993*, Woodbridge, 1994, p.99

11.4 Dorothea Sharp *Children in the Shallows* (Sims Gallery)

11.5 The Chancel in Porthleven Church
as redecorated by the Bradshaws (Western Morning News)

Commander Bradshaw changed the blue for saffron, which presents a cheerful sunlight effect, and gave the angels white robes, blue capes and gilded harps.

The reredos he has painted the colour of stone with gilt panels and has also effectively re-coloured the figure of Christ, which stands in front of the centre panel. He has struck a contrast by painting the heavy moulding between the apse and the top of the reredos in blue and silver.

Commander Bradshaw has been assisted by Mrs Bradshaw, who is also a member of the St Ives Society of Artists, and the work has taken between three weeks and a month. The result is as pleasing as it is effective." [8]

Given the distance of Porthleven from St Ives, the Bradshaws may have stayed in Porthleven while they were undertaking the work. How Bradshaw won the original commission for the Lady Chapel is not known and its current decoration, with the apse merely being painted duck egg blue, does not give any clue as to the style of decoration utilised by Bradshaw. In the Chancel, the angels, with their blue capes and gilded harps, remain, but the background colour has been changed from saffron to white, with the result that the warm sunlit effect that Bradshaw considered appropriate for the East End has been lost. On the reredos, the unusual colours used to pick out the heavy moulding have also been replaced so that the whole has the appearance of stone. The subtle touches, which provided the principal impact of the Bradshaws' work, have accordingly been lost.

The fanciful scenes often favoured by Bradshaw in his interior designs give a glimpse to a side of his character, of which most probably only his family were fully aware. His ability to conjure up sea monsters, mermaids and other fanciful creations make it no surprise that his son was aware of him being a warm and kind-hearted father. Whereas Bradshaw may have permitted himself from time to time one of his deep belly laughs as another creation came to fruition, he would have relished the challenge that each new project brought as regards perspective, composition, and colour tonality. Completely different demands would have been made on his painting techniques from those which normally tested him. The popularity of such a style of internal decoration did not, however, survive the advance of the modern movement and, sadly, no decent pictorial record remains.

[8] Western Morning News and Daily Gazette, 26/7/1935

REACTIONS TO MODERN ART IN THE 1930s

As the twenty-first century begins, it is easy to forget how long it took for the explorations into non-figurative art at the start of the twentieth century to be understood first by critics and fellow artists and then by the wider public. Nowadays, even non art lovers will be aware of, will accept and, possibly, will be amused by the latest attempts to push back the boundaries of "art". Meanings, possibly not obvious to even an informed observer, are spelt out by the artist at length. Abstract painting has, in fact, become rather outmoded. However, in the 1920s and 1930s, the art world was turned upside down as artists, brought up on traditional values, which placed importance on drawing and perspective and the construction of an illusion of reality, struggled to come to terms with the consequences of Cezanne's use of colour, of Picasso's and Braque's explorations of space in their Cubist works and of the trend towards complete abstraction. A number of St Ives artists had studied in Paris or elsewhere on the Continent but mostly this was before the 1920s when the Fauvist, Cubist and Futurist experiments began to influence students. For Bradshaw, however, as with most of the St Ives artists, there would have been few opportunities of seeing original works by the French modernists. In making any assessment, they were reliant on such prints as may have filtered into this country or, more likely, on the imitative works of less talented English artists. In 1932, the Editor of the influential arts magazine, *The Studio*, ran a series of articles with the title *What is wrong with Modern Painting?* in which he bemoaned the influences from the Continent which had led young British artists to abandon their artistic heritage and to produce imitative work of poor quality, with subjects "as similar to one another as if they had been turned out by a machine. The same fat woman, the same cardboard tree, the same apple on a napkin, the same assortment of geometric shapes, reappears time after time with an awful monotony." [1]

New styles of art had come and gone before, but what concerned the traditionalists greatly was that these new tendencies threatened their whole ethos - it was not just a way of painting that was under attack, it was a way of life. If technical competence was no longer of relevance in judging quality, on what basis could a work be assessed? If standards of draughtsmanship no longer mattered, if perspective was irrelevant, if colour could be used indiscriminately, how could the talented freshman be distinguished from the charlatan? These were the issues that fostered such lively debates within the colony. Modern art was a topic raised by distinguished Royal Academicians when they opened new exhibitions, it was a subject raised repeatedly in the pages of the local paper, particularly in 1933, the year in which a new feature, *Art Notes*, was introduced and it would surely have been a regular discussion point when the artists met for a beer. Given that the major fission in the St Ives Society of Artists in 1949 resulted from violently opposed views on modern art, it is worthwhile reviewing the attitudes towards modernism prevalent in the colony in the 1930s. From this distance in time, the arguments then utilised in criticising modern art may not seem any more valid than those in the heated exchanges in the late 1940s. However, a picture does emerge of a common view - a view embraced and expounded by Borlase Smart, so that one can begin to understand the sense of betrayal felt by Smart's long-standing friends and colleagues, as he changed his views and used his influence to encourage modernists to join the Society.

Terrick Williams was a highly regarded artist with a fine sense of colour values. Although clearly influenced by the Impressionists, Williams was not attracted to more recent trends in French art, where he detected that novelty was being seen as an end in itself. In the course of his opening address at the 1930 Spring Exhibition, he commented:-

[1] The Studio, 1932 CIII, p.63-4

"I do not understand why some people get angry over modern art; they need not look at it, if it annoys them. Modern art often amuses me but it does not make me angry. I am unable to understand all of it and what amuses me is that the daily and weekly press produce a new 'genius' every fortnight. I do not see why according to modern ideas, everything must be a novelty. A novelty is often nothing in itself; anyone can be novel, even by being ridiculous. In forty years, the present modern art will be old-fashioned; a good picture, however, is never old-fashioned, and a picture is not good necessarily, because it is new-fashioned." [2]

These views were widely applauded by the members present and many may feel that, in the age of 'shock-art', they still have some relevance.

It was also in 1930 that St Ives received a return visit from Wyly Grier, who along with his brother, Louis, had been one of the first artists to settle in the town. Having lived in Canada for over thirty years, Grier was appalled at the influence of modern French artists on English painting and wrote a strong letter to the *Times*, bemoaning the lack of "original conceptive power and sedulously trained craftsmanship" in contemporary works. He commented:-

"In the wilderness whence I come, promising students return from a sojourn in Paris and thereafter produce bad Cezannes, bad Gauguins and bad Van Goghs of inexpressible dullness and uniformity. At the bottom of it all, I think I discern a widespread contempt for craftsmanship. As we mentally pass to review the great masters - Phidias, Michelangelo, Titian, Hals, Grinling Gibbons..., one begins to despair of a generation whose painters despise technique." [3]

In 1933, the subject of modern art frequently cropped up in the artists' various contributions to *Art Notes*. Both Herbert Truman and Leonard Richmond felt that there was a danger of the public being taken for a ride unless artists did more to make their work intelligible or provided some sort of explanation. How could a potential purchaser tell whether he was being offered a masterpiece or being duped into buying a pup? Truman, who thought deeply about his art, felt that a comparison could be drawn between abstract painting and music and that such painting could transcribe sensations and produce intellectual and emotional rapture. However, he comments:-

"Many ultra-modern painters have plunged headlong into the above theory in the hope of creating emotional ecstacy. We feel that perhaps they do amongst themselves. The layman at present, however, is left high and dry on the mainland of sober academic culture. There he will remain, until there is lucid explanation of these abstract principles, backed by practical examples which can be understood." [4]

Leonard Richmond, the well-known artist, art critic, author and poster designer, at this stage had not settled in St Ives permanently but he was a regular summer visitor. In his contribution to *Art Notes*, he commented, "However experimental a painter may be in his studio work, it is not expedient to exhibit pictures which neither the artist - nor the public - can understand." He then went on to tell a story, which was no doubt apocryphal:-

"A young lady - a member of an extremely modern group in London - was discovered in the gallery on a certain private view day, sobbing bitterly and apparently heartbroken. On being asked by a sympathetic visitor the reason for her dire distress, she managed between choking gulps (partly smothered in a sodden handkerchief) to give a staccato-like reply, 'that the subject matter in one of her exhibited pictures had that morning been recognised by a member of the audience'." [5]

[2] St.Ives Times ("S.I.T."), 18/4/1930
[3] Times, 11/8/1930. Reproduced in S.I.T., 22/8/1930. The Editor of The Studio came to the same conclusion. "In the international art centre, the painter seems to learn not technique, but a contempt for technique." See Note 1 above.
[4] S.I.T., 4/8/1933
[5] S.I.T., 26/5/1933

12.1 Bernard Ninnes *St Ives Harbour* (David Lay)
Ninnes' style, particularly his use of colour, led to comments about his 'modern' touch

12.2 Leonard Richmond *Smeaton's Pier* (W.H.Lane & Son)

Given Borlase Smart's future role in introducing the modern artists into the Society, it is interesting to see what views he held in the 1930s. In 1932, he told students of the Penzance Art School:

> "Beware of the modern touch. It is only a passing phase. The British people are more sensible than they are given credit for, especially in artistic appreciation. The ultra-modern note which has been rampant for the past few years is passing, and there is a return to tradition." [6]

The following year, in one of his contributions to *Art Notes,* he expanded on these views:-

> "A few years before the War, I saw the first exhibition of French impressionist art ever held in this country at the Brighton Gallery. Impressionism, Cubism, Futurism, Pointilistic and Triangular work were all represented. Clever experiments in most cases to obtain light and atmosphere. The result of the scientific application of paint to gain luminosity. I doubt if some of the artists ever intended them to be exploited. The exhibition was a sensation, and the Press with an eye to 'copy' went all out. The result was that the English School went modern. Cezanne and Matisse derivations were the order of the day. Some artists altered their style to keep in touch with the general trend of things. And so it went on, until now a reaction has set in. At the time, the innovation of 'the cult of the ugly' provided a veritable war between the traditionalists of the English School and the moderns.
>
> Such descriptions as 'camouflaged incompetence' and 'a labour-saving method of painting' aptly described the posterings of the younger artists eager for the quick recognition of a temporary limelight. The climax has come. Last year the Paris Salon reverted to a dignified sanity in its exhibition. Today a noted French dealer states that modern art is not wanted in France, and that modern masters could not be sold at any price. The Alpha and the Omega.
>
> But something has arisen out of all this chaos. British Art has scored. It has become happier in palette discipline. Gone are 'the amber notes' of the Victorians. The experiments of the French masters of painting have been analysed. The ugliness of form and idea has been sifted, leaving us with a quickened sense of colour and we acknowledge their influence in this respect.
>
> The cult of the ugly is waning and the English school is emerging revitalised along the lines of a happier outlook on Nature." [7]

This piece is typical of Borlase Smart. It is resonant with his enthusiasm for art. He may not as yet have been persuaded by the virtues of modern art, but nevertheless he felt something had been learned - a new sense of colour, and that British art, and more particularly, the art of the St Ives Society of Artists could exploit this and prosper. One can imagine him spinning this line as he arranged further exhibitions for the Society around the country.

Julius Olsson, however, took a more reactionary stance. When giving the opening address at the Society's 1936 Cheltenham exhibition, he commented:-

> "Three-quarters of the new kind of art is pure rubbish. Although we all have open minds about things and are willing to admit the beauties in any particular kind of work, there is so much of this new stuff about, which is really appalling. Some of this modern work, I or anybody here could copy and you could not tell the original. It is done with splashes of paint and in such a manner that you don't require ability to do it." [8]

[6] S.I.T., 29/1/1932
[7] S.I.T., 2/6/1933
[8] S.I.T., 20/11/1936

12.3 Julius Olsson *Evening Shower off the Needles* (David Lay)

12.4 Lamorna Birch *Morning at Lamorna Cove* (Williamson Art Gallery & Museum Birkenhead)

Perhaps one would have expected a more considered exposition of views from a Royal Academician. Perplexed laymen frequently commented that modern work looked as if it had been done by a child but, although one is not privy to the works that prompted such caustic comments, one suspects that Olsson's mind was not as open as he professed. Birch, too, could not stomach the 'nouveaus'. "Why should I tear my hair out when I can't finish a picture properly?", he asked his wife. "Why not send it to the Academy covered with yellow and blue and call it *Spring*?"[9]

Bradshaw did not commit his views on modern art to print but it is unlikely that his opinions altered over the years and his problems with the modernists at the time of the split in the St Ives Society of Artists are discussed later. However, he is likely to have been in full agreement with the opinions recorded above. Lily Weller states that Bradshaw and her husband used to bemoan the state of modern art on a regular basis and that one of her husband's favourite comparisons, with which Bradshaw would no doubt have concurred, was that buying good art was akin to buying a good suit - and that you would not buy a suit from a tailor who did not know how to cut cloth properly. The comparison may not be considered to be particularly apposite, but the underlying concern, like that of Wyly Grier, is at the lack of technique. For an artist brought up to appreciate the finer points of painting technique, the sight of a work that flouted the established rules was difficult to accept as good art. It was the lack of any traditional yardstick by which to judge a painting's quality which caused unease. The expression of a particular artist's own vision or emotional state was considered too personal, too ephemeral. There were no rules by which it could be contrasted or compared with other work. The years spent in training, tedious times often spent staring at antique casts, the months spent experimenting with composition and design, the days spent perfecting drawing techniques and mastering perspective, the hours spent learning the correct combinations of pigments for different effects, the colds caught as one sketched out in the open - surely all this was eventually reflected in one's work. It was unthinkable that new perceptions might bypass these qualities. It was indeed a whole ethos that was threatened.

St Ives might be situated far from the hub of the contemporary art world but such views, embracing as they do those of leading Royal Academicians, distinguished art critics and prominent journalists, should not be thought reflective of a provincial outlook. Similar opinions were widely held by large sections of the art hierarchy and, as will be seen, later Presidents of the Society of Marine Artists and, indeed, of the Royal Academy held even stronger views.

[9] A.Wormleighton, *A Painter Laureate*, Bristol, 1995, p.220

O.H.M.S. – AGAIN

Bradshaw's happy existence as one of a group of dedicated and professional artists, working together in the promotion of the St Ives art colony, was abruptly brought to an end by the outbreak of the Second World War. Bradshaw, having served with such distinction during the First World War, was one of the first to be called up in August 1939 but his summons was by no means welcome. He had not forgotten the treatment that he had received at the time of his court martial. When asked if he would take command of a ship at the beginning of the Second World War, he said he would, with reluctance, "provided that it was carrying beer"! Such a comment highlights his absolute frustration that he was being summoned away from his wife, to whom he was still devoted, his young son and heir and a contented and successful existence to fight yet another war. Surely he had done enough for his country already. Nevertheless, he had no option but to report for duty. His feelings explain how, on his return to St Ives after the war, he had little time for those artists who had managed, by one means or another, to avoid active service.[1]

Bradshaw was posted initially to Falmouth as an officer in the Defensively Equipped Merchant Shipping (D.E.M.S.) section. The principal objective of this section was to enable merchant ships to defend themselves as much as possible. In addition to the installation of an anti-aircraft gun, the ships were also degaussed. This involved putting a cable around the ship to remove its magnetic force, so that magnetic mines did not work.

Borlase Smart, another veteran of the Great War, was very keen to help in what ever way he could and pestered Bradshaw to get him some form of position. Eventually, Bradshaw managed to arrange for him to be put in charge of the Royal Navy Magazine at Falmouth under the Admiralty. After a breakdown in health, however, he was appointed Intelligence Officer of the local Home Guard Battalion.

Despite Bradshaw's absence from St Ives, he arranged for paintings to be made available to the exhibitions of the Society. As regards his exhibits at the 1939 Autumn Show, the reviewer commented:-

> "Commander G.F.Bradshaw was never better. *The Crabber* is a fine attainment and a worthy sea subject which enhances his reputation as a marine painter. The same almost applies to his other painting of *Crabbers in the Bay*, with its onward rush of French crabbers to their moorings through a lively sea...*Summertime in the Bay* is a picture of St Ives yachts in full sunlight, reflecting their form and colour on an ultramarine sea. In the background, various fishing craft and the golden tone of the Towans looking towards Carn Brea, clarify the general tones of the foreground yachting incident. The intense depth of blue of the sea is the keynote of the picture..." [2]

Kathleen Bradshaw's work *Decoration* also received favourable comment:-

> "Her small picture is a floral design to fit a given space. It has massive qualities of composition and a rich harmony which make it a perfect decorative gem. In fact, without undue flattery, it has a Brangwyn-esque feeling about it."

The hostilities and a ban on outdoor sketching soon had a severe impact on the activities of the Society, as Smart later recorded:-

[1] Bradshaw, like Smart, would have abhorred an attempt by one St Ives artist to avoid active service on the basis that (a) his work was of inestimable importance, (b) he had an original outlook governed by deep aesthetic feeling and (c) he should be considered to be a national asset and so protected - St.Ives Times ("S.I.T."), 7/3/1941.
[2] S.I.T., 13/10/1939

"St Ives did not escape the crisis to the art world caused by the Second World War, when public interest and support largely ceased. However, by exercising the utmost economy, this time of anxiety passed, although it was feared that the Society might have to suspend its organisation. Such a serious break in its continuity might have had fatal results but, thanks to the loyalty of members, the exhibition standard was maintained."[3]

With Bradshaw away on active service, Moffat Lindner often incapacitated through illness and Francis Roskruge retired, Borlase Smart needed the considerable support of Leonard Fuller during this period, particularly as he himself was for a while *hors de combat* due to his wartime duties or through illness.[4] The Society also lost its respected curator, Marjorie Sandow, who resigned and was replaced by Charles Proctor's daughter, Sheila. The tradition of Show Day was maintained, with the work of Smart, Fuller and the disabled Ninnes to the fore and war subjects having prominence, although, after the Blitz, the enthusiasm for submitting works to the Royal Academy diminished because of the risks involved. Due to the situation in London, a number of artists sought refuge in St Ives, including Marcella Smith and Dorothea Sharp, who moved to 1, Balcony Studios, and Fuller's Painting School was well-attended. A new arrival of considerable standing, who also advertised painting lessons, was Francis Barry, summarily ordered out of Bordighera by the Italian authorities. Barry had previously been based in St Ives during the Great War.[5] A well-regarded Czech artist, Joza Belohorsky, who had been forced to flee his homeland, also joined the Society.

Bradshaw's work for D.E.M.S. was not without risk and he had a lucky escape when his ship detonated a magnetic mine in Falmouth Bay. The force of the explosion thrust his hands through the pockets of his oilskin and he was thrown in the water. Kathleen and Robert witnessed the explosion and, for a while, there was considerable anxiety as to its consequences. Although, initially, it appeared as if Bradshaw had come through relatively unscathed, subsequently, he began to experience considerable pain in his hip and was eventually forced to use a stick. The pain from this injury, often excruciating, came to blight the last years of his life.

Bradshaw official responsibilities do not appear to have left him much time for painting. A few Naval works and a dramatic night rescue (fig 13.2), as a boat full of survivors is picked up in searchlights, are known from this period but little else. During the early years of the War, Bradshaw exhibited on several occasions, *The Night Watch* (possibly, fig 13.1), showing a graceful barque under moonlight and starlight but this is likely to have been executed prior to the War.

While in Falmouth, Bradshaw did maintain some contact with friends in St Ives but this changed in 1942, when he was posted up to Sunderland to be the Naval Officer in charge of the port. The Russian Navy was based in Sunderland and, to a large extent, Bradshaw's role was to liaise with the Russian Commanders. Kathleen and he lived in a terraced house , overlooking a nunnery and were able to watch the nuns ice-skating in winter. There was again little opportunity for painting, although he did depict the *D*-class cruiser, *H.M.S.Delhi* (fig 13.3), which Sunderland had adopted during the War, and donated the work to the municipal Art Gallery.[6] This cruiser had been assigned to the Baltic in 1919 and it is possible that Bradshaw knew it from those days, as it appears to have spent little time in its adopted port. Bradshaw clearly established a good rapport with the curator of the Art Gallery, as in April 1944, he mounted a small exhibition of twelve works at the Gallery and secured a number of sales. The Gallery itself bought off him *Lobster Fishing* (Plate 15), a fresh treatment of a familiar subject, showing Bradshaw very much at the peak of his powers. The work probably dates from the late 1930s but there is no record of it being exhibited, unless it was originally known as *The Crabber*.

[3] B. Smart, *The St.Ives Society Of Artists*, The Studio, 1948
[4] Roskruge retired as Treasurer in 1940, to be replaced by Shearer Armstrong, who performed the role for four years.
[5] Barry also offered to do posthumous portraits. Gresty was another artist who started painting, drawing and design classes.
[6] *H.M.S.Delhi* was built by Armstrongs and was completed in 1919. Her length was 471 feet, displacement 4850 tons and her top speed was 29 knots. She had 6 6" guns. She was scrapped in 1948.

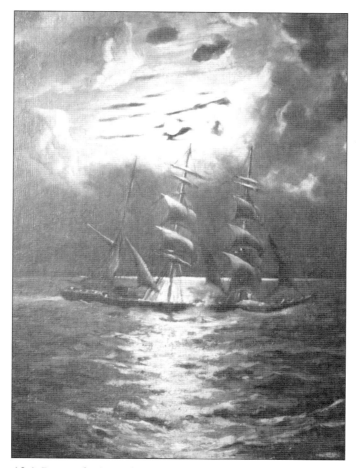

13.1 *Barque by Moonlight* (detail) (Oil on canvas)

13.2 *Rescue* (Oil on board)

(Sims Gallery)

13.3 *H.M.S. Delhi* (1942) (Oil on canvas) (Sunderland Museum and Art Gallery)

In 1943, Kathleen Bradshaw gave birth to their second child, Anne. The proud father was now aged 56. As Naval Officer in Charge, Bradshaw had a Wren allocated to him to drive him around and she became a firm friend of the family, often helping Kathleen with Anne. She was also prepared to babysit for them but this was a mixed blessing, as far as Kathleen was concerned, as she found the social functions which they were obliged to attend terribly dreary. They also had to do quite a bit of entertaining as, from time to time, members of the Naval hierarchy would come up to visit them. Kathleen, who was much younger than most of the wives of the Admirals, found their company taxing. They also entertained Russian Naval Officers on a regular basis. They would always come round, bringing vodka and boxes of cigarettes. Their saving grace was that they were passionately interested in children and, accordingly, as soon as Anne started to cry, they would all troop upstairs and coo over the baby. One of the Russian Officers, with whom they had frequent dealings, was the future Russian leader, Mr Gromyko. Bradshaw often took his son, Robert, with him on his tours of inspection and it proved an exciting time for a young boy.

In 1944, Kathleen was asked to launch a frigate, *H.M.S. Farnham Castle*. In the absence of champagne, a bottle of cider was used for the launching ceremony. As it was a custom for a gift to be given to the ship, Kathleen donated one of her painted lampshades. Having had all her teeth out the previous day, she found the occasion rather a trial.

While he was based in Sunderland, Bradshaw suffered a serious coronary. Again, it was felt that the shock that he had suffered when his boat had been blown up by a magnetic mine in Falmouth may have been a contributory factor. Although he was able to resume his duties, his health deteriorated. In a short period, he had aged considerably and he found it more difficult to tolerate the boisterous antics of his young children.

Despite living at the other end of the country, Bradshaw seems to have ensured that he was represented in most of the Society's shows during the War. Barns-Graham recollects that a number of works remained stored in 3, Porthmeor Studios, and that Smart made selections from them, if new work was not forthcoming. Great pains were taken to emphasize at the Society's

13.4 Leonard Richmond in his St Ives studio in 1947 correcting book proofs with his daughter, Olive Dexter. (Estate D.Val Baker)

shows during the War that nearly all work exhibited was new, but Bradshaw's status and his particular circumstances would have ensured dispensation from this requirement.

Notwithstanding all the political and economic hardships, the Society continued to flourish. Works continued to sell - 72 pictures realised £559 in 1942 and, with increased attendances in 1943, sales rose to £763. In 1942 alone, fifty new members joined, the result of a conscious policy to ensure financial stability by offering associate membership to many of the student painters. The need for a larger Gallery was becoming obvious. Newcomers of note arriving during or shortly after the War included the marine artist, Maurice Hill, David Cox, known for his sensitive and luminous canvases of figure and landscape subjects, the New Zealand born illustrator and caricaturist, Harry Rountree and Thomas Heath Robinson, a specialist in ecclesiastical designs. Somewhat belatedly, Charles Simpson decided to join the Society and Leonard Richmond was now based in Carter's Flats in St Ives and so could take a more active role in the Society's affairs.

At the 1945 A.G.M., Borlase Smart commented:-

> "It is significant that each war year has brought greater success than its predecessor, and the past twelve months have been truly astonishing. I am personally glad that sales extend over so many members of the Society, and not to just half-a-dozen fortunates. I think it proves the standard generally is higher. Certainly, brightness of tone and the vitality of colour is a speciality with members of the Society, and I have noticed that dark pictures are now almost a thing of the past, and I want to thank members generally for their loyal response to the matter of lighter frames." [7]

[7] S.I.T., 9/2/1945. Smart was very particular about the manner in which paintings were framed. The Society's Regulations for Exhibitors forbade all black frames and the use of white cut-out mounts for oils and gold mounts for watercolours.

After the War ended, Borlase Smart was not slow to rekindle enthusiasm amongst the artists and to resuscitate the full range of the Society's activities. It was, he said, "a new era" and the traditions of the Society had to be maintained. In 1945, Show Day was moved to a Saturday so that those at work had the opportunity of attending and, in 1947, the concept of two Show Days was introduced, one on the traditional Thursday and the other on Saturday. The need for more hanging space was immediately addressed and confidence amongst members was sufficiently high to countenance a move of the Society's headquarters from the Porthmeor Galleries, that had served so well since the early days, to the recently deconsecrated Mariners' Chapel in Norway Square, which is still used now.[8] This became known as the New Gallery. Smart, writing in 1947, commented:-

> ".. when the crisis passed, public support was so encouraging during the succeeding years that in August 1945, the Society moved across the way into a large empty unconsecrated church, the interior of which was reconstructed to form an art gallery with the most perfect lighting for the pictures. The large crypt has recently been fitted as another gallery to accommodate one man shows and exhibitions connected with the Arts Council of Great Britain. The gallery buildings also provide a home for the sketch club which meets once a week and provides a common meeting ground for serious painters and students of the arts." [9]

Smart was also keen for the Society to resume its promotional activities and Bradshaw must have been intimately involved in the organisation of the provincial touring exhibition which, in 1945, started at Sunderland Art Gallery and then proceeded to Shipley Art Gallery, Gateshead, and the public Galleries in Carlisle and Darlington before terminating at Swindon in January 1946. This exhibition contained 83 works. The most important painting was Dame Laura Knight's *The Young Hop-Picker* and significant oils were also contributed by Lamorna Birch, Arnesby Brown, Charles Simpson, Leonard Richmond and Stanley Spencer. Charles Pears and Maurice Hill, respectively the President and Secretary of the new Society of Marine Artists, exhibited as well as old stalwarts like Lindner, Smart, Park, Ninnes, Hewitt, Shearer Armstrong and Stuart Weir and more recent arrivals like Barry, Rountree, Fuller and one of his students, Isobel Heath, who had one of her war studies selected (see, for example, fig 13.5). Bradshaw's exhibits were *Sunlit Sea* and *Off the Coast of Portugal*, while Kathleen sent a sketch in watercolour of a child's head, which, as it was not for sale, was presumably of Anne or Robert. Stuart Weir contributed the exquisite period-piece still life *Top Hat* (Plate 27), which had won high praise when it was first exhibited at the 1939 Autumn Exhibition :-

> "[Miss Weir] gets away from the obvious in her work and it certainly takes courage to arrange a still life with a top hat in it.....The painting is lovely, and note how easily she does it all. See the flat background in this picture, in fact in all her recent work. While other artists make life difficult for themselves with backgrounds of folds they cannot paint, or windows behind their groups that make the flowers seem as if they were done behind the bars of a prison, Miss Weir's quick sense of proportion eliminates all seeming etceteras, she makes her objects fit a given space, and her backgrounds form part of the decorative whole, and so, we have a real picture, not an illustration for a seedman's catalogue of the post Victorian era."

The exhibitions were very successful with 15,000 visitors in Sunderland alone in the 27 days that the show was there. In each place, the interest taken in the pictures by returning servicemen was remarked upon. In Swindon, there were 2,500 visitors and three paintings were bought by F.C.Phelps for presentation to the town's future Art Gallery. These were Arthur Hambly's *Near*

[8] Millar Watt first suggested the Chapel as a possible site for a new Gallery - S.I.T., 9/2/1945. It was felt by many to be appropriate that the Chapel should become the home of the Society of Artists as the early artist settlers had been one of the principal groups that had contributed funds towards the building of the Chapel in 1902 in memory of Canon Jones and had donated pictures for the decoration of the ecclesiastical upper room and the fishermen's club room underneath.
[9] B. Smart, *The St.Ives Society Of Artists*, The Studio, 1948

13.5 Isobel Heath *Sheet Metal Dept., Munitions Factory* (1944)

13.6 Arthur Hambly *Near Archerton, Postbridge, Devon*

13.7 Francis Barry
Tower Bridge, London - A War-time Nocturne (detail)

(fig 13.6 and fig 13.7 - Swindon Museum and Art Gallery)

Archerton, Post Bridge, Devon (fig 13.6) and two war subjects, Kathleen Williams' *Refugee* and Francis Barry's superb *Tower Bridge, London - A War-time Nocturne* (fig 13.7). Barry did a number of paintings using searchlight patterns for compositional effect and the title recalls Whistler's nocturne featuring fireworks over Battersea Bridge. Phelps also appears to have bought for his personal collection a Maidment watercolour - either *A Bit of Old St Ives* or *Gypsy Encampment, Helston*. In the meantime, Smart negotiated the sale to the new Gallery of his 1943 Royal Academy exhibit *Ebb-tide on the Reef* (fig 8.6), which he described as one of his best sea pictures. It was painted at Clodgy and was a favourite subject, as the same reef features in four of his Royal Academy pictures. This time he employed an unusual technique, painting it first in tempera and then finishing it with thick oil paint put on with a palette knife.[10]

The correspondence with Smart retained by the Gallery reveals interesting insights into the way that he went about organising these shows. He suggested the simple title *St Ives* so as to make use of the holiday connection and recommended the cinema as the best form of advertising. He then arranged to stay a week in the town, acting as guide lecturer and giving a talk on *100 Years of Cornish Painting*. He also visited schools and gave talks to servicemen and groups of women. He signed off by hoping that the Society and the new Gallery might co-operate again with "a really tip-top big show".[11]

When, after the end of the War, Bradshaw was eventually discharged from the Navy in August 1946, Kathleen and he not surprisingly decided that they would like to return to St Ives. While Bradshaw was performing the last of his official duties, Kathleen went down to St Ives with her mother, who had come over from Rhodesia, in order to see what state Ship Studio was in as, during the War, it had been let to a family, who had been bombed out of London. They discovered that the house had not been looked after at all well. The fireplace had been painted with pink emulsion, mattresses and carpets had to be thrown out and, when they tried to repair the broken skylight, a huge amount of sand, which had blown off Porthmeor beach, landed in the house. Bradshaw, on his return, repainted the outside golden ochre and white, a colour combination praised by Borlase Smart in a letter to the local paper in which he urged householders to use colour washes more for their properties so that "St Ives would strike a fresh note of happiness and vitality".[12]

Bradshaw's Porthmeor Studio had also been let during the War. Through Borlase Smart, this had been taken by Wilhelmina Barns-Graham, a non-figurative artist. She had arrived in St Ives in March 1940 to stay with Margaret Mellis, as they had studied together at the Edinburgh College of Art, and she had been tempted to stay on. On Bradshaw's return, she moved into 1, Porthmeor Studios and her husband, David Lewis, commented:-

> "I loved the huge windows of her studio overlooking Porthmeor beach. On the hot, calm days, even though it was the end of the season, the sands were covered with holiday-makers, and the studio was filled with the shrieks of children and seagulls. Then came the majestic storms of autumn and winter when the wind moaned across the roofs and waves pounded up the beach to the granite base of the building, encrusting the studio windows with crystalline spray. It has always seemed to me that Willie's Swiss Glacier series of paintings that followed the balustrades, majestic and sensuous experiences of whites, blues and greys, transparencies and opacities, were more paintings of that window than they were of ice and snow at Grindelwald." [13]

If sand from Porthmeor was a nuisance in Ship Studio, this was nothing compared to the sand problem at the Porthmeor Studios, where sand was banking up at an alarming rate on the beach.

[10] Smart sent five works for inspection by the Gallery Committee. Not every one would agree that it is one of his best sea-pieces.
[11] I am indebted to Clare Taylor of Swindon Museum and Art Gallery for providing me with this correspondence and details of the Gallery's acquisitions. Smart may have been involved in arranging a Society of Marine Artists show in Swindon in 1947. After his death, the connection continued and the St Ives Society's 1949 Swindon show precipitated the split in the Society.
[12] S.I.T., 6/12/1946
[13] Tate Gallery, *St Ives 1939-64*, London, 1985, p.25

By 1944, the dunes so created were some twenty-five feet above road level, affording views directly into some first floor bedrooms. In one storm alone, Smart noted that the sand mountain had increased by five feet.[14] Smart was clearly in touch with Bradshaw about the problem as he stated that "a distinguished Naval Officer" had suggested that the fire service let their hoses play on the bases of the dunes in an effort to undermine them at various points, but the costs involved were deemed unacceptable in wartime. Accordingly, Smart was left to fume about "the daily task of brushing up buckets of sand inside our houses, sealing up all windows, reorganising our larders where no sand can cover our food, and generally speaking, 'living on the front line' like soldiers in the trenches of Dunkirk." When Bradshaw returned, the sand covered a good part of the windows of the Porthmeor Studios. This impacted not only on the quality of light enjoyed by the artists but also on their work, as the sand mountains proved an irresistible lure for the local kids. Brian Stevens remembers that it was considered good sport to distract the artists by making faces through the windows and then slide off down the sand bank, with an assortment of curses ringing in their ears.

Bradshaw was lucky to have a studio to come back to. Many landlords had taken advantage of the War to convert studios, which could only be let out at small rents, into more attractive money-making properties, such as shops and guest houses. One artist was even turned into the street to make way for a fish and chip shop. Of the 100 studios that had formerly existed, only 38 remained. The situation resulted in extended correspondence in the local and national papers. Bradshaw was spared that worry but more serious trials and tribulations awaited him when he rejoined his old colleagues in the Society of Artists.

[14] S.I.T., 18/2/1944

14.1 Maurice Hill *Clifftop Cottage* (David Lay)
Hill was Secretary of S.M.A. and later a member of the St Ives Society

14.2 Charles Pears *Longships Light from Land's End*
Pears' cross-hatching technique for the depiction of water is distinctive

THE SOCIETY OF MARINE ARTISTS

It is extraordinary to recount that it was again Borlase Smart who was one of the principal instigators for the creation of the Society of Marine Artists. In 1938, he wrote to the *Daily Telegraph* suggesting that "contemporary masters of marine art" should join together as a body. This suggestion was taken up by Charles Pears, a distinguished marine artist, who was an official naval artist in both World Wars. In his letter to the *Daily Telegraph*, which was published on 29th December 1938, Pears said:-

> "I have had practical experience in the formation of such a Society. Shortly after the War, I got together the first exhibition of modern paintings this country has ever had and the formation of a Society of Marine Artists was then in view. I have worked steadily with the idea since then, latterly joined by my colleague, Mr Cecil King." [1]

However, Pears considered that, at that juncture, there were too few marine artists to form a self-supporting body and felt that external financial help, either from public funds or from lay members, would be essential for such a Society to thrive.

Encouraged by the considerable correspondence received as a result of the publication of this letter, a meeting was held on Wednesday 22nd February 1939 in the library of the Royal Cruising Club at the Welbeck Hotel, Welbeck Street. Arthur Briscoe, another distinguished marine artist, who had studied at the Slade School under Brown and Tonks and at the Academie Julian in Paris, felt that it was an inauspicious time to start a new Society and "would mean subscriptions for hard-pressed artists with a poor outlook as regards returns". Borlase Smart agreed that present conditions for artists were poor, stating that 1939 had been his worst year since 1919. Nevertheless, he saw the potential of such an organisation. Eventually, it was agreed that a Society with the name 'Society of Marine Artists' should be formed and that the subscription should be one guinea. The initial committee comprised Arthur Briscoe, Arthur Burgess, who had been exhibiting with the St Ives Society since 1931, Frank Emanuel, another artist well-known in St Ives circles, Bernard Gribble, Cecil King, Claude Muncaster, Charles Pears, Borlase Smart, Norman Wilkinson and Lieutenant-Colonel Harold Wyllie.

The first Council Meeting was held on 4th April 1939; fifty-one people had sent in the foundation subscription of one guinea. The annual subscription was set at four guineas and, for exhibitions, charges were to comprise a submission fee of 2s 6d, a hanging fee and a 12% commission on sales by members. Lay members would be encouraged and should pay a subscription fee of one guinea a year, in return for which they would be guests at an annual dinner and receive admission to exhibitions. A picture purchased by the Society would also be raffled amongst the lay members.

At the second Council Meeting, on 16th May 1939, Charles Pears was elected President, Maurice Hill was elected Secretary and Borlase Smart Treasurer. As Charles Pears, being a keen sailor, spent a good deal of the year at St Mawes and as both Borlase Smart and Maurice Hill were based in St Ives, there was a strong Cornish connection within the first Committee and it is not surprising that Bradshaw was encouraged to join. He probably did not need much encouragement, as the Society offered the opportunity of greater exposure to the all important London market. To date, Bradshaw had had few opportunities to show his works in London. He had, of course, been successful a respectable number of times at the Royal Academy, but the St Ives Society of Artists, probably fully cognisant of the London market, had concentrated on exhibitions at provincial Galleries, and members had only contributed to the occasional show in

[1] R.S.M.A., *A Celebration of Marine Art : Fifty Years of the R.S.M.A.*, London, 1986 at p.147

the capital. Bradshaw never managed to find a London agent for his work. He may not have even tried - marine painting, as many of the proponents of the new Society had found - was not fashionable amongst art connoisseurs, who had already turned their attention away from traditional art to embrace modernist trends.

At a General Meeting held on 24th April, the Committee reported that they felt that the inaugural exhibition of the Society should be held at the New Burlington Galleries but the outbreak of the Second World War resulted in the indefinite postponement of this exhibition. Bradshaw, whether for reasons of personal preference or for reasons of cost, was not an extensive traveller and did not accompany Borlase Smart to any of these initial meetings of the Society. However, as one of the founder members of the Society, he contributed two works - *The Crabber* and *Frenchmen in the Bay* - to the United Artists Exhibition at the Royal Academy, which was shown between January and March 1940, the proceeds of all sales being divided equally between the Lord Mayor's Red Cross and St John's Fund and the Artists' General Benevolent Institution. A room at the exhibition was specifically set aside for marine paintings.

A second United Artists' Exhibition at the Royal Academy in 1941 was prevented by bomb damage and was eventually staged between January and March 1942 and, again, Bradshaw exhibited as a member of the Society of Marine Artists, contributing two works *The Night Watch*, a barque under moonlight and his 1935 Royal Academy exhibit *Cruisers Manoeuvering*, a painting that now had topical interest. A reduced subscription of two guineas was asked by the Society for 1942, the first subscription being deemed to be effective until the end of 1941.

Also in 1942, the Society began a series of exhibitions at provincial galleries and between 23rd March - 19th April, ninety-two works, submitted by thirty-five members of the Society and four non-members, were shown at the art gallery in Peel Park, Salford. Bradshaw was again represented. In 1943, a third United Artists' Exhibition was held at the Royal Academy, in which nearly 1,100 pictures were hung. Twenty-one artists exhibited in their capacity as members of the Society of Marine Artists, and Bradshaw contributed some new wartime works, *Night Raid* and *In Convoy*. The subscription for the Society for 1944 was reduced to a token 10s 6d, purely to cover incidental expenses, but no meetings of the Committee were held between 21st October 1943 and 29th June 1945.

At the beginning of 1946, the members of the Society again made a significant contribution to an exhibition of naval art held at the Suffolk Street premises of the Royal Society of British Artists but the inaugural exhibition of the Society itself was not held until 14th November 1946 at the newly constructed Guildhall Art Gallery in the City of London. The display comprised one hundred oil paintings and about seventy water colours and Bradshaw's contributions were two oils entitled *French Crabbers off the Cornish Coast*, his great success at Show Day in 1939, which he indicated at the time he had reserved for the first exhibition of the new Society, and *Early Morning off Sunderland*, one of the few paintings he completed during his northern sojourn. The exhibition was opened by the Right Honourable A.V. Alexander, First Lord of the Admiralty, who had recently been elected Minister of Defence. In the introduction to the 1947 Exhibition, Charles Pears referred to the inaugural exhibition as a "pronounced success" and that "the Society finds itself one of no small importance, thus justifying the prophecy of those who advocated its foundation."[2]

One of the declared objects of the Society was to improve the public's appreciation of marine art and to obtain recognition that such art was an essential feature of the artistic life of a maritime nation. Accordingly, it must have been particularly satisfying for the founder members that the public quickly showed a considerable interest in the Society's own exhibitions. In 1948, when Bradshaw was showing four oils, entitled *Summer Night*, *St Ives Crabber*, *Bringing in White Heather* and *Hauling Pots in Rough Weather*, 11,000 people viewed the exhibition. *Summer*

[2] I am considerably indebted for all the information included so far in this chapter to Arthur Credland's history of the R.S.M.A. included in R.S.M.A., op.cit,.p.147-53

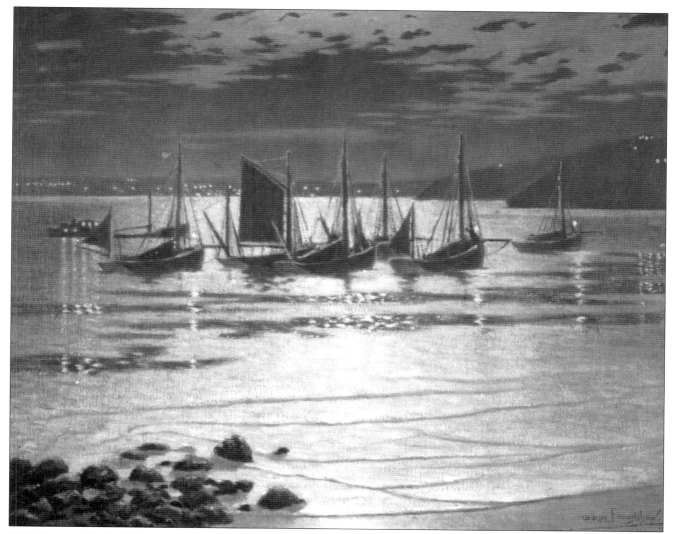

14.3 *Summer Night* (Oil on canvas)

Night came on to the market in 1990 and is a fine picture, depicting a group of French fishing boats, anchored off Porthminster beach, silhouetted in the moonlight, with the lights of Godrevy in the distance. Bradshaw has captured in a delightful fashion the twinkling of the lights of the boats on the water and the moonlight bathing the gentle waves lapping on the seashore. In the following year, the attendance at the S.M.A. Exhibition reached nearly 14,000. In the catalogue, Charles Pears wrote:-

> "The Society of Marine Artists is now one of the most successful art societies. Curators, asking why it is so, answer the question by presuming that it is good organisation. That may well be, but there is another reason - Marine Painting was a neglected Art until the Society was formed and now it is being regarded as a very important medium of artistic expression with a large and very faithful collection of appreciators."

At this exhibition, Bradshaw exhibited two oils, *In St Ives Bay* and *The Stranger*, both of which he had exhibited previously in the Spring Exhibition of the St Ives Society of Artists, when they were priced at £42 and £25 respectively. *In St.Ives Bay* (Plate 31) is again a delightful work, full of movement and fresh colour. It is a sunny, but breezy day, as the choppy water and white horses testify, and a French crabber under full sail is thundering towards us, sending spray over her bows. A trawler is shown in profile on the left heading out to sea, with Godrevy lighthouse behind her bow and, being under power with only her steadying sail up, her movement through the water is quite different. Unusually, for a St Ives boat, on either side of her foremast are trawl gallows - large U-shaped frames. John McWilliams, who takes a keen interest in St Ives fishing boats, feels that the boat is loosely based on *Girl Renee* - ss 78, a large trawler built in Brixham

for St Ives in 1946. Her novel features would have immediately attracted Bradshaw. He comments on the other boats in the background as follows:-

> "To the right, a white pleasure launch with a brown varnished canopy or steering shelter is taking some, surely very sick, visitors around the Bay and, in the distance is the white sail of a yacht, probably the Paynter family's *Mamie*, on a similarly gruesome mission with her freight of now repentant trippers." [3]

The pleasure launch was a new arrival on the scene, the first of these, *Gay Dawn*, owned by Cyril and Bill Stevens, being registered in 1947.[4] Bradshaw highlights, therefore, the variety of craft that could be found in the Bay at any one time - local and foreign, working and pleasure, new and old, under sail and under power.

One of Bradshaw's 1951 exhibits, *Moonlight Bay* (Plate 35), was subsequently given to his son as a wedding present. The scene is again St Ives Bay, but this time Bradshaw uses a higher vantage point and incorporates the dark mass of the old harbour breakwater as an interesting break in the composition in the near foreground. This provides a sharp contrast to the moonlit waters, touched with a golden tinge. Amongst the lights in the background, he has depicted the carriages of the St.Erth - St.Ives train. Robert remembers accompanying his father on sketching outings to this spot at night and Bradshaw executed various versions of this scene from slightly different positions.

Although Bradshaw played little part in the administration of the Society, he continued to submit good quality works to the Society's exhibitions for the remainder of his life. In fact, as his art no longer found favour with the Royal Academy, he reserved his best work for the S.M.A. Exhibitions. Here was a Society that valued the traditional skills of the artist - a place where technique was appreciated and applauded, rather than despised, and where realism based on keen observation was still recognised as a valid goal. His paintings hung with works that complemented each other, by artists whose ability had to be high enough to meet the stringent requirements laid down by the Society for new members. In 1950, Charles Pears commented:-

> "The standard of the Society of Marine Artists is being very carefully watched, and it is pretty difficult to get elected as a painter member; the new blood just has to be found, and of the right group."

Charles Pears was a strong and outspoken leader. As Claude Muncaster later commented, Pears had a loathing "of any kind of humbug, either in art, in life generally, or in his contemporaries. If this at times made him forthright in speech, it was a quality which endeared him to his friends, for one realised at once that here was no hypocrisy." [5] Pears, after the War, frequently exhibited with the St Ives Society of Artists and Bradshaw, his fellow Vice-President, would have had empathy with Pears' views on modern art, which he was unafraid to express in the Foreword to various exhibition catalogues. For instance, in the 1952 catalogue, he commented:-

> "Fortunately we have no need to worry about artistic controversies, art dictatorships, distorters of the form divine, Himmlers of imbecility, and the incompetent forms of ultra Modern Art. You can't distort the sea and its meanings, you can't order it about, and there is nothing but hard work and deep study which will enable an artist to make it live on canvas. A ship has two sides and they are both exactly alike, the top edge of these sides is called the sheer - often a line of beauty, and it takes skill and observation to draw such things correctly. It must be a pleasure to the ship-lover to find these things truly done. Yet, as things are trending, it will not be long ere a generation of artists will be produced who will be quite unable to draw such things, and this is only one of the reasons why the work and tradition of this Society must be encouraged and built up."

[3] Letter to the Author dated 30/12/1999
[4] *Gay Dawn* was soon followed by a little group of similar craft - Pollard's *Silver Star* and the Paynters' *Cornish Belle*, *Blue Bell* and *Cornish Queen*. I am again indebted to John McWilliams for this information.
[5] S.M.A. Exhibition Catalogue 1958, Foreword

14.4 Charles Pears *Sailing Vessel* (W.H.Lane & Son)

Bradshaw's exhibits at the S.M.A. seem to have been exclusively oils. The prices attached to the works tended to be between £30 and £60 but, in 1951, he clearly exhibited a major work, entitled *Coming on to Blow*, which he priced at £105 and the works *In Mounts Bay* (1954) and *The Western Ocean* (1956) were each priced at £63. At most Exhibitions, he showed three works. A full list is included in Appendix 2.

When Charles Pears died in 1958, the presidency of the S.M.A. was assumed by Claude Muncaster, who was already President of the St Ives Society of Artists. Two other officers of the St Ives Society at the time, Bradshaw and Hugh Ridge, were also S.M.A. members. The close links between the Societies continued for many years.

15.1 Shearer Armstrong *Girl with Green Apple* (1942)
Armstrong was one of the few long-standing members to be influenced by Nicholson

THE GREAT RIFT

The damaging split in the St Ives Society of Artists engineered by Ben Nicholson and Barbara Hepworth in February 1949, when the entire section of modern artists resigned, may have been predictable but the manner in which it occurred caused considerable ill-feeling. Bradshaw, who played a leading role as spokesman for the traditionalists, came to the inescapable conclusion that he had been 'set up' and, for the rest of his life, would cross the road, if he saw Ben Nicholson approaching, so as not to have to acknowledge his presence, and would often shake his stick at Barbara Hepworth. Bradshaw, in fact, found it very difficult to control his wrath at the decimation of the Society that had so painstakingly been built up over the last twenty-two years. Barbara Hepworth admitted to being "terrified of the Commander".

The seeds of discontent within the Society had been sown long before Bradshaw's return from Sunderland in 1946. During the War, Borlase Smart felt that it was wrong that Ben Nicholson and Barbara Hepworth, who had already established international reputations, should be living in the locality and not be members of the Society of Artists. Although, originally, he had had little time for modern art, which he had described as "the cult of the ugly", his views had subsequently become much more progressive. Accordingly, he contacted Wilhelmina Barns-Graham and asked her to effect an introduction. In a letter written in 1984, she recalled her impressions of Borlase Smart and this event:-

> "Borlase Smart was an academic painter and it is to his credit, in these last years of his life, he had an ever-increasing open mind, tremendously energetic and busy devoting himself to widen the Society with 'new blood' and arranging travelling exhibitions at home and abroad.
>
> After many talks together, Borlase thought it deplorable having artists living in the area of the calibre of Ben Nicholson and Barbara Hepworth not exhibiting in the St Ives Society of Artists, and knowing I knew them, and he had got hold of a catalogue about them, asked for help. He was primarily an enthusiast and this is the word I used when preparing the way for Borlase with my telephone call to Ben Nicholson, himself an enthusiast and a feeling for people he'd call 'very alive'.
>
> Borlase immediately followed up this introduction and returned to my Studio with his success. BN and BH had agreed to exhibit in the Gallery! He later came in for some harsh criticism from his colleagues for 'bringing in the moderns with their rubbish'! He was quite undaunted, passionate for knowledge - eager to learn, for sharing and an understanding of art, however much in contrast to his own work.
>
> Only a matter of weeks and days before his last illness in 1947, with me sitting at his feet at St Christopher's Guest House, where he was a frequent visitor, and I was a resident, he excitedly announced to me, hissing his s's as was his manner of speech, he said 'I have just done my firsst and besst painting'! He was 65!" [1]

Ben Nicholson and Barbara Hepworth joined the Society in 1943 and on Show Day in 1944, Borlase Smart invited Ben Nicholson to exhibit along with him in his studio. The astounding contrast was remarked upon by the reviewer in the *St Ives Times*, who commented, "This innovation of modern art was a surprise to many visitors". It was a shock to his colleagues.

[1] Tate Gallery, *St.Ives 1939-64*, London,1985, p.102

15.2 Borlase Smart and Leonard Fuller outside Fuller's School of Painting

(Roy Ray)

15.3 Harry Rountree in his studio
(*Gulls* picture on floor) (Roy Ray)

15.4 Harry Rountree *Gulls in the Harbour*

(W.H.Lane & Son)

Smart emerged from the War years bursting with new ideas, as he strove to give the Society as high a profile as it had enjoyed in the late 1930s. As always, he was keen to bring Art to a wider public and to remove any stigma of elitism. He hoped that the Crypt of the New Gallery could be used for further exhibitions of works by amateurs and local schoolchildren, such as those that Fuller and he had already organised during the War, and for free lectures on Art aimed at the general public. He envisaged a form of community centre devoted to fostering greater awareness of and interest in a wide range of artistic and cultural pursuits. His proposal in 1945 to move Show Day to a Saturday to enable the ordinary worker to participate is typical of his line of thinking at this period. In 1946, Smart suggested that the Society should market itself more in Cornwall itself; he was particularly keen to introduce Art to Cornish villagers. To this end, he suggested mounting small displays in farmhouses or inns. "The reaction of the farming community, who are very close to nature, would be most interesting." - he observed.[2] He persuaded Egbert Barnes of St Austell of the value of bringing contemporary art to people living in inland centres and a series of exhibitions were mounted at The White Horse Hotel in St Austell, sponsored by the St Austell Brewery. A special show, devoted solely to *Cornish Inland Landscapes*, was staged in January 1946 and works by Smart, Nicholson, Barns-Graham and Dorothy Bayley were bought by the directors.

A more obvious target were visitors to other Cornish resorts and the first show aimed at this market was held in Newquay in August 1946. The following year, Smart arranged a large travelling exhibition around some of the principal towns in the county, including Bude, Falmouth, Truro, Fowey and Perranporth, with excellent results.

Another innovation was what Smart termed "the biggest art event of its kind ever to be seen in the Duchy" - an exhibition of *Great Masters of British Art*, lent by the Walker Art Gallery and organised by the Society in conjunction with the Arts Council. For three weeks, paintings by famous names of the past, including Reynolds, Gainsborough, Turner, Wilson, Zoffany, Raeburn and many others, were able to be viewed in Smart's Porthmeor studio.[3] Yet again, only Smart would have been able to pull off such a coup.

Smart, however, had even grander plans. He wanted the Society to take to the international stage and he achieved this by organising a touring show to South Africa of 150 works to coincide with the King's visit in March 1947. Most members of the Society were represented, but the modern contingent did not find favour, with only Barns-Graham being included.[4] The Exhibition commenced at the Maskew Miller Art Gallery in Cape Town, which acquired Park's painting for its permanent collection, and then moved on to Johannesburg.[5] Smart's further overseas plans were to hold touring exhibitions of the Society in the U.S.A., to pick up on the interest of American troops who had been stationed in Cornwall during the War, and in Brittany, which he termed "the French counterpart" of Cornwall.

The Society's own shows in the New Gallery were immensely popular. In fact, the explosion of interest in art after the War was quite remarkable. Whereas just before the War, the Society could be sure that 600 catalogues would be sufficient for an exhibition, in 1947, they were having to produce 6,000 and the New Gallery that year had 18,000 visitors.[6] Just twenty years before, in the Society's first year in the Porthmeor Gallery, the figure had been 500. What a success story!

Despite all this activity and good levels of sales, Smart was aware of tensions building up between the traditional artists, many of whom had been close friends and stalwarts of the Society prior to

[2] St Ives Times ("S.I.T."), 9/8/1946

[3] A full list of the artists included in this exhibition is given in S.I.T., 26/4/1946

[4] A list of artists included is set out in S.I.T., 1/11/1946. An initial notice in S.I.T., 13/9/1946 stated that 150 works had been invited and that the Society was making the selections. However, only 121 works were sent from St Ives. It may be that other works were added in London, either from the Tate's collection or from the studios of artists based in London. If the final selection was not influenced by the South Africans, it is surprising that the moderns were so poorly represented.

[5] It was hoped that the show would then move to Durban, Bloemfontein and Pietermaritzburg but I have not established whether this occurred.

[6] In addition to the normal exhibitions, the New Gallery hosted a retrospective devoted to the late Ernest Procter.

the War, and Ben Nicholson and Barbara Hepworth, around whom had gathered a number of young non-representational artists, such as Peter Lanyon, Sven Berlin, John Wells and Bryan Wynter. The modern contingent felt that their works were not appreciated and, even if selected, tended to be placed in a corner of the New Gallery near the font. In 1946, a number of the young modern artists put on their own exhibition in the Crypt of the Gallery. This was opened by Borlase Smart, which infuriated some of the traditional artists. Harry Rountree immediately wrote to *The Western Echo*:-

> "Surely those who are encouraging our young modern artists are doing a great dis-service both to the artists and art. What a pitiful racket this alleged art is ... Fifty years I have been a professional artist and I see nothing original in these alleged modern ideas ...This modern racket started in France; it rotted French art - in France it is now dead...Young men, drop it, get back to work and sweet sanity".[7]

In subsequent correspondence, Rountree makes reference to Borlase Smart:-

> "I would remind him that some people are so tolerant that they hunt with the hounds and run with the hare. Surely this brand of tolerance commands no respect".[8]

15.5 Tea in the Studio - with Peter Lanyon (hiding Guido Morris), Sven Berlin, Wilhelmina Barns-Graham and John Wells
(Estate D. Val Baker)

[7] Western Echo, 21/9/1946
[8] Western Echo, 5/10/1946

Borlase Smart was unbowed:-

> "I have been accused of running with the hares and hunting with the hounds. That is precisely my outlook, as I definitely intend to like the best in both traditional and advanced art".[9]

This, then, was the atmosphere within the Society when Bradshaw returned to St Ives. Borlase Smart had always referred to Bradshaw as "my old faithful one", in recognition of the unswerving support that Bradshaw had given him over the years. It is doubtful, however, whether Bradshaw would have felt able to support Smart at this juncture and, although Rountree's outburst was further discredited when it appeared that he had not even visited the Crypt Group exhibition, Bradshaw shared other members' concern at the direction in which the Society was heading.

Bradshaw had difficulty with the modern painters for a number of reasons. In common with the other traditional artists - and many other people at that time -, he had difficulty in understanding what modern art was seeking to achieve. The tendency of the moderns to ignore or to be disinterested in technique was the key issue. He could appreciate the work of Picasso, as he considered that Picasso was a fine draughtsman. However, there was little he could detect in the work of the majority of the St Ives modern section that demonstrated any mastery of the basic painterly skills, such as drawing, composition or use of colour. If the creation of an illusion of reality was also to be dismissed as unimportant, then the traditional yardsticks by which paintings had been judged for centuries had been discarded. As an artist who had striven after realism throughout his career, he found non-representational work difficult to judge, and where, in his view, painting technique was also absent, he gave short shrift to contentions that such art was not only worthy but also the way forward.

Bradshaw's inability to accept any form of compromise with the modern artists may have been affected by issues outside art. Bradshaw was one of the generation that had been forced to serve its country in two World Wars. After his traumatic experiences of the Great War, he resented being required to give up his idyllic existence in St Ives for further service during the Second World War, particularly as his health had suffered as a result. He had little respect, therefore, for pacifists, like Nicholson, who had avoided active service. Furthermore, he had maintained the Victorian values of his upbringing and did not approve of the way of life and morals of some of the modern painters. Consequently, he had difficulty both on a personal and artistic front with these artists, whom he felt had infiltrated his Society and "soiled his patch".

At his last A.G.M in June 1947, Borlase Smart, now President and Secretary, appealed to members to "think widely and work vitally" as the standard of their shows must be progressive - their tradition demanded it and their representation hung on the issue.[10] His wish was fulfilled at the exhibition of 132 selected works held at the National Museum of Wales in Cardiff in October that year. Side by side with a range of Royal Academy exhibits from recent years by traditional artists such as Leonard Fuller, Dod Procter, Charles Pears, Maurice Hill, Stanley Gardiner and Thomas Maidment were modernist works by Nicholson, Barns-Graham, Lanyon, John Wells, Bryan Wynter and Terry Frost, with sculpture by Hepworth and Sven Berlin. The list of exhibitors was impressive with contributions also from the late Stanhope Forbes, Lamorna Birch, Charles Simpson, Stanley Spencer, Richard Weatherby, Norman Wilkinson, Bernard Fleetwood-Walker and stalwarts like Smart himself, the Bradshaws, Richmond, Sharp, Smith, Hewitt, Bottomley and Ninnes. This mix of traditional and modern was the direction that Smart wanted the Society to take and the modernists cannot complain that they were inadequately represented in this show. However, the day after the Exhibition ended, Smart was dead and his vision died with him.

To what extent Smart would have been able to have diffused the tensions within the Society is

[9] Western Echo, 19/10/1946

[10] S.I.T., 6/6/1947. When Moffat Lindner decided to resign as President of the Society in 1946 at the age of 94, Dod Procter was elected to the post for a year but Borlase Smart assumed the Presidency in 1947

debatable. At least, he did not live to witness the implosion and, at the date of his death, he could take justifiable pride in the national reputation of the Society which, to a very considerable extent, was the result of his own extraordinary efforts. No-one else would have achieved so much - and there was no other member who could boast the same combination of characteristics that had made him widely respected - unquestioned integrity, never-ending energy and enthusiasm, an open and enquiring mind and a selfless approach. His death left a void that was impossible to fill.[11]

In selecting their preferred choice to succeed Smart as President, the Society aimed high - no less than the President of the Royal Academy - , and when it was announced at the 1948 A.G.M. that Sir Alfred Munnings had accepted, cheers rang round the room. It was no doubt recognised that Munnings would mainly be a figurehead, giving increased kudos to the Society. The day-to-day administration of the Society would be in the hands of its other elected officers, Chairman - Smart's life-long friend, Leonard Fuller, Secretary - David Cox and Treasurer - E.W.Colwell. Other members on the Committee were Birch, Park, Richmond, Dorothea Sharp, Marcella Smith, Shearer Armstrong and Fred Bottomley, with the moderns being represented not by Nicholson or Hepworth but by Peter Lanyon and Hyman Segal. Bradshaw is another notable absentee and, given such a large and distinguished Committee, his ability to influence its deliberations is questionable and yet, in the catalogue to *St Ives 1939 to 1964*, David Lewis, the former husband of Wilhelmina Barns-Graham, comments:-

15.6 Dorothea Sharp in 1940 with typical examples of her work (The Artist)

[11] A memorial fund was launched in his honour and the funds raised, when combined with a generous Arts Council grant, enabled the Porthmeor block of studios to be acquired from Moffat Lindner and placed in trust. Without such action, there is little doubt that the studios would long ago have been redeveloped. Unfortunately, Helen Knapping's bequest of the Piazza studios to the RBA did not result in redevelopment being thwarted.

"The Society was dominated by a feisty old painter of storms at sea, Commander Bradshaw. He was as violently opposed to modern art, particularly art of the non-figurative variety, as his seas were to the puny ships they tossed about. Because no-one had the courage to stand up to the redoubtable old sea-dog with the walking stick, modern works were relegated to a small area by the big doors. I wasn't sure whether they were being permitted charitably to come a little way in, or were made, like naughty children, to stand in the corner: but there you would find a group of small things by Ben and Barbara, and also one or two paintings by Lanyon, Wells, Wynter and Barns-Graham. It was not much, but something. There was a feeling of revolt in the air, a quiet sense of advances being made." [12]

Certainly, during 1947 and 1948, there was an increasing trend by the younger artists to hold one-man shows, frustrated by the limited opportunities that the Society offered them.

If Lewis' words record the perspective from the modern painter's point of view, the fears of the traditional artists were heightened by changes to the rules of the Society, which were rushed through at the 1948 A.G.M. without anyone, other than the Secretary, David Cox, having the ability to consider them at any length. One of the changes meant that there was now no guarantee that a member of the Society (members always being elected on merit) would have at least one work hung at each exhibition. Nicholson's influence on this amendment was noted. The traditional artists are normally accused of having blinkered vision, but Nicholson was also not noted for having an open mind. In 1926, he had become Chairman of a London Society known as the Seven and Five Society, which included John Piper and Ivon Hitchens. Having purged the Society of watercolourists and portrait painters, he then insisted that all exhibits should be non-representational, which so divided the membership that many either resigned or were voted off and the Society came to an end.

The discovery that the Society held another Exhibition at Swindon at the beginning of 1949 explains why matters came to a head at that time.[13] The new rule - that membership did not guarantee selection - may have been in place for some months but this was the first practical application of it, for the catalogue reveals some notable absentees from the list of exhibitors. Of particular interest, in view of their later actions, is the exclusion of works by Harry Rountree, T.H.Robinson and Frances Ewan but Pauline Hewitt, Helen Stuart Weir, Helen Seddon, Maurice Hill and Midge Bruford are also unusually absent. The courtesy of including one of Lindner's works had also been ignored. This exclusion of respected colleagues from the Exhibition spread alarm amongst the traditionalists and three Committee members, Dorothea Sharp, Marcella Smith and Fred Bottomley, also expressed their unease at how matters had been handled.

Aware that tensions were rising, Nicholson and Hepworth devised a way to bring about a major fission in the Society. The ploy decided upon was to stir up Harry Rountree. In the words of Sven Berlin, "That cock-sparrow of a little man was ginned up and emasculated" by the "abstemious" Ben Nicholson and the "calculating" Peter Lanyon.[14] Quite what was said to Rountree has not been recorded, but from his comments the following year, one can hazard a reasonable guess. Rountree had had great success with a series of advertisements for Cherry Blossom polish and in *Down Your Way* in 1950, he came out with the quip that Fine Art was only bad commercial art. Rountree claimed such views were expressed tongue-in-cheek but one suspects that Rountree had been informed the previous year that the Society was a Fine Art Society and that, as he was a *commercial* artist, he could not expect to be hung.

[12] Tate Gallery, *St.Ives 1939-64*, London,1985, p.26

[13] No mention of this exhibition has, to my knowledge, been made before, its very existence being submerged by its consequences. I am indebted to Clare Taylor at Swindon Art Gallery for discovering the old catalogue. The exhibition opened on 29th January but the selection process will clearly have taken place some weeks before. The letter requisitioning an Extraordinary General Meeting is dated 25th January. The exhibition itself was small by the Society's standards, comprising just 72 works. Major pieces were contributed by Lamorna Birch, David Cox, Leonard Fuller, John Park, Charles Pears, Dod Procter, Leonard Richmond and Richard Weatherby. The modern artists were, however, fully represented as well.

[14] S.Berlin, *The Dark Monarch*, London, 1962, p.167

15.7 Barbara Hepworth in her Trewyn Studio home (Estate D.Val Baker)

15.8 Harry Rountree - Signature with typical bird illustration (Roy Ray)

Whatever was said, the result, as anticipated by Nicholson and Hepworth, was that three of the excluded artists, Harry Rountree, T.H.Robinson and Frances Ewan, along with the three dissatisfied Committee members Dorothea Sharp, Marcella Smith and Fred Bottomley, found support from George and Kathleen Bradshaw, Bernard Ninnes and [H]Todd-Brown for their proposal to requisition an Extraordinary General Meeting "to discuss a more satisfactory conduct of the above-named Society which would be more in keeping with traditions of the said Society".[15]

The signatories felt that the whole ethos of the Society, which had bound the artists together for over twenty years, was threatened. Bradshaw was elected spokesman and read a statement to the meeting. The minutes, as later published by the traditionalists, record:-

> "This statement paid tribute to Moffat Lindner and Martin Cock for the work they had done for the Society in days gone by. It taxed the Chairman for not holding a tight enough rein on his Committee and for taking matters too much into his own hands. The Honourable Secretary was accused of acting too much on his initiative and without reference to his Committee. The signatories considered that all members having been elected on merit should be entitled to have one work, at least, in each exhibition.

> Finally, it was strongly claimed that the existing rules of the Society were inadequate, that the manner in which they had been introduced at the A.G.M. in 1948 had not allowed the members an opportunity of proper consideration or discussion, and that they should, therefore, be re-drafted and submitted for consideration to the next A.G.M..

> A great deal of discussion then took place concerning the adequacy of the present rules. Commander Bradshaw, for the ten signatories, stated that the rules in question were presented at the last A.G.M. in a final printed form before hardly anyone, other than the Secretary, had seen them at all. Some further discussion ensued as to their legality, and it was pointed out by the Secretary that the said rules had been voted on by those present at their last A.G.M. when 22 had voted in favour and 11 against their adoption. It was generally agreed, however, that this had not been satisfactory and it was decided that the rules should be revised and properly submitted for approval.

> By agreement, the second proposal on the agenda was not taken to the meeting, and it was then agreed, by a substantial majority, to elect an ad-hoc committee of 7 members, including the Chairman of the Society, to draft revised rules which should be circulated to all members, so as to allow time for their adequate consideration and subsequent adoption or amendment at the next A.G.M..

> The Chairman then announced that Mr David Cox had tendered his resignation as Honorary Secretary of the Society, and Mr Cox, in stating his reasons, said that he had always worked for a progressive, vital and catholic Society, and one which encouraged the introduction of young and promising artists. He could not operate on any selection jury which did not, in his opinion, work to the highest artistic standards.

> The Chairman then made it clear to the meeting that his views also were at variance with those of the ten signatories, and the meeting was then declared closed." [16]

These minutes do not begin to indicate the stormy nature of the meeting and the strong emotions that were aroused - emotions that affected many participants for the rest of their lives. Hyman Segal, one of the young modern artists who resigned (but who later fell out with Nicholson), recalled the scene in 1986 in his witty account *Storm In A Paint Pot - A Private View*:-

[15] Richmond, Park and Birch - all Committee members - , although not available to sign, would no doubt also have supported the motion. The minutes refer to three Todd-Browns - A., H., and W. H.Todd-Brown has proved elusive. William would seem the most likely to have been the signatory.
[16] S.I.T., 18/2/1949

"It was in the winter of 1949 that a gale force wind hit the backwaters of the unconsecrated Mariners' Church, the home of the St Ives Society of Artists. A Most Extraordinary General Meeting had been convened by some dissident members, and a Naval Commander - painter of sail and sea - held his fist aloft and brandished it uncomfortably close to the chin of the Chairman, a respectable, respected portraitist. The old sea-dog's quarter-deck expletives thundered and gusted within quiet walls which here-to-fore had echoed but approbation or mild criticism. They now shuddered at the stormy sounds of character assassination. Brother Brushes bristled, and the Chairman resigned. The raised fist became a signal for mutiny. A number of youngish artists abandoned ship, stripping their work from the corner of the Gallery which had harboured it grudgingly for a while as a hand-across-the-sea gesture to Contemporary Art".[17]

Sven Berlin's account of the meeting in his book *The Dark Monarch* concentrates on the role of Nicholson and Hepworth in pre-planning the split and orchestrating the resignations. In the book, which is presented as if it were fiction, Nicholson is referred to as 'Sir Stanislas' and Hepworth as 'Coracle'. After Bradshaw's criticisms of the actions of the Committee, some of the modern artists suggested that the Committee members should resign and a good deal of heckling was promoted. Berlin comments:-

"I watched Stanislas observe the fall he had planned, as he had watched others he once told me in the past, when only he was left.[19] A face cold and uncompromising, transparent as white alabaster. Coracle, more active, with a head like a Archipenko in white marble, drove her hecklers, but, like Sir Stanislas, did not speak herself. I was feeling sorry for my friend the Secretary, who stood in the light looking just like the ghost of Robert Louis Stevenson, with his trailing moustaches and white face, his fingertips touching the table, unable to make himself heard.

"I demand a vote of confidence in the honourable Secretary!" I shouted.

"Expel him!" shouted another.

"Resign!"

"Get out!"

"Die!"

"Take a bloody aspirin and disappear!"

Coracle dug me in the back. "Expel. Expel. Expel!" she hissed in my ear.

"Go to hell, woman!"

"Shout 'Expel!', you fool!"

"Damn you, I won't!" - I shouted angrily. "Shut up telling me what to do!"

Other artists shouted for her and I wept in my heart for their betrayal.

When I came out under the cold moon, I felt the bowl of light had been broken. What tigerish act was this? What destruction of an organism that could well have been resuscitated! What vandalism had been done?" [19]

In his autobiography, Sven Berlin gives a similar account of the meeting and comments that the continued dedication of Borlase Smart and others to the traditional structure of art "was an

[17] H.Segal, *As I Was Going to St Ives*, St Ives, 1994, p.97

[18] This is a reference to the Seven and Five Society.

[19] S.Berlin, *The Dark Monarch*, London, 1962, p.167-8

15.9 Leonard Fuller *Sven Berlin* (Roy Ray)

honest and valuable contribution to preserve the setting where an Art might grow and absorb the
new life force with each generation. That it became hidebound was inevitable, but this, like dead
limbs in a tree, can be dealt with by an honest surgeon. It was not necessary to fell the tree and
replace it with a sapling with square roots."[20] Berlin decries that the "hard intellectual thought" of
Nicholson's circle should have been the death of romance:-

> "No more the apple blossoms of the wise old painters and those few everlasting seas. The
> tragedy was that these should die along with the meringues and shortcake and the
> toothpaste marvels of the bloomered Lesbians."[21]

[20] S.Berlin, *The Coat of Many Colours*, Bristol, 1994, p.173
[21] S.Berlin, *The Dark Monarch*, London, 1962, p.167

15.10 Bernard Ninnes *St Ives Harbour - The Fleet preparing to Sail*
(Phillips, Exeter)

The extraordinary respect that the majority of artists had for Borlase Smart is evidenced by the fact that both camps, after the rift, claimed that they had retained the moral high-ground by following the principles espoused by Borlase Smart. Accordingly, the new Society formed by the breakaway group, which was called 'The Penwith Society of Arts in Cornwall', stated that its aim, as visualised by the late Borlase Smart, was to present exhibitions of "the most vital art and craftsmanship, regardless of label, in the Penwith area of Cornwall". Later, it was claimed that the Penwith Society had been "founded as a tribute" to Smart.

On the other hand, at the first A.G.M. of the St Ives Society of Artists after the rift, the Vice-President, Bernard Ninnes, stated that, although another Society had been formed, which claimed to be carrying out the ideals of Borlase Smart, he thought that Captain Smart's whole heart was in the old Society, and had he known of the crisis which had occurred during the last year or so, he would have approved of what they had done in trying to pull the Society out of the mire and put it once more on a sound foundation. These comments provoked a strong response, in particular from Smart's widow. She stated:-

> "At the Extraordinary General Meeting, held in February, it was evident that the ten signatories who had the meeting called, were throwing over the Borlase Smart tradition, and it was on this point, and this point only, that the eight or so members resigned from the Society, among whom were lifelong friends of my husband. Mr Leonard Fuller and Mr David Cox stated at that meeting, and in the press afterwards, that they would never agree to go back on Borlase Smart's policy, which was a progressive one embracing modern art, with exhibitions for the advancement of art in Cornwall, and for the highest possible standard in work shown at the Gallery; which policy he knew, in his last months, was not acceptable to several of those whose names were on the statement read at the Extraordinary General Meeting. Having split the Society on this question of principle, it is amazing to have Mr Ninnes now use my husband's name as he did at the A.G.M. on March 31st. Borlase Smart stood for kindliness and tolerance and would never have associated with a policy based on vindictiveness and intrigue as displayed at the Extraordinary General Meeting." [22]

From these various accounts of that landmark meeting, one can only conclude that Bradshaw's

temper got the better of him. The question that has intrigued me is 'Why?' In histories of the modern movement, Bradshaw has been portrayed as a feisty old retired Naval Commander, who dabbled in art and was incapable of countenancing non-representational work. He is presented as the archetypal reactionary. That is much too simplistic. I have shown that Bradshaw was a, if not the, prime instigator of the formation of the Society. During its heyday in the 1930s, the Society was a central feature in Bradshaw's life - it was, as he said, "his patch". Unlike other St Ives artists, he did not travel extensively and so he was the ever present stalwart, on hand if the need should arise. Bradshaw also did not exhibit with the range of other Societies that his colleagues did and so relied heavily on sales at the Society's Exhibitions. The welfare of the Society, therefore, was of paramount importance to him and he must have been immensely proud that the Society that had started out so tentatively had blossomed into a nationally acclaimed body.

In the tense atmosphere within the Society after the War, and in particular, after Smart's death, there was clearly some jostling for position, with Nicholson and Hepworth, frustrated at the luke-warm reception given to the work of the modernist members, seeking a greater input. What alarmed Bradshaw and the other signatories about the change to the rules that had been rushed through was their perception that it signified an attempt by Nicholson to gain control over the future direction and make-up of the Society. The point at issue - the right of a member to have at least one work selected per exhibition - may not seem of fundamental importance. In a vibrant Society - it could be argued - the hanging committee, keen to put on the best show, should be able to exclude an artist if his or her contributions fell below the requisite standard on that occasion. However, the ten signatories were aware from whispers and rumours that this amendment was merely the thin end of the wedge. Nicholson was ultimately seeking to have power to exclude works that did not fit in with his own personal artistic vision. On the basis of the experience of the Seven and Five Society, traditional artists still espousing the cause of realism might then find themselves struggling to have works selected, or even to remain members. That was the fear - and that it was a wholly reasonable one was soon vividly demonstrated by the early travails of the Penwith Society.

The issue, therefore, was not just about modern art versus traditional art, or about the right to be hung at each exhibition, it was about control. The stakes were high and that is why emotions ran high. Bradshaw's beloved Society was, in his view, facing a significant threat. Perhaps, initially, the traditionalists will have been glad to have rid themselves of Nicholson and Hepworth and their machinations but, when his temper had cooled, Bradshaw must have been distraught at the size of the rift, with good artists of the traditional persuasion, like Fuller and Cox, Heath and Segal, joining the ranks of the defectors. Even the Bradshaws' long-standing colleague, Shearer Armstrong, had resigned. No doubt Bradshaw steeled himself to put on a brave face but, in his heart of hearts, he will have realised that the heady days when the St Ives Society of Artists was a real force in the land were over.

That the Society's heyday had lasted so long is a tribute to the efforts of all involved. In 1932, the Editor of *The Studio* had bemoaned the fact that British painting was "unorganised, undisciplined, straggling like wayward hedgerows" and that groups and associations of artists never lasted long before disintegrating.[23] He commended, however, the early business-like efforts of the St Ives Society of Artists and would have been astounded that such unity of purpose had been maintained for over twenty years.[24]

Bernard Leach indicated that "the break was not a matter of personalities but of principles".[25] Nevertheless, given the personalities of the chief protagonists, there was very little chance of an acceptable compromise being able to be hammered out and the split became inevitable. I doubt that even Borlase Smart, if he had lived, would have been able to prevent the rift, but he might have reduced the level of ill-feeling caused by it. Bradshaw's outburst was not forgotten by anyone present.

[23] In *The Younger School of Painting*, The Studio, 1932 CIII, pp.3-20
[24] The Studio, 1932 CIII, p.365
[25] S.I.T., 13/5/1949

15.11 Hyman Segal *Ben Nicholson* (H.Segal)

Segal's reaction to a Nicholson painting being hung upside down at the first Penwith show

THE FINAL DECADE

Bradshaw would not have been human if he had not derived some satisfaction from the squabbles that almost immediately enveloped the Penwith Society. At the Committee Meeting of the Society on 26th May 1949, Barbara Hepworth suggested that future hanging committees should have two sculptors, two craftsmen, two traditional and two modern artists plus the officers and that members should choose to which group they should belong and mark their works accordingly when sending them in for consideration. When electing hanging committee members, an artist's vote would only count towards the selection of members representing his or her particular group. No decision was taken at the May meeting but in November the proposal was approved by a majority and representational painters were designated as the "A" group, abstract painters as the "B" group and craftsmen as the "C" group. Several of the founder members were fundamentally opposed to this method of categorising artists and Sven Berlin, Isobel Heath and Hyman Segal declined to be placed in a group. In the early part of 1950, Berlin, Segal and Heath resigned, followed closely by Peter Lanyon and Guido Morris. Hyman Segal wrote to the *St Ives Times*, stating:-

> "Had these terms been mentioned when first the Society was formed, they would have been laughed to scorn. I deeply deplore the turn which events have taken, but having registered my protest, I have no further wish to be associated with a Society whose rules now make a mockery of the original high ideals."[1]

Guido Morris in the same paper stated that it was ridiculous for the committee to attempt to pass the new rules off as an "administrative measure only" and indicated that the foundation members had wished to collaborate in a Society "entirely opposed to exclusiveness and antagonism."[2] David Cox, the former Secretary of the St Ives Society of Artists, also wrote to the paper:-

> "The Society was founded as a tribute to Borlase Smart, having democratic and catholic ideals embodying the principle that Modern and Traditional artists can work together as a unified whole. The introduction of the new rule is in complete contradiction of these ideals. The regimentation and division of members into small water-tight compartments of minor monopolies voting for themselves is not true democracy and does not preserve the independent voting of members. The strength of a Society lies in the true and free expression of the majority of all the members, not in that of any minority. I do not know if the new rule has been inspired by the belief that certain artists are unable to give a valuable vote on work that is of a different outlook from their own but this is certainly the implication. To the serious artist, this belief amounts to complete nonsense. The argument that a traditional artist is unable to vote on the work of a modern or vice versa is insulting in its assumption of inadequacy, and it was completely disproved by the hanging committee of the Society's first exhibition, when work of every school was voted on, on even terms, by an entirely mixed committee. I am afraid that it is all too obvious that certain elements are once again motivated by a desire to safeguard their own interests. In my opinion, a Society should be founded on mutual good faith and respect for the judgement of fellow members, and the designing of a rule to replace this is an admission of complete failure."[3]

Bradshaw could no doubt be heard muttering, "I told you so"! This further rift in the artistic community in St Ives aroused just as strong emotions as the original split in 1949. The influence

[1] St.Ives Times ("S.I.T."), 3/3/1950
[2] S.I.T., 3/3/1950
[3] S.I.T., 17/3/1950

of Ben Nicholson and Barbara Hepworth over the Penwith Society was considered by Lanyon, Berlin and others to be unhealthy. In 1953, Berlin, disillusioned, and Guido Morris, broke, left St Ives. Lanyon also seriously considered leaving "because of the bitterness which has been bred in myself and my fellow exiles" but he stayed and continued to express his views quite forcibly in a series of letters to the *St Ives Times* over the years. In 1956, he wrote:-

> "The school that has developed is due to the influence upon this Society [the Penwith Society] of Ben Nicholson and Barbara Hepworth, and their work in achieving this has led to the present position of painting in St Ives. While this Society, by constitution, aims to maintain the older and more realist tradition, it is clear to anyone visiting the gallery, that this painting is being strangled, and that a largely abstract Society of painters is emerging." [4]

How then did the St Ives Society of Artists fare after the split? Sven Berlin commented that the split left the Society as "the sad sisterhood of Lady Spinster Silkworm Painters led by a Naval Commander RT".[5] Bradshaw certainly was now to take a leading role as Secretary, but initially he would not have been discouraged by the quality of his fellow members, as they included such distinguished artists as Sir Alfred Munnings, Lamorna Birch, Moffat Lindner, John Park, Fred Bottomley, Dorothea Sharp as well as Harry Rountree and Bernard Ninnes. At the A.G.M. held in April, Ninnes mentioned "the extraordinarily spontaneous expressions of goodwill" that the Society had received from the people of St Ives since the crisis and that the Society had experienced a feeling of uplift it had not known for years. [6]

At the meeting, Sir Alfred Munnings was confirmed as President of the Society. He too was no fan of modern art, as he demonstrated in dramatic fashion shortly afterwards in his retirement speech given at the Royal Academy Banquet in 1949, in which he scattered invective at a motley selection of targets, including Picasso, Matisse and the "affected juggling" of what he termed "the school of Paris".[7] Having so "enlivened the breakfast table of a jaded Britain", increased interest was shown in the Spring Exhibition of the Society. A critic, writing for Denys Val Baker's new *Cornish Review*, commented:-

> "Every member would, we thought, be a brave Horatio holding the bridge for the art of Arnesby Brown and Julius Olsson. Alas! Far from calling forth the faintest cheer from the ranks of Tuscany, the show disappointed some of the Society's loyalest supporters. It illustrated only too obviously the policy, disputed by the "rebels", that a member's work should be accepted more or less automatically as one of the rights of membership. There were 153 works on view. After inspecting them, I went away feeling, rather dazedly, that this policy required as corollary, the further right of members to be the only persons to see the work when it was hung. It would be extraordinary if the St Ives Society of Artists, or any society of the size and kind, could produce 153 first-class, or even second-class, pictures for a quarterly show.....With a few exceptions, the only defenders of Sir Alfred's bridge were [the] Newlyn members and such St Ives veterans as John A. Park, G.F.Bradshaw and Fred Bottomley." [8]

[4] S.I.T., 6/7/1956

[5] S.Berlin, *The Dark Monarch*, London, 1962, p.167

[6] S.I.T., 8/4/1949

[7] This speech is often referred to and, although it clearly was ill-judged, a little of its background and its aftermath may be of interest. Munnings had intended to resign as President the previous year, as he found the politics of the R.A. trying. However, he had been persuaded by his great friend, Winston Churchill, to stay on for another year to preside over the re-introduction of the famous Banquets that had ceased during the War years. Churchill had said, "Let's have a rag". Apparently forgetting that his speech was to be recorded by the B.B.C., Munnings had made few notes and approached his topic very much as if he was speaking to a group of his drinking companions at his club. Denigrating particular works of art and the views of particular critics was not tactful and his comments and criticisms were neither eloquent nor reasoned, albeit heart-felt. Nevertheless - and this is the point which is always glossed over - his speech, which was severely criticised by the B.B.C., produced an enormous response with sack after sack of mail being delivered to the R.A. and from this mass of correspondence from all around the world, only four letters were critical of his views. The majority congratulated him for speaking out. A telegram from the North merely said, "Well done! Helvellyn shook!" A.Munnings, *An Artist's Life*, London, 1955, p.222-229

[8] Cornish Review, 1949, p.87. A review in S.I.T., 22/4/1949 was more complimentary, highlighting works by Park, Ninnes, Bradshaw, Birch and Simpson.

16.1 Sir Alfred Munnings *Does the Subject Matter?*
(The Sir Alfred Munnings Art Museum, Castle House, Dedham, Essex, England)

Having caused considerable controversy with his comments on modern art in his speech as retiring President at the Royal Academy Banquet in 1949, Munnings returned to the fray in 1956 when he insisted, contrary to the wishes of the then President, on showing at the R.A. this lampoon, featuring Sir John Rotherstein (then Director of the Tate Gallery), Humphrey Brooke and Professor Mavrogordato examining a piece of 'contemporary' sculpture - based on a work by Barbara Hepworth. The catalogue entry contained the lines:-

> "And why not purchased for the State?
> The State, alas, has come too late,
> Because the subject's so profound,
> Twas sold for twenty thousand pound."

Although it was hung inconspicuously, it became "the season's most talked about picture."
(S.Booth, *Sir Alfred Munnings 1878-1959*, London, 1978, p.20)

Rotherstein was a particular target of Munnings' wrath. When opening the Stanhope Forbes Memorial Exhibition in Newlyn in 1949, Munnings was outraged that the Tate had not made available *The Health of the Bride*, allowing it to languish in a cellar while "absurd paintings by Matisse were hung preciously on the walls with half a mile between each one", and urged Newlyn people to march in a body on the Tate "and really frighten Rotherstein".

(A.Wormleighton, *A Painter Laureate*, Bristol, 1995, p.240)

The Society had, of course, for many years been putting on shows comprising many more works than this, but this review is symptomatic of the attitude adopted by modernist sympathisers, who attempted to portray the split as the result of the desire of the traditionalists to reduce the standard of exhibitions. Not surprisingly, comments of this nature infuriated the traditionalists and there were heated exchanges of letters in the local paper.

As far as the public was concerned, the Society of Artists remained as popular as ever. In 1949, 11,000 people visited the Gallery and sales doubled. In 1950, the number of visitors was down to 7,000 but sales of pictures increased to £3,362. This compared with 4,300 visiting the exhibitions of the Penwith Society and sales of only £417 (1951-£476). Membership numbers were not a problem and, in fact, in 1951, the Committee deemed it prudent to close the membership at 89 full members and 20 associate members, principally owing to the limited hanging space in the Mariners' Church. It was decided, however, in 1950 to reduce the number of exhibitions held by the Society itself from four per year to three. It became the custom for the Lord Mayor of St Ives to open the exhibitions and the Bradshaws provided tea to the official party at Ship Studio, just along the lane, after the opening ceremony.

At the A.G.M. in 1950, it was reported that agreement had been reached with the Church Council for the Society to have an assured tenancy of the Gallery for one year with an option for a further twelve months. The rent was considerably higher but several good alterations had been made and the amenities improved. Munnings was replaced as President by Lamorna Birch with Park as acting President. Park's organisational abilities, however, were not renowned - unless it was for a drink in the 'Sloop' - and it was Bernard Ninnes, as Vice-President, who became the public spokesman for the Society. Charming man as he was, he was not a dynamic leader, in the Borlase Smart mould, and his walking disability put him at a great disadvantage. The provincial touring exhibitions ceased, purportedly on financial grounds, leading to many of the non-resident members ceasing to exhibit with the Society. Furthermore, publicity in the local press for the Society's activities diminished considerably. The Penwith Society and its members came to dominate the headlines.

As far as his own art was concerned, Bradshaw was happy to continue painting marine scenes in a traditional style, but some works show the influence of modern colour values, particularly in his depiction of water, where he adopted a more impressionist approach. Good examples are *Sunset's Flush* (Plate 34) and *Steamship in a Shimmering Sea* (Plate 33). Nevertheless, the traditional values to which he worked were still appreciated. Clare White, in her review of Show Day in 1951, comments:-

> "George F Bradshaw in *Breezy Day, St Ives*, *Moonlight from Porthgwidden* and other pictures, shows his great gifts as a marine painter and knowledge of the sea in all her moods. Rarely in these days does one see so much knowledge of the sea and boats allied with the ability to translate it into finished works of art." [9]

During the 1950s, Bradshaw became fascinated by the challenges offered by moonlight scenes and these feature regularly among his exhibited works. For instance, in the Winter Exhibition in 1953, he exhibited *Moonlit Bay*, about which the reviewer commented:-

> "In his treatment of this subject, he has succeeded almost magically in the art of painting moonlight into, as it were, the texture of the water." [10]

With Porthmeor beach so close, young children could be entertained for hours on its golden sands and both Kathleen and the children developed a keen interest in surfing. George's surfing days were now over but he was happy to set up his easel on the beach and sketch the wave patterns on the foreshore and the ever-searching gulls. Picnics were still popular family outings and the

[9] S.I.T., 9/3/1951. Clare White also singled out Kathleen Bradshaw's exhibits, "Kathleen Bradshaw shows original paintings in oils on greased paper. Very intriguing is *A Courtier and his Butterfly* and there are flower pieces with admirable brushwork."
[10] S.I.T., 25/12/1953

16.2 George and Kathleen look for suitable place to paint while Anne gets digging
(c.1947) (Roy Ray)

16.3 George Bradshaw sketching by the cliff path watched by Kathleen and Anne
(c.1957)
(Estate D. Val Baker)

Bradshaws had a favourite cove by Man's Head. Bradshaw would take his easel and paints in his boat, *Punch*, and start sketching and Kathleen, who loved walking, would put together a picnic hamper and join him with the children later. Titles like *Our Cove* (fig 7.7) or *Low Tide in the Cove* will be depictions of this favourite spot. One painting captures Robert climbing into the boat while his schoolfriend, Mike Westbrook, now a well-known jazz musician, sunbathes on the rocks. Kathleen also took her sketch-book but, with the children in tow, rarely achieved much. "However, I usually get a few notes for my sketch-book and then I paint my pictures at home."[11] She had no preferred medium, being equally happy and adept with pastel, tempera, watercolour and oil.

Throughout 1950 and 1951, the sand problem on Porthmeor beach had been getting worse, with sand now covering the windows of the Porthmeor studios, but the Council still vacillated as to whether or not to take any action. No very convincing reason for this build-up of sand was given by the experts, although it was felt that the removal of the wreck of the *Alba* might encourage the sea to reduce it over time. Some terrific gales at the beginning of 1952 exacerbated the problem and, in some cases, only the roofs of houses fronting the beach were visible. The front of Bradshaw's studio eventually caved in under the pressure and ten tons of sand cascaded in. Bradshaw, who had not lost his sense of humour, depicted a skeleton on the inside of the window and when eventually the sand mountain was cleared, the workmen were so taken in that a rumour ran around the town that a body had been found in the Commander's studio. All told, 19,000 tons of sand had to be moved and an appeal was launched to fund the operation.

The impact of the split on the Society of Artists soon started to become more noticeable. The advanced age of many of its principal members was a problem. In fact, they became known by the younger artists as "the bathchair brigade" and, in the first three years after the split, the Society experienced a depressing series of losses from its senior ranks.[12] Former President Moffat Lindner, who was still exhibiting, died in 1949 at the grand age of 97. Shortly after the split,

16.4 Sand menace, Porthmeor Beach, December 1951 (St Ives Museum - Brian Stevens)

[11] Unidentified newspaper article 17/3/1939
[12] The expression was used by Peter Lanyon in a letter to S.I.T., 15/9/1950, in which he wondered whether the bathchair method of painting was a reason for the sand menace on Porthmeor not affecting the Piazza studios, home to many of the older painters.

Leonard Richmond announced he was returning to London. Harry Rountree died in 1950, having infuriated the modernists with his tongue-in-cheek comments on modern art on *Down your Way* with Richard Dimbleby. In 1952, William Todd Brown, who had had a distinguished career as an artist and art teacher, and Maurice Hill both died as did former Treasurer Francis Roskruge and stalwart supporter Jack Titcomb. Then, in December 1952, Bradshaw suffered a second coronary and was so poorly for an extended period of time that he was forced to resign as Secretary of the Society, his place being taken by fellow marine painter Hugh Ridge, who was quick to acknowledge Bradshaw's "valued service" and "untiring efforts".[13] In the same month, John Park decided to move to Devon, thus ending his lengthy St Ives connection. The loss of so many long-standing colleagues must have left Bradshaw increasingly concerned about the state and future health of the Society. Although certain artists did drift back from the Penwith Society, Bradshaw would have recognised that the Society was a pale shadow of its former self and that talented newcomers were few.

One of the reasons for this was that the modern artists had much greater vitality and became excellent self-publicists. In the words of Hyman Segal, "Artfully articulated articles on Art appeared in profusion, adding confusion - the unenlightened blinded by science, with commentaries by intellectuals intelligible only to the few." [14] However, on occasions, claims made on behalf of the Penwith Society went too far for some to bear. Both Guido Morris and Denys Val Baker felt that Patrick Heron's review of the third exhibition of the Penwith Society, had indulged in flights of fantasy.[15] Val Baker commented:-

> "His words, like those of certain other people who have recently written about the Penwith Society, appear carefully calculated to sustain a myth about the Society's national and even international importance. This sort of thing, however well-meant, will eventually do untold damage, unless checked now. The Penwith Society is not unique, and with the exception of a handful of exhibitors, there is little to distinguish the technical standards of its artists from those of artists exhibiting at other Cornish art galleries." [16]

Nevertheless, it was the Penwith Society that managed to obtain grants from the Arts Council, with both the Newlyn Society and the St Ives Society of Artists being overlooked, much to the chagrin of Peter Lanyon and Bradshaw. Lanyon commented in a letter to the *St Ives Times* in 1956:-

> "Having supported this Society [the Penwith Society], through the Arts Council, the public may now consider it appropriate to question the administration of public funds and to enquire whether the Arts Council should continue to support a Society so one-sided and clearly determined to uphold abstract as opposed to realist painting, and whether an additional grant to this Society for educational purposes would not be better used by other Societies.
>
> The Newlyn Society of Artists has not been able to obtain a grant from the Arts Council, when with its assistance these younger realist painters could develop in Cornwall and have a gallery.
>
> Either the Newlyn or the St Ives Society of Artists should now receive the support of public funds and those artists who paint outside the abstract style, the younger realists included, should be welcomed into the Societies." [17]

[13] S.I.T., 9/10/1953
[14] H.Segal, *As I Was Going to St Ives*, St Ives, 1994, pp.98-9
[15] In his article, he had indicated that, besides possessing as members "the most distinguished sculptress, painter and potter working in England today" (namely, Barbara Hepworth, Ben Nicholson and Bernard Leach), the Society included amongst its membership "certainly the most important abstract painter of his generation in Britain today" (namely, John Wells) and "an artist who might well be considered our most distinguished romantic landscape painter since Graham Sutherland" (namely, Bryan Wynter) - S.I.T., 7/7/1950
[16] S.I.T., 14/7/1950
[17] S.I.T., 6/7/1956

16.5 Hyman Segal *African Heads*

Segal recalls that when he held a one-man show of his African drawings in the Crypt of the New Gallery in 1947, Borlase Smart had a quick look round and then left. Segal was feeling rather disappointed that his work had not merited greater scrutiny when Smart returned with the local reporter, having insisted that the exhibition was so unique and praiseworthy that it should be reviewed at length.

Notwithstanding the bitterness of the original split, the Penwith Society and the St Ives Society of Artists did manage to collaborate in a number of enterprises. In 1951, in connection with the Festival of Britain, a fund was established to which the Arts Council, Borough Council and both Societies of Artists contributed and, at each of the Societies' Festival Exhibitions, works were selected to be added to the Town's permanent collection. In the case of the St Ives Society of Artists, the successful artists were Bernard Ninnes, John Park, Dorothy Bayley, Tom Maidment and the woodcarver, Faust Lang and, in the case of the Penwith Society, the winners were Wilhelmina Barns-Graham, Barbara Hepworth and Bernard Leach.

Bradshaw had urged members to make a special effort to produce top work for the 1951 Festival of Britain Exhibition and, again in 1953, the Coronation and Festival Exhibition was intended to be a showcase for the Society. It was opened by Prince Chula Chakrabongse of Thailand and was felt to be the most interesting and stimulating show seen at the New Gallery for many years, with "modern technique combining with traditional sense of drawing and balance of design to give certain works an almost startling power".[18] Birch, Bradshaw, Ninnes, Simpson, Hewitt, Fuller and his wife, Marjorie Mostyn were to the fore, with more recent members like Ridge, "Fish", Clare White, Medora Bent and Malcolm Haylett well represented and a strong sculpture section including Faust Lang, his son, Wharton Lang and Barbara Tribe. Yet, in the B.B.C. broadcast on the St Ives Festival, the exhibition was slated. Of all people, Ben Nicholson was sufficiently incensed to write to the *St Ives Times*:-

> "It appears to me that in a programme such as *The Critics*, for one critic to pull an exhibition of paintings to bits and for another to put it together again, or vice versa, represents a healthy airing of divergent viewpoints, but for a single critic to appear in

[18] S.I.T., 10/4/1953

St Ives on behalf of the B.B.C. and give over the air his particular negative viewpoint on a group of artists (as this particular critic did in reference to the St Ives Society of Artists) is, to put it mildly, a superfluous piece of broadcasting which can interest no-one." [19]

The attitude of the B.B.C. commentator was typical of the increasing hostility that critics developed towards artists still producing work in the traditional style. The artists' lack of desire to embrace modern attitudes immediately discounted them from being worthy of serious consideration, their skill at their craft being of no relevance at all. However eloquent the traditionalists may have been, there was little that they could do or say to alter the change in attitude that was occurring. Nevertheless, their resentment at being dismissed so lightly was considerable. When Denys Val Baker wrote about the St Ives art colony in 1959, he was

16.6 Marjorie Mostyn *A Sunny Window* (W.H.Lane & Son)

[19] S.I.T., 3/7/1953

apologetic about the relative lack of space that he devoted to the traditional painters as compared to the modern contingent:-

> "It is difficult in general to say a great deal about these more orthodox paintings - even the painters themselves make very little commentary on their work. The simple reason for this is that everything is so immediately understandable; we have grown up in a world where until now, at any rate, traditional painting - the view as seen, the face as recognised - has become an accepted part of life. This has particularly been so in St Ives, where, from the heyday of Julius Olsson to the swansong of his star pupil, John Park - a span of nearly fifty years - people coming to St Ives have expected to find paintings of all the lovely scenes around them, and they have found them. By contrast, abstract artists have been forced to develop a voice, indeed a propaganda, of their own in order to try and explain themselves and their motives to a public unfamiliar with such 'goings on'. The result, now that the moderns are enjoying their period of growing success, has sometimes seemed, paradoxically, a tendency to obscure the achievements of traditional painters. The truth is of course that much of the traditional work going on in St Ives is of a very high standard, and speaks immediately for itself." [20]

It would have been strange if the attitude of the critics had not had some impact on collectors. Since the split, sales had progressed remarkably well but, at the A.G.M. in October 1953, it was reported that sales of paintings had dropped by nearly £900 in the previous year and that the Society was overdrawn at the bank.[21] Hugh Ridge expressed some concern at the quality of some of the exhibits at the Society's exhibitions and felt that it was important, if the Society was to retain its good name, that the standard of work must remain high, even if fewer pictures were hung. The selection of new members should also be a matter for careful consideration. The new Committee elected comprised Bernard Ninnes as Vice-President and Chairman, Mrs Vera Wilkins as Treasurer, Hugh Ridge as Secretary, with other Committee members comprising Charles Breaker, Stuart Armfield, Jack Merriott, Clare White and the Reverend A.G.Wyon. Notwithstanding the fact that a number of the Committee were talented artists, for the first time, it had a lightweight look about it.

When Lamorna Birch died at the beginning of 1955, the well-known marine painter, Claude Muncaster, was elected President. Bradshaw had recovered sufficiently to be elected Vice-President and Chairman and he found himself often playing the role of President, as Muncaster rarely attended the opening ceremonies of the Society's exhibitions. The tone of addresses by dignitaries at these openings reveal the considerable difficulty that even reasonably well-informed laymen still had with modern art. Although the work of some members betrayed modern influences, the main body of exhibits were considered to represent a haven of sanity from the moderns, who had now, "amid endless arguments", fragmented into numerous cliques, with "petty sectarian labels".[22]

On his return to office, Bradshaw had to deal with what Hugh Ridge termed "an ugly financial crisis". Bradshaw referred to the problem in his address at the opening of the 1955 Spring Exhibition:-

> "Many of you may be asking, 'How is the Society getting on, after being struck by a full gale a few months ago?' Well, I am glad to say we are holding our own at present. After taking legal advice, we have decided to make an effort to get some of the money owing to us returned. But even if we are successful, it will probably be only a very small amount of the total that we have lost." [23]

[20] D.Val Baker, *Britain's Art Colony by the Sea*, London, 1959, p.48

[21] Sales had been:- 1948 - £951, 1949 - £2355, 1950 - £3362, 1951 - £3342 and 1952 (when the gallery had been closed for 3 months) - £2689.

[22] C.Noall, *The Art Colony at St Ives*, S.I.T., 15/3/1956

[23] S.I.T., 1/4/1955

16.7 Hugh Ridge *Falmouth Docks*

16.8 Hugh Ridge *Boats off Falmouth*

16.9 *Setting Moon* (1957) (Oil on canvas)

From hints given by Kathleen, the problem appears to have been caused by the then Curator removing works from the Gallery and selling them without accounting for the proceeds. Her good looks and flirtatious manner had resulted in the scam not being investigated sooner, although Bradshaw had never trusted her.

Another serious problem faced Bradshaw in 1956, when the Society was threatened with the termination of its lease on the Mariners' Chapel, due to the local Church Council being obliged to sell the building. In order to preserve its exhibition gallery, therefore, the Society had to raise sufficient funds to purchase the building. The £2800 required was generously lent by Dr and Mrs.W.E.Glover. Hugh Ridge commented:-

> "It was a wonderful day when the Society found itself in its own Gallery, and the Officers and the Council, under the able chairmanship of Commander Bradshaw, were quick to make the necessary arrangements for repaying the loan and interest. Only three members declined to agree with the purchase, and it was decided to raise the annual subscription to ensure payment of the interest." [24]

Despite his recovery, Bradshaw remained in constant pain, as his arthritis worsened and this did not help his irascibility. He ended up needing to take huge quantities of aspirin to dull the pain. Nevertheless, he continued painting and occasionally a critic appreciated his traditional skills. For instance, on Show Day in 1956 - a year in which expense had put off many artists from submitting to the Royal Academy - his exhibits attracted attention.

> "For action contrasted with serene beauty, the pictures of George Bradshaw are worth a visit. One can imagine the force of his waves and can almost sense the spray and wind on one's cheek in his fishing boat studies. The shimmering softness of the sea bathed in

[24] S.C.Caple, *St Ives Scrapbook*, Truro, 1961, p.113. The increase in subscription was very significant - from 30s to 3 guineas. A Fabric Fund was set up in April 1957 and a letter asking for donations was printed in S.I.T., 5/7/1957.

moonlight in various settings depicted on other canvases show a completely different side of the artist's thoughts and are very effective." [25]

Moonlight scenes feature prominently in the last few years of his life, as titles such as *Summer Night*, *Nocturne*, *Moonlight*, *Summer Moon*, *Night Arrival*, depicting a barque silhouetted by moonlight, and *Setting Moon* attest. Borlase Smart, who was also keen on moonlit scenes, commented:-

> "Moonlight is one of the most wonderful phenomena in Nature, from an artistic and pictorial point of view. Such an effect, however, demands restraint in colour, and dignity in composition. It is not a scene of mere black and white. There is colour in the fullest sense, but muted in tone." [26]

Bradshaw mastered the technical challenges of nocturnes to produce some of his most pleasing studies. *Setting Moon*, painted in 1957, is a magnificent large work, fit to stand comparison with an Olsson, an acknowledged master of moonlit scenes. It depicts the moon setting before dawn seen from Porthmeor beach and Bradshaw's use of a multitude of coloured dashes to depict the effect of moonlight on the waves as they run up the beach is the most striking effect. The darkness of the headland of Clodgy is relieved by a light gleaming from the small look-out bunker. The painting was brought for £50 by his plumber, a welcome confirmation that Bradshaw still possessed the ability to inspire people to part with hard-earned cash.

Generally, however, Bradshaw became increasingly disenchanted with life in general and his painting. The significant increase of tourists to St Ives after the War, and the manner in which such tourists behaved, displeased him and he was always glad when the summer crowds and the accompanying noise abated. His poor health and the almost constant pain from his hip made it much more difficult for him to concentrate for long periods and he acknowledged that, in an effort to adapt slightly to modern trends, his work had become somewhat "spotty". The colours in a number of his later works are also much harsher and the inability to get out with Job Boase or other fishermen or to take his painting equipment along the cliffs meant that he was relying increasingly on memory for subjects and effects of sea and sky.

As attention became more focused on the modern painters in St Ives, so old traditions such as Show Day dropped away and Bradshaw's exhibits ceased to be singled out for particular mention in reviews of exhibitions.[27] His paintings also no longer sold with great regularity and this exacerbated his already difficult financial position. Kathleen and he were keen for their son Robert to attend Kelly College but, despite the scholarships available to ex-Naval officers, the fees were a great drain on their resources and Bradshaw's Victorian upbringing made him feel ashamed that Kathleen had to go out to work at a factory. Olive Cann, serving in the local shop, can remember Kathleen being quite open about their poverty, saying that she did not even have enough money to buy a pair of stockings. Undoubtedly, Bradshaw became somewhat embittered and Robert recalls his parents appearing to spend inordinate amounts of time drinking tea and running down the characters of others in the town.

As far as many of the local people were concerned, Bradshaw remained the well-spoken, courteous gentleman that they had always respected. He was a big man, known always as "the Commander", and he had a certain presence, which led some to hesitate before engaging him in conversation, but those that did found him perfectly pleasant. However, many among the artist community that recall Bradshaw from these days indicate that he was rather a bully, becoming irascible if his own views and values were not shared by others. With the death of Dorothea Sharp in 1955 and the departure of Pauline Hewitt, Fred Bottomley and Thomas Maidment, Bradshaw

[25] Western Morning News, 2/3/1956
[26] B.Smart, *The Technique of Seascape Painting*, London, 1934, p.114
[27] Reviews tend to concentrate on the portrait section, which was particularly strong. Leonard Fuller, who was a member of both St Ives Societies, had been joined by Leonard Boden, the Royal Portrait painter, and their respective wives, Marjorie Mostyn and Margaret Boden. The portraits of Malcolm Haylett, Hyman Segal and John Barclay were highly rated too. The sculpture section of the two Langs and Barbara Tribe was also distinguished. Ninnes, although no longer involved on the Committee, was still exhibiting.

205

16.10 George and Kathleen with Robert and Anne c.1958

16.11 George Bradshaw in Ship Studio c.1960 with future daughter-in-law, Rosemary

no doubt saw himself, as the senior surviving founder member, responsible for keeping up the ethos of the Society. Certainly, his attitude to the moderns never softened and their highly publicised successes merely fuelled his feelings of burning resentment. He longed for the Society to recapture its former status but his own poor health reduced his energy and enthusiasm and a succession of B.B.C. programmes that ignored or misrepresented the views of his colleagues and himself merely increased his despair. What use were his efforts when, in his view, the public had been bamboozled by the moderns and misled by the media?

Rosamunde Pilcher's description of the aged Lawrence Stern in *The Shell Seekers* evokes in many respects Bradshaw's final days.

> "The cold, damp wintry weather caused him considerable pain, and he had taken to walking with a stick. He was bowed, he had grown very thin, his crippled hands curiously waxy and lifeless, like the hands of a man already dead. Incapable now of doing very much around the house and garden, he spent most of his time, mittened and shawled in rugs, by the sitting room fire, reading the newspapers or well-loved books, listening to the wireless, or writing letters in his painful, uncertain hand, to old friends who lived in other parts of the country. Sometimes, when the sun shone and the sea was blue and dancing with white caps, he would announce that he felt like a little fresh air, whereupon Penelope would fetch his caped overcoat and his big hat and his stick, and they would set off together, arm in arm, to make their way down the steep streets and alleyways and into the heart of the little town, strolling along the harbour wall, watching the fishing boats and the gulls, perhaps calling in at the Sliding Tackle for a drink of anything that the landlord could produce from beneath his counter; and if he had nothing to produce, then downing tumblers of watery, lukewarm beer. Other times, if he was feeling strong enough, they went on as far as the North Beach and the old studio, locked now and seldom entered; or took the sloping lane that led to the Art Gallery, where he was happy to sit, contemplating the collection of paintings that he and his colleagues had somehow gathered together, and lost in an old man's silent and lonely memories." [28]

By the end, Bradshaw was not a contented man and his death in the Royal Cornwall Infirmary, following an operation, on 27th October 1960 at the age of 72 was probably a blessed release.

[28] R.Pilcher, *The Shell Seekers*, Sevenoaks, 1988, p.386-7. The author has confirmed that the character, Lawrence Stern, is not based on Bradshaw. However, she did know Bradshaw in his last years when he was suffering from arthritis and this description clearly evokes life in St Ives

INFLUENCES, TECHNIQUE AND APPRAISAL

Despite the esteem in which Bradshaw's works were held in his prime, he is not well represented in public collections. The Royal Navy Submarine Museum at Gosport does have a large collection of his early submarine paintings, which are of interest because they demonstrate his ability prior to settling in St Ives, but their specialist nature means that they do not necessarily have a wide appeal, even if they were to be exhibited. In truth, many are of mediocre quality. The only known sales to public institutions are *Lobster Fishing* (Plate 15) to Sunderland Art Gallery in 1944 and *St Ives Bay* and *Breakers* to the MacKelvie Collection in Auckland, New Zealand in 1930 but these two unexceptional works have now reappeared on the market. Given that many of his colleagues in the St Ives Society of Artists (including, for instance, McCrossan, Maidment, Truman and Ninnes) did have several works purchased by provincial Art Galleries, Bradshaw's lack of success is somewhat surprising. However, he did not attempt to make contacts in the wider artistic hierarchy or to break into the London market and he did not travel to exhibitions of the Society. He, therefore, did not market himself outside St Ives. Smart, on the other hand, clearly generated significant sales of his own works by being the spokesman for the Society.

Without Bradshaw's work being well-represented in public galleries, it has been easy for his contribution to the artistic success of the St Ives Society of Artists to be overlooked. There has been no body of work to study and evaluate, particularly as the family have not retained a large collection of good quality works. There has been no opportunity to gauge his influences or to assess his place in the history of British marine painting. His reputation to date in the literature on Cornish art, if his name has been mentioned at all, has been based on his leadership of the "reactionary" traditionalists at the infamous meeting in 1949 and his claims as an artist have been dismissed, without serious consideration, as being as unmeritorious as his views on modern art. Like Smart, he is not even included in Archibald's *Dictionary of Sea-Painters*.

For the last ten years, the computer search service of Thesaurus Group has enabled me to keep track of all Bradshaw paintings coming on to the market in the United Kingdom.[1] They do appear quite regularly - about seven a year - and, not surprisingly, David Lay and W.H.Lane & Son, the Penzance auction houses, handle most sales. This has enabled me to compile representations of a significant body of paintings, many of which I have been able to study at first hand. In fact, the majority of the illustrations of Bradshaw's works in this book are of paintings that have been sold at auction in the last ten years. How, then, does an assessment of these works compare with the glowing critiques that have been reproduced throughout this book? Did the proximity of critic to artist lead to rose-tinted reviews? Clearly, local critics were unlikely to savage the work of a local artist, but they could ignore it and, in the 1950s, when Bradshaw's style was out of fashion, this is what tended to happen.

In fact, the works passing through the auction rooms confirm much that has been able to be gleaned from newspaper reports and their numbers indicate most tellingly that Bradshaw, for most of his career, had little difficulty selling his works. Not surprisingly, the vast majority of works would be classified as marine subjects, but the term 'marine painting' can be applied to works covering a wide variety of scenes, ranging from depictions of the open sea, studies of boats of all sorts, cliff and coastal subjects, beach compositions, harbour studies - often with figures, and even river landscapes. As has been seen, Borlase Smart considered that seascape painting, which, whilst admitting the depiction of rocks and cliffs, concentrated on the moods of the sea, was a nobler form of art than marine painting, which relied on incidents of boats and figures. One

[1] In recent years, I have included Moffat Lindner and Borlase Smart in the search service and have been surprised that very few paintings of good quality have come on to the market - a marked contrast to Bradshaw

evocative seascape, which could fit the title *Roll on thou dark and deep blue ocean, roll...* (1949) (fig 17.1), appeared at Christie's, South Kensington in 1993 but pure seascapes by Bradshaw, if one excludes beach compositions, are rare. Bradshaw, along with many others, would, in any event, take issue with Smart and would argue that the correct depiction of boats at sea was an equally difficult - possibly a doubly difficult - art. Certainly, the auctions confirm that Bradshaw chose to concentrate principally on the combination of boats and the sea, a combination favoured by none of the artists - Olsson, Simpson, Smart and Park - who might be seen as potential influences on his work. Boats, of all different descriptions, were clearly a fascination for Bradshaw and the long hours at sea during his Naval career made him appreciate the many moods of the ocean. In 1939, he said of his time in the Navy:-

> "The knowledge I gained of ships and the sea has led me to specialize in marine painting - without getting all the details wrong." [2]

However, it is not merely the subject matter selected that is different to his contemporaries - Bradshaw's style of painting developed along different lines as well.

Notwithstanding the fact that the Olsson school had closed and Olsson himself had returned to live in London by the time Bradshaw arrived in St Ives, his potential influence should not be discounted, as he was the pre-eminent marine artist of the era and was warmly welcomed on his return visits to St Ives. He was also a frequent contributor to the exhibitions of the St Ives Society of Artists. Bradshaw, therefore, would have had plenty of opportunities to discuss technique with him and would have been able to study his works at first hand. Furthermore, Bradshaw's friends, Smart and Park, had studied under Olsson themselves and would no doubt have imparted to Bradshaw a number of his tips. However, with his love of boats, pure seascape was rarely going to interest Bradshaw and it is only in his later moonlight scenes, in his use of multi-coloured dashes amongst the white of the breaking waves (see, for example, Plate 36), that Bradshaw may well have looked to Olsson, as the acknowledged master of moonlit seas, for inspiration. Otherwise, the presence of boats as central features made it preferable for his seas to roll rather than rage. For Olsson, on the other hand, who was relying on the sea for his prime effect, dashing breakers, spray-inducing turbulence or a dignified calm to enhance reflection were more apposite.

Simpson's initial influence, leading to Bradshaw's portrayal of water becoming more realistic, has already been noted, but it is difficult to trace any influence in Bradshaw's mature seas from work by any of his St Ives contemporaries. Simpson's seas often have a compelling coolness, with green a prominent colour, whereas Bradshaw's are much more varied and he frequently used a red ground, giving vibrancy and warmth. He would no doubt have approved of Smart's advice on the art of depicting water:-

> "Don't paint waves as if they were frozen hard. Make your forms elusive. The water is pliant. Don't paint it like bits of sharp tin, dangerous to the touch. The sea is fresh, the colour pure, whether on a sunny day or a grey one." [3]

However, he was not interested in Smart's search for the larger patterns in the sea's movement or in the vibrantly coloured impressionistic approach of Park and Turland Goosey. He was more concerned with the realistic portrayal of water and was fascinated by the fact that sea-water seems to vary in composition and consistency according to the conditions under which it is viewed. As Baldry states, "At one time it is solid, opaque, ponderous and sombre in colour, and at another it is light, transparent and full of delicate tints. As it is a reflecting substance as well as one through which light can pass, it alters its appearance in the most surprising manner under the incidence of sunlight or in response to the variations in atmospheric effect; and as it is a moving body it appears to be subject to no laws of construction and to have no sort of method in its restlessness." [4] For

[2] Unattributed article in 1939 entitled, *Artist Served his Apprenticeship - in the Navy*
[3] S.I.T., 2/6/1933
[4] A.L.Baldry, *British Marine Painting*, The Studio, Special Edition, 1919, p.17

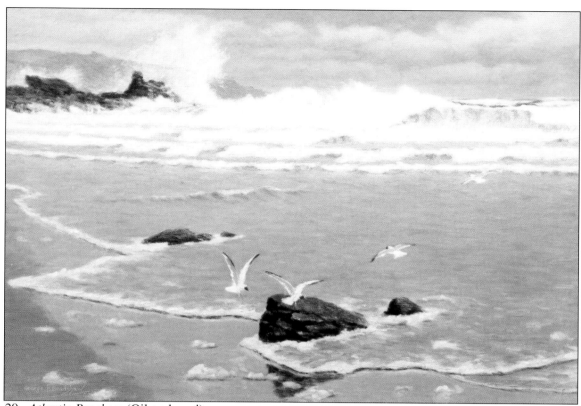

29. *Atlantic Breakers* (Oil on board)

30. *Anne, Aged 3 ½* (1947) (Oil on board)

31. *In St.Ives Bay* (1949) (Oil on canvas) (Phillips, Cardiff)

32. *Up Channel* (1955) (Oil on board)

33. *Steamship on a Shimmering Sea* (Oil on board)

34. *Sunset's Flush* (Oil on canvas)

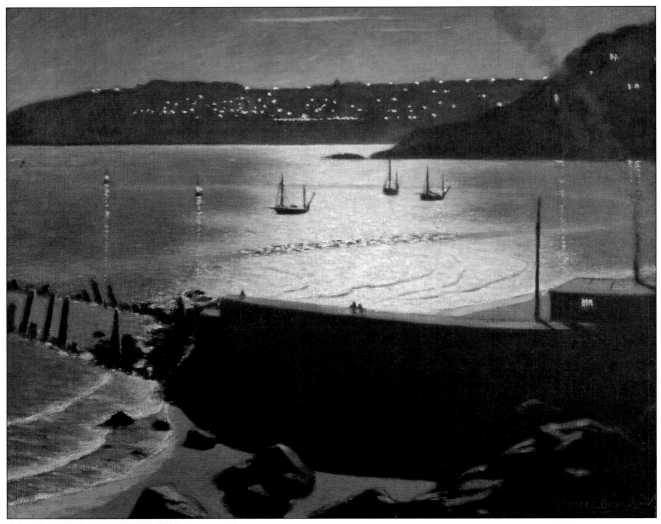

35. *Moonlight Bay* (1951) (Oil on canvas)

36. *Moonlit Breakers* (Oil on board)

17.1 *Roll on thou dark and deep blue ocean, roll...*(Oil on board)

17.2 Julius Olsson *Moonlit Sea*

(David Lay)

Bradshaw, the beauty of the sea was constantly changing and, accordingly, there was no need for his water to be painted in a formulaic manner, with little regard to weather conditions. He records the gales and storms that batter the Cornish coast as much as the hot summer days, so prevalent in Park's work.[5] One almost senses the pleasure that he derived from capturing in paint yet another of the sea's many moods and whether he is depicting the open sea or a rocky cove, waves breaking on a beach or the tranquil waters of a harbour, one detects the impact of his considerable powers of observation. Bradshaw's seas come across as real seas, not patterns or colourful impressions inserted for pictorial effect.

Such a hankering after realism may seem a little outmoded in an age fast moving towards complete abstraction, but whereas artists had for hundreds of years been painting realistic still lifes and landscapes, a glance at any history of marine painting shows how few artists had successfully captured the true freshness of the sea and how often romance and sentiment had conspired against reality. To attempt to follow Moore rather than Monet seems not in itself a course to criticise, although failure to embrace novelty is so often equated somehow with lack of inspiration, or even lack of talent. The impressionist can, however, hide errors or uncertainties in his 'impression': the realist requires complete perfection to withstand the observer's more meticulous scrutiny.

A change in Bradshaw's approach to the depiction of water can, however, be seen in some of his later works. There are similarities in the treatment of hull, sails and water in *Sunset's Flush* (Plate 34), with *Off the Spanish Coast* of 1955 (fig 1.8), which lead me to place this work in the same year. Although effective, the depiction of the reflections in the water in *Sunset's Flush* is more coarsely handled, with stabs of different colours juxtaposed, than the neatly finished representations of the pre-War period. This is presumably what Bradshaw was referring to when he admitted that, in an effort to keep up with modern trends in the use of colour, he had allowed himself to become too "spotty". In some paintings, such as *Steamship on a Shimmering Sea* (Plate 33), the spottiness works as an effective impression. However, this use of colour is still a far cry from the turmoil of paint from which Park conjured his magic.

Simpson's marine scenes often included figures but Bradshaw's figure studies seem to have been restricted to members of the family (see Plate 30). In *Sunset's Flush* (Plate 34), the depiction of figures on the quayside as the principal foreground is quite unusual for Bradshaw. His son confirms that he tended to shy away from figures having a leading role in a composition, as he felt less assured handling them. Simpson probably felt much the same way about boats, which were unquestionably Bradshaw's forté. Baldry felt that many marine artists were let down by their inability to represent convincingly a ship on water, let alone one on the move.

> "A ship provides one of the severest tests of draughtmanship: it is such a complicated collection of lines and curves and so hard to put into proper perspective that it makes exceptional demands on the artist's powers. Moreover, every ship has its own individuality, a character peculiar to itself, and to express this individuality as much analytical effort is needed as to draw the the right distinction between the differing types of humanity....The painter of shipping has, too, a wide field to cover. He has to range from the yacht to the warship, from the liner to the rusty, weather-beaten tramp; he has to show how the lively movement of the sailing ship differs from the steady, methodical progression of the steamer: he has to understand the behaviour of all sorts of craft under all sorts of weather conditions: and to make this varied assortment of knowledge intelligible in his pictures, he has to depend almost entirely on his powers of drawing."[6]

Sailing ships clearly fascinated Bradshaw and feature regularly - more often than one might assume from the titles of works exhibited. Titles like *Cape Horn* (1928) and *Dusk* (1932), in fact, have barques as the main feature. At a time when these ships were disappearing off the high seas, such subjects had appeal, and still do. The attractive multi-tiered sails and complex rigging meant

[6] A.L.Baldry, *op. cit.*, p.20

that there was little need to include any additional incident. *Trade Winds* (1927) (Plate 2), *Sailing Ship* (1928) (Plate 10 and fig 17.7) and *Wind and Canvas* (1930) are good examples, where Bradshaw has merely set a barque in an ocean running with a heavy swell.

Rarely does Bradshaw indicate that he is depicting particular ships. The painting of the *Cutty Sark* (1923) may have been a commission from Laity's but in 1993, a watercolour of *Hougomont - Australia to England - off Falmouth* was sold by Duke and Sons of Dorchester. The carriage of grain from Australia to England was one of the last employments for sailing ships. They retained this business because they were prepared to go to the smaller ports, even to anchor off farmers' jetties. Steamers could not afford "to lie long weeks at open anchorages, taking in their cargoes piecemeal a few sacks at a time".[7] However, the number of ships winning charters had decreased from 140 in 1921 to 20 in 1933 and *Hougomont* was yet another of the great sailing ships soon to be consigned to oblivion. Due merely to the fact that her metal foremast had sat down an inch on its rusted heel, her whole complex rigging system was put out and repair was not viable. The hull was sunk as a breakwater for a small outport, an inglorious end for a fine ship.[8] As Falmouth tended to be the destination of the grain ships, Bradshaw's 1934 Show Day exhibit *Grain from Australia* is likely to be another picture of a sailing ship off Falmouth.[9] The arrival of a tall ship in Falmouth was an event of note that was often recorded by the *Western Morning News*. In June 1936, the presence of five sailing ships at one time was considered exceptional[10], drawing big crowds, and when shortly afterwards the Erickson grain ship, *Herzogin Cecilie*, went ashore off Hope Cove, great concern was shown by the whole community as to its welfare. Photographs of each new arrival were published and these may well have been a source of detail used by Bradshaw in his paintings.

17.3 *Decks Awash* (detail) (1932) (Tempera on board)

[7] A.J.Villiers, *Last of the Wind Ships*, London, 1934, p.4

[8] A.J.Villiers, op. cit., p.13

[9] Bradshaw was given a copy of Villiers' book in 1934 and this painting may have been inspired by Villiers' descriptions. However, the only photograph in the book of the *Hougomont* shows it in a forlorn state, deprived of its rigging. No paintings are clearly based on photographs in the book.

[10] These were the *Penang, Viking, Ponape, Archibald Russell* and the *Olivebank*, all of which had been taking part in the grain race from Australia. The *Penang* recorded the quickest time - 112 days from Port Victoria.

The wind direction meant that the grain carriers had to battle with the weather around Cape Horn on their journey to England. It is not known whether Bradshaw experienced the perpetual gales and storms of a trip round the Horn himself, but *Decks Awash* (1932) (fig 17.3) gives an indication of the wild conditions that would be met, with the sea repeatedly raging over the decks. Villiers' description of weather conditions at the Horn could easily apply to the painting:-

> "At last! The real Cape Horn wind - roaring gale and roaring sea, hail and sleet and snow, and the old ship shortened down and foaming on. It is a fresh south-west gale, hard and powerful in the squalls, with a vindictive, foam-streaked sea.....It rises through the day until, at nightfall, it is wicked enough for anything - the same old deep valleys, with the grey sea streaked white and smoking with spume and the high crests snarling as they break." [11]

In such conditions, soaked to the skin and frozen to the marrow, the sailors had to tend to the ship's needs, in danger at all times of being swept overboard. Bradshaw depicts men up in the rigging taking in yet further sail as the gale increases. It was not a life for the faint-hearted.[12]

In addition to the remaining grain carriers, there were a handful of barques carrying Baltic timber down to London and other ports. One of these - an old Danish sailing ship loaded with timber - is depicted in *Heavy Weather in the Atlantic* (1926). Ice was another commodity that was brought by sail from the Baltic to England. This was used by the long distance trawlers, so that they could extend their range. Tea clippers on the China run, like the *Cutty Sark*, had become obsolete after the opening of the Suez Canal but there were still a number of wool clippers, which attracted Bradshaw's attention. In 1991, Phillips, Exeter, sold a large painting of *The Wool Clipper, Medon, off St.Ives* and, in 1997, another sailing ship picture sold by the same auction house was probably the highly regarded *The Wool Clipper* exhibited in 1925.

Coastal sailing ships plying between the china clay and coal ports were regular sights into the 1930s. The most frequent visitors to St Ives were the coal ships that beached on the sands and unloaded into horse-drawn carts. The grain carriers and the training ships were too big. When Bradshaw depicts sailing ships in harbour, it is not always easy to identify the location. This is the case with *Sunset's Flush* (Plate 34), in which the romantic image of the sailing ship is evoked as a group of men on the quay watch the crew take in the sails, while the ship, set against a pink sky, comes in to dock. An extract from a poem is inscribed upon the back of the canvas:-

> "Then in the Sunset's Flush they went aloft,
> and unbent sails in that most lovely hour"

However, by way of contrast, Bradshaw shows a stream of black smoke emerging from the funnel of a steamship docked nearby, perhaps to indicate that the sun was also about to set on the era of the sailing ship.

Bradshaw's knowledge of the great wind ships was not shared by any of the other marine artists working in St Ives at the time. His paintings of sailing clippers, therefore, stood out and were greatly admired and this, coupled with the fact that they sold easily, encouraged him to make such depictions one of his specialities. They certainly exude more atmosphere and authority as to detail than Henry Tuke's representations, despite the latter often selling for five times the price.

The unusual lateen-rigged Gozo boats were another favourite subject for Bradshaw - the triangular sail and colourful paintwork being attractive features, whether the boats are powering

[11] A.J.Villiers, op. cit., p.18
[12] One of the biggest problems facing sailing ship owners after the Great War was the shortage of experienced crew. Most youngsters realised that there was no future in sail and that life at sea was much easier on steam boats. However, there was still a demand for sailing ships for training purposes, as there were a number of European countries that made service in deep-sea sail compulsory for all aspirants for seagoing officers' certificates. Many of the crew were, accordingly, very young and inexperienced. When Claude Muncaster, the marine artist who later became President of the St Ives Society of Artists, experienced a trip on a sailing ship from Australia to Cardiff in 1931, the average age of the crew was 20. His account of the harshness of life in these vessels is reproduced in the biography by his son, Martin, *The Wind in the Oak*, London 1978, pp.40-47

towards the viewer, as in *Off Malta* (1930) (Plate 9), or are seen side-on as in *Off Gibraltar* (fig 1.9) or *Maltese Fruit Boats* (fig 1.10). Painted years after his retirement from the Navy, these paintings, like many of his depictions of sailing ships, are based on sketches made during his Naval career. Robert recollects that his father had a large collection of sketches, which unfortunately were thrown away after his death.

Given St Ives' continued close involvement in the fishing industry, it is not surprising that many paintings feature fishing boats of various types, although Bradshaw's observation of detail was not as thorough in his representation of fishing craft. The local boats most frequently depicted are the long-distance mackerel luggers and the St Ives motor gigs used mainly for herring drifting, trawling or "crabbing". The gigs were principally designed for herring drifting in the Bay, the season being from about October to Christmas. In *Departure for the Herring Fishing* (1939) (fig 17.4), Bradshaw has captured an authentic scene. Herring drifting was done at night and two St Ives motor gigs, typical of the type built in the 1920s, have been moved by the outside steps of Smeaton's Pier so that they will not be aground when it is time to depart. Two other crews are heading for their boats in their punts, sculled with one oar over the stern. Although firm identification is not possible, John McWilliams thinks that the gig alongside the quay is similar to *Trevose* - ss 63, the one outside her, without a wheelhouse, resembles *Stolen Residue* - ss 74 and the gig going to sea may be *Endeavour* - ss 23.

The motor gigs were also used for trawling for white fish. Some also went long lining for white fish in the spring and summer, although they were generally thought a bit small for this. "Crabbing" was a summer activity and fishermen hauling lobster pots into the boat was one of Bradshaw's most favoured subjects, an activity that he witnessed repeatedly on his trips out with Job Boase, and Boase's motor gig *Our Girls*, with and without its wheelhouse, features regularly in Bradshaw's paintings (see Plate 23 and fig 8.2).

Mackerel boats were built for deep water fishing. In *Smeaton's Pier* (1930) (Cover), Bradshaw features the mackerel lugger, *Gratitude* - ss 626, built in 1887.[13] The boat was owned by

17.4 Bradshaw with *Departure for the Herring Fishing* (1939) (H.Segal)

[13] For all information on fishing craft depicted by Bradshaw, I am deeply indebted to John McWilliams. The *Gratitude* is still in use and was recently seen in the Mediterranean near Greece.

THE HARBOUR, ST. IVES, CORNWALL.

17.5 St Ives Gigs - *Our Girls* ss 131, *Our Boys* ss 150, *Thrive* ss 148 and *Silver Spray* ss 28
(Postcard from John McWilliams collection)

H.Paynter and had a distinctive raised washboard at its stern. It was also unusual in having three engines and three propellers, its first engine being fitted in 1914. Bradshaw shows nets being loaded or unloaded from her and from the other boat moored behind her against the quay. It is an attractive work, with some exquisite reflections and a fine rendering of the lighthouse on the pier.

Another mackerel boat is featured in the dramatic painting, *Up Channel* (1955) (Plate 32). Given Bradshaw's seafaring past and his concern about detail, one would expect him to record correctly a boat's number and this is certainly the case with his various depictions of *Our Girls* and *Gratitude*. The mackerel lugger featured in *Up Channel* clearly has the number ss 9, which would make her the *Jane Barber*, built in 1883 and owned by R.Welch. She was one of the bigger mackerel boats that went mackerel drifting or long lining 'in the Channel'. There is nothing in the details of the boat in the picture that would prevent her being the *Jane Barber*, except that the boat left St Ives for service in the Galapagos Islands in 1930, some twenty-five years before the painting was exhibited.[14] However, a plate attached to the painting indicates that the boat is the *Barnabas*, a smaller mackerel boat of similar vintage owned by Barney Thomas and numbered ss 634. The *Barnabas* is now the only example of a St Ives dipping lugger still sailing, being owned by the Cornish friends of the Maritime Trust and based in Falmouth, and it may be her notoriety that has led to this attribution. However, John McWilliams feels that such attribution cannot be supported, as Bradshaw depicts the boat with her punt aboard on the port side and the Barnabas at 37ft was too small to carry her punt. Whichever boat is in fact depicted, *Up Channel* is one of Bradshaw's most appealing works, with the mackerel lugger working its nets, as it drifts across the path of a three-masted fully-rigged sailing ship in a stiff breeze. Both boats are full of movement and provide strong, but opposing, diagonal impulses, that of the sailing ship being enhanced by the direction of the breaking waves.[15]

Bradshaw will have encountered repeatedly the East coast drifter trawlers, small steam-powered vessels, that came each spring from ports like Lowestoft to fish off Cornwall but the large long

[14] There is the possibility that the painting was executed much earlier. Its style is more akin to that Bradshaw was using in the late 1920s than in the 1950s. Bradshaw could also, of course, have utilised a sketch from the past.
[15] John McWilliams has picked up some errors in detail about the mackerel boat. He considers that as the lugger is working her gear - seen here leading away from the starboard bow -, her foremast should be lowered down. In such circumstances, the boat would normally be facing into the wind, but for compositional reasons, Bradshaw has shown her at right angles to the wind. He also points out that Cornish luggers always carried their mizzen sail on the port side of the mizzen mast, not on the starboard side as depicted by Bradshaw.

distance trawlers that Bradshaw depicted in *The Trawlers* (1928) (Plate 8) were probably from Hull or Grimsby. He may well have been familiar with these from his days in the Navy, as many of them were taken into Naval service for mine-sweeping and anti-submarine work. French boats, based in Camaret, were regular visitors to the nearby fishing grounds and French crabbers and other French boats feature in a number of works - for instance, *Fishing Boats In St Ives Bay* (fig 0.1) and *In St Ives Bay* (1949) (Plate 31). The boats tended to anchor in the Bay off Porthminster beach (see fig 14.3) and would have been familiar sights. In *Sunset and Evening Star* (1932) (Plate 14), Bradshaw depicts them at dusk off Hayle Towans. Bradshaw also made cargo-carrying steamships, tankers and colliers central features of some compositions. They could be old and rusty, but Bradshaw would detect some evocative quality about them and, when merged into a composition with special effects of sea and sky, they would appear transformed. *Old Timer* (1945), for instance, will feature a boat, not a person.

Correct delineation of the features of boats, albeit, as Charles Pears commented, a consummate skill, does not by itself ensure a successful marine painting. The boats have to sit naturally on the water and need to be full of movement. One of the modern contingent, when speaking of Bradshaw, said:-

> "He was as violently opposed to modern art...as his seas were to the puny ships they tossed about" [16]

A glance at some of the illustrations demonstrates how wrong such an observation is. The leading boat in *The Trawlers* (1928) (Plate 8), listing over in the swell, with spray shooting over the bow, has a fine sense of movement, the smoke emanating from her funnel showing not only the direction but also the strength of the wind. There is a wonderful sense of surging power in the depiction of the Frenchman in *In St Ives Bay* (1949) (Plate 31) and in *Hauling Pots in Rough Weather* (Plate 23), the heavy swell with which the boat is battling is convincingly portrayed, as the waves lap the edge of the gunwales and break against the nearby cliff face before being hurled back in a white foam. In his early submarine paintings, Bradshaw's ships may have sat uncomfortably on their seas, but this is not a criticism that can be levelled at the majority of his mature paintings. His skill as a draughtsman, his own experiences at sea and his store of knowledge of detail all combined to ensure that his boats were realistically portrayed and behaved naturally. By contrast, it would take a brave person to go to sea in some of John Park's creations!

Composition or design was considered a crucial feature of a painting by the traditionalists. Borlase Smart commented, "A successful picture embraces balance, symmetry, growth, movement, massing and spacing." [17] Although Bradshaw's compositions are refreshingly varied, certain standard ploys can be detected. He was keen on picking up the diagonals leading from the bottom corners of the painting, whether for the direction in which his boats headed, as in *Up Channel* (Plate 32), or for the line of a breaking wave or a beach, as in *Porthmeor Beach - Summer* (Plate 22), or for the shape of a rock formation. The crest of a wave or the path of flight of seagulls are again often used to lead the viewer's eye to the central feature in a painting. Bradshaw, perhaps as a result of tips given him by Charles Simpson, was rather good at depicting gulls, as a glance at *Atlantic Breakers* (Plate 29) and *Hauling Pots in Rough Weather* (Plate 23) confirms, and the skill involved is confirmed by Herbert Truman, when responding to criticism of his own efforts:-

> "Why do my pictures of sea-gulls look so hard and washed out? That is the very thing that I should like to know! I strongly suspect that it is due, first, to incorrect tonal values, and, secondly, [to] badly painted edges. I find these two technical faults very difficult to overcome. Of course, the edges of the gulls could be softened and lost in the background, but this would be 'begging the question'. Another method would be the use of broken

[16] Tate Gallery, *St Ives 1939-64*, London, 1985, p.26
[17] B.Smart, *The Technique of Seascape Painting*, London, 1934, p.11

colour; this would tend to soften the edges and bring the gulls away from the background. However, to the expert eye, the correct tonal values of edges would still be missing in these pictures." [18]

To assist with the illusion of distance, Bradshaw nearly always included on the far horizon another boat, often delineated merely by a puff of smoke or a small sail, breaking into the sky. Cloud effects were not a significant feature in many paintings, although a light blue sky with fluffy clouds was certainly not the only effect used. *Steamship on a Shimmering Sea* (Plate 33) is an exceptional work in which sky and sea, depicted looking into a bright sun, combine to produce almost a study in white. The date of the painting is unknown, but the treatment of the sea has similarities to the moonlight scenes and its unusually modern feel probably make it one of his later works. Here 'spottiness' is definitely successful. In more traditional works, Bradshaw was always sure to match his sky to the weather conditions suggested by his sea, and colours in the sky tended to pick up hues utilised elsewhere in the painting.

Bradshaw was happy to adjust the horizon line to the demands of the subject and to utilise unusual vantage points, requiring a full mastery of perspective. *Rolling Home* (1937) (Plate 16) is a good example. When depicting small coves, the sky may not feature at all, so as to increase the impact of the sharp drop down to the turquoise waters or the claustrophobic proximity of the cliff-face (see Plate 23).

Bradshaw worked quickly. With marine painting, one has to. Light and sea effects are constantly changing. Too much detail tends to result in forms becoming frozen, whereas fluidity and movement are what the artist is seeking to convey. In his only recorded utterance on his technique, Bradshaw stated:-

"I work for economy of painting, and with the idea of getting the most striking effect" [19]

The illustrations show the wide variety of effects that Bradshaw observed - sunsets both golden and pink-tinged, the ethereal silver light of the moon dappling gentle waves, hot summer days on which the placid calm of the sea offered scope for reflections, breezy days with billowing sails and waves capped by white horses, chilling storms with grey forbidding skies, waves crashing on to beach or cliff, sending spray high into the air, quiet coves with deep green water and tranquil harbours. The list could go on. Having been famously described by David Lewis as a "feisty old painter of storms at sea", one might imagine that there would be a proliferation of such subjects but, although storm scenes did feature amongst Bradshaw's exhibited work, as titles like *Heavy Weather in the Atlantic* (1926), *Tempest* (1928) and *Decks Awash* (1932) attest, they were not so common as to warrant being singled out as his trademark.[20] Similarity of subject matter is rare and the concept of 'pot boilers' dashed off for quick sales seems for Bradshaw to have been unacceptable. The contrast with Olsson and Park is self evident. In fact, Bradshaw seems to have made a conscious effort to avoid the standard views of St Ives and its harbour, repeatedly produced by artists like Park, Arthur Hayward and Arthur White. The instantly recognisable lighthouse included in *Smeaton's Pier* (1930) (Cover) is, for Bradshaw, a rare subject and, on other occasions when he depicted boats in the harbour, he used an unusual perspective. For instance, in *Departure for the Herring Fishing* (1939) (fig 17.4), the viewer looks down on the fishing luggers from the pier, so that the identity of the harbour is not clearly revealed.

Naval works are frequently seen in the sale-rooms but inspire little interest. There have been a number of depictions of single destroyers and frigates, clearly painted as commissions for Naval officers. Several times a home has tried to be found for an enormous exhibition piece of 1946, showing battleships ablaze amidst violent depth-charge detonations - well-painted but not living room material. Naval Museums might well in due course regret not acquiring these useful records of historical events and boats of the past.

[18] S.I.T., 3/10/1928
[19] Unattributed article in 1939 entitled, *Artist Served his Apprenticeship - in the Navy*
[20] Tate Gallery, *St Ives 1939-64*, London, 1985, p.26

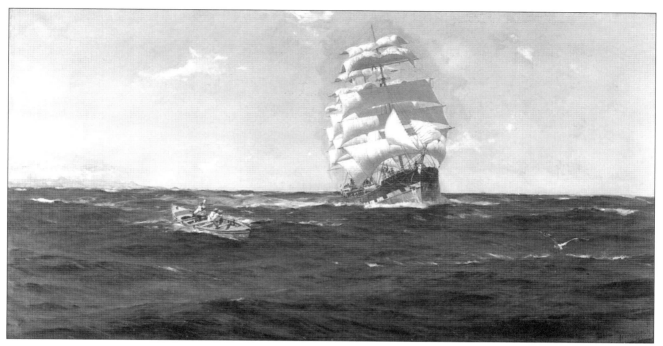

17.6 Thomas Somerscales *Off Valparaiso* (Tate Gallery, London, 1999)

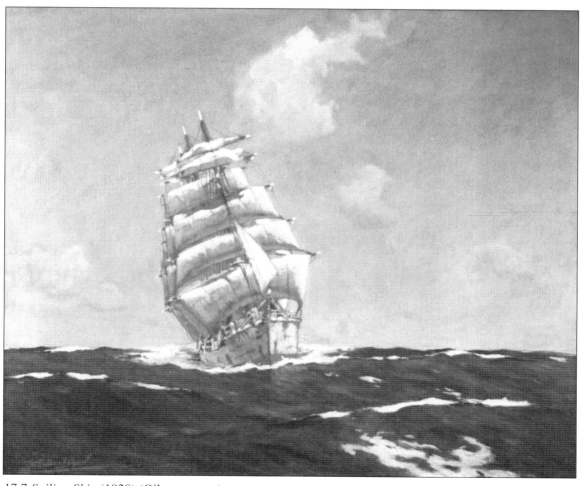

17.7 *Sailing Ship* (1928) (Oil on canvas)

Marine painting requires the use of full colour and it is accordingly no surprise that Bradshaw's favourite medium was oil. For his major pictures, he painted on canvas but he preferred painting on board. However, he did experiment with tempera. He probably learned how best to use this medium from Charles Simpson, who was particularly adept in it. An early work of 1924, *Ship Shortening Sail*, is stated to be in tempera and, in 1932, two important paintings, *Sunset and Evening Star* (Plate 14) and *Decks Awash* (fig 17.3) are in in the medium, but the loss of full, glowing colour is noticeable. Occasionally, works appear in bodycolour or watercolour but he was not as adept in these media. Whereas Moffat Lindner found watercolour most suited to his style, Bradshaw agreed with Smart that oil was the most suitable medium for a marine painter. Smart based the whole of *The Technique of Seascape Painting* on the use of oil. "I feel that the sea with all its dignity and power can be best expressed in this bolder method of work. There seems to be a sympathy between the subject and its translation in this medium." [21]

Having indicated that the influence on Bradshaw's art of his contemporaries Olsson, Simpson, Smart and Park was relatively small, it remains to be determined the extent to which Bradshaw forged an unique style of his own. Bradshaw has left no comment on his influences and his work was never likened with that of another marine artist. However, a review of the work of Thomas Somerscales (1842-1927) does highlight a number of similarities. Somerscales was a Naval man, who had served on sailing ships, before being invalided out in 1868. He then settled in Chile and established a considerable reputation in that country both as an artist and an art teacher. On his return to England in 1892, he exhibited regularly at the Royal Academy, his startling realism immediately attracting attention, and his 1899 exhibit *Off Valparaiso* (fig 17.6) was bought by the Chantrey Bequest. The popularity of this painting was immense - it has been described as the finest ever painted of a four-masted barque[22] - and reproductions were widely available.

A succession of atmospheric works featuring sailing ships followed - *Homeward Bound* (1903), *The Nitrate Ship* (1908), *Outside Valparaiso Bay* (1909) and *In the Doldrums* (1915) to name a few - and these contain certain characteristic features which reappear in Bradshaw's work. The dark blue rolling waters, with crisp foam flakes acting as compositional aids, so favoured by Bradshaw are likewise used by Somerscales. Both men, however, would have experienced personally the long unbroken swells of the southern seas, with their variations of deep blues - a type of swell not seen in home waters. The inclusion of other vessels to set off the featured sailing ship was handled in similar ways by both artists. Somerscales also uses distant specks of shipping to break the horizon line; smaller boats travelling in different directions create additional compositional lines and steamboats, pounding relentlessly through the water and belching black smoke, provide a telling contrast. Both men use the single gull to emphasise the loneliness of the open sea. More importantly, their treatment of the main feature - the square rigger - is comparable. Both knew their subjects intimately and strove to be correct on detail, but did not allow detail to impinge on the overall effect. Both were masters at handling light and shade on sails; both knew where the canvas and gear would be bleached by the sun and where continuous drenching by spray would rust the steel hull. Their ships were realistic, full of movement, and fitted perfectly into what Hurst calls "the whole sweep of their environment". The two men may never have met and Bradshaw may not have had the opportunity to study Somerscales' work at first hand but, in my view, reproductions of such work must have been known to Bradshaw. Somerscales seems the key influence.

As one would expect with paintings being put up for auction, the quality of works on offer has varied significantly and, accordingly, so have prices. This is not surprising given that Bradshaw himself in the 1940s was valuing some works at in excess of £100 and others at a mere £10. However, the fact that to date Bradshaw's life and achievements have remained unresearched means that even his best quality work sells at a significantly lower price than lesser quality paintings by better known marine artists. For so many dealers and collectors, the name is more important than the quality of the work in question.

[21] B.Smart, *op. cit.*, p.vi
[22] In A.A.Hurst, *Thomas Somerscales, Marine Artist*, Brighton, 1988 at p. 131

In conclusion, the best of the works that have appeared on the market in the last ten years confirm that Bradshaw was an extremely talented artist. Although he restricted himself, to a large extent, to the one genre, that of marine painting, his works show considerable variety and originality in conception, an excellent sense of colour and impressive technical skills. The regularity of the favourable reviews that he received indicates that he was also remarkably consistent. This in itself might have warranted this in-depth study, but, as has been seen, Bradshaw's career is so inextricably intertwined with the fortunes of the St Ives Society of Artists that its development is a crucial backdrop to his life. It was at his instigation that the Society was formed and, although he was prepared to drop back to allow the greater motivational talents of Borlase Smart to come to the fore, he maintained a keen interest in its progress, as the number of proposals introduced by him attest. On Smart's death, he again took a leading role, fighting hard for the protection of "his" Society from the undesirable influence of Nicholson. After the split, he was the elder statesman of the Society, but the artistic climate had become hostile to traditionalist art and his resentment grew. Most of his colleagues from the successful days of the 1930s did not live long enough to experience the full swing of the pendulum. Bradshaw, however, did and it must have been very hard to be lauded at one moment as a master of his art and then to feel the effects of comparative oblivion, to hear his type of art being dismissed as worthless, while artists, whose work he failed to understand, secured all the grants, received the publicity and won the plaudits. And it was not only his artistic pride that had to suffer - the last few years of his life were desperate financially.

The ultimate success of the modernists should not now be allowed to obscure the very real achievements of the traditional artists who were the backbone of the Society during its first twenty years. Given that the Society was, in its early days, faced with the effects of the Depression, its success did not come lightly. It required enthusiasm and hard work and a strong commitment to the good of the colony as a whole. It also, of course, required talent. Bradshaw was one of the central core of artists that devoted these qualities to the cause and the unity of purpose that was maintained for over twenty years was extraordinary. Their success was an achievement judged not by a critical elite but by the public, through the popularity of their exhibitions, which attracted a huge number of visitors, and by the level of sales of work. They may not have been pioneers - but their public did not want them to be. They wanted attractive, well-composed scenes painted with verve. They wanted to recognise what they saw, to judge for themselves how successful the artist had been. Often they wanted a memory, an evocation of the Cornwall they loved, a Cornwall that the artists themselves may have first introduced to them. More was done by the artists of the 1930s to publicise the attractions of Cornwall than any group of Cornish artists before or since. That, in itself, is a worthy achievement. Bradshaw's art, like that of most of his colleagues, will not feature in any assessment of art's progression during the twentieth century but to his chosen genre, to his beloved Society and to the town that he made his home for almost forty years, he made a significant and individual contribution, which deserves greater recognition.

ILLUSTRATION ACKNOWLEDGEMENTS

All paintings illustrated are by George Fagan Bradshaw, unless otherwise stated.

A book such as this gains immeasurably from its illustrations and I am immensely grateful to an enormous number of people for assisting me in this connection. Without such generosity, the project may not have come to fruition. I am particularly indebted to Robert and Anne Bradshaw for the provision of family photos and for their consent to the reproduction of the works of their father and mother. Rosemary Bradshaw likewise kindly provided photos of family and art.

All photographs credited RNSM, particularly those in Chapter 2, were selected from the excellent RN Submarine Museum Photograph Archive, Haslar Jetty Road, Gosport, Hampshire.

The co-operation and generosity of both David Lay of the Penzance Auction House, Alverton, Penzance and Graham Bazley of W.H.Lane & Son of Jubilee House, Lower Queen Street, Penzance have been remarkable. I am also most grateful to Leon Suddaby (Sims Gallery), Sotheby's, Phillips, Exeter and Bearnes, Exeter. As a result of all their respective contributions, so generously made, I have been able to include reproductions of work by a large number of Bradshaw's colleagues.

I am grateful to the following Art Galleries and Museums for providing photographs and for the favourable discounts to their reproduction fees many were prepared to offer:-

Williamson Art Gallery & Museum, Birkenhead
Birmingham Museums & Art Gallery Cheltenham Museum and Art Gallery
The Sir Alfred Munnings Art Museum, Castle House, Dedham, Essex
Leamington Spa Art Gallery and Museum Walker Art Gallery, Liverpool
Tate Gallery, London Manchester City Art Galleries
Laing Art Gallery, Newcastle-upon-Tyne Newport Museum and Art Gallery
Plymouth City Museum & Art Gallery Harris Museum and Art Gallery, Preston
The Potteries Museum and Art Gallery, Stoke-on-Trent St Ives Museum
Sunderland Museum and Art Gallery Swindon Museum and Art Gallery
Royal Institution of Cornwall, Truro Rochdale Art Gallery

Particular thanks are due to Alison Plumridge at Leamington, Guido Martini at the Tate, Robin Hawkins at Newport, Mel Twelves (Sunderland/Newcastle), Clare Taylor at Swindon, Brian Stevens at St Ives and Tamsin Daniel at Truro, all of whom went out of their way to be helpful. Top prize for quick reaction goes to Audrey Hall at Liverpool.

The Western Morning News kindly permitted me to take photographs of and to reproduce illustrations accompanying their accounts of Show Days.

I am also greatly indebted to Martin Val Baker, John McWilliams, Roy Ray, Hyman Segal, Marion Whybrow and Austin Wormleighton for the generous provision of photographs and to the photographers Murray King, Linda Lane and Alan Watson for quality work.

The copyright on images used belongs to the galleries, institutions and individuals listed in the text or, where none is listed, to myself. I have attempted to locate relatives of all artists whose work is reproduced herein for the requisite copyright consent and am grateful to all who have kindly given such consent. It has not proved possible in all cases to locate the relevant persons, despite reasonable endeavours. I trust that the additional publicity afforded such artists is welcome.

SPECIFICATIONS OF BRADSHAW'S SUBMARINES

	C-7	G-13	L-11	K-15	X-1 (C.H. Allen)
Completed	15/2/1907	23/9/1916	27/6/1918	30/4/1918	23/9/1925
Pennant No.	37	5C	11L	15K	X1
Displacement - tons					
- surfaced	287	703	914	1980	2579
- submerged	316	837	1089	2566	3600
Dimensions					
- length	142' 2½"	187' 1"	238' 7"	330'	363' 6"
- beam	13' 7"	22' 8"	23' 6"	26' 7"	29' 10"
- mean draught	11' 2"	13' 4"	13' 6"	17'	15' 9"
Crew					
- officers	2	3	4	5	8
- ratings	14	28	34	54	101
Range - miles					
- surfaced	1360 at 9 knots	3160 at 10 knots	2800 at 17 knots	12500 at 10 knots	16200 at 10 knots
- submerged	50 at 4.5 knots	95 at 3 knots	14 at 10.5 knots	30 at 4 knots (or 8 at 8 knots)	18 at 4 knots
Armament					
- bow torpedo tubes	2 x 18"	2 x 18"	4 x 21"	4 x 18"	6 x 21"
- beam torpedo tubes	-	2 x 18"	-	4 x 18"	-
- other torpedo tubes	-	1 x 21" (stern)	-	2 x 18" (superstructure)	-
- torpedoes carried	4	10	8	16	12
- guns - forward	-	1 x 3"	-	1 x 4"	-
- guns - other	-	1 x 12-pdr (aft)	1 x 4" (bridge)	1 x 3" (superstructure)	4 x 5.2" (twin turrets)
- mines	-	-	16	-	
Max. Speed - knots					
- surfaced	12	14	17	24	19.5
- submerged	7	9	Not Given	10	Not Given

The above information has been taken from the service histories of the submarines prepared by the Royal Navy Submarine Museum, Gosport

APPENDIX 2

G. F. BRADSHAW - EXHIBITED WORKS

Key
R.A.- Royal Academy
R.S.A.- Royal Scottish Academy
R.W.A. - Royal West of England Academy
S.M.A.- Society of Marine Artists

L.G.- Lanhams Galleries
H.S.- Harris and Sons, Plymouth
S.I.S.A.- St. Ives Society of Artists
S.D.- Show Day

This list includes all works exhibited at R.A., R.W.A. and S.M.A. However, exhibits at S.D., L.G., H.S. and S.I.S.A. have had to be extracted from newspaper reviews. Not all exhibitions are reviewed and not all reviews mention Bradshaw's works by name, particularly in the 1950s.

1922	S.D.	*Up Channel*		L.G.	*Putting To Sea* (fig 3.8)
		The Lady in White			*The Wreck*
		Outward Bound			*The Straits*
		A Broadside from a Super-Dreadnought			
		At the Back of the Pier			
1923	S.D.	*The White Barque*		R.W.A.	*The White Barque*
		Line Ahead			*Mid-Channel*
		The Cutty Sark			
	R.A.	*The White Barque*			
1924	S.D.	*A Pensive Sky, Sad Days, and Piping Winds*		H.S.	*Battleship in a Rough Sea*
		An Epic of the Merchant Service		R.W.A.	*The Old Timber Ship*
		The Old Timber Ship			
	R.A.	*The Western Ocean* [*A Pensive Sky...*renamed]			
1925	S.D.	*The Wool Clipper*		R.S.A.	*The Western Ocean*
		Maltese Fruit Boats (?fig 1.10)		R.W.A.	*In the Tropics*
		Sunset Sails			
1926	S.D.	*Crabbers Returning*		R.W.A.	*Sea and Rocks*
		Heavy Weather in the Atlantic			
	R.A.	*Crabbers Returning*			
1927	S.D.	*Laying Long Lines off the Wolf*		L.G.	*Squalls at Sea*
		Trade Winds (?Pl. 2)			
		Breakers			
	R.A.	*Trade Winds* (?Pl.2)			
		Breakers			
1928	S.D.	*November Twilight, St. Ives*		S.I.S.A.	*Summer Evening*
		The Trawlers (Pl .8)			*Tempest*
		Cape Horn		L.G.	*Passing Showers*

George Bradshaw in Ship Studio with *Crabbers Returning* (RA 1926) (R.N.S.M.)

1929	S.D.	*The Golden Shore*		S.I.S.A.	*Heralds of the Sea*
		Flood Tide at Evening			*Jones' Travelling Amusements* (Pl. 18)
		At Sea			*French Crabbers*
		Passing Showers			*Prussia Cove*
	R.A.	*At Sea*			*White Bait*
					Southwards She Thundered
1930	S.D.	*Wind and Canvas*		S.I.S.A.	*At Sea*
		Off Malta (Pl. 9)			*Smeaton's Pier* (Cover)
		Herald of the Storm			*Wind and Canvas*
					Blue Sea and White Boats
					Onward
					Sunset
				L.G.	*Off the Coast of Spain*
					Herring Fishing
					St. Ives Bay
1931	S.D.	*Porthmeor Beach*		S.I.S.A.	*Jones' Travelling Amusements* (Pl. 18)
		After Rain			*Westward and Candida* (Pl. 13)
		Onward			*Sunset*
					Onward
1932	S.D.	*Decks Awash* (fig 6.7)		S.I.S.A.	*At the Foot of the Cliffs*
		Porthmeor Beach, St Ives			*Sunset and Evening Star* (Pl. 14)
		West Wind			*Zennor Church Town*
	R.A.	*Decks Awash* (fig 6.7)			*Fishers Returning*
	Brighton	*Wind and Canvas*		L.G.	*North East Wind*
		Porthmeor Beach, St Ives			*Dusk*
		Rough Sea			*French Crabbers*
	Stoke	*Wind and Canvas*			
1933	S.D.	*Off Malta*		S.I.S.A.	*Porthmeor Beach*
		Fishermen			*Near Godolphin*
		Zennor Church Town			
	R.A.	*The Lobster Fishers* [*Fishermen* renamed]			
1934	S.D.	*On a Dorset Farm*		S.I.S.A.	*French Fishing Boats*
		Grain from Australia		L.G.	*Man's Head*
		Trawler			
	Oldham/Southport	*Trawler*			
		The Lobster Fishers			
	Lincoln	*Zennor Church Town*			
		Porthmeor Beach			
		A Bridge over the Dart			
1935	S.D.	*Surf Bathing*			
		Cruisers Manoeuvering			
		Sixty South			
	R.A.	*Cruisers Manoeuvering*			

Bradshaw with his 1937 RA painting *Surface Patrol* (Western Morning News)

1936 S.D. *Outposts*
 Inside the Longships
 Summer Evening
 Eastbourne Tour *The Lobster Fishers*
 Zennor Church Town
 Penzance
 Birmingham Tour *Inside the Longships*
 Bosigran Castle (Pl. 17)
 Cruisers Manoeuvering

S.I.S.A. *Cruisers Manoeuvering*
 Frenchmen in the Bay
 Low Tide, St. Ives
 Regatta Day, St. Ives

1937 S.D. *Surface Patrol*
 Gulls
 St. Agnes Beacon

S.I.S.A. *Off St Ives*
 Penzance Harbour
 Rolling Home (Pl. 16)

1938 S.D. *Hor Point*
 R.A. *Low Tide in the Cove*
 Portsmouth *Bathing in the Cove*
 The Unfinished Pier

S.I.S.A. *Round the World if need be*
 and Round the World Again
 Trees in Winter
 Porth Zennor Cove
 St. Hilary Spire
 Bosigran Castle (Pl. 17)

1939 S.D. *French Fishing Boats off the Cornish Coast*
 Gold and Silver
 Departure for the Herring Fishing (fig 17.4)

S.I.S.A. *Blue Boat*
 Penzance Harbour
 The Crabber
 Crabbers in the Bay
 Summertime in the Bay

1940 United Artists *The Crabber*
 Frenchmen in the Bay

S.I.S.A. *The Night Watch* (? fig 13.1)
 Summer at St Ives
 Porthmeor Beach
 Penzance Harbour
 Sailing
 Godrevy Lighthouse

1942 United Artists *Cruisers Manoeuvering*
 The Night Watch (? fig 13.1)
1943 United Artists *Night Raid*
 In Convoy

1944

S.I.S.A. *Round the World if need be*
 and Round the World Again

1945 Sunderland Tour *Sunlit Sea*
 Off the Coast of Portugal

S.I.S.A. *Old Timer*
 Deep Water
 The Straggler
 War-time: An 'Empire' Ship
 Leaves Sunderland

Bradshaw with his 1938 RA painting *Low Tide in the Cove* (Western Morning News)

1946 S.M.A. *French Crabbers off the Cornish Coast*
 Early Morning off Sunderland

1947 S.D. *French Crabber off Porthminster Beach* L.G. *Low Tide*
 Porthmeor Beach S.I.S.A *Gold and Silver*
 S.M.A. *Northerly Gale* *Low Tide, Hayle Bar*
 Deep Waters
 Cardiff *Low Tide, Porthmeor Beach*

1948 S.M.A. *Summer Night* (fig 14.2) L.G. *Breakers*
 St. Ives Crabber *Low Tide*
 Bringing in the White Heather *Cloudy Bay*
 Hauling Pots in Rough Weather (?Pl.23) S.I.S.A *Passing Showers*
 Pen Enys Point

1949 S.D. *The Stranger* S.I.S.A. *In St. Ives Bay* (Pl. 31)
 Roll on thou dark and deep blue ocean, roll..(?fig 17.1) *The Stranger*
 The Seventh Wave *St Ives Crabber*
 S.M.A. *In St Ives Bay* (Pl. 31) *Moonlight*
 The Stranger *Sunbathers*

1950 S.D. *Breakers* S.I.S.A. *Sea at Rest*
 His Majesty's Sea-Bound Mails *Our Girls*
 S.M.A. *Grey Sea*

1951 S.D. *Breezy Day, St. Ives*
 Moonlight from Porthgwidden
 S.M.A. *Moonlight Bay* (Pl. 35)
 A West Country Harbour
 Coming on to Blow

1952 S.D. *Up Channel* S.I.S.A. *Fresh Breeze*
 S.M.A. *The Wind and the Sea*
 A Blue Day
 Seining for Bait

1953 S.M.A. *Breezy Weather* S.I.S.A. *Moonlight*
 Moonlight *Summer Evening*
 Bathing in the Cove *Moonlit Bay*

1954 S.M.A. *Round the World if need be* S.I.S.A. *North Atlantic*
 and Round the World Again *Summer Days*
 In Mount's Bay *Night Departure*
 Night Arrival *Atlantic*

1955 S.M.A. *Breezy Day* S.I.S.A. *Fresh Breeze*
 Surf *Night Arrival*
 Off the Spanish Coast (fig 1.8) *Up Channel* (Pl. 32)

1956 S.M.A. *Moonlight*
 The Western Ocean
 Pendeen Watch

1957 S.M.A. *Cornish Coast Scene* S.I.S.A. *Leaving Valetta, Malta*
 Northerly Gale *Nocturne*
 Afterglow Porthmeor
 North Wind
 Summer Moon
 Breezy Day
 Setting Moon (fig 16.8)

1958 S.M.A. *Breakers* S.I.S.A. *Frenchmen Entering St. Ives Bay*
 Moonlight *The Longstones*
 Northerly Gale *Off the Cornish Coast*
 Hull (S.M.A.) *Cornish Coast Scene* *Edge of the Sea*
 The Fringe of the Sea

1959 S.M.A. *Summer Sea* S.I.S.A. *Round the World if need be*
 Cornish Cove *and Round the World Again*
 Moonlight
 Hauling the Seine
 Summer Morning
 Ebb Tide
 Coastal Waters

1960 S.I.S.A. *Breakers*
 Cornish Cove
 Pen Enys Head, Cornwall
 North Wind
 Northerly Gale
 Off the Island
 Ebb Tide
 Breakers

APPENDIX 3

PRINCIPAL MEMBERS
OF THE ST IVES SOCIETY OF ARTISTS (1927-1960)

Key: SISA[] = St Ives Society of Artists [dates of membership, if known]
 FM = Founder Member 1927
 Pr. = President V.P. = Vice-President
 Ch. = Chairman Sec. = Secretary
 Tr. = Treasurer
 Exh. R.A.[] = Exhibited at Royal Academy [number of times in career]
 Br.32 SISA - Brighton 1932
 Li.34 SISA - Lincoln 1934
 Bi.36 SISA - Birmingham & Cheltenham 1936
 Su.45 SISA - Sunderland, Gateshead, Carlisle,
 Darlington & Swindon 1945/6
 SA.47 SISA - South African Tour 1947
 Ca.47 SISA - National Museum of Wales 1947
 Sw.49 SISA - Swindon Jan/Feb 1949
 Coll. Some Municipal Collections in which work held

Principal Members 1927-1949

Alixe Jean Shearer Armstrong (1894-1984) Exh.RA[10]
SISA[FM- resigned 1949, Tr.1940-4] Exh. Br.32, Li.34, Bi.36, Su.45, SA.47, Sw.49.
Born London into a family who had become wealthy through the Yorkshire wool trade. Slade trained under Tonks and Steer and later studied portraiture in Karlsruhe, Germany under Otto Kemmer. Brigadier husband died young. Moved to Carbis Bay in 1921. Had lessons from Forbes and Talmage. Studios at 1, Piazza and 9, Porthmeor. To begin with, specialised in flower paintings but during the 1930s, developed an individual style of still life, with a medley of objects, animals and views of distant landscape, which resulted in her works having an exotic flavour. Used drawings made at the zoo in Kew Gardens and at the Natural History Museum. Committee 1935-7 & 1948 and Treasurer through WW II. By the late 1930s, experimenting with some startling figure work and during the War, became influenced by Ben Nicholson. Her modern leanings led to her resignation in 1949 and she became a leading figure in the Penwith Society.

Alfred Charles Bailey (b.1883)
SISA[FM-at least 1943] Exh. Br.32, Li.34, Bi.36.
Born Brighton and studied at Brighton and under Louis Grier, but largely self-taught. Painted marine subjects, landscapes and old buildings in watercolour. Had various one-man shows in London and exhibited at Salon and provincial Galleries. Distinct and unusual technique, with initially a somewhat extravagant use of colour, but got "freshness and a pleasing quality of pattern". Included in 1925 Cheltenham show. Used Atlantic Studio. Threatened to resign in 1930 as considered unfairly treated by Hanging Committees. Still a member in 1938 but living in Chelsea.

Percy des Carriére Ballance (b.1899, still exh.1969) Exh.RA[15]
SISA[1932-late 1930s] Exh. Bi.36.
Born Birmingham. Landscape and seascape painter. In early 1920s, he worked with his sister, Marjorie, from 1, Piazza Studios. A breezy personality whose seascapes were hailed for their vitality, reflecting the "rollicking gaiety of undaunted youth" (S.I.T., 19/3/1921), but one Show Day, a stray cat walked into his studio, looked at his painting of a rough sea and was promptly sick on the spot! Included in 1925 Cheltenham show but moved away in 1927 and not a member until 1932. Also included in 1933 Barbizon House show and features regularly in exhibitions for rest of the decade. The work of **Marjorie Ballance** (Exh.RA[1]) was brilliantly coloured and highly decorative. She also did clever painted wooden models. Lived at 1, Albany Terrace. Resigned in 1949 but rejoined the same year. In 1950, took issue with Rountree's comments on *Down Your Way*. No longer a member in 1957. Elected President of Arts Club 1956, where she had been a member since 1914.

Hurst Balmford (b.1871) Exh. RA[8]
SISA[c.1927-late 1930s] Exh. Li.34
Studied Royal College of Art and Julians, Paris. Headmaster of Morecambe School of Art. Painter of landscapes praised for richness of colour and spontaneity in handling. Beach Studio. Exhibited Show Day 1926 and at some exhibitions in late 1920s. Great lover of music, playing violin and viola. Lacklustre in his support of the Society. Still a member in 1938 and showing at Lanham's but address in Blackpool.

John Rankine Barclay (1884-1964) Exh.RA[1] RSA[52]
SISA[1936-1964] Exh. Bi.36
Born Edinburgh. Studied Royal Scottish Academy Schools. Decorative and mural painter and woodcut artist. Moved to St Ives 1935. Work welcomed as "modern in spirit and yet in touch with tradition". Large mural decorations of the Seasons a feature of Show Day 1938. Committee 1938. One-man show at Lanhams in 1939 contained landscapes with sky studies, studies of London parks and Cornish scenes of both harbours and moors. Served in RAF in WW II and may have ceased to be a member for some while thereafter. Did murals in St Ives Bay Hotel and a series of paintings for Curnow's Café (1940), depicting important events in the history of St Ives. These led in 1953 to a commission for a huge mural (32ft x 11ft) in the clubroom of Wembley Stadium. One-man show in Castle Inn in 1954 *Impressions of New York and Connecticut.*

Sir Claude Francis Barry RBA (1883-1970) Exh.RA[17]
SISA[1939-1946] Exh. Su.45.
First came to St Ives in 1911 and stayed during Great War. Returned in 1939, having been thrown out of Italy. Made a significant impression with his combination of technical excellence and originality in treatment. Used searchlight patterns for compositional effect in wartime scenes. Also fine etcher believing in the large plate. Left for Paris as soon as peace returned. His wife did fine needlework pictures. Coll. Swindon - bought from 1946 show.

Dorothy Bayley
SISA[1932- resigned 1949 but rejoined] Exh. Br.32, Bi.36, SA.47.
Landscape and figure painter. Most commented upon work was *The Pursuit of Pleasure* (1937) depicting a group of cyclists on a rain swept road, leaving behind the turmoil of town life as symbolised in the background with factory and electricity poles. *Trencrom* bought by brewery directors at 1946 St Austell show. Although resigned in 1949, rejoined and Town Council acquired her *Dutch Boat, Hayle* from 1951 Festival Exhibition. Still a member in 1957.

Frederick Samuel Beaumont RI (b.1861) Exh. RA[15]
SISA[1929-c.1947] Exh. Bi.36, Ca.47.
Born Huddersfield and studied at RA Schools and Julians, Paris. Work included portraits, landscape and mural decorations. 23 decorative panels were bought by P & O. Lived in London. Contributions to Society shows infrequent. His *Interior - St Paul's Cathedral* bought by H.M. The Queen in 1933. *National Gallery, Interior* praised at 1938 Summer show and also exhibited at Cardiff.

Samuel John Lamorna Birch RWS RWA **RA**(1934) (1869-1955) Exh.RA[237]
SISA[1930-1955, Pr.1950-55] Exh. Br.32, Li.34, Bi.36, Su.45, SA.47, Ca.47, Sw.49.
Born Cheshire. Studied in Paris in 1896 and settled in the Lamorna Valley 1892. A number of painters and writers were later drawn to Lamorna and many of these also joined the Society. Prolific, successful and well-known landscape painter in oil and watercolour, who contributed many works, often of Lamorna and its environs, to the Society's shows. Although he exhibited with the Society from 1928, he was not formally asked to be an honorary member until 1930. Lectured to the Society on watercolour painting and gave opening addresses. Committee member 1932/3 & 1948 and became President after the split. Immensely important figure to the Society - his reputation and the quality of his exhibits ensured attention.

Fred Bottomley (1883-1960) Exh.RA[10]
SISA[1929-c.1952] Exh. Br.32, Li.34, Bi.36, Su.45, SA.47, Ca.47, Sw.49.
Slade-trained painter, best known for his pictures of St Ives but also did still life and landscape and etchings. Loyal Society man who made an important contribution. Declined the role of Secretary in 1933 but regular Committee member. One of the ten signatories requisitioning the 1949 meeting. Probably moved to Southport in 1952.

George Fagan Bradshaw S.M.A (1887-1960) Exh. RA[10]
SISA[FM-1960, Sec.1927 & 1949-1952, V.P.&Ch.1955-7] Exh.Br.32, Li.34, Bi.36, Su.45, SA.47, Ca.47, Sw.49
Born Belfast. Studied under Dingli in Malta whilst in the Navy and arrived in St Ives in 1921 for further study at the Simpson School. Became Assistant at the School. Marine specialist. Principal instigator for formation of

Society and first Secretary. Committee member 1930-3, 1935-9 & 1946 and acting Secretary when Cochrane/Smart were away. Elected spokesman of the traditionalists at the meeting in 1949. Elder statesman during 1950s, taking various offices. Coll. Sunderland and Royal Navy Submarine Museum.

Kathleen Bradshaw (née Slatter) (1904-1997) Exh. RA[1]
SISA[FM-at least 1960] Exh. Br.32, Li.34, Bi.36, Su.45, SA.47, Ca.47, Sw.49.
Born Rhodesia. Arrived in St Ives 1921 to study at Simpson School. Married George Bradshaw 1922. Specialised in still life but worked in all media and keen to experiment. Also designed lampshades. Universally liked and worked on Ladies' Committees for teas etc. First elected to Committee 1951. After G.F.B.'s death, married Jim Bailey and gave up painting until shortly before her death.

Sir Frank Brangwyn RA(1919) (1867-1956) Knighted 1941 Exh.RA[55]
SISA[1935-c1944] Exh. Bi.36
Born Belgium. Early training from Welsh architect father. Also at age 15 studied under William Morris before going to sea. Painter of architecture, marine and historical subjects with a significant international reputation. Masterful etcher and lithographer. Exhibited several paintings and a number of highly rated etchings with the Society in late 1930s but is not involved post-War.

John Mallard Bromley RBC (1858-1939) Exh.RA[17] RBA[87]
SISA[exh.1929-39] Exh. Br.32, Li.34, Bi.36
Born London and studied under his father William Bromley and Bonnat in Paris. Oil and watercolour painter of landscapes and seascapes. Won medals at International shows in 1879 & 1884. Resident in St Ives from 1897. Lived and worked at Quay House, The Wharf, which he built himself and from which he painted numerous pictures of the harbour and the Bay. Included in 1925 Cheltenham show but does not feature in Society exhibition reviews until 1929. In twilight of career.

Sir John Alfred Arnesby Brown RWA RA(1915) (1866-1955) Knighted 1938 Exh.RA[141]
SISA[1928-1947] Exh. Br.32, Li.34, Bi.36, Su.45, SA.47.
Born Nottingham. Studied under Herkomer at Bushey. Principally, a landscape painter with penchant for depicting cattle. He worked from St Ives as early as 1891 and had been President of the Arts Club in 1904. He was one of the first distinguished artists to be invited to be an honorary member and was a regular contributor throughout the Society's first 20 years. On several occasions exhibited studies for his RA pictures of that year. Retrospective in Norwich Castle Museum 1935. He did not take any active part in the Society's affairs and his work is not mentioned in reviews of Society shows after 1947. His involvement and his reputation important in the Society's early years.

Marjorie (Midge) Frances Bruford (b.1902) Exh.RA[32]
SISA [1938-beyond 1957] Exh. SA.47, Ca.47.
Born Eastbourne. Studied Newlyn and Paris. Lived mainly in Paul, near Penzance. Portraitist. Had 3 works hung at RA the year she joined. At Cardiff, contributed her 1946 RA exhibit *The Visitor*. Not included in Sw.49.

Charles David Jones Bryant ROI RBA (1883-1937) Exh.RA[15]
SISA[1932-1937] Exh. Li.34, Bi.36.
Born New South Wales. Marine painter who had studied under Olsson. Vice-President of the Royal Art Society of New South Wales. Visited St Ives in 1932, when elected a member. Contributed to Exhibitions in mid-1930s, including 1933 Barbizon House show. *Yacht Race, Sydney Harbour* a regular exhibit. RA exhibits in 1933, 1935 & 1936 all St Ives scenes.

Arthur James Weatherall Burgess RI ROI RBC (1879-1957) Exh.RA[57]
SISA[1931-1949] Exh. Br.32, Li.34, Bi.36, SA.47, Ca.47, Sw.49.
Born New South Wales. Settled in England 1901. Studied Sydney and St Ives. Marine artist of high reputation. Official Naval Artist for Australia 1918. Art Editor *Brassey's Naval & Shipping Annual* 1922-1930. Illustrator for *The Graphic*, *Illustrated London News* and *The Sphere*. Lived in London but regular contributor to the Society's exhibitions. *The Restless Deep* highly rated at Bi.36. Coll. Derby, Lincoln and Nuneaton.

Eleanor Charlesworth (b.1891) Exh.RA[7]
SISA[1932-c.1947] Exh. Br.32, Li.34, Bi.36, SA.47, Ca.47.
Slade-trained landscape and flower painter, based in London. Regular contributor during 1930s. Her 1943 RA exhibit *Syringa* was included in the Cardiff show. Last RA exhibit 1945. Still recorded as exhibiting elsewhere in 1960 but no longer a member in 1957.

Alfred Cochrane (d.1947)
SISA[FM-1947, Sec.1928-1933] Exh. Br.32, Li.34, SA.47.
Delicate and refined still life and landscape. His period as Secretary was highly appreciated, with compliments being paid to his natural tact and geniality. His wife, **Taka Cochrane**, was an artist member from 1931. She also specialised in still life. Exh. Br.32 & Bi.36.

Nell Marion (Tenison) Cuneo SWA (1867-1953) Exh.RA[11]
SISA[1928-c.1945] Exh. Li.34, Su.45.
Born London. Studied Cope's School, Colarossi's Academy, Paris and Whistler School. Widow of book illustrator, Cyrus Cuneo. Lived and worked at Down-along House. Portrait and figure painter and illustrator (e.g. for *Black and White*). Portraits praised for their fine colour schemes and interesting arrangements. Included in 1925 Cheltenham show. Restored *The Copper Kettle* on The Wharf. Left St Ives 1930 but continued to contribute to Society exhibitions. Son **Terence Cuneo** (b. 1907) studied art at Chelsea and the Slade and was a member at least 1932-8. Although he became a successful portrait painter, painting many notables including H.M.The Queen, his contributions to the Society's shows were irregular due to his extensive travelling.

John Christian Douglas (1860-1938)
SISA[FM-1938] Exh. Br.32, Li.34, Bi.36.
Lived at 10, Park Avenue. Landscape painter, making a special study of the rocks and sea of the Cornish coast. Has the honour of being the first member to sell a work at one of the Society's Exhibitions. Also well-known photographer.

Mabel Douglas (née Bucknall) (Exh.1898-1947) Exh.RA[22]
SISA[1928-at least 1947] Exh. Br.32, Li.34, SA.47.
Specialist miniature painter. Flower pieces, portraits and seascapes on ivory. Exhibited with the Society in 1927 at Lanham's. In late 1930s, the miniature section, comprising Douglas, Blanche Powell (who lived in Alverton) and Ethel Roskruge was highly regarded and many of their works were hung at the RA. Her RA exhibits were all portraits and included her husband, John (twice), Mrs Claude Barry (described as full of luscious harmony and tinting), General Sir Herbert Blumberg and the photographer, W.H.Lanyon and his wife.

Lowell Dyer (1856-1939)
SISA[FM-1939] Exh. Li.34.
Born Brooklyn, USA. Studied under Gérome at the Beaux Arts and with Collin in Paris. Came to St Ives 1889 for a summer holiday and stayed. Renowned for his wit and a keen golfer, making nearly all his strokes with one club, described as "a battered old wooden spoon". Figure painter in oils with a penchant for painting angels. Studio in grounds of Talland House. Included in 1925 Cheltenham show but was infrequent exhibitor with Society. Keen Arts Club member.

Frances Ewan
SISA[1932-beyond 1957] Exh. Br.32, Li.34, Bi.36.
An artist about whom little is known. Came to St Ives from Marlow. She exhibited a series of portraits, some out of door sketches and some studies of landscape backgrounds for portraits on Show Days in the early 1920s. Her technique was described as crisp and emphatic, with the forms carefully drawn. Attended one of foundation meetings and exhibited at Lanham's in 1928 but not a member until 1932. Principally still life in watercolour but also some fine oils of the harbour. One of the signatories requisitioning the 1949 E.G.M. as omitted from Sw. 49.

Bernard Fleetwood-Walker ROI RP RWS **RA**(1956) (1893-1965) Exh.RA[147]
SISA[1936-c.1949] Exh. Bi.36, Ca.47, Sw.49.
Lived in Birmingham and studied in Birmingham, London and Paris. Portrait and figure painter in oil and watercolour. Made immediate impression at 1936 Autumn Exhibition with his 1934 RA exhibit *The Maidens* but when this was required for an exhibition at the Walker Art Gallery, Liverpool, he replaced it with his 1936 RA exhibit *The Toilet,* depicting a girl kneeling on the grass and watching in a hand mirror the dressing of her hair by a female attendant. This was equally highly praised. Ca.47 included his 1947 RA exhibit *Nude* and Sw.49 included his portrait of the Secretary, David Cox.

Maude Stanhope Forbes (née Palmer) Exh.RA[24]
SISA[1933-c.1949] Exh. Bi.36, SA.47, Ca.47, Sw.49.
Still life, landscape and figure painter. Second wife of Stanhope Forbes. They met while she was a student at his School. Elected honorary member in 1933. Ca.47 included her 1938 RA exhibit *Statuette* and Sw.49 featured a portrait of her late husband.

Stanhope Forbes RA (1857-1947) Exh.RA[247]
SISA[1928-1947] Exh. Br.32, Li.34, Bi.36, SA.47, Ca.47.
Born Dublin. An artist of immense stature, acknowledged as the father of the Newlyn School. Unaffected by any movements, he brought out the beauty of his subjects in a way all could appreciate. One of the first Newlyners to be invited to join as honorary member. Offered to pay from 1931. Always a welcome guest in St Ives but declined to give a talk due to 'nerves'. There was little need for him to support the Society but he did his bit, contributing a range of work. Titles include *Roseworthy, At the Cottage Door, The Terminus, Penzance, Cornish Riviera Express* and portraits of *The Violinist, Walter Barnes* and *Madame Gilardoni*. In 1939, he spoke of his debt to Borlase Smart. In 1949, a retrospective exhibition was held at Newlyn at which Munnings again sounded off about modern art.

Leonard Fuller ROI RCA (1891-1973) Exh.RA[31]
SISA[1938-resigned 1949 but rejoined, Ch.1946-9] Exh. Su.45, SA.47, Ca.47, Sw.49.
Born Dulwich. Studied Clapham and RA Schools. Highly regarded portraitist. Taught art at Dulwich College from 1927 before persuaded by Smart, a friend from the Great War, to open a School of Painting in St Ives in 1938. This School is still in existence, now under the control of Roy Ray. Immediate and important influence. First elected on to Committee 1939 and played important role during War. *Knitting* (1939) (Plate 24) is a portrait of his wife Marjorie Mostyn (see below), also an artist of repute. His RA exhibits include a portrait of Moffat Lindner in 1943. As Chairman, attempted to pursue Smart's vision but annoyed traditionalists and resigned in 1949. His style of painting, however, sat uneasily in Penwith Society and he rejoined SISA.

Stanley Horace Gardiner (1887-1952) Exh.RA[18]
SISA[1938-1952] Exh. SA.47, Ca.47.
Born Reading. Studied at Arbroath. Gave up lecturing art at University College, Reading to devote himself to painting landscapes. Settled in Lamorna in 1924 and became for a time the studio assistant of Lamorna Birch, who was clearly an important influence. Exhibited occasionally with the Society from its early days but not a member until 1938. Ca.47 included his 1947 RA exhibit *The Torridge Vale, N.Devon*.

Geoffrey Sneyd Garnier ARWA (1889-1970) Exh.RA[2]
SISA[1932-late 1930s] Exh. Br.32, Li.34, Bi.36.
Born Wigan and studied at Bushey, Toronto and under Stanhope Forbes. Engraver of figure subjects and landscapes. Exhibited with the Society in 1927 at Lanham's. Important contribution to 'black and white' section in 1930s. Coloured aquatints highly regarded. Still a member in 1938, when living in Newlyn. His wife, **Jill Garnier**, whom he had met in 1916 at Forbes' School, was also a member for a time. Her portraits were her strongest work and she was also an accomplished needlewoman. Exh. Li.34, Bi.36.

Hugh Gresty (1899-1958) Exh.RA[20]
SISA[FM-1931]
Born Nelson, Lancashire. Studied Lancaster School of Art and Goldsmith's College. His wife, Elizabeth, came from a wealthy family. Specialised in paintings of ancient buildings, with his drawing style conveying their monumentality most effectively. His work was marked by a calm dignity, with a masterly sense of proportion and his watercolours were as strong in execution as his oils. Painted to music of Sibelius. Travelled extensively and loved cookery. Increase in subscription in 1932 meant did not rejoin. Stayed in St Ives, living on The Wharf and continued to be successful at RA. Moved to Carbis Bay 1938. Coll. Burnley, Southport, Bradford and Liverpool.

Mary Grylls Exh. RA[1] SWA [11]
SISA[FM-late 1930s] Exh. Br.32, Li.34, Bi.36.
Studied Crystal Palace School of Art and at Newlyn under Norman Garstin. Figure, flower and landscape painter in watercolour. Blue Studio but lived in Lelant. A critic commented, "Her pictures are of the type to hang on a wall in an intimate room and go to at odd moments for pure joy of seeing them....Much restraint in style, a little support from the pen, and a sparing use of colour."(S.I.T., 17/3/1933). Moved to London and continued exhibiting elsewhere until 1950.

Fred Hall (1860-1948) Exh.RA[69]
SISA[1936-1948] Exh. Su.45, Ca.47.
Born Stillington, Yorks. Studied at Lincoln and at Antwerp under Verlat. Landscape, genre and portraits. Gold medal, Paris 1912. Had lived in Newlyn, although little influenced by the Newlyn School, but now living in Newbury. Contributed to 1928 show but not elected member until 1936. Another highly regarded artist, whose works were noticed.

Arthur Creed Hambly RWA (b.1900) Exh.RA[2]
SISA[1930-1970s] Exh. Br.32, Li.34, Bi.36, SA.47, Ca.47, Sw.49.
Born Newton Abbot. Studied Schools of Art in Newton Abbot under Wickcliffe Egginton and Bristol and became Headmaster of Camborne and Redruth School of Art. Landscape painter in watercolour. An etching *Tin Mines of Carn Brea* was described as one of the gems of Show Day 1931. First exhibited with Society in 1929 and was regular contributor for many years. Coll. Swindon from 1946 Exhibition.

Alfred Hartley RE RWA RBC (1855-1933) Exh.RA[65]
SISA[FM-1933] Exh. Br.32, Li.34.
Born Stocking Pelham, Herts. Studied at South Kensington and at Westminster under Brown. Subjects include landscape, architecture and boats and worked in oil and pastel but best known for his etchings and aquatints, winning various medals at international exhibitions. Founded New Print Society St Ives in 1923 and was undisputed head of the 'black and white' section, always willing to help and dispense sound advice. Smart commented, "To see him pull a proof on his press was like watching a magician." Twelve works included in 1925 Cheltenham show. In 1932 won gold medal in Los Angeles for *Snow Scene on the Alps* and had aquatints purchased by the Italian Royal Family. The secret of his work was the atmosphere he expressed in the open aquatint ground of his plates. Represented in many national and international collections, including British Museum, V&A, Adelaide, Rome, Venice. Moved to Llandrindod Wells for health reasons in 1931. A memorial exhibition was held at Lanham's in 1934.

Nora Hartley Exh.RA[13]
SISA[FM-1934] Exh. Br.32, Li.34.
Wife of Alfred, and herself a respected flower and domestic painter. In 1928, she exhibited a portrait of The Ranee of Sarawak. Appears not to have exhibited with Society much after her husband's death. Last RA exhibit 1932.

Harold Harvey (1874-1941) Exh.RA[55]
SISA[1928-1931]
Born Penzance. Studied under Norman Garstin and at Julian's, Paris. Lived in Newlyn. A highly regarded artist who was one of the first to be offered honorary membership but, having made important contributions in the first few years, he had ceased to be a member by 1932.

Arthur Hayward (1889-c.1950) Exh.RA[22]
SISA[FM-1931]
Born Southport. Won bronze medal at South Kensington for design. Gave up architecture for painting and studied at Warrington and under Stanhope Forbes. Set up own School of Painting in 1924. Included in 1925 Cheltenham show. Recognised as best portraitist in the colony before the advent of Fuller. A number of his RA exhibits are in fact disguised self-portraits (see Plate 28). Also painted colourful depictions of boats in the harbour which were marketed in poster format by Frost and Reed. Active Committee member 1927-1930. Objected to the doubling of the subscription in 1932 and never exhibited with Society again.

(Beatrice) Pauline Hewitt ROI SWA (1873-1956) Exh.RA[19]
SISA[1927-1954] Exh. Br.32, Li.34, Bi.36, Su.45, SA.47, Ca.47.
Studied at the Slade under Augustus John and William Orpen and in Paris. Landscapes, beach scenes, portraits and still life. St Peter's Studio, Porthmeor and later St Andrew's Studio. Travelled extensively. Vigorous style with striking use of colour. Other descriptions speak of her work as powerful, fearless and full of vitality. Not at the foundation meeting but joined soon after. Committee 1928, 1931 and more regularly from 1942. Her *The Empty Plate* of 1944 rated as the best portrait seen for for some time in St Ives. Long-standing colleague and friend of the Bradshaws. Left St Ives in 1954 due to failing health in order to be near her son and died in Surrey.

(Philip) Maurice Hill SMA (1892-1952) Exh.RA[2]
SISA[1939-1952] Exh. Su.45, Ca.47.
Son of a judge, he was a man of many parts. He qualified as a solicitor and became general manager of the UK Chamber of Shipping, whilst also exhibiting his paintings at the Paris Salon and the principal Galleries in the UK. First Secretary of SMA, founded in 1939, and persuaded to join SISA by Smart, who was also on first Committee. First exhibit was an oil of Corsica which was complimented on its "rich and refined palette". The Cardiff show included his 1941 RA exhibit *The Depth Charge*. Probably had a base in St Ives from 1939 but did not move permanently until c.1948. He was a devout Roman Catholic and he and his wife painted the panels of Christ and the 12 Apostles and the four Doctors of the Church on the front of the organ loft at St Ives Roman Catholic Church. When he died, he had just completed a new translation of the Greek poet Sappho.

Eleanor Hughes (née Waymouth) RI (b.1882) Exh.RA[37]
SISA[1933-late 1940s] Exh. Li.34, Bi.36, SA.47, Ca.47, Sw.49.
Born New Zealand. Studied under Stanhope Forbes. Married Robert Hughes and after a spell at Lamorna, settled at St Buryan. Landscape painter in watercolour, favouring outline and wash. Once described as a portrait painter of trees. Well-known and highly respected among St Ives artists and her contributions to the Society's shows were often praised.

Robert Morson Hughes (1873-1953) Exh.RA[21]
SISA[1933-late 1930s] Exh. Li.34, Bi.36.
Educated Sevenoaks. Studied London. Landscape and marine painter. Moved to Lamorna 1910 and became friendly with Birch. Similarly fond of the rod and the gun. One of the Lamorna circle that contributed so significantly to the Society's success. Somewhat surprisingly, given his wife's continued involvement, he did not contribute post-War. Both he and his wife were not hung at the RA after 1939.

Dame Laura Knight RWS RE SWA **RA**(1936) (1877-1970) DBE 1929 Exh.RA[282]
SISA[1936-c.1945] Exh. Su.45.
Born Long Eaton, Derbyshire. Studied Nottingham. Landscape, figure and portrait painter and etcher. Favourite subjects include ballet, circus, theatre and gypsies. Based in Cornwall 1908-1919. Elected honorary member 1936. Chantrey work 1935 & 1939. *Self-Portrait and Model* a major feature of 1937 shows. Involvement with Society interrupted by WW II but contributed *The Young Hop-picker* priced at £238 to Su.45.

Bernard Howell Leach (1887-1979)
SISA[FM- resigned 1949] Exh. Bi.36.
Born Hong Kong. Studied Slade and London School of Art. Best known for his pottery but also painter and etcher. Lived in Japan for ten years studying Japanese pottery processes. Founded Leach Pottery in St Ives in 1920. Whereas a selection of 28 of his pots were included in the 1925 Cheltenham show, crafts were excluded from other Society exhibitions, his contribution to Bi.36 being a portrait. Resigned in 1949 and became founder member of Penwith Society, where craftsmen more recognised.

Sydney Lee RBA RE **RA**(1930) (1866-1949) Exh.RA[105]
SISA[1931-late 1930s] Exh. Li.34, Bi.36.
Born Manchester. Studied Manchester and Paris. Painter, etcher and wood-engraver, who lived in London. Probably encouraged to join by Job Nixon and his involvement ceases around the time of Nixon's death. His etchings were highly praised and *The House of Mystery* was purchased by Cheltenham and Hereford during the Birmingham tour. Just beaten by Luytens in the 1938 election for President of the RA. Also Coll. Tate - London, Liverpool and Manchester.

(Peter) Moffat Lindner RBA ROI RI RWS RWA RBC (1852-1949) Exh.RA[68]
SISA[FM-1949, Pr. 1927-1945] Exh. Br.32, Li.34, Bi.36, Su.45, SA.47, Ca.47.
Born Birmingham into a wealthy family. Studied at the Slade and Heatherley's. One of the early settlers in St Ives, although maintained a London property in Bedford Gardens. Landscape and marine painter, equally adept in oil and watercolour, with a distinctive impressionist style, who had won various medals at international exhibitions. Earned sobriquet 'Moonlighter' for his fascination with nocturnes and moonlight scenes. A critic commented, "Like his spiritual mentor, Turner, [he] is more concerned with the strangeness and beauty of colour effects than with form and line." (S.I.T., 22/10/1926). Travelled extensively and subjects from Venice, Dordrecht and Etaples dominate his work in his later years. Without doubt the figurehead of the Society but one who took an active role, rarely missing Committee meetings. The Society's ultimate success gave him immense pleasure and satisfaction. His contacts in the art world and his financial assistance at several crucial times were vitally important to the continued well-being of the Society. Expert dry fly fisherman, an interest he shared with Birch. To mark his 90th birthday, two of his works were bought by the members and presented to the Town. Only retired as President when 93. Coll. Wellington (NZ), Barcelona, Paris, Cape Town, Hull, Cheltenham, Liverpool, Bradford, Oldham, Doncaster, Dublin, Huddersfield and Bury.
His wife **Augusta (Gussie) Lindner** (FM, Exh. Br.32, Li.34, Bi.36), who was one of Olsson's first pupils, specialised in still life and flower paintings.

John Littlejohns RBA RI RBC Exh.RA[6]
SISA[1933-late 1940s] Exh. Li.34, Bi.36, Su.45, SA.47.
Born near Bideford, Devon but lived in London. Landscape painter in watercolour but also illustrator, lecturer and writer on art. Joint author with Leonard Richmond of books on painting in pastel and in watercolour. Exhibited regularly at RBA and RI. His watercolour *Tantallon Castle* (1933) was described as "a painting lesson in constructional value" but it is rare for his exhibits to be highlighted.

Thomas Maidment (1871-c.1960) Exh.RA[21]
SISA[1932-at least 1957] Exh. Br.32, Li.34, Bi.36, Su.45, SA.47, Ca.47, Sw.49.
An artist about whom little is known. He first exhibited at the RA in 1905, when he was living in Ilford. By 1910, he had moved to Newlyn but for 20 years from 1912 he did not exhibit at the RA. In 1932, however, he moved to St Ives and his RA exhibits throughout the 1930s are all St Ives scenes, executed with his normal painstaking attention to detail. He was particularly interested in capturing the patina on roof tiles, chimney bricks and crumbling walls. The intricacy of his depictions always aroused comment and he was one of the artists who publicised the attractions of old St Ives. Committee 1939-1942. He moved to Torquay in 1952 but was still a member in 1957. Coll. Birkenhead, Brighton, St Ives & Manchester.

Mary McCrossan RBA (1863-1934) Exh.RA[20]
SISA[1928-1934] Exh. Br.32, Li.34.
Born Liverpool. Studied Liverpool, at Delacluse's Paris and under Olsson in St Ives. Landscape and marine painter in oil and watercolour, particularly fond of Venice, Provence and Brixham. Painted St Ives harbour often but chose unusual viewpoints. Lived at 126 Cheyne Walk and travelled extensively until 1929 when moved to St Ives. Highly regarded artist, with an individualistic style, who contributed extensively to the Society's exhibitions until her death. "No one else sees nature quite in the same way", commented one critic. In his appreciation, Smart observed that she had a predilection for silver grey, pale gold and pastel blue and showed a lively reaction to the pattern of her subject (S.I.T., 9/11/1934). In her watercolour work, she used the white paper as source of light. In her sea pictures, she showed a remarkable sense of movement and transparency of water. Coll.- Liverpool, Southport, Contemporary Art Society.

Arthur Meade ROI (1852-1942) Exh.RA[62]
SISA[1927-1942] Exh. Br.32, Li.34.
Studied in Paris under Gérome and at Bushey under Herkomer. Arrived in St Ives about 1891 and, accordingly, along with Lindner and Milner, was one of the artists who remembered the colony in the days of the early settlers. Successful landscape painter in pastoral tradition, earning sobriquet 'Bluebell Meade'. In 1920s using Back Road Studio and still producing highly acclaimed work. Not at foundation meeting, but will have joined soon after. Last RA exhibit 1929 and irregular contributor during 1930s. Memorial exhibition at Lanham's in March 1943. Coll. Rochdale, Worcester, Preston, Southport.

Fred Milner RBC RWA (c.1860-1939) Exh.RA[43]
SISA[1927-1939] Exh. Br.32, Li.34, Bi.36.
Arrived in St Ives in 1898 from Cheltenham. Landscape painter primarily in oils, with a preference for large canvases, but also did Cotman-influenced watercolours and some mezzotints. Depicted the quiet, peace and dignity of the countryside. Had a fascination with Corfe Castle, which repeatedly featured in his work. Some early marine paintings highly regarded. Worked in the immense 2, Piazza Studios. Not at the foundation meeting but joined soon after. Smart summarised his characteristics as "An intense loyalty and faithfulness of purpose, hard work in the open air and in the studio, a distinguished style of painting, a charm of friendly intercourse with other artists and interest in their work, and a broad principle of encouragement to younger painters." (S.I.T.,10/1939) Committee 1934/5. Memorial Exhibition at Lanham's in December 1939. Coll. Sunderland, Truro, Cheltenham, Preston and Buenos Aires.

Robert James Enraght Moony RBA (1879-1946) Exh.RA[24]
SISA[1928-1946] Exh. Br.32, Su.45.
Born The Doon, Athlone. Studied Julians, Paris. Distinctive imaginative and symbolic subjects. A critic commented, "He invests the most simple subjects with a halo of romance, and fairies dance and play in Cornish dells and along spray-swept golden Cornish strands." Lived at Mount Hawke, Truro. Exhibited with the Society in 1927 at Lanham's. Held a one-man show in 6, Piazza Studios in 1936 and a joint show with Ruth Davenport in 1937. Coll Chicago.

Marjorie Mostyn (1893- 1979) Exh.RA[4]
SISA[1938- resigned 1949 but rejoined] Exh. Su.45, SA.47, Ca.47, Sw.49.
Daughter of artist, Tom Mostyn. Trained at the St John's Wood and Royal Academy Schools, where won medals. Married Leonard Fuller. Did commercial work before coming to St Ives in 1938, when reverted to portrait painting and still life. David Cox commented, "Not an imaginative interpreter but she sees clearly....Her greatest gift....is her discernment of light" (S.I.T.,18/6/1948). Her 1954 RA exhibit *Misomé Resting* featured fellow artist Misomé Peile. Taught with her husband in School of Painting and, after his death, ran it herself, helped in her last years by Roy Ray.

Bernard Ninnes RBA ROI (1899-1971) Exh.RA[4]
SISA[1932-1971, V.P. & Ch. 1949-1954]　　　　　　　　Exh. Br.32, Li.34, Bi.36, Su.45, SA.47, Ca.47, Sw.49.
An extremely important figure in the Society. Studied in the West of England College of Art, Clifton and at the Slade. Painter in oil, praised for highly original, gaily-coloured studies in the modern style. Very successful in the touring exhibitions with works being bought by Stoke, Leamington, Hereford and Bournemouth. His wide range included typical St Ives scenes, Welsh landscapes, still life, Majorcan subjects and the occasional caricature, such as *At the Sign of the Sloop*. Worked in Dolphin Studio. A well-liked man, who made light of his walking disability. He had the difficult task of being Chairman after the split. First elected to Committee in 1934. Left St Ives briefly in 1939. One-man show in Downings 1949. *A Cornish Hamlet* bought by Town Council from 1951 Festival of Britain Exhibition.

Job Nixon RE ARWS (1891-1938) Exh.RA[36]
SISA[1931-1938]　　　　　　　　　　　　　　　　　　Exh. Br.32, Li.34.
Born Stoke-on-Trent. Studied at the Slade and South Kensington and at the British School in Rome. Executed landscapes and topographical scenes in watercolour but best known for his etchings, which were admired for their fine draughtsmanship and accuracy of detail. He was teaching engraving at South Kensington when he was persuaded by Birch to settle in Lamorna in 1931. In 1934, he moved to St Ives, taking St Peter's Studio and immediately being elected on to the Committee. He was well-liked and was a leading figure in the 'black and white' section. His teaching abilities were much appreciated and he briefly ran a School of Painting in Back Road West. "With his large black hat and his beard, he fulfilled the conventional idea of what an artist should look like." (S.I.T., 29/7/1938). Left to teach at the Slade but died aged only 47.

Julius Olsson RBA ROI RWA RBC **RA**(1920) (1864-1942) Exh.RA[175]
SISA[1928-1942]　　　　　　　　　　　　　　　　　Exh. Br.32, Li.34, Bi.36.
Born Islington, London. The pre-eminent sea-painter of his era. Largely self-taught but influenced by Henry Moore. Started School of Painting in St Ives in 1895 but returned to London in 1915. Described by Folliott Stokes as "A big man with a big heart, painting big pictures with a big brush in a big studio." Retained a keen interest in St Ives and was one of the first distinguished artists to be asked to become an honorary member. A staunch supporter of the Society in the pre-War period, performing a number of opening ceremonies and contributing good work on a regular basis. Encouraged many of his former students to join the Society. When he visited St Ives in August 1933, Bradshaw suggested that an 'At Home' should be held in the Gallery so that members could have the benefit of meeting the great man. 150 attended.

John Anthony Park RBA ROI (1880-1962) Exh.RA[72]
SISA[FM-at least 1957, Acting Pr. 1949-50]　　　　　Exh. Br.32, Li.34, Bi.36, Su.45, SA.47, Sw.49.
Born Preston. Studied under Olsson and Talmage and then in 1905 at Colarossi's under Delacluse. Moved back to St Ives in 1921. Highly regarded artist whose paintings of St Ives and its harbour, vibrant with colour, are now much sought after. Recent biography by Wormleighton and touring exhibition. Regular committee member. One of central core of artists but moved away for periods in 1932/3 and 1935-8. Important contributor to Society's exhibitions. Not a signatory to the notice requisitioning 1949 meeting but sympathetic and appointed Acting President after the split. Finally moved away in 1952 but still a member in 1957. Coll. Preston, Manchester, Oldham, Southport, Newport, Cheltenham, Salford, Kettering, Leamington, the Tate, Cape Town, Auckland.

William Samuel Parkyn ARCA ARWA SMA (1875-1949) Exh.RA[3 up to 1940]
SISA[1933-c.1945]　　　　　　　　　　　　　　　Exh. Li.34, Bi.36, Su.45.
Born Blackheath. Studied at Newquay and in St Ives under Louis Grier. Landscape and marine painter, repeatedly praised for his ability to depict sand. Lived in Cornwall for some time at The Lizard. Exhibited at Lanham's 1928 but not member until 1933. Regular contributor.

Charles Pears ROI SMA (d. 1958) Exh.RA[16]
SISA[1945-1958, V.P.1957-8]　　　　　　　　　　Exh. Su.45, SA.47, Ca.47, Sw.49.
Born Pontefract. Official war artist in both World Wars. First President of SMA. Distinctive cross-hatched formula for depicting water. Illustrated books and designed posters. Lived in London and St Mawes. Keen sailor. The Cardiff show included his 1944 RA exhibit *Torpedoed Tramp Under Searchlight*. Became leading figure in Society in 1950s. His abhorrence of modern art matched Bradshaw's.

Dod Procter RA (1942) (1892-1972) Exh.RA[218]
SISA[1937-resigned 1949, Pr. 1946]　　　　　　　Exh. SA.47, Ca.47, Sw.49.
Born London but brought up in Newlyn and studied under Forbes and also Colarossi's in Paris. The fame of her 1927 RA painting *Morning* meant that she (and her husband Ernest Procter) were invited to exhibit with the Society from its outset. However, she showed little commitment to the Society and was only offered honorary

membership in 1937. She did then exhibit regularly and, on Lindner's retirement in 1946, she was elected President but was not re-elected the following year. During her Presidency, the Society hosted a retrospective of the work of her husband, who died in 1935. Became founder member of the Penwith Society.

Leonard Richmond RBA ROI (c.1890-1965) Exh.RA[32]
SISA[1931- at least 1954] Exh. Br.32, Li.34, Bi.36, Su.45, SA.47, Ca.47, Sw.49.
Born Somerset. Studied at Taunton and Chelsea Polytechnic. Commissioned as First World War artist by Canadian Government. Landscape painter, with bold impressionist style, which won many international awards. Many Royal patrons. Visited St Ives regularly in 1930s and in 1935 set up Summer Painting School. Author of books on painting techniques, art lecturer, illustrator and poster designer. Many of his paintings of old St Ives and the harbour reproduced as postcards. In 1943 did series of paintings of blitzed areas of London, one of which was bought by National Gallery. Based in St Ives 1946-9. Committee 1946-9. Sw.49 included his study of *David Cox in his Studio*. His move from St Ives just after the split was another blow for the traditionalists. In 1954, he sent a work from San Francisco to a Society exhibition.

Thomas Heath Robinson (1870-1954)
SISA[1942-1954] Exh. Su.45, SA.47, Ca.47.
Brother of the cartoonist W.Heath Robinson,whose name has passed into the language as an adjective for any doubtful contrivance. Gifted illustrator of historical and religious books, the *Strand* and schoolboy magazines. Came to St Ives during WW II and, for the rest of his life, concentrated on book plates, testimonial designs and religious paintings. Exclusion from Sw.49 led to him being one of ten signatories for 1949 E.G.M. When died had just completed a set of pictures illustrating the Mysteries of the Rosary. Often remarked that his studio had the aura of another world.

Francis John Roskruge (1871-1952)
SISA[FM-1952, Jt.Sec.1927 Tr. 1928-1940] Exh. Br.32, Li.34, Bi.36.
Born at St Keverne, Cornwall and educated in Truro. Served in South Africa in the Boer War and East Africa in the First World War, being mentioned in despatches and being awarded the D.S.O. and O.B.E. Moved to St Ives on his retirement from the Navy in 1922. Best known for his etchings and illustrations. Drew map of studios for Show Day brochure (fig 5.5) and was an officer of the Society for the first twelve years of its existence. Keen actor and also wrote plays. Appears to have ceased exhibiting after his resignation as Treasurer in 1940.

Harry Rountree (1878-1950)
SISA[1942-1950] Exh. Su.45, SA.47.
Born Auckland, New Zealand. Settled in England 1901. Well-known illustrator of books on travel, on animals or for children, often of a humourist nature. Also undertook commercial work (e.g. for boot polish). President of London Sketch Club. Did series of caricatures of locals which hung in the 'Sloop'. Popular in some quarters for his sense of humour but vilified in others. Publicly criticised Smart for associating with the moderns. Excluded from Sw.49 and then stirred up by the moderns, so that the 1949 E.G.M. was called. In 1950, his comments on modern art on *Down Your Way* caused howls of protest from modernist sympathisers but Rountree, and many of his friends, argued that his comments had been tongue-in-cheek and that his detractors suffered from a serious lack of a sense of humour.

Helen Priscilla Seddon
SISA[1928-beyond 1957] Exh. Br.32, Li.34, Bi.36, Ca.47.
Born Shropshire. Daughter of New Zealand sheep farmer. Studied art in Edinburgh and Paris. Exhibited at Show Day 1924. Landscape, marine and architectural subjects in watercolour and still life in oil. Her speciality was flower paintings. Morvah Studio, The Warren. Committee 1939.

Dorothea Sharp RBA SWA ROI (1874-1955) Exh.RA[54]
SISA[1933-1955] Exh. Li.34, Bi.36, SA.47, Ca.47, Sw.49.
Born Dartford, Kent. Studied in Paris. Well-known for her studies of children on the beach, which are full of vitality and happy colouring. Some late still lifes are exceptional (see Plate 21). Acting President of SWA until 1933. Lived with Marcella Smith in London but visited St Ives often. However, did not become a member until 1933. Moved to St Ives during WW II. As member of the Committee in 1948, unhappy with direction of Society and, accordingly, one of the ten signatories requesting the 1949 meeting. Coll. Johannesburg, Auckland, Belfast, Bournemouth, Newcastle, Cardiff, Northampton, Doncaster, Leamington, Rochdale, Newport, Worthing, Manchester, Monmouth & Maidstone.

Charles Walter Simpson RI RBA ROI (1885-1971) Exh.RA[48]
SISA[1943-beyond 1960] Exh. Su.45, SA.47, Ca.47.
See Chapter 3. Given Simpson's strong and recent connections with St Ives, his omission from membership until 1943 is most puzzling. His main work on the Sunderland tour was his 1936 RA exhibit *September Morning on the Cornish Coast*. Continued to support Society after the split.

Borlase Smart RBA ROI RBC (1881-1947) Exh.RA[22]
SISA[1928-1947, Sec.1933-1947, Pr.1947] Exh. Br.32, Li.34, Bi.36, Su.45, SA.47, Ca.47, Sw.49.
Born Kingsbridge, Devon. Studied Plymouth and South Kensington and later under Olsson in St Ives. Principally marine painter, but did a number of architectural studies, particularly of old St Ives (see Plate 12), and some landscapes. Also some etchings. Had moved to Salcombe when the Society was formed. Elected member on his return in 1928. Ocean Wave Studio, then 1, Porthmeor. First elected to Committee in 1929. Soon made presence felt and assumed responsibility for publicity. Took over as Secretary when Cochrane taken ill. Principal organiser and motivator, constantly expanding the goals of the Society. The success of the Society largely due to him. In 1930s went on painting trips to Scotland most summers. After his death, Memorial Fund established which acquired Porthmeor Studios and Retrospective Exhibition held in Penwith Gallery. Coll. Imperial War Museum, National Maritime Museum, Bombay, Auckland, Truro, Plymouth, Bristol, Swindon, Leamington.

Marcella Smith RBA (1887-1963) Exh.RA[27]
SISA[1933-1963] Exh. Li.34, Bi.36, SA.47, Ca.47, Sw.49.
Born East Moseley, Surrey. Studied USA School of Design, Philadelphia and Paris. Landscape and flower painter. Came to St Ives in 1914, when forced to leave Paris and made a significant impact on the St Ives art scene during and immediately after the Great War. In 1920, offered classes in oil painting. In early 1920s left to live in London with Dorothea Sharp but retained use of 3. Porthmeor Studios until Bradshaw took over in c.1931. Increasingly concentrated on large flower studies, "Powerful, direct, pure in colour, they reveal a method of of direct handling that retains the freshness of the subject." In 1924 took up hat design. In 1929 had painting bought by H.M.The Queen. Visited St Ives often and moved to the town during WW II, when organised Lanham's Exhibitions. Regular Committee member in 1940s and one of ten signatories requisitioning 1949 E.G.M.

Stanley Spencer (1891-1959) Exh.RA[66]
SISA[1939-1949] Exh. Su.45, Ca.47, Sw.49.
Born Cookham, Berks. Slade-trained painter in oil of religious and figure subjects, landscapes and portraits. Resigned as ARA in 1935 when two of his works were rejected. Re-elected ARA & RA 1950. Visited St Ives in 1938 and immediately became a member, with his work attracting considerable attention. A critic commented, "[His] visit is still in the minds of those who saw him at work in the Digey and on the Malakoff. An amazing personality, and equally astonishing was his array of tiny brushes - but they co-operated with the master mind in the production of great art." (S.I.T., 10/11/1939) Involvement interrupted by WW II, during which he was an official War artist. For Su.45 contributed *Choosing a Dress* and for Ca.47 & Sw.49 *Looking at a Drawing*.

Adrian Stokes RA(1919) (1854-1935) Exh.RA[125]
SISA[1928-1935] Exh. Br.32, Li.34, Bi.36.
Born Southport. Studied South Kensington and Paris. First President of Arts Club in 1890. Author of *Landscape Painting* 1925. Awarded medals Paris and Chicago. Chantrey works 1888 & 1903. One of the first distinguished artists to be invited to become an honorary member. Travelled extensively in Europe and a number of French landscapes included in the Society's shows, particularly *A Shadowed Stream in the Dauphiné*. Contributions somewhat irregular.

Algernon Talmage RBA RWA **RA**(1929) (1871-1939) Exh.RA[140]
SISA[1928-1939] Exh. Br.32, Li.34, Bi.36.
Born Oxford. Studied at West London School of Art and at Bushey under Herkomer. First lived in St Ives in 1893. Assisted Olsson with his School. Official artist for the Canadian Government in France 1918. Paris silver medal 1913 and gold 1922. Contributed five works, incl. *Winter Pastures*, to 1925 Cheltenham show. Invited to become an honorary member soon after Society's formation. Regular and important contributor in early years. Titles include *Reflections* and *St Tropez*. Represented in many public collections at home and abroad.

Herbert Truman Exh.RA[5]
SISA[FM-1939] Exh. Br.32, Li.34, Bi.36.
Born Dawlish. First exhibited at the RA in 1912, the year when he went to Egypt as Chief Inspector of Art and Trade Schools. His art is first reviewed in St Ives in a joint exhibition with Bradshaw at Panton Art Club in June 1925. Worked with Bradshaw on plans for the formation of the Society but his stringent criticisms of the Committee's actions during 1927 meant that the two fell out. First elected on to Committee in 1928 and played a

leading role for two years. Somewhat prickly character and not re-elected in 1930 or thereafter. He thought deeply about his art and had an extraordinary range of styles. His Egyptian studies, often based on tomb designs, were unique and attracted great interest. He developed a fascination for China Clay pits, painted in cool tones and his paintings of old St Ives were clearly influenced by Park. Some 60 of his works were sold as prints and his excellent GWR poster has recently been reproduced. Moved to Devon probably 1936 as not exhibiting Show Day 1937. One man shows in Plymouth 1935 & 1937. Still showing with the Society in 1939.

George Turland (Goosey) (d.1947)
SISA[1928-early 1930s]
Born USA. Successful architect of skyscrapers in USA but gave up career to concentrate on painting and etching. However, designed St Ives War Memorial and reconstructed the interior of his home, Skidden House. Specialised in paintings of the harbour and did a series of etchings of the old streets and by-ways of the town. Exhibited with the Society in 1927 at Lanham's and invited to join in 1928 but rarely showed. Keen participant in theatrical entertainments of the Arts Club. Not a member in 1932 and died in Los Angeles.

Reginald Turvey Exh.RA[3]
SISA[1931-3] Exh. Br.32,
Born South Africa. Landscape and flower painter. Exhibited on Show Day 1925, when his 'advanced' style was noted. Exhibited with Society from 1929 but only offered membership in 1931. In 1932, living in Carbis Bay. Contributed to 1933 Barbizon House show. By 1940, living in Totnes.

Ann Fearon Walke (1888-1965) Exh.RA[1]
SISA[1936-1949] Exh. Bi.36, Ca.47, Sw.49.
Studied at Chelsea and under Augustus John and Sir William Orpen. Married to the Rev. Bernard Walke of St Hilary. Singular religious works aroused great interest. *Christ Mocked* (fig 10.4) included in Bi.36, Ca.47 & Sw.49. Also showed portraits, often of children. *Cornish Children* (1937), showing two girls in pensive attitude, praised as "a real gem of painter-like qualities, reminiscent almost of the Dutch masters" (S.I.T., 1/10/1937).

Amy Watt (d.1957) Exh.RA[19]
SISA[1935-1945] Exh. Bi.36.
Wife of Millar Watt, who had already had some success at the RA before her arrival in St Ives. Four of the five works selected for 1938 & 1939 RA were views of the harbour from her studio. She also did still life.

(John) Millar Watt Exh.RA[3]
SISA[1935-1945] Exh. Bi.36, Su.45.
Cartoonist who created 'Pop' but his landscape and still life paintings in traditional style well-regarded. Only successful at the RA during his short stay in St Ives. His *Bouquet* of 1939 was hailed for its dignity of purpose, beautiful arrangement and exceptional craftsmanship. A visitor compared it to an old master. Elected on Committee shortly after arrival and served 1936-7 but had moved to Crediton by Show Day 1939. Returned during WW II and again served on Committee. Suggested Mariners' Chapel as potential new Gallery.

Richard Copeland Weatherby Exh.RA[24]
SISA[1929-1949] Exh. Li.34, Bi.36, SA.47, Ca.47, Sw.49.
Based in Mullion. Good friend of Lamorna Birch. Specialised in horse paintings and portraits but Indian scenes feature repeatedly in his exhibited works. Bold style which had vitality and freshness and considerable luminosity. His distinctive style made a forceful contribution to many of the Society's shows. His portrait of fellow member S.H.Gardiner at the 1938 Autumn show was hailed as "a complete change of outlook in life-size portrait painting" and praised, amongst other things, for its "attack and white hot application". It was exhibited at RA 1945. Committee 1944.

Helen Stuart Weir RBA ROI RBC SWA (d.1969) Exh.RA[22]
SISA[1928-beyond 1957] Exh. Br.32, Li.34, Bi.36, Su.45, SA.47.
Born New York. Studied in USA, Germany and England. Primarily a still life painter of fruit, flowers, pewter and glass, but also practised sculpture, in 1919 exhibiting a bronze at the RA. Replaced Dorothea Sharp as Acting President of SWA in 1933. Lived mainly in London but had studio on the Wharf and was one of the leading female artists in the Society and a regular contributor of exquisite still life paintings to its exhibitions. Still a member in 1957 but did not contribute to Summer show.

Arthur White (1865-1953)
SISA[1938-1953] Exh. Ca.47
Born and studied Sheffield and ran School of Painting there with J.G.Sykes. Well established in St Ives by 1920s

and yet does not appear to have joined Society until 1938. Landcape and marine painter best known for his pictures of old St Ives, which often included the tower of the Parish Church. "No artist is more true to St Ives subjects" commented one reviewer. Also keen musician.

Mary Frances Agnes Williams Exh.RA[1]
SISA[FM-1936] Exh. Br.32, Li.34, Bi.36.
Born Whitchurch, Salop. Studied in Paris 1912-7 and exhibited frequently at Paris Salon. Figure painter, chiefly of children, and landscape painter in oil and watercolour. Described as a master of tone. Enys Studio, Victoria Place. *The Fairy Story i*ncluded in 1925 Cheltenham show. Her greatest success was her 1933 work *Melody*, which was singled out for praise at the RA.

Terrick Williams RBA RI ROI **RA**(1933) (1860-1936) Exh.RA[142]
SISA[1929-1936] Exh. Br.32, Li.34, Bi.36.
Born Liverpool. Studied in Antwerp and Paris. Acclaimed marine and landscape painter, who had won medals at the Paris Salon. Created evocative atmospheric effects through an acute awareness of tonal values. First visited St Ives in 1890. Invited to become an honorary member in 1929 but insisted on paying a subscription. Well-liked man and regular contributor to the Society's exhibitions, frequently Cornish scenes. Gave opening address in 1930. One of the distinguished artists who gave kudos to the Society and its shows in its early years.

Other Artist Founder Members

Emily Allnutt (member until death in 1944), Winifred Burne, Mrs K.G.M.Day, Miss E.Fradgley, Miss M.W.Freeman and Helen Knapping (a respected elderly artist who, on her death in 1935, bequeathed the Piazza Studios to RBA) and Messrs J.S.Yabsley and Lockwood, Hampden A. Minton, R.Morton Nance, Francis Spenlove (elected to first Committee in 1927 but no further involvement) and John Henry Titcomb (member until death in 1952).

Other Artist Members recorded in 1932

E.Allnutt, W.Angier, W.E.Arnold-Foster, Mrs Bainsmith, Joan H.Birch (from 1931) (Br.32), Lucy Bodilly (Br.32, Li.34), Miss W. Cooke, Miss L.Cork, Shallett Dale (Br.32), Mrs K.G.M.Day, W.Emery, C.S.Everard, Dorothy Everard, Mrs Fenn, Anna Findlay, W.H.Fowler, Miss E.Fradgley (Br.32), Miss M.W.Freeman (Br.32), Miss K.Glover, Miss Gunn (from 1929), A.F.G.Henderson, R.Heyworth ROI (in 1925 Cheltenham show -from 1929, Br.32), Winifred Humphery (exh. Show Day 1922 and still a member in 1957), Miss C.Jackson, J.Tiel Jordan (Br.32), Helen Knapping, Miss Cecil de W.Lane (1932), H.A.Minton, Capt. Frank Moore (from 1928) (Br.32), R.Morton Nance, Mrs Oxland, E.W.Pulling, R.Tangye Reynolds RWA (Br.32), Edith Reynolds (from 1929) (Br.32), Ethel Roskruge (FM-associate, full member from 1931) (Br.32), Ashley Rowe, Dr H.T.Rutherfoord (from 1930), Mrs Shone, Miss A.Bliss Smith (Br.32), Miss K.Smith Batty, Miss Ethel Stocker, J.H.Titcomb (Br.32), Mrs Trewella, H.W.J.Turner, Beatrice Vivian (Br.32), Nina Weir-Lewis, Miss Webb, Miss E.M.Wilkinson (Br.32), Violet Wright (from 1930), J.S.Yabsley.

The following artists also exhibited at Br.32:-
Caroline Jackson (sculptor), Phyllis Tiel Jordan, Grace Pethybridge, Reginald F.Reynolds RBA, Mary E.Richey, Mildred Turner-Copperman (also contributed to 1933 Barbizon House show).

Other Artists Members recorded in 1938

M.J.Adams (Li.34, Bi.36), E.Allnutt, E.Houghton Birch (Bi.36), G.A.Boden (Bi.36), Constance Bradshaw ROI RBA (Bi.36), Hilda Brown, Annie Bryant (Li.34), Emma Bunt, Muriel Burgess (Li.34, Bi.36), Irene Burton (Bi.36), Richard Chatterton, Arderne Clarence (Bi.36), A.C.Dalzell (Bi.36), K.G.M.Day, Vere Dolton (Bi.36), Dorothy Everard (Bi.36), Anna Findlay (Li.34, Bi.36), A.M.Foweraker, Miss M.Winnifred Freeman (Li.34, Bi.36), M.Gunn, W.A.Gunn (still a member in 1957), Jessica Heath (Bi.36), Winifred Humphery (Bi.36), Fairfax Ivimey (Bi.36), Miss Phyllis Tiel Jordan, Reginald Guy Kortright (Bi.36), [L-R missing], Elmer Schofield, Sidney Schofield, Hely Augustus Morton Smith RBA RBC (Li.34, Bi.36), Ada Somerville, Ethel Stocker (Li.34), M.E.Thompson, J.H.Titcomb, Charles W.Tracy, G.E.Treweek, S. Van Abbe RBA RE, Beatrice Vivian (Bi.36), Emily Wilkinson, J.Coburn-Witherop ARCA, J.G.W.Woods (d.1944) (Li.34, Bi.36), Violet Wright (Li.34).

The following artists also exhibited at Li.34:-
Nina Berry, Percy Robert Craft RCA, Harry Fidler RBA, Frank Gascoigne Heath, E.M.Herring, Caroline Jackson (sculptor), L.M.Larking, Isabel Macpherson, Emily Nicholl, Emily M.Paterson, Phyllis Pulling, Raymond Ray-Jones RE ARCA (elected member 1933), Mary E.Richey.

The following artists also exhibited at Bi.36:-
Sir John William Ashton ROI, Frank Gascoigne Heath, Daphne Lindner ARE, Grace Pethybridge, Phyllis Pulling, Arthur Quigley, Edith Reynolds, Eleanor E.Rice, Nina Weir-Lewis.

Post-War Exhibitors

The following artists contributed to one or more of Su.45, SA.47, Ca.47 or Sw.49:-
[A name in **bold** type signifies an artist who resigned in 1949 and exhibited as a member in first Penwith Society show.]
[A name underlined signifies an artist who in 1957 remained a member of SISA or who had by then rejoined.]

Gilbert Adams (Su.45, Ca.47), Marcus Adams (Su.45, SA.47), E.W.Aldridge (Su.45), Marjorie Alington (Ca.47), Malcolm Arbuthnot RI (Su.45, SA.47, Sw.49), **Garlick Barnes** (Su.45, SA.47, Ca.47, Sw.49), **Wilhelmina Barns-Graham** (Su.45, SA.47, Ca.47, Sw.49), Joza Belohorsky (Su.45), Medora Heather Bent (Su.45, Ca.47, Sw.49), **Sven Berlin** (Ca.47, Sw.49), Kathleen Temple Bird (Su.45), Francis M.Blair (SA.47, Sw.49), G.A.Boden (Su.45, SA.47), Charles Breaker (Sw.49), Emma Bunt (SA.47), Irene Burton (SA.47, Ca.47, Sw.49), Arderne Clarence (Su.45), J.Coburn-Witherop ARCA (SA.47, Ca.47), Sir Francis Cook (Ca.47), **David Cox** (SA.47, Sw.49), Eirys Davies (Ca.47), Olive Dexter (Sw.49), **Agnes Drey** (Ca.47, Sw.49), Ann Duncan (Su.45, Ca.47), Dorothy Everard (Su.45,Ca.47), P.E.T.Fisher (Su.45), Terry Frost (Ca.47),

Meta Garbett (Su.45, Ca.47), Alethea Garstin (SA.47, Ca.47), William A.Gunn (Su.45, SA.47), Gertrude Harvey (SA.47, Ca.47), Hilda Harvey (Su.45), **Isobel Heath** (Su.45, SA.47, Ca.47), **Barbara Hepworth** (Ca.47), Forrest Hewitt RBA (Su.45), Amy E.B.Hicks (Su.45), **Marion Grace Hocken** (Su.45, SA.47, Sw.49), Alex J. Ingram (Su.45), Greville Irwin (SA.47, Ca.47), Eileen Izard (SA.47), E.Lamorna Kerr (SA.47, Ca.47), Frank Jameson (Su.45, SA.47, Ca.47, Sw.49), **Hilda Jillard** (Su.45, Ca.47, Sw.49), Leslie Kent RBA (SA.47, Ca.47, Sw.49), **Peter Lanyon** (Su.45, Ca.47, Sw.49), D.Alicia Lawrenson (Ca.47), W.L.Lister (Su.45, Ca.47), Violet MacDougall (Su.45), W.Westley Manning RBA ARE (Ca.47, Sw.49), George H.Martin (Ca.47), **Jeanne du Maurier** (Ca.47, Sw.49), Edith Boyle Mitchell (Su.45, SA.47), **Denis Mitchell** (Sw.49), Arminell Moorshead (Ca.47),

Ben Nicholson (Ca.47, Sw.49), Minnie Painter (Su.45), **Misomé Peile** (Su.45, SA.47, Ca.47), Brig. J.W.Pendlebury (Su.45), George F.Pennington (Ca.47), Dora Pritchett (SA.47, Sw.49), Edith C.Reynolds (SA.47), Eleanor.E.Rice (Su.45, SA.47, Ca.47, Sw.49), Alison Rose (Su.45, SA.47, Ca.47), **Hyman Segal** (Ca.47, Sw.49), William Todd-Brown ROI (SA.47, Ca.47, Sw.49), Lucia E.Walsh (SA.47, Ca.47, Sw.49), Billie Waters (SA.47, Sw.49), **John Wells** (Ca.47, Sw.49), Fred Whicker (Ca.47, Sw.49), Gwen Whicker (SA.47, Ca.47, Sw.49), Norman Wilkinson RI ROI (SA.47, Ca.47), N.Winder Reid SMA (Ca.47), Denise Williams (Su.45, SA.47, Ca.47), Kathleen Williams (Su.45, SA.47), Rendle Wood (Su.45, SA.47, Sw.49), Beryl Woollcombe (Ca.47), Col. L.D.Woolcombe (Su.45, SA.47, Ca.47, Sw.49), Violet Wright (Ca.47), **Bryan Wynter** (Ca.47, Sw.49), Eileen Wyon (Su.45, Sw.49).

Other artists who were members of SISA in 1957 include:-
The President, Claude Muncaster RWS RBA ROI SMA, Secretary Hugh Ridge SMA and Treasurer R.J.Penrose (Bradshaw and Pears being the two other officers) and E.Lovell Andrews, Stuart Armfield, Amelia Bell, Howard Barron ARAS (Austr.), S.J.Bland, Leonard & Margaret Boden, Oliver Bedford SGA, A.C.Butler, E.Bridge, Frederick T.W.Cook RWA, Sybil Mullen-Glover, Eric Hiller, E.Bouverie Hoyton, Inez Hoyton, Malcolm Haylett, Denys Law, Faust, Una & Wharton Lang, Jack Merriott RI, L.Staniland Roberts, Dorcie Sykes, Anne Sefton (Fish), G.E.Treweek, Barbara Tribe, Clare White, Constance White, Sibylla Wightman.

THE ST IVES SOCIETY OF ARTISTS
COMMITTEE MEMBERS 1927-1957

1927 President - M.Lindner, Joint Secretaries - G.F.Bradshaw & F.Roskruge,
A.Hayward, H.Truman, F.Spenlove & A.C.Bailey (Librarian).

1928 President - M.Lindner, Treasurer - F.Roskruge, Secretary - A.Cochrane,
A.Hayward, H.Truman, H.Gresty, P.Hewitt & J.C.Douglas (Librarian).

1929 President - M.Lindner, Treasurer - F.Roskruge, Secretary - A.Cochrane,
A.Hayward, H.Truman, H.Gresty, B.Smart, J.C.Douglas (Librarian).
M.Cock appointed to represent Associate Members, who are henceforth always
represented on the Committee.

1930 President - M.Lindner, Treasurer - F.Roskruge, Secretary - A.Cochrane,
A.Hayward, H.Gresty, B. Smart & G.F.Bradshaw. Librarian post abolished.

1931 President - M.Lindner, Treasurer - F.Roskruge, Secretary - A.Cochrane,
B.Smart, G.F.Bradshaw, J.A.Park & P. Hewitt.

1932 President - M.Lindner, Treasurer - F.Roskruge, Secretary - A.Cochrane,
B.Smart, G.F.Bradshaw, J.A.Park & L.Birch.

1933 President - M.Lindner, Treasurer - F.Roskruge, Secretary - A.Cochrane (until June),
Acting Secretary (from June) - B.Smart
B.Smart, J.A.Park, L.Birch, J.Nixon & (from June) G.F.Bradshaw.

1934 President - M.Lindner, Treasurer - F.Roskruge, Secretary - B.Smart,
J.Nixon, F.Milner, F.Bottomley & B.Ninnes.

1935 President - M.Lindner, Treasurer - F.Roskruge, Secretary - B.Smart,
G.F.Bradshaw, B.Ninnes, F.Milner & S.Armstrong.

1936 President - M.Lindner, Treasurer - F.Roskruge, Secretary - B.Smart,
G.F.Bradshaw, B.Ninnes, S.Armstrong & J.Millar Watt.

1937 President - M.Lindner, Treasurer - F.Roskruge, Secretary - B.Smart,
G.F.Bradshaw, B.Ninnes, S.Armstrong & J.Millar Watt.

1938 President - M.Lindner, Treasurer - F.Roskruge, Secretary - B.Smart,
G.F.Bradshaw, F.Bottomley, J.Barclay & A.Quigley.

1939 President - M.Lindner, Treasurer - F.Roskruge, Secretary - B.Smart,
G.F.Bradshaw, L.Fuller, T.Maidment & H. Seddon.

1940 President - M.Lindner, Treasurer - S.Armstrong, Secretary - B.Smart,
L.Fuller, T.Maidment, J.A.Park & J.Millar Watt.

1941 President - M.Lindner, Treasurer - S.Armstrong, Secretary - B.Smart,
L.Fuller (acting Secretary), J.A.Park, J.Millar Watt, T. Maidment & W.A.Gunn.

1942 President - M.Lindner, Treasurer - S.Armstrong, Secretary - B.Smart,
L.Fuller (acting Secretary), B.Ninnes, P.Hewitt, D.Sharp & M.Smith.

1943 President - M.Lindner, Chairman - L. Fuller, Treasurer - S.Armstrong, Secretary - B.Smart, J.Millar Watt, J.A.Park, W.A.Gunn & M.Smith.

1944 President - M.Lindner, Chairman - L. Fuller, Treasurer - S.Armstrong, Secretary - B.Smart, P.Hewitt, W.A.Gunn, W.Todd-Brown & R.C.Weatherby.

1945 President - M.Lindner, Chairman - L. Fuller, Treasurer - E.W.Colwell, Secretary - B.Smart, B.Ninnes, W.A.Gunn, L.Richmond & H.Rountree.

1946 President - D.Procter, Chairman - L. Fuller, Treasurer - E.W.Colwell, Secretary - B.Smart, G.F.Bradshaw, L.Richmond, J.A.Park & H.Rountree.

1947 President & Secretary - B.Smart, Chairman - L. Fuller, Treasurer - E.W.Colwell, L.Richmond, B.Ninnes, F.Bottomley & M.Smith.

1948 President - Sir A.J.Munnings, Vice-President & Chairman - L.Fuller, Treasurer - E.W.Colwell, Secretary - D.Cox, L.Birch, J.A.Park, L.Richmond, D.Sharp, M.Smith, S.Armstrong, F.Bottomley, P.Lanyon & H.Segal.
A.G.M. held in June (rather than February) for first time.

1949 President - Sir A.J.Munnings, Acting President - J.A.Park, Vice President - B.Ninnes, Treasurers - E.W.Colwell & V.Wilkins, Secretary - G.F.Bradshaw, P.Hewitt, M.Smith, H.Rountree, A.G.Wyon & W.Todd-Brown.
A.G.M. held in April (i.e.after the split).

1950 President - L.Birch, Acting President - J.A.Park, Vice President - B.Ninnes, Treasurer - V.Wilkins, Secretary - G.F.Bradshaw, F.Bottomley, C.Breaker, W.A.Gunn, H.Rountree & A.G.Wyon.

1951 President - L.Birch, Acting President - J.A.Park, Vice President - B.Ninnes, Treasurer - V.Wilkins, Secretary - G.F.Bradshaw, F.Bottomley, W.A.Gunn, C.Breaker, H.Ridge & K.M.Bradshaw.

The records available to me are hereafter incomplete. Birch remained as President until his death in 1955 when he was replaced by C.Muncaster. Park left St Ives in 1952 and Bradshaw resigned as Secretary in December 1952 through ill-health, his place being taken by H.Ridge. At the A.G.M. in 1953, held in October, new Committee members were S.Armfield, J. Merriott & C.White. Bradshaw was elected Vice President and Chairman in 1955.

1957 President - C.Muncaster, Vice President - C.Pears, Vice President & Chairman - G.F.Bradshaw, Treasurer - R.J.Penrose, Secretary - H.Ridge, K.M.Bradshaw, G.Whicker, J.Barclay, C.Breaker, W.Lang & W.Redgrave.

SELECTED BIBLIOGRAPHY

Primary Sources
G.F.Bradshaw, Private Diaries, 1905-6
St.Ives Times, 1920-1960
St Ives Society of Artists - Minute Book 1927-1933
Western Morning News, 1925-1940
Naval and Military Record, 1905-1921

Naval
W.G.Carr, *By Guess and By God*, London, 1930
W.G.Carr, *Hell's Angels of the Deep*, London, 1932
R.Compton-Hall, *Submarines and the War at Sea 1914-18*, London, 1991
A.S.Evans, *Beneath the Waves - A History of H.M. Submarine Losses 1904-1971*, London,1986
R.M.Grant, *U-Boats Destroyed*, London, 1964
Jane's Fighting Ships of World War 1
F.W.Lipscomb, *The British Submarine*, London, 1954
S.W.C.Pack, *Britannia at Dartmouth*, London, 1966
E.P.Statham, *The Story of the Britannia*, London, 1904

Art
E.H.H.Archibald, *Dictionary of Sea Painters*, Woodbridge, 1980
D.Val Baker, *Britain's Art Colony by the Sea*, London,1959
S.Berlin, *The Dark Monarch*, London, 1962
S.Berlin, *The Coat of Many Colours*, Bristol, 1994
D Cordingly, *Marine Painting in England 1700-1900*, London, 1974
T.Cross, *The Shining Sands*, Tiverton & Cambridge, 1994
T.Cross, *Painting the Warmth of the Sun - St Ives Artists 1939-75*, Penzance & Guildford, 1984
C.Fox, *Painting in Newlyn 1900-1930*, Penzance, 1985
A.A.Hurst, *Thomas Somerscales, Marine Artist - His Life and Work*, Brighton, 1988
M.Muncaster, *The Wind in the Oak - A Biography of Claude Muncaster*, London, 1978
R.Pilcher, *The Shellseekers*, Sevenoaks, 1987
R.S.M.A., *A Celebration of Marine Art : Fifty Years of the R.S.M.A.*, London, 1996
H.Segal, *As I Was Going to St Ives*, Hayle, 1994
B.Smart, *The Technique of Seacape Painting*, London, 1934
Tate Gallery, *St Ives 1939-64*, London,1985
O.Warner, *An Introduction to British Marine Painting*, London, 1948
M.Whybrow, *St Ives 1883-1893*,Woodbridge, 1994
N.Wilkinson, *A Brush with Life*, London, 1969
A.Wormleighton, *A Painter Laureate: Lamorna Birch and his Circle*, Bristol, 1995
A.Wormleighton, *Morning Tide: John Anthony Park and the Painters of Light*,
Stockbridge, 1998

Articles
A.L.Baldry, *British Marine Painting*, The Studio, Special Number 1919
F.L.Emanuel, *The Charm of the Country Town*, Architectural Review, July 1930
News Chronicle, Eastbourne, *Ships that Pass (Out) in the Night*, 27 June 1936
R.Pilcher, *My Country Childhood*, Country Living, May 1996
B.Smart, *The St Ives Society of Artists*, The Studio, 1948

Alba, S.S. — 1, 142-46, 198
Armfield, S. — 202, 241, 243
Armstrong, Shearer — 67, 70, 73-74, 78, 94, 107, 120, 127, 133, 135, 141, *142*, 144, 164, 168, 184, 191, 228, 242-3
 Still Life with Staffordshire Figure — 134
 Girl with Green Apple — 178
Arts Council — 168, 181, 184, 199-200
'Aurora Borealis' — 141-142

Bailey, A.C. — 66, 70, 72-3, 89, 228, 242
Ballance, M. — 57, 127, 228
Ballance, P des C. — 66, 120, 144, 228
Ballynascorney — 17, 21
Balmford, H. — 89, 144, 228
Barclay, J.R. — 137, 144, 205, 229, 242-3
Barns-Graham, W. — 99, 166, 170, 179, 181-3, 185, 200, 241
Barry, C.F. — 164, 168, 170, 229
 Tower Bridge, London - A War-time Nocturne — 169, 170
Bayley, D. — 181, 200, 229
Beaumont, F.S. — 117, 229
Belohorsky, J. — 164, 241
Bent, M.H. — 200, 241
Berlin, S. — 2, 101, 114, *115*, 116, 182-3, 185, 187-9, 193-4, 241
 Lion — 115
Birch, S.J.L. — 7, 37, 43, 50, 78, 83, 85, 89, 91-2, 96, 106, 120-2, 136-8, 144-5, 162, 168, 183-5, 187, 194, 196, 200, 202, 229, 242-3
 A June Morning: The Deveron.. — 137, plate 6
 November, Bissoe, Cornwall — 96, plate 7
 St Ives — 145
 Morning at Lamorna Cove — 161
Blumberg, Sir H.& Lady — 73, 109
Boase, J. — 105, 119, 205, 213
Boden, L. — 205, 241
Borough-Johnson, Mrs E. — 56
Bottomley, F. — *103*, 117, 120, 144, 149, 183-5, 187, 194, 205, 229, 242-3
 Fore Street, St Ives — 118
Bradshaw, C. — 117, 149, 240
Bradshaw family — 9-11, 21-2, 116
Bradshaw, G.F. — *passim*, 44, *108*, *142*, *146*, *147*, *197*, *206*, *224*, *225*, *226*
 Illustrated works - colour
 U-boat sinking Barque by Gunfire — 36, plate 1
 Trade Winds — 74, 210, plate 2
 The Trawlers — 78, 122, 215, plate 8
 Off Malta — 86, 117, 212, plate 9
 Sailing Ship (oil) — 211, plate 10, 217
 Westward and Candida — 91, plate 13
 Sunset and Evening Star — 96, 214, 218, plate 14
 Lobster Fishing — 164, 207, plate 15
 Rolling Home — 141, 216, plate 16
 Bosigran Castle — 137, plate 17
 Jones' Travelling Amusements — 83, 98, plate 18
 Porthmeor Beach - Summer — 99, 215, plate 22
 Hauling Lobster Pots in Rough Weather — 118, 213, plate 23
 Atlantic Breakers — 99, 215, plate 29
 Anne, Aged 3 1/2 — plate 30
 In St Ives Bay — 118, 175, 215, plate 31
 Up Channel — 214-5, plate 32
 Steamship on a Shimmering Sea — 196, 210, 216, plate 33
 Sunset's Flush — 196, 210, 212, plate 34
 Moonlight Bay — 176, plate 35
 Moonlit Breakers — plate 36

 Illustrated works - black and white
 Fishing Boats in St Ives Bay — 3, 215
 Boats in St Ives Harbour — 4
 Sailing Ship (w/c) — 5
 Moonrise, St Ives Bay with Herring Fleet... — 7
 A Brigantine off Malta — 18
 Off the Spanish Coast — 19, 20, 210
 Off Gibraltar — 19, 20, 47, 201, 213
 Maltese Fruit Boats — 22, 213
 On Patrol — 35, 36
 Putting to Sea — 46
 Submarine X-1 — 63
 Decks Awash — 94, 211, 216, 218
 Our Cove — 110, 198
 Children Watching a Rough Sea — 112, 113
 Lobster Fishing in 'Our Girls' — 119
 H.M.S.Whirlwind — 140
 Departure for the Herring Fishing — 147, 213, 216
 Barque by Moonlight — 165
 Rescue — 164, 165
 H.M.S. Delhi — 164, 166
 Summer Night — 174, 175, 205
 Setting Moon — 204, 205
 Roll on thou dark and deep ocean, roll.. — 208, 209
 Crabbers Returning — 66, appendix 2
 Surface Patrol — 35, 140, appendix 2
 Low Tide in the Cove — 144, 198, appendix 2

Principal subject matter
 Beach/Wave studies — 74, 89, 92, 99, *110*, 114, 198, *plate 29*, *plate 30*
 Boats:-
 French Crabbers — 3, 96, 147, 163, 174, *175*, 215, *plate 14, plate 31*
 Lobster Fishing — 82, 118, *119*, 163, 164, *plate 15, plate 23*
 Maltese Fruit Boats — 19, *20*, 22, 47, 64, 86, 117, 213, *plate 9*
 Racing Yachts — 163, *plate 13*
 Sailing Ships — *5, 18, 19, 46*, 47, 59, 60, 64, 66, *73*, 78, 83, 86, 90, 92, *94*, 141, 145, *165*, 196, 210, *211*, 212, *217*, *plates 1, 2, 10, 16, 32, 34*
 Steamships — 60, 82, 196, 216, *plate 33*
 St Ives Mackerel Boats — 213, *cover, plate 32*
 St Ives Gigs — *3*, 66, 82, 118, *119*, 213
 Trawlers — 78, 122, 175, 214-5, *plate 8, plate 31*
 Coastal Scenes — 112, *113*, 137, *plate 17*
 Harbour Subjects — *4*, 141, 213, *cover, plate 34*
 Landscapes — 83, 96, 117, *plate 18*
 Moonlight Scenes — 7, *165*, *175*, 196, *204*, 205, *plates 35, 36*
 Naval - Submarine — 35, *36*, *63*, 138, 140, *plate 1*
 Naval - Surface — 63, 137, *140*, 164, *165*, *166*, 174, 216
 Seascapes — 76, 82, 89, 92, 168, 208, *209*
 Sunset Scenes — 78, *plates 8, 34*
Bradshaw, K. — 1, 39-42, *43*, *44*, 45, 50, 64, 73, 76, 79, 82-3, 86, 88, 92, 102, 106-7, *108*, 109-10, 112, 114, 116, 125, 138-41, 144, 149, 154, 163-4, 166, 168, 170, 187, 196, *197*, 198, 204-5, *206*, 230, 243, *plate 25*
 Still Life with Roses — plate 26
 Robert Asleep (tempera) — 139
 Robert Asleep (conté) — 149
 Floral Decoration — 149
 Lampshades — 64, *154*, 166
Brangwyn, F. — 135, 145, 163, 230
Breaker, C. — 202, 241, 243
Brest, — 18
Brett, J. — 40
Briscoe, A. — 173
British Broadcasting Corporation — 194, 200-1, 206
Bromley, J.M. — 66, 230
Brown, J.A.Arnesby — 7, 76, 83, 85, 92, 120-1, 144, 168, 173, 194, 230
 Silver Morning — 77
Bruford, M.F. — 144, 184
Bryant, C.D.J. — 117, 120, 230
Burgess, A.J.W. — 117, 120, 144, 149, 173, 230

Care, R. — *110*
Cheltenham Art Gallery — *64-5, 91, 135, 137, 160*
Churchill, W. — *24, 26, 30, 194*
Cochrane, A. — *70-1, 77, 86, 89, 117, 242*
Cock, M. — *72-3, 76, 187*
Colwell, E.W. — *184, 243*
Couchman family — *38, 40, 43-4, 108*
Country Living — *113*
Cox, D. — *167, 184-5, 187, 190-1, 193, 241*
Crypt Gallery (see New Gallery)
Cuneo, N.M.T. — *78, 144, 231*
Currie, D. — *43,* **44**
Cutty Sark — *58, 154, 209, 212*

Daily Sketch — *66, 74, 139*
Dingli, E.C. — *26, 45, 64*
Douglas, J.C. — *70, 73, 76, 149, 231, 242*
Douglas, M. — *57, 94, 231*
Down-a-long — *44, 54-5, 83, 86, 128-9, 131*
Drage, W.C. — *149, 151*
Dyer, L. — *51, 53, 58, 66-7, 70-3, 107, 149, 231*

Emanuel, F. — *105, 173*
Ewan, F. — *67, 117, 184, 187, 231*

Fancy Dress Balls — *106*
Fleetwood-Walker, B. — *117, 137, 144, 149, 183, 231*
Forbes, M. — *144, 231*
Forbes, S.A. — *7, 42-3, 66, 78, 83, 85, 89, 92, 108, 116, 120, 122, 138, 144-5, 149, 183, 195, 232*
Fortescue, W.B. — *53, 58*
Foster, Capt. C. — *60-1*
Fuller, L. — *144,* **146, 147,** *149, 162, 168,* **180,** *181, 183-5, 190-1, 200, 205, 232, 242-3*
 Knitting — *144,* **plate 24**
 Laity's — **153**
 Sven Berlin — **189**

Gardiner, S.H. — *70, 76, 121, 183, 232*
Garnier, G.S. — *96, 122, 232*
 Trencrom Castle — **96**
Garstin, C. — *107*
Gibraltar — *17-9, 26, 47*
Glover, Dr W.E. — *204*
Glover, S.M. — *204*
Gotch,T.C. — *78, 89*
Gratitude - ss 626 — *213-4,* **cover**
Gray, A. — *110*
Gresty, H. — *73, 76, 78, 81-3, 88, 91-2, 94, 127, 144, 146, 164, 232, 242*
 Spanish City Avila — **81**
Gribble, B. — *173*
Grier, L. — *7, 40, 49, 51, 64, 74, 158*
Grier, W. — *158, 162*
Grylls, M. — *73, 117, 232*
Guildhall Art Gallery — *174*

Hall, F. — *141, 232*
Hambly, A.C. — *168-9, 233*
 Near Archerton, Postbridge, Devon — *168,* **169,** *170*
Hamilton Jenkin, A.K. — *105*
Harris & Sons, Plymouth — *58, 63, 135*
Hartley, A. — *55, 57-8, 64, 67-8, 70-4, 78, 89, 95-6, 122, 233*
 Christchurch Gate, Canterbury — **97**
Hartley, N. — *66, 70, 73, 94, 120, 233*
Harvey, H. — *7, 76, 78, 83, 85, 90, 136, 149, 233, 241*
Haylett, M. — *200, 205, 241*
Hayward, A. — *64-5, 67, 70, 72-4, 78, 83, 88-9, 92, 94, 105, 132, 144, 146, 216, 233, 242*
 The Onion Man — **plate 28**
 Summer Evening, Harbour — **129**
 In a Sunlit garden — **65,** *66*
Heath, F.G. — *121, 135, 138, 240*
Heath, I. — *168-9, 191, 193, 241*
 Sheet Metal Dept., Munitions Factory — **169**
Hepworth, B. — *116, 179, 182-5,* **186,** *187-88, 191, 193-4, 199-200, 241*
Heron, P. — *5, 199*
Herzogin Cecilie — *211*
Hewitt, B.P. — *66, 68, 70, 78, 91, 107-8, 144, 149, 168, 183, 185, 200, 205, 233, 242*
 Kathleen Bradshaw — **plate 25**
Hill, P.M. — *167-8, 173, 183, 185, 199, 233*
 Clifftop Cottage — **172**
Holt, Alderman — *138*
Hougomont — *211*
Howard family — *43-4*
Hughes, E. — *7,* **43,** *99, 121-2, 144, 234*
Hughes, R.M. — *7, 43, 99, 120-1, 144, 234*
 The Usk from Abergavenny — **99**

Irwin, G. — *102, 241*
 The Inner Harbour, Mevagissy — **102**
Island Studios — *55, 78*

Jacob, L. — *108,*
Jane Barber - ss 9 — *214,* **plate 32**
John, A. — *78, 108, 144*
John, G. — *108*
Jordan, J.T. — *102, 240*

Kennedy, H. — *112*
King, C. — *173*
King's Jubilee (1935) — *1, 59, 106, 131, 133, 135*
Kipling, R. — *28-9*
Knapping, H. — *73, 184, 240*
Knight, A. — *42, 85, 90, 117, 141, 144-5, 168, 234*
 Self-Portrait and Model — **142**
 Bernard Shaw — *145,* **146**

Laity's (James Laity & Sons) — *59, 152,* **153,** *211,* **plate 12**
Lang, F. — *200, 241*
Lang, W. — *200, 241, 243*
Lanham's Galleries — *46, 58, 66-70, 72-74, 78-9, 86, 88, 94, 125, 147*
Lanyon, P. — *182-5, 193-4, 198-9, 241*
Leach, B.H. — *64, 70-3, 89, 135, 191, 199-200,*
Lee, S. — *96, 120, 122, 137, 234*
 House of Mystery — **134**
Lewis, D. — *170, 184-5, 216*
Lindner, A. — *52, 70, 234*
Lindner, D. — *117, 240*
Lindner, P.M. — *1, 52, 64, 68, 70, 78,* **79,** *83, 89, 91, 94, 100,* **142,** *144, 183, 207, 234, 242-3*
 Venice from the Lagoon — **plate 3,** *136*
 Golden Autumn — **65**
Littlejohns, J. — *89, 117, 234*

MacKelvie Collection, Auckland — *65, 89, 207*
Madeira — *19*
Maidment, T. — *93-4, 117, 128, 133, 144,* **147,** *170, 183, 200, 205, 207, 235, 242*
 Old Houses, St Ives — **126**
 The Old Harbour, St Ives — **134**
Malakoff — *126, 128, 133, 137, 145*
Malta — *17-9, 24, 26, 64, 86, 117, 213*
Manning Sanders, J. — *78*
'Marcus' — *61-2, 89-90*
Marine Painting - General — *4, 6, 40, 122-3, 207, 208, 210*
Mariners' Chapel (see New Gallery)
Marmaris — *17*
Marriott, C. — *50*
Matheson, G. — *105-6, 111-2*
McCrossan, M. — *66, 83, 88, 120, 136, 207, 235*
 Ruins in the Forest — **82**
 Brixham — **122**
McWilliams, J. — *2, 175, 213-4*
Meade, A. — *1, 53, 57, 78-9, 83, 95, 98, 136, 149, 235*
 The Fishing Fleet — **plate 5**
 St Michael's Mount — **54**
Meadow, The, — *44*
Merriott, J. — *202, 241*
Milner, F. — *1, 53, 55, 64, 66, 68, 73-4, 78, 83, 89, 92, 94, 98, 101-2, 106, 136-7, 146, 149, 235, 242*
Moore, F. — *58, 62, 240*
Moore, H. — *40, 123, 209*
 The Newhaven Packet — **41**
Morris, G. — *182, 193-4, 199*
Mostyn, M. — *144, 200, 205,* **plate 24**
 A Sunny Window — **201**
Muncaster, C. — *173, 176-7, 202, 241*
Munnings, A. — *39, 184, 194-6, 243*
 Does the Subject Matter? — **195**

Naval and Military Record — 18, 19, 27, 42
Naval Officers:-
 Allen, C.H.,Cdr — 26-8, **28** 34-5, 38, 45, 62-3, **64**, 66, 107, 140,
 Bailward, M.W., Cdr — 35
 Carr, W.G., RNR — 29, 32-4, **33**
 Donaldson, Capt. — 30, 36
 Godfrey, J.H., Lt — 21
 Keyserling, Capt. (Latvia) — **64**
 Masservy, Eng-Cdr — **44**
 Nasmith, M.E.,Cdr — 36
 Ormand, F.T., Lt — 21
 Sandford, R., Lt — 36-7
 Tryon, J.F., Lt — **28**
 Whyham, Eng-Lt — **25**
Naval Training staff — 13-15
Naval Vessels (surface):-
 Aurora — 16
 Bickfield — 35
 Bonaventure — 25-6
 Britannia — 2, 11-16, **12**, **16**
 Canterbury — 37-8
 Delhi — 164, **166**
 Farnham Castle — 166
 Forth — 23, **24**
 Hindostan — **12**, **13**
 Isis — 16
 Lucia — 29, 32, 35
 Majestic — 17-19, 22, 27
 Minotaur — 22
 Moltke — 35
 Onyx — 23, **24**
 Prince George — 17
 Resolution — 37
 Russell — 22
 Wave — 14-16
Naval Vessels (submarine):-
 Holland — 23
 A-1 — 23
 A-3 — 26
 B-9 — **25**, 26
 B-10 — **25**, 26
 Bremen — 31-2, 35
 C-7 — 26-9, **26**, **27**, 223
 C-11 — 26
 C-30 — 35
 D-4 — 35
 Deutschland — 31
 E-24 — 27
 E-42 — 35
 E-49 — 29-30
 G-11 — 36-7
 G-13 — **29**, **31**, 34, 37, 223
 L-11 — 34-7, **35**, 223
 K-15 — 37, **38**, 223
 U-98 — 35
 UC-43 — 30
 UC-76 — 30
 X-1 — **63**, 223
Navy - D.E.M.S. — *163-4*
Navy - Sunderland — 27, 164, 166, 174
Navy Week — *138, 140*
New Gallery — 168, 181-2, 188, 196, 200, 204
 Crypt Gallery — 168, 182-3, 200
Newlyn Society of Artists — 69, 72, 84-5, 199

Nicholson, B. — 3, 178-9, 181-5, 187-9, 191, **192**, 199-200, 219, 241
Ninnes, B. — 1, 93, 117, 120-1, 133, 135, 137-9, 141, **142**, 146, 164, 168, 183, 187, 190, 194, 196, 200, 202, 205, 207, 236, 242
 The Boatbuilder's Shop — 138, **plate 11**
 In for Repairs — **93**
 St Ives Harbour — *159*
 The Fleet Preparing to Sail — **190**
Nixon, J. — 91, 94, 96, 120-1, 124-5, 149, 236, 242
 The Slipway, St Ives — **97**
Norway Gallery (see New Gallery)

Olsson, J. — 6-7, 40, 42, 51, 64, 70, 76, 78, **79**, 83, 85, 89, 92, 98, 117, 121, 122, 125, 138, 144-5, 149, 160, 162, 194, 202, 205, 208, 216, 218, 236
 Moonlit Shore — **41**
 A Fine Summer Morning — **76**
 Evening Shower off the Needles — **160**
 Moonlit Sea — **209**
Our Girls — **119**, 213-4, **plate 23**

Park, J.A. — 1, 38, 42, 57-8, 66, 68, 70, 72, 74, 78-9, 83, 86, 88, 91-2, 94-6, 101-3, 106, 120-1, 132, 136, 138, 144, 146, 149, 168, 181, 184-5, 187, 194, 196, 199-200, 202, 208, 210, 215-6, 218, 236, 242-3
 Fringe of the Tide — 96, 138, **plate 19**
 The Sloop Inn — **101**
 Down-a-long — **129**
Parkyn, W.S. — 117, 236
Passe, G. — 116
Pears, C. — 168, 173-4, 176, 183, 185, 215, 236, 243
 Longships Light from Land's End — **172**
 Sailing Vessel — **177**
Penwith Society of Arts — 190, 192-4, 196, 198-200,
Phelps, F.C. — 168, 170
Piazza Studios — 40, 53, 73, 102, 184, 198
Pilcher, R. — 2-3, 112-3, 154, 206
Porthleven Church — 154, **155**, 156
Porthmeor Beach - Sand Menace — 170-1, **198**
Porthmeor Galleries — 78-81, 86, **88**, 94-5, 121, 124-5, 135, 168, 181
Porthmeor Studios — 78, 86, **98**, 112, 114, 125, 166, 170-1, 181, 184, 198
Primitive Methodists — 2, 102-5
Procter, D. — 7, 83, 85, 141, 144-5, 149, 183, 185, 236, 243
Procter, E. — 7, 76, 78, 83, 85, 135, 138, 181, 236
Proctor, C. — 60, 64, 70, 88, 96, 98, 103, 127, 138-40, 165
Proctor, S. — 165
Prynne, T. — **146**, **147**

Ranee of Sarawak — 94-5

Ray-Jones, R. — 96, 117, 122, 240
Reeve Fowkes, A.F. — 137-8
Regent Hotel, St Ives — 153
Richmond, L. — 117, 120-1, 128, 132, 137, 144, 158, 167-8, 183-5, 187, 199, 237, 243
 The Harbour at St Ives — **137**
 Smeaton's Pier — *159*
Ridge, H. — 177, 199-200, 202, 204, 241
 Falmouth Docks — **203**
 Boats off Falmouth — **203**
Robinson, H.H. — 51
Robinson, T.H. — 167, 185, 187, 237
Rogers, S. — 101
Roskruge, F.J. — 62, 67, 70, 72-4, 78, 86, 89, 92, 106-7, 120, 122, 133, 164, 199, 237, 242
 Map of the Studios — **75**
Rountree, H. — 101-2, **103**, 167-8, **180**, 182-3, 185, 187, 194, 199, 237, 243
 Gulls in the Harbour — **180**
 Bird Illustration — **186**
Royal Academy
 Banquet — *194-5*
 Exhibitions — 8, 19, 47, 51-3, 57-60, 62, 64, 66, 74, 78, 82-3, 85, 88, 92-4, 96, 98, 117-8, 120, 122, 125, 132, 135-9, 144, 170, 173-4, 183, 218, 224-241
 Members/Associates — 7, 70, 83, 85, 91, 96, 100, 120-1, 132, 135, 144, 149, 157, 162, 184
Royal Cornwall Polytechnic Society — 79, 133, 135
Royal Navy Submarine Museum — 2, 26-7, 35, 63, 66, 207

Scala Cinema — 151-2
Schofield, E. — 141, 145, 240
Scott family — 9, 112
Sedding, D.P. — 55, 237
Seddon, H.P. — 70, 116, 185, 242
Sefton, A. (Fish) — 200, 241
Segal, H. — 2, 184, 186, 188, 191-3, 199-200, 205, 213, 241
 Ben Nicholson — **192**
 African Heads — **200**
Seven and Five Society — 185, 188, 191
Sharp, D. — 57, 89, 117, 121, 144, 149, 154, 164, 183, **184**, 185, 187, 194, 205, 237
 Still Life — 184, **plate 21**
 Children in the Shallows — **155**
Ship Studio — 45, 64, 79, 108, 110, 128, 131, 154, 170, 196, 206
Show Day — 45-6, 50-3, 57, 59-60, 62, 64, 66, 73-4, 78, 80-2, 86, 90, 92-3, 106, 114, 117, 120, 124, 131, 133, 137-9, 144, 146-7, 149, 150, 154, 164, 168, 174, 179, 181, 196, 204-5, 211
Sidgwick, A. — 43
Sidgwick, C. — 43
Simpson, C.W. — 7, 39-51, **43**, **47**, 57, 59, 64, 66-7, 70, 167-8, 183, 194, 200, 208, 210, 215, 218, 237

Kathleen Bradshaw — **44**, *45*
Loading the Carts — *47*, **48**
The Herring Season from My Studio Window — *47*, **48**
The Saddling Enclosure at the Rodeo — **49**
The Line Fishing Season — *57*
Simpson, R. — *39-40, 42,* **43***, 45-6, 51*
 The American — **43**
Slatter family — *39-40, 43,* **108***, 116*
Sloop Inn — *101-3, 139, 141, 196*
Smart, I. — *190*
Smart, R.B. — *1, 6-7, 19, 42, 45-6, 51, 55, 57-8, 66, 74, 80-3, 85-7, 89, 91-2, 94-5, 98, 100-2, 106,* **107***, 117, 120, 122-4, 127-8, 130, 132-3, 135, 137-8, 140,* **142***, 144, 146,* **147***, 148-9, 153, 157, 160, 163-4, 166-8, 170-1, 173-4, 179,* **180***, 181-4, 188, 190-1, 193, 196, 205, 207-8, 215, 218-9, 238, 242-3*
 The Pilot's Boathouse — **plate 12**
 Morning Light, St Ives — **53**
 A Plymouth Crabber off the Mewstone — **80**
 St Michael's Mount from Marazion Marshes — **87**
 St Ives Arts Club — **107**
 Ebb Tide on the Reef — **123***, 170*
 Sea Power — *147,* **148**
 Etching for Catalogue Cover — **150**
 The Technique of Seascape Painting — *6, 122-3, 218*
Smith, M. — *57, 98, 117, 121, 164, 183-5, 187, 238, 242-3*
Society of Marine Artists — *2, 5, 162, 168, 170, 173-7*
Society of Women Artists — *57*
Somerscales, T. — *218*
 Off Valparaiso — **217**
Spencer, S. — *128, 145, 168, 183, 238*
St Ives Arts Club — *51-3, 55, 58, 68, 72, 78, 107, 113, 128*
St Ives Lifeboats — *1, 120, 142-4, 146*
St Ives Mackerel Boats — *213-4,* **cover, plate 32**
St Ives Motor Gigs — *3, 66,* **70***, 82, 118,* **119***, 213,* **214**
St Ives School of Painting — *144, 232, 235*
St Ives Slum Clearance Scheme — *2, 128, 130-1*
St Ives Society of Artists
 Curators — *82-3, 88, 164, 204*
 Exhibitions outside Cornwall
 Birmingham — *85, 135-8, 228-241*
 Blackpool — *135, 138*
 Brighton — *92-4, 96-7, 228-241*
 Cardiff — *136, 183, 228-241*
 Carlisle — *168, 228-241*
 Cheltenham — *64, 66, 91, 135, 137, 160, 228-241*
 Darlington — *168, 228-241*

Eastbourne — *102, 135, 137-8*
Gateshead — *168, 228-241*
Harrogate — *122*
Hereford — *135, 137*
Huddersfield — *91*
Leamington — *135, 138*
Lincoln — *122, 135, 138, 228-241*
Oldham — *122, 133, 136, 145*
Portsmouth — *91-2*
South Africa — *7, 77, 181, 228-241*
Southport — *122, 133*
Stoke-on-Trent — *92-3, 96*
Sunderland — *168, 228-241*
Swindon — *136, 168, 170, 185, 228-241*
Formation — *67-74*
Galleries (see Porthmeor & New Galleries)
Lectures — *71, 76, 89, 181*
Officers — *see appendix 4*
Petition for Royal Charter — *140*
Sales — *78, 82, 86, 92, 100, 120, 124, 132-3, 141, 167, 173, 181, 191, 196, 202*
 1927-1930 — *67-84*
 1930-1933 — *85-100*
 1933-1935 — *117-126*
 1935-1939 — *133-140, 144-150*
 1939-1946 — *163-4, 167-170*
 1946-1949 (incl. split) — *179-191*
 1949-1960 — *193-206*
St Ives Times — *42, 45-7, 49-51, 53, 55-9, 62-4, 66-9, 72-4, 76, 79-85, 88-96, 98-100, 103, 105-6, 109, 112, 114, 118, 120-1, 124-5, 127-8, 130-3, 135, 137-9, 141-5, 149, 151-4, 158, 160, 163, 167-8, 170-1, 179, 181, 183, 187, 191, 193-4, 196, 199-202, 204, 208, 216*
 Art Notes — *127, 157-8, 160*
St Ives Upon A Sunday - poem — *105-6*
Stewart Smith, J.C. — **61**
Stokes, A. — *7, 51, 76, 83, 85, 92, 120, 135, 238*
Stokes, M. — *51*
Studio, The — *6, 92, 108, 113, 157, 191*
Sullivan, Councillor — *130-1*
Sunday Riot (1929) — *105*
Sunderland Art Gallery — *168, 207*

Talmage, A. — *7, 51, 64, 76, 85, 92, 108, 120, 144-5, 149, 238*
Tate Gallery, St Ives — *7, 45, 116*
Thesaurus Group — *207*
Thirkell White, Sir H.& Lady — *108, 109, 112*
Thomas, T. — *119*
Titcomb, J.H. — *53, 73, 101, 199, 240*
 Ponte Vecchio, Florence — **54**
Titcomb, W.H.Y. — *51, 53, 64, 76, 142*
Todd-Brown, A. — *187*

Todd-Brown, H. — *185, 187*
Todd-Brown, W. — *187, 241, 243*
Tourism — *84, 127, 131-2*
Trevessa S.S. — *1, 59,* **60**
Tribe, B. — *200, 205, 241*
Truman, H. — *1, 67,* **68***, 69-74, 76, 78, 83, 86, 92, 94-5, 98, 120, 124-5, 132-3, 136, 158, 207, 215, 238, 242*
 Gorsedd 1933, Roche — **124**
 Old St Ives — **68***,* **132**
 The Wreck of the Alba — **143**
Turland (Goosey), G. — *86, 107, 208, 239*
Turvey, R. — *94, 120, 239*

United Artists Exhibitions — *174*

Val Baker, D. — *194, 199, 201-2*

Walke, A.F. — *8, 135, 239*
 Christ Mocked — **136**
Watt, A. — *117, 137, 140-1, 144, 149, 239*
Watt, J.M. — *117, 140-1,* **142***, 168, 239*
Weatherby, R.C. — *8, 121, 135-6, 138, 144, 149, 183, 239, 243*
Weir, H.S. — *57, 117, 144, 149, 168-9, 185, 239*
 Top Hat — *168,* **plate 27**
 Still Life with Fruit, Pewter and Glass — **58**
Wells, J. — *182-3, 185, 199, 241*
Western Hotel, St Ives — *152*
Western Morning News — *19, 68, 83, 85, 143, 146-7, 155-6, 205, 211,*
White, A. — *67, 216, 239*
 The Harbour, St Ives — **130**
 Barnoon Hill, St Ives — **130**
White, C. — *196, 200, 202*
Wilkins, V. — *202, 243*
Wilkinson, N. — *132, 173, 183, 241*
Williams, K. — *170*
Williams, M.F.A. — *66, 70, 73, 239*
Williams, T. — *7, 76, 85, 89, 92, 120, 122, 127, 135, 138, 157, 239*
 The Quiet Harbour, Mevagissy — *138,* **plate 4**
 Low Tide, St Ives — **87**
 Evening, Mousehole — **plate 20**
Wyllie, H. — *173*
Wynter, B. — *180, 183, 185, 199, 241*
Wyon, Rev. A.G. — *149, 202, 241, 243*

Zeppelins — *30*